MOUNT HOPE CEMETERY of BANGOR, MAINE

MOUNT HOPE CEMETERY of BANGOR, MAINE

THE COMPLETE HISTORY

TRUDY IRENE SCEE

Charleston · London

THE
History
PRESS

Published by The History Press
Charleston, SC 29403
www.historypress.net

First published 2012

Manufactured in the United States

ISBN 978.1.60949.337.0

Library of Congress Cataloging-in-Publication Data

Scee, Trudy Irene.
Mount Hope Cemetery of Bangor, Maine : the complete history / Trudy Irene Scee.
p. cm.
Includes bibliographical references.
ISBN 978-1-60949-337-0
1. Mount Hope Cemetery (Bangor, Me.)--History. 2. Bangor (Me.)--History. 3. Bangor
(Me.)--Buildings, structure, etc. 4. Bangor (Me.)--Biography. I. Title.
F29.B2S25 2012
363.7'5097413--dc23
2012005897

CONTENTS

Preface 7

PART I: MOUNT HOPE CEMETERY IN THE NINETEENTH CENTURY, 1833–1900

The Establishment of Mount Hope Cemetery 13

Early Years 27

Expansion and Development in the Mid-1800s 47

Continued Growth and Cemetery Beautification: Ponds, Ponds and More Ponds, 1878–1889 65

Corporate Benevolence: Mount Hope Donations to the Broader Community, 1860–1900 87

Other Burials of the 1800s 99

New Roads, New Water, New Construction: Mount Hope Approaches the Twentieth Century, 1887–1900 113

PART II: A TWENTIETH-CENTURY HISTORY OF MOUNT HOPE CEMETERY

An Introduction to Mount Hope Cemetery 133

Mount Hope Grounds and Buildings 143

Mount Hope Twentieth-Century Land Transactions 163

Late Twentieth-Century Modernization: Mount Hope Crematory, Mausoleum and Related Developments 171

Twentieth-Century Monuments and Memorials 185

Protection, Repair and Restoration of Mount Hope Monuments 193

CONTENTS

The Famous and the Infamous: Films and "Glamour"
 Surrounding Mount Hope Cemetery 203
Mount Hope Trustees and Personnel: Long Tenures and
 Lasting Links 215
Mount Hope in the 1990s 229

**PART III: MOUNT HOPE CEMETERY IN THE LATE 1990s AND
THE TWENTY-FIRST CENTURY**
Sequel, 1999–2012 237
List of Mount Hope Officers and Superintendents 255

Notes 257
Selected Bibliography 281
About the Author 285

PREFACE

This book was initially written as two separate publications. In the late 1990s I was hired by the Mount Hope Cemetery Corporation to write a history of Mount Hope Cemetery since 1900. The board requested that I limit my work to that era, as an older work or booklet—written by a former longtime corporate treasurer, Albert W. Paine—addressed portions of the cemetery's history before 1900. The board also requested that I limit my book to roughly the same number of pages as had been contained in the earlier work. Paine's book was published in 1907 as a short monograph discussing some of the highlights of the cemetery's pre-1900 history; it is an interesting work that provides solid information on the Corporation's land acquisitions, but it lacks the detail and research methodology of later historians. I, of course, followed the board's guidelines, although I managed to squeeze in much more information in roughly the same number of pages (well, in perhaps in a couple score more) by use of tighter spacing and a larger format than that used by Paine, but of course I could not totally limit myself to just 1900 onward—I added an introduction discussing the cemetery's earlier years.

Even those adjustments left much of the cemetery's history still inadequately covered, at least by my own standards. I continued to occasionally mention to the president of the board, Charles Fred Bragg 2nd and later to his son and successor, John Woodbury Bragg, that I felt that a more complete history should be written, one exploring in detail the earlier decades of the cemetery's history. I also mentioned this on

more than one occasion to the superintendent of the cemetery, Stephen G. Burrill. I kept in touch with some members of the board and the staff after publication of my book *Mount Hope Cemetery: A Twentieth-Century History* in 1999, as besides my historical interest in Mount Hope, like much of the local community I simply find the place compelling and often walk along its avenues. Eventually, in 2010, everyone on the board accepted the idea of a new publication, and I initiated the following work.

Published by The History Press, the following contains my newest project, in essence a prequel to the first book that traces the history of Mount Hope to its origins in the early 1830s, plus a sequel to my earlier *Mount Hope Cemetery: A Twentieth-Century History*, which brings the earlier work up to date. The complete version of *Mount Hope Cemetery: A Twentieth-Century History* is printed herein as Part II, Part I essentially being *Mount Hope Cemetery: A Nineteenth-Century History*. Part III consists of the sequel to the 1999 publication plus various end materials, including a list of Mount Hope Cemetery Corporation officers from 1834. Parts I and III were written in the same style as the earlier work to make for a smooth transition and a coverage of roughly the same depth.

I greatly enjoyed researching and writing *Mount Hope Cemetery of Bangor, Maine: The Complete History.* All of the board members I worked with over the years have proved intelligent, competent and willing to answer any and all of my questions. In particular, I would like to thank John W. Bragg and Charles F. Bragg 2nd the two presidents I worked with on the projects. Charles Bragg died before the current work was undertaken, but in the years since the publication of *Mount Hope Cemetery: A Twentieth-Century History*, Charles Bragg and I became friends, and indeed I wrote the history of his family business, N.H. Bragg & Sons, during the interim. Charles was also instrumental in convincing more than one person that a project dear to both our hearts should be undertaken before his death: an in-depth history of the City of Bangor since 1769. Aided greatly in my endeavors in securing community support for that project by John W. Bragg, that work was published by The History Press in late 2010 as *City on the Penobscot: A Comprehensive History of Bangor, Maine.* I wrote a few other books in the interim as well, but returning to my earlier work on Mount Hope Cemetery has tied up what always felt like a bit of a loose end to me.

Superintendent Stephen G. Burrill proved more than helpful on both Mount Hope Cemetery projects, and I would also like to extend my gratitude to him and his assistant, Edward McCloskey III, as well as board

member Joni Averill White, who (like John Bragg and Stephen Burrill) read the draft of the history. So, too, would I like to thank the staff of The History Press for their support of the book, in particular Whitney Tarella and Ryan Finn, as well as the Bangor Public Library, the Maine Historical Preservation Commission and the Bangor Police Department for allowing us to print some of the photographs herein (many early illustrations of Bangor and its citizens are available at both the Bangor Public Library and the Bangor Historical Society archives). Any errors or omissions remain the responsibility of the author.

The following was written as the preface to the earlier Mount Hope Cemetery: A Twentieth-Century History.

In 1901, the treasurer of Mount Hope Cemetery Corporation, Albert W. Paine, suggested at the Corporation's annual meeting that a history of Mount Hope Cemetery be published. Paine, an attorney of prominence throughout Maine, had served as the Corporation's treasurer for forty-nine years at the time and had long been interested in preserving the cemetery's history for posterity. The Corporation voted to leave the matter in the hands of the Executive Committee. The following year, upon Paine's retirement as treasurer, the Executive Committee voted to procure Paine's history and have it "printed in a convenient form for distribution."[1]

Paine continued work on his history, and in 1903, the Executive Committee authorized President James Adams to make arrangements to have the manuscript printed. The work was not accomplished for some time thereafter, however, and in 1907, the Committee again acted on the matter and voted to "arrange with Mr. Paine to write an historical sketch of the Corporation—to pay for said sketch a sum to be mutually agreed upon—and to have printed such number of copies of the same as the Committee may deem advisable." The Executive Committee made its arrangements, and the history appeared in book form that same year. Sadly, by the time the Committee reported on the book's publication in early 1908, both Albert Paine and President Adams had died.[2]

The History of Mount Hope Cemetery, Bangor, Maine, or simply *Mount Hope Cemetery*, was published in 1907 by O.F. Knowles and Company of Bangor. The 104-page book contained numerous black-and-white photographs and covered the history of the cemetery from 1834 to the early twentieth century.[3] The book remained the only history of the cemetery in book form until the late 1990s publication of this volume.

In the early 1990s, the Executive Committee began the discussion of having an updated history of the cemetery written. In the following few years the Committee explored different options and even commissioned a writer for the project, but with little tangible result. Then, in autumn 1995, the Executive Committee elected to hire a professional historian to undertake the project. I ultimately became the fortunate author selected for the work. Researching and writing *Mount Hope Cemetery: A Twentieth-Century History* proved very enjoyable, as did the process of following the project through to completion—from helping to choose a publisher to providing locations and captions for the numerous photographs selected for the book.

Any errors in the following pages remain the responsibility of the author. I do, however, owe much to the vigilance and keen eyesight of President Charles F. Bragg 2nd and Superintendent Stephen G. Burrill, both of whom read the rough draft submitted in early 1997 and made valuable editorial suggestions, as well as pointed out typographical errors. Executive Committee member M. Ray Bradford Jr. later aided the process by reviewing the revised manuscript. I would also like to acknowledge the help of former superintendent Harold S. Burrill Jr. and Assistant Superintendent Edward McCloskey III, who—as did President Bragg and Stephen Burrill—helped answer my numerous questions and provided guidance in locating various cemetery records. Jennifer Elliott and her associates at Tilbury House, Publishers, supplied invaluable advice and service during the publication process.

Part I

MOUNT HOPE CEMETERY IN THE NINETEENTH CENTURY, 1833–1900

The Establishment of
Mount Hope Cemetery

B y the early 1800s, Bangor, Maine, was a thriving community in dire need of new cemetery space. Caucasians first settled in the area in 1769, and Native Americans had had a strong presence in the region long before that time. The new settlement, situated at the confluence of the Penobscot River and the Kenduskeag River (or Stream), was initially known as Kenduskeag Plantation. In 1791, with about 170 residents, the community incorporated as the town of Bangor under the Commonwealth of Massachusetts, of which Maine was a part until 1820. In 1834, needing a more cohesive and stronger form of local government, the town incorporated under the State of Maine as the City of Bangor. By 1834, Bangor was becoming a booming lumber and transportation center with a rapidly growing population. The city had about 1,200 residents by 1820 and grew to roughly 8,000 residents by 1834, the massive population growth based largely on lumbering and recent transportation developments. The community by the early 1830s had several needs for the new municipality to attempt to meet, one of them being an increased demand for burial space.[4]

Earlier burial grounds established in what became the downtown area found themselves pressed by an ever-growing population by the 1820s. These included a number of small sites located near what became the downtown area, centered on the Penobscot River and the Kenduskeag Stream.

According to one early source derived from oral history, initially one burial lot was located on what became Thomas Hill near Highland Avenue and Highland Street, but it was soon abandoned. One was then reportedly established on either side of Kenduskeag Stream before the first bridge

was built across the Kenduskeag in 1808. Bridging the stream was a major development in Bangor's history, as would be bridging the Penobscot River, as discussed by the author in *City on the Penobscot*, which traces the community's history since 1769. Seemingly both of the newer lots were established before or near the turn of the century.[5]

One of the two newer sites was located near Oak and Washington Streets and was fenced by 1803. The other was established off Hammond Street. Later, during construction to extend what would be Court Street to Hammond Street, "it became necessary to dump the hill into the valley adjoining, on which occasion many human remains were carelessly dumped with the soil," according to Albert W. Paine's *History of Mount Hope Cemetery, Bangor, Maine*, a brief work discussing the early years of Mount Hope. When the disinterments came to the attention of the general public, in large part due to "the exhibit of a coffin protruding from the premises," the practice of casually dumping the graveyard contents ceased. The two cemeteries were then abandoned, or at least largely so. In 1814, the town purchased an acre of land from Philip Coombs for $100 for use as a new burial site and soon stopped using its older location closer to the river. Any and all existing sites were small and overcrowded. The town purchased more land in 1823 near the river, where a depot for rail trains would later be built, but soon the new cemetery was also perceived as taking up valuable land and additional burial space was again needed.[6]

Bangor citizens responded to the ongoing need for interment space by searching for new burial places that would have the potential to meet community needs for decades to come. The first of these new spaces would become Mount Hope Cemetery. But even before the creation of Mount Hope, the young town had to ensure that interments were actually made in official lots and not just in any available space citizens might locate. With cemeteries being small, overcrowded and liable to open and close at what might have seemed near randomness, burying a body in whatever place one might deem suitable was not necessarily a peculiar idea.

Local ordinances in the 1820s had mandated that only the city could approve a burial location. Town selectmen were charged with appointing undertakers and funeral porters (the people who dug graves). Selectmen also had charge of the town's "public burial grounds," as the community's 1829 ordinance termed it, and related matters. Anyone who dug a grave or erected a tomb without permission would be fined five dollars.[7]

In the early 1830s, Bangor leaders sought to meet community needs in a manner heretofore unseen. They took a novel approach in securing land

for a new cemetery and ensuring that their new burial grounds would be something unique on the American landscape. Before the 1830s, and well beyond that in many places, Americans buried their dead at grounds deemed suitable for the dead, often in churchyards or odd public spaces or even simply—especially outside towns and cities like Bangor, which had passed stricter local ordinances—on private (often family) property. Generally, no major efforts were made to make the burial grounds overly welcoming to the living.

During the early years of the 1830s, however, some individuals began to perceive the benefits of creating cemeteries that would serve the needs of the living as well as provide burial sites for the dead, cemeteries that would create green spaces and add to the beauty of their communities. Bangor citizens were some of the first to embrace the new sentiment and would create what is considered the second-oldest garden cemetery in the United States, Mount Auburn Cemetery in Massachusetts being deemed the first. Mount Auburn was established in 1831, only a few years before Mount Hope became a reality, and it seems that citizens of both communities were engaged in planning for their new facilities at about the same time.

In 1833, if not earlier, a group of Bangor residents organized for the purpose of establishing a horticultural society. The members submitted a petition for incorporation to the Maine State Legislature, and on February 28, 1834, the legislature approved their petition. Under the legislation passed by the fourteenth state legislature, the Bangor Horticultural Society, incorporated under that name, received the power "to sue and be sued; to make by-laws for the management of their affairs, not repugnant to the laws of the State; to purchase and hold real estate not to exceed in amount Ten Thousand Dollars, and personal estate not exceeding in value Five Thousand Dollars." It was also entitled to make improvements to its estate "as from time to time they may think proper, and to have all powers incident to and usually granted to like Corporations."[8]

The February 1834 "Act to Incorporate the Bangor Horticultural Society" listed fourteen men by name and recognized that the powers conferred to the society also applied to these individuals' "associates and successors." The first man listed by name was John Barstow, who would prove to be a critical part of the future cemetery's early history; he was followed by John C. Dexter, John Hodgdon, John Barker, Warren Preston, Milford P. Norton, Joseph Treat (another critical person in establishing the cemetery), Thomas Drew, John Wilkins, Albert G. Jewett, George B. Moody, Charles K. Miller, John Stevens and Samuel Hudson, in that order.[9]

The Maine State Legislature instructed the petitioners that any two of the fourteen listed individuals could call the first meeting of the new corporation by giving notice at least seven days before the meeting, stating the time and place.[10] The State did not specify the notification method, but once the society organized, it established the precedent of posting notification of meetings in the local newspapers.

Although the new corporation did, as its name would imply, undertake work with ornamental tress, shrubs and other plants, the group also sought to establish a cemetery in Bangor, one that had already been drawn by early spring by architect Charles G. Bryant. The plans were complete by April 1834, and the organization met to organize its goals. The group sought to establish a large cemetery on the shore of the Penobscot River a few miles from the downtown area, which by 1834 had become congested and had no further space available for burials. The Bangor Horticultural Society negotiated a purchase agreement

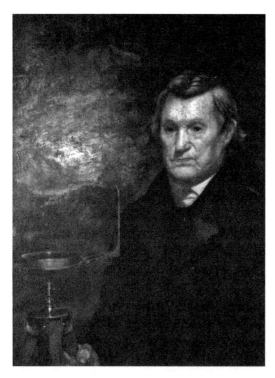

Park Holland was *the* surveyor of early Bangor, and circa 1802–3, he surveyed the lots that became part of Mount Hope Cemetery in the early and mid-nineteenth century. Seen here in a painting by Jeremiah Hardy. *Courtesy of the Bangor Public Library.*

with Joseph Treat, one of the initial petitioners for incorporation. It seems that the organization and Treat had been planning all along to establish a cemetery, although the act of incorporation did not state as much. According to the purchase agreement as recorded in April 1834, the society would appropriate a portion of the fifty acres to be purchased to the purposes of horticulture and the balance to a cemetery. This was in keeping with the plans that Bryant had drawn. Bryant would become a prominent architect in the city—he had also been a leader in a volunteer militia group assembled to fight something of a mob and sailor revolt in Bangor in 1833.[11]

The land purchased was fifty acres of Lot 27, the lot having been previously surveyed by Park Holland, *the* surveyor of Bangor during the earlier years of the century, specifically 1801–2. The land did not include all the property that many people would later associate with the cemetery: land extending from just before what became the main gate on State Street or the "Road to Orono" (or, more commonly, the "County Road," which did exist in 1834), circling around the hill and bordering State Street the entire way, to what would become Mount Hope Avenue (which did not exist in 1834 as a thoroughfare); from there it continued westerly on both sides of the present location of Mount Hope Avenue. Instead, as purchased in the 1830s, the property bordered State Street and the Penobscot River for some distance, cut north across the hill to near where Mount Hope Avenue would be built, extended to a path on the north side of the brook that would become so central to the cemetery in terms of its significance and then turned and extended farther west in that direction than people associate with twentieth- or twenty-first-century Mount Hope Cemetery (MHC). From there, the border turned south back to State Street and the river.[12]

There was some irregularity in the original purchase to compensate for the landscape, the road and some pathways. The entire purchase was roughly forty rods east–west by two hundred rods south–north, or roughly 660 feet by 3,300 feet. According to the deed as ultimately signed on July 14, 1834, and received by the Penobscot County Register on December 24, 1834, Thomas A. Hill and his successors would take possession of an existing house and barn on the property, while Treat would have the right to "use and occupy the land and shore lying southerly of the county road as now travelled across."[13] Later purchases would augment the property purchased from Treat, although another portion, on the northwestern side of the brook, would soon be sold.

The April 23, 1834 agreement, as later recorded, was signed by another group of men than had signed the previous act, although there was some overlap. John Barstow and Joseph Treat were the major signees of the April agreement, and George W. Pickering, Amos Patten, Thomas F. Hatch, Albert G. Jewett, Edward Kent, Asa Davis, W.T. Pierce, H. Pierce, Philip Coombs, Nathaniel Harlow, Charles H. Hammond, John A. French and James Crosby made up thirteen of the thirty-two signers who, in effect, became the proprietors of the cemetery.[14] As true with previous and subsequent acts and actions relating to the cemetery, the men associated with the April 1834 agreement were leaders of the local community.

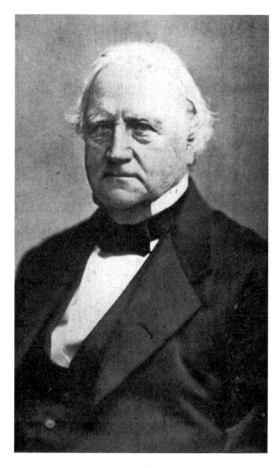

Edward Kent served as Bangor's second mayor (1834–36), as well as a Maine governor, and he aided Mount Hope Cemetery during its early years. He would choose to be buried elsewhere but had an impressive memorial erected at Mount Hope. *Courtesy of the Bangor Public Library.*

The plan as proposed would leave a substantial imprint on the cityscape. Although the area was undeveloped at the time, John Barstow, the first individual listed on the act of incorporation, was to make the actual purchase of the land from Treat (according to the plans as developed thus far), with a significant group of Bangor men to purchase shares of the land assessed at $100 each. There were to be thirty-five shares total, with the purchasers of the shares to serve "as a corporate body," as set out in the original petition for incorporation. Although the actual deed to the property would be given directly to the Corporation by Treat, as planned in April 1834, a grant of a "Deed of the Garden Lot" would be given to John Barstow. Barstow and his heirs would retain the right to reside on the property and build appropriate structures to that end, and in return they were to practice horticulture on the property—thereby increasing the beauty of the site—and set out and maintain a thorn hedge that would serve as a fence around the cemetery property.[15]

The Garden Lot was later identified as containing about six acres of land—and later still as consisting of twelve acres. The discrepancy may be explained by the fact that one of the early deeds specified that about twelve acres of land were included in the garden area, but it also noted

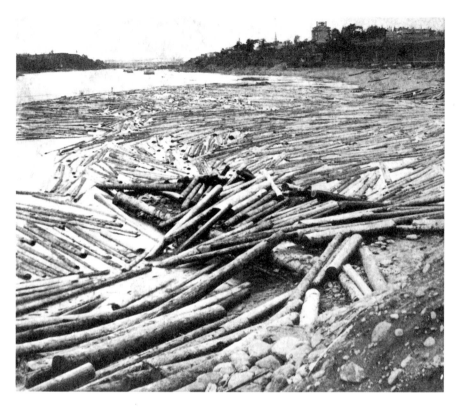

Shown here in the 1800s, the Penobscot River has served as a major transportation route since the 1760s, and after 1800, it became a celebrated log driving river. It contributed immeasurably to Bangor's becoming the "Lumber Capital of the World" during the era. The Mount Hope Cemetery Corporation would purchase land along the river and eventually lease a portion of it to a boom company, the shorefront used primarily for sorting lumber. The cemetery would later construct a windmill on its shoreline. *Courtesy of the Bangor Public Library.*

that this excluded a "swampy area" at the foot of the hill; also, the building already constructed and others that Barstow might construct were seemingly considered part of the twelve acres. No matter the exact boundaries of the Garden Lot and the other cemetery property as understood at the time of the initial lease, the section fronting the north bank of the Penobscot River was not to obstruct a passage across the property, as Joseph Treat was to maintain the use of the property below the brook to the river shore during the remainder of his life, so long as he should desire to maintain that right. The various landscape issues, the extant buildings, the approved living area and the legal restrictions on the site may have reduced the land available as a garden area to being closer to six acres than twelve.[16]

John Barstow was charged with building or having built a public-use street, fifty feet wide on the west side of the property from the County Road to the brook, and also with fencing the perimeter of both sides of the same with a "good fence," as laid out in Bryant's plans. A hedge or hedge and fence combination was to surround the property next to the Garden Lot.[17] Some of the hedging and fencing requirements seemed vague in their written instructions, and they would cause problems for years to come. The problem seems not to have been that Barstow did not meet all the criteria, clear or not, but rather that he seemingly met *none* of it.

Future fencing issues were not known in the spring of 1834, however, and the group, whose membership seems to have changed over time, signed the agreement. The agreement was to go into effect as soon as the thirty-five shares were sold. George W. Pickering, another leading Bangorite, signed the agreement first. Amos Hatch signed the agreement second. He was followed by Albert G. Jewitt, one of the original petitioners, as was Joseph Treat, who signed forth. The fifth person to sign was Edward Kent, Bangor's second mayor (serving as such from 1836 to 1938) and a future state governor. Other names already associated with the project and with the community followed, including several whose surnames would reappear throughout much of the history of the cemetery and the city in the coming century, such as Coombs, Pierce, Dutton, Dwinel, Preston, Crosby, Hill, Harlow, French and Hammond.[18]

The signers were to each purchase a share in the cemetery for $100, but a listing in the ledgers of the cemetery shows that varying amounts were received. Those who initially paid less that the $100 may well have made up the difference at a later date. Asa Davis apparently only paid $50 for his share.[19]

Thirty-two men—many but not all of them having been signers of the previous agreement—applied to a justice of the peace of Penobscot County for incorporation under the general law soon thereafter, stating that they desired to incorporate "as a Body Politic for the purpose of Purchasing Land for a burying ground and making and maintaining the fences enclosing the same." This was a different application than what had been given to the State earlier; it clearly stated their intentions to establish a cemetery. They requested that the justice direct one of their number to contact the subscribers to meet for the purpose of forming said "Body Politic" and choosing corporate officers, as well as for the meeting to take place at least seven days after notice of the meeting was given.[20]

On July 19, 1834, the State of Maine, via Justice of the Peace Jonas Cutting, ordered John Barstow as one of the signers of the petition to

personally notify the petitioners to meet at 7:00 p.m. in Barstow's offices on September 24 of that year for the purposes stated on their petition.[21] Barstow did so.

The petitioners met as scheduled. They chose Edward Kent as their moderator and John Barstow as their clerk. They also appointed a committee to report on the bylaws to be established by the Corporation.[22]

Two days later, the petitioners met and approved a set of bylaws. The bylaws established in 1834 would not change again substantively for the next twenty-four years, and even thereafter some elements of the 1834 bylaws would remain in place. The 1834 bylaws established officers, consisting of a president, secretary, treasurer and an Executive Committee—originally composed of three individuals. The officers would be elected annually.

The president was to preside at all corporate meetings. The president, or the Executive Committee in his absence, could call special meetings as necessary. The 1834 bylaws limited shares in the Corporation to thirty-five, valued at $100 each. Each shareholder, often then called a "proprietor," would have two votes. The annual meeting was set for the second Tuesday of each June, with notification posted in one of the local papers seven days before the meetings. The Executive Committee could fill any vacancies created during the year caused by deaths, resignations or other reasons. Any changes to the bylaws required a majority vote.

Under the 1834 bylaws, the treasurer would collect and hold all corporate funds, "receive and make all conveyances of real estate" and report on financial affairs at the annual meeting upon request by the Executive Committee. The secretary was to keep records at any meetings of the proprietors and of the Executive Committee. The Executive Committee in the 1830s, and for many years into the future, would have "the general superintendence of the concerns of the Corporation, subject to the votes of the proprietors."

As of September, the land for the cemetery still had not been officially purchased from Joseph Treat, and the Executive Committee was to take charge of that critical action. It was subsequently to lay out the grounds into cemetery lots, lease any land not intended for the cemetery and arrange for any monies acquired to be used at least partially "for any fencing and ornamenting the grounds as may be directed by the Proprietors." This was a change from previous plans. It did not, however, rule out that Barstow would be in charge of any such fencing and ornamentation, with Barstow and his heirs, as previously arranged, paying for such in return for their property lease. The Committee would report at annual corporate meetings.

The secretary under the new bylaws was to issue to the proprietors certificates to be signed by the president and the treasurer. The treasurer would certify any sales, and the secretary would record them "in a book" and likewise record any property transfers and issue new certificates to the new assignees.

The proprietors present at that early meeting chose Amos Patten as corporate president, Thomas A. Hill as treasurer and John Barstow as secretary. The first elected Executive Committee members were Patten, Hill and Joseph Treat. They, like the officers, would serve until the following June, when they might or might not be reselected to fill their positions. Although members of the new organization would continue on as the Mount Hope Cemetery Corporation (MHCC) and remain such well into the twenty-first century, in 1849 another group of community members, many of them involved with MHC, established another local organization. This organization assumed the initial title of the group that had established Mount Hope Cemetery: the Bangor Horticultural Society. It incorporated in 1849 under the State of Maine.

In the meantime, other work needed undertaking at Mount Hope. In June 1835, the 1834 officers and committee members were reelected. The secretary had kept himself busy "examining, correcting, and executing deeds and lots" that year, as he would over the next few years, and he was paid $39.00 in 1835 for that year's work to date on the same. The cemetery had spent $8.00 on deed research over the previous year and had paid "Gilman" a little over $9.00 for surveying and copying or drawing plans, plus another $25.00 to Barstow for, it seems, "deed work." Barstow was also paid $35.00 that year for setting trees. The Corporation spent $1.25 on advertising during its first year, paying it to Merchant and Smith, as well as paying $1.00 and $1.50 respectively for other advertising.[23]

In other matters, and also during the years after the incorporation, Thomas A. Hill, in his role as treasurer and "pursuant to the instructions from the Executive Committee...executed to Sam A. Hyde a deed to him of Lot No. 82 and a deed to Ford Whitsman of Lot No. 89, at $25 each." What the cemetery took in payment was not money, however, but rather "an assignment of John A. French's share as proprietor in the Corporation, and the re-conveyance of Lot No. 1 in the cemetery to the Corporation."[24] In other words, the new organization was trying to consolidate its landholdings rather than simply sell lots for immediate profit. Long-term planning would become a hallmark of the Mount Hope Cemetery Corporation actions during its history.

Work in improving the grounds and selling burial plots was underway though in its early stages. The Corporation would spend other monies and energies in the next few years trying to ornament the grounds and make its various sections more readily accessible, as well as trying to beautify the cemetery in keeping with its initial establishment as a horticultural society but doing so within its still limited financial means. In particular, during its first few years, MHCC investigated what species of trees and how many of them should be planted along Western Avenue and along some of the other early roads or carriage ways in the cemetery.[25]

In December 1836, the new MHCC called together what was apparently its first special meeting. Those who attended met at the offices of Philip Coombs, Esquire (many of the men involved in the cemetery were attorneys), in Bangor on December 19 and advertised the same in the *Bangor Daily Whig & Courier*.[26]

The Corporation voted at its first special meeting to create a corporate seal that would feature the Emblem of Hope—an anchor—and bear the words and year "Mt. Hope Cemetery Corporation 1834." The proprietors authorized the members of the Executive Committee to secure such a seal. They did, and the seal remained in use well into the twenty-first century.[27]

Arguably just as important, if not more so, at the same December meeting the Corporation voted to "receive from the lessee" Lot 27, "conveyed to said corporation by Joseph Treat, Esq., a release of all that part of said lot which lies north of a line described in the lease made by said corporation to a John Barstow, as running twelve feet north of the Brook on said lots, and that there upon said Treasurer execute a Deed of said part of said lot to the City of Bangor, the conveyance being requested." Over the following decades, some of the land, in particular land bordering or near the brook—whose course would be modified over the years—would be returned to MHCC.[28] However, due to the current organization of the Corporation and its deed conveyance mechanisms, the Executive Committee followed a rather circuitous route in conveying the land.

Early in 1836, the proprietors called another special meeting at Coombs's office for February 5. The objective of the meeting was to discuss the question of conveying to Philip Coombs land previously leased to John Barstow as recorded by the Penobscot Registry of Deeds. The land in question lay twelve feet north of the brook and followed "the windings of the Brook to a point 10 rods distant from the easterly line of said lot and thence crossing at said Brook and crossing easterly to said line and at right angles thereon."[29]

The Corporation posted notice of the meeting and voted at the meeting that the treasurer execute a warrantee deed to Philip Coombs as just described. According to Penobscot County and later cemetery records, the transfer was made for consideration of one cent.[30] Barstow did continue to occupy the Garden Lot and would do so until 1845 although his tenancy proved a difficult one for the Corporation, but the portion of land described by the February 5, 1836 deed was soon sold to the City of Bangor.

The bulk of the property deeded to the City—land sold more than a year after Mount Hope Cemetery reincorporated and a few years after it initially petitioned for incorporation as the Bangor Horticultural Society—would become and remain part of a new city cemetery, also known as Mount Hope Cemetery or, more properly in subsequent years, as the Mount Hope Cemetery City, Public or Municipal Section. The deed granting the land to the City specified that the property, as previously conveyed to Philip Coombs, contained "30 acres more or less" and that $1,500 had been "paid by the inhabitants of the City of Bangor" for the property. As described in the previous transaction, the property started at a "stake 12 feet north of the brook."[31] The brook would change its course, with some human help, over the next two hundred years, but looking at the southerly and easterly borders of the cemetery decades after its establishment, one can tell roughly where the stake would have been. During the 1800s, the City of Bangor would maintain its portion separately, a situation or division that was—at least to some—visually ascertainable and that created some management problems. Even in the twenty-first century, the demarcation, due to early landscaping and lot layout choices, remained noticeable, although most sections remained aesthetically pleasing to most visitors.

The Corporation completed its land purchases and sales, as well as the leasing of the Garden Lot, and did some basic layout work on the grounds. Thus prepared for its first year of official operations, in terms of burials, it opened the cemetery for lot sales, and on July 21, 1836, the Corporation held a dedication ceremony at the cemetery.

In preparation for the opening, the Corporation began to advertise or post notices in the local papers, notably the *Bangor Daily Whig & Courier* (*BDW&C*). It posted a notice dated July 8, 1836, that would run several times over the next few weeks. In many ways, it was much more detailed than general cemetery meeting records of the era and expressed the desires of the corporate leadership:

> *The Directors of the Mount Hope Cemetery propose offering the Lots at Auction, on THURSDAY, the 21ˢᵗ of July inst., at the same minimum*

heretofore fixed—the bids to be for a choice. The Directors hope that this alteration may be acceptable to those who may be desirous of obtaining lots, and that the sales may enable them to discharge the expenses of improvements already made, and encourage further appropriations for ornamenting an inclosure which, if consecrated to the use designed, will hereafter be visited with increasing interest.

Arrangements are being made for an Address, and other services appropriate to the occasion. The meeting to be half past two o'clock P.M. in the grove on the hill, and the sale to take place immediately after the other services.

The notice bore the names of corporate directors Amos Patten, Thomas A. Hill and Joseph Treat.[32]

A large number of people turned out for the festivities, which were held near the brook in an area that would later hold an administrative building. According to the editor of the *BDW&C*, a rough platform had been built for the occasion under the spreading branches of an oak and festively decorated with flowers. Many "rustic seats" were set out under "the stately oaks and spruce growth." However, it seems that a heavy shower "thoroughly drenched…very many of our fair ladies" on Thursday, July 21, the day set for the ceremony, and the event was thus adjourned until Friday, at which time the women, and seemingly the men, "manifested the true Bangor energy by early attendance at the adjournment." That day proved "delightful," as every seat was filled and "nature crowned every hill and shrub and tree with her most precious and delightful smiles, and every heart seemed to enter deeply into the feelings which an occasion like this, so naturally inspiring." Many a tear was observed during the ceremony and while "the singing, under the direction of Mr. Johnson, echoed among the trees and seemed to lift the soul in raptures and bear it nearer its better home."[33]

Mayor Edward Kent presided. Kent would be active in cemetery affairs for several years, and although he had a monument built in his honor at Mount Hope, he would have his body interred at Mount Auburn Cemetery, the one garden cemetery in the nation deemed older than Bangor's Mount Hope Cemetery.[34]

At the consecration ceremony, Kent spoke "of the propriety of consecrating a spot to the memory" of the departed worthy of those memories. He spoke of the "soul-chilling appearance of our graveyards" and how they "accord not with the feelings of our nature." Mount Hope would be a different type of cemetery, Kent seemingly implied, a place where "the beauties of nature scattered on every hand was calculated to give a chastened and holy calm to the mind, and to lead the thoughts to study nature in her works, and to God as the

Samuel Call was the first person whose body was interred at Mount Hope Cemetery (obelisk, center), although some questions remain about the details of his interment. *Photograph by Stephen G. Burrill.*

great author." As the local editor summed it up, "every heart must have joined the speaker when he set aside that hill—the extended field, the leafy woods, the calm retreat, and the complaining brook, to the service, and the resting place of the dead—*forever.*"[35]

It is unclear exactly where the editor quoted directly from Kent in his coverage of the ceremony, but he seems to have followed Kent's address very closely. It is clear from the editor's words, however, that in the end he felt that he could not convey to the reader just how moving the ceremony had been because he could not truly convey the beauty of the cemetery. He concluded that "I can only say I was enraptured." He also wrote that if he died, as he knew he would one day, he would be comforted by the knowledge of the beauty of the land above his grave—were he to be buried at Mount Hope Cemetery.

Three ministers also spoke at the ceremony: Reverend Frederick H. Hedge of the Unitarian Church and Reverends Swan L. Pomroy and John Maltby of the local Congregational churches. Hymns were sung, and then Edward Kent delivered his address, one that Albert Paine, future cemetery treasurer, deemed "eminently fitted and appropriate to the occasion." Although he would have been just about twenty-two years old at the time, Paine would write in the early twentieth century that he had attended and enjoyed the ceremony.[36] In the meantime, as advertised, lot sales started immediately upon the conclusion of the consecration.

EARLY YEARS

O pening ceremonies may have been over; the work of the Mount Hope Cemetery Corporation was not. Lots previously designated as available for sale went up for auction the day of the dedication and continued to be marketed over the next few years, just as work on the grounds continued. The Corporation entered the late 1830s and early 1840s with the same roster of officers it had in 1836—Amos Patten as president, John Barstow as secretary and Thomas A. Hill as treasurer—and continued to meet at various locations, namely the offices of its officers, generally prominent attorneys and businessmen of Bangor and the region. On occasion it met in the offices of other Corporation members.

Soon after the July 1836 dedication ceremony, the board met on September 2, 1836, at the counting room of Willis Patten at 13 Broad Street, then a bustling waterfront part of the city. The members assembled primarily to discuss "what motion they will take to defray the expenses already incurred and for such improvements as may be deemed proper upon the cemetery grounds," as advertised in the *Bangor Daily Whig & Courier*. The main expense, as revealed at the meeting, was the creation of an avenue from the County Road into and "about the cemetery," as well as the cost of surveying and planning the same. The board decided that it would sell, as soon as possible and deemed proper, some two hundred burial lots. The monies thus received would be used to "discharge expenses already incurred" and cover future expenses for cemetery improvements.[37] Unfortunately, other than for the September 1836 meeting, records from the late 1830s and early 1840s were extremely skimpy,

generally just noting when and where the proprietors met, as well as, at annual meetings, who they elected to the various offices. The Executive Committee continued to have three members, with the biggest change being that while Treat and Hill remained on the Committee, John Barstow was replaced, but not as corporate secretary, by Warren Preston in 1839 and 1840. Further changes in the Committee would occur thereafter.[38]

Judging by some rather confusing notes in corporate books, and according to a later source, the two hundred lots made available to the public after the middle of 1836 were set at a $25 minimum bid. Higher bids would secure a greater selection or a specific lot, were it highly desired and the bid high enough, and the more desirable locations generally did secure much larger bids than those deemed less desirable. Of the two hundred offered at auction, some eighty lots were initially sold for a total of $3,688. Other lots were sold subsequently, and throughout the century the cemetery would enjoy steady lot sales, although the specific number sold would vary from year to year. A standard price was soon set at $30 for a lot, but variations occurred—in some cases, the lots sold for substantially more—and a general price of $225 would be the norm by the close of the 1800s. In general, lots in the mid-1800s were about twenty feet square. Single graves would also be sold as the century progressed, and they were generally less expensive.[39]

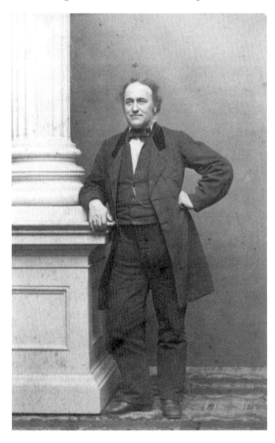

Another of Bangor's civic leaders and businessmen involved in the cemetery's formative years, Samuel Veazie, lumber magnate, would have a town named for him and a tomb constructed that, before his death, would serve as a "receiving tomb" for more than one Bangorite. *Courtesy of the Bangor Public Library.*

Samuel Veazie's tomb would hold the remains of more than one Bangorite before the city built its own receiving tomb on the boundary between the private and public cemeteries at Mount Hope. The tomb is situated on Cemetery Hill, facing the main cemetery road and the lodge built in the early 1900s. *Photograph by Trudy Irene Scee.*

Although not necessarily the first lot sold, the first burial at Mount Hope was that of Samuel Call, brother of Henry Call, who was active in cemetery and local affairs. Samuel Call died on July 9, 1836, and was buried at Mount Hope that year. Henry Call had purchased the lot, no. 101, for his brother's remains, the grave being located at the top of Cemetery Hill, the major hill at Mount Hope. Henry Call died in early 1878 in Providence, Rhode Island, and was buried at Mount Hope on January 23.[40] Before Henry Call's death, however, the proper or allowable use of his lot would become an issue for the MHCC.

General Samuel Veazie had a tomb erected for his use soon after the initial sale of lots was opened. The tomb—the first constructed at Mount Hope—was built on the side of the hill facing the western boundary of the cemetery, and it was later used for a short period as a place to store bodies until Veazie was himself interred. Subsequently, the cemetery and city took other measures for storing bodies. Later requests for tomb construction would find that permission was not necessarily granted.[41]

An issue (if it may be called such) that continued to concern the cemetery board in the 1840s was that of the so-called Garden Lot and its immediate environs. Located at the front of the cemetery grounds and facing the river, the condition of the site and its management was critical to this new venture into horticultural cemetery management. In June 1842, at the offices of Amos Davis, the Corporation voted to establish a committee to review the accounts of the treasurer at an adjourned meeting, to elect officers at that adjourned meeting and, perhaps most importantly, to determine if the conditions of the lease given to John Barstow had been fulfilled. Barstow still served as corporate secretary.[42]

When the proprietors met again several days later, the special committee made a verbal report—which does not survive, as is true for most such business from the era—and requested additional time to investigate the matter of the lease. However, a new group of men was elected into office that day, one selected perhaps to enable the Corporation to address its current difficulties without any appearance of conflict or favoritism: James Crosby replaced Thomas Hill as president, Asa Davis replaced Hill as treasurer and Samuel Thatcher Jr. replaced John Barstow as secretary. Thomas A. Hill stepped down as president and treasurer but did maintain his critical position on the Executive Committee. George W. Pickering and Joseph Treat joined Hill on the Committee.[43]

The Corporation voted that day to grant the treasurer 5 percent of any monies he received from the sale of lots as compensation for his services, as well as voted to enable the Executive Committee to purchase a deed from Joseph Treat for his land "given to make Webster Avenue"—which opened off State Street and would later become part of the main entrance to and road through the cemetery—"if it can be done on reasonable terms." Those proprietors then voted to adjourn again until July 12 at Davis's office.[44]

More meetings followed. The issues proved difficult to resolve, and within a short time the Executive Committee and the treasurer were empowered to settle the Corporation's accounts with John Barstow, "make such agreement as they think proper with him" and report on this at yet another future meeting. On July 30, the Corporation finally resolved to "take the subject of the contract and lease between…John Barstow and the Corporation into consideration and adjust and settle the existing misunderstanding relative to the hedge fence and other matters." They could do so by making a new contract with Barstow, "or by ejecting him from the front grounds and buildings, and leasing the same to some other 'person,' as said committee shall under all the circumstances deem best."[45]

After a few adjourned meetings in 1843, Asa Davis again was selected president and, it seems, treasurer (at least pro tem), while Samuel Thatcher Jr. retained his seat as secretary. In July, Thatcher took an oath of office, and from that point in time, the secretary elected at the annual meetings began taking an oath before a justice of the peace—seemingly always one involved with cemetery affairs—regarding his intention to perform his duties "to the best of his abilities." James B. Fiske swore in Thatcher in 1843. After this seemingly initial oath taking, the Corporation voted to lay a petition from Bangorite Henry Call on the table, seemingly one concerning his already purchased lot and, quite likely, a request to build a tomb on his lot, an issue that the Corporation would address in following years. Besides having purchased a lot for his brother and having fought with Charles Bryant in Bangor's 1833 uprising of sailors and some community members, Call was one of the founders of the Bangor Mechanic Association, an organization with which a number of officers of the cemetery were associated into the twenty-first century. The proprietors then voted to authorize the Executive Committee to have the lots in the cemetery "staked and numbered according to the plans and to propose some mode for dividing [among] the owners of the stock the remaining lots now unsold, or for disposing of the lots in such other way as they may deem" otherwise in the best interests of the Corporation. They were to report on the same at an upcoming special meeting, which the president issued notice of on December 21.[46]

The special meeting was held at the counting room of James Crosby on Tuesday, December 28, 1843. At the meeting, the major issue was determining whether the Corporation would lease a portion "of their land and buildings, and if so, on what terms" and what measure the MHCC would "adopt for the care, protection, and improvement of their grounds." The board met as planned, discussed these and other matters, had Davis fill in as secretary pro tem and voted to meet again four weeks later at the same place on January 25, 1844.[47]

The cemetery, now essentially a decade old, had to revisit the issue of leased land yet again in January 1844. The proprietors finally voted to have the lease granted to John Barstow on December 20, 1834, revert to the Corporation "by reason of the unfulfillment of the conditions thereof." The proprietors furthermore voted to "grant a new lease of a *portion* of the property" granted in that December 1834 lease, "being the Garden Lot containing about six acres," on the condition that John Barstow build or have built a post and rail fence around the borders, as stated in his original lease, "on or before the first day of July next."[48]

Not having set out, or not having done so sufficiently, the thorn hedge "fence" previously required on his lease, Barstow now had to build a post and rail fence and have it planed and painted. The finished fence had to be at least five feet in height in some sections and constructed of cedar eight feet high in other places, the width and thickness to be established by the Corporation; all had to be done to the satisfaction of the Executive Committee. Barstow was also then required to pay all taxes due on the property and release the property from all fines and such that had been levied on the property via its tax assessments. If Barstow failed to meet all these obligations, the Corporation, it appeared, was finally going to oust him and revoke his lease. However, if Barstow did meet the specified conditions—and if by July 2, 1846, he had built a similar fence to separate the Garden Lot from the rest of the cemetery and kept all fencing in proper repair and well painted, as well as continued to pay all assessed taxes on the leased property—the Corporation would grant him a new lease on the land with the terms specified on the original lease, although the size of the leased property would be different. Perhaps uncertain of the outcome of the proposed conditions, the proprietors voted to adjourn until February 29, at which time they adjourned again until March 9, and then adjourned yet again until March 16.[49]

It seems that marauding bovines became an issue. Animals were frequently a problem in downtown Bangor and in the city's residential areas, and it seems that Mount Hope was not immune to the problem. At the March 16, 1846 meeting, those present voted to have all fencing around the cemetery immediately repaired to keep the grounds "safe from all depredations of cattle" over the coming season. Although not mentioned specifically, pigs were also a major issue in the city during the mid-nineteenth century, and local ordinances stipulated how and where the animals of these and other species could be kept—or, more specifically, where they could *not* be kept or allowed to wander, graze or root.[50]

Fencing for protection from animals or for visual impact not being sufficiently underway nor likely, taxes not having been paid and assurances not having been received that these matters would be adequately addressed, the Corporation finally determined in April 1846 that as all efforts with John Barstow had been unsuccessful, the members would settle their accounts with him. The Executive Committee was therefore "to commence a suit against Barstow for the possession of the premises described on said lease."[51]

The MHCC met and adjourned twice more over the next few months, and in June 1844, at the annual meeting, held at the office of John

Crosby—who was selected as president, along with Abner Taylor as treasurer and Samuel Thatcher Jr. as secretary—the Corporation took on two other issues, both of which would be problematic for a number of years. One matter dealt with Henry Call and his lot, the other with the disposition of unsold cemetery lots.[52]

As to the first issue, the Corporation voted at the 1844 annual meeting to "take back the Tomb Lot deeded to Henry Call and lay out another lot for him, on such terms as he shall deem reasonable."[53] Part of the problem, most likely, was a concern that the Corporation had about the creation of tombs, and it would reverse its policy a few times on the subject.[54]

As to the second issue, the Corporation voted at the same meeting to dispose of any lots in the cemetery that remained unsold on terms they deemed "reasonable." The board also voted to "convey to the proprietors of each share a lot in said cemetery, when called for, and charge the same to the grantee an account of said share, at such price as the Executive Committee may deem reasonable, excepting those proprietors who have already received a lot or lots on account of each of their respective shares."[55]

Two months later, on August 12, 1844, the proprietors met again at the Penobscot Exchange Coffee House after posting the time of the meeting in the *Bangor Daily Whig & Courier*. The meeting had to adjourn, however, to the counting room of John Bright. There they heard an account of the situation at the cemetery concerning the state of the cemetery grounds. Captain William Passott, a civil engineer, made a report, or had his report presented for him, along with his plan and survey of the cemetery. The Executive Committee voted that the treasurer be authorized to collect all overdue accounts on cemetery lots and that Passott be hired to aid him and review the record of deeds held by the cemetery compared to the deeds given for lots to verify their accuracy. The treasurer, "when in funds," was to pay Passott and Joseph Treat for "resurveying, lotting, and marking the cemetery grounds."[56] Passott had his own offices, called Passott and Nolt, and the proprietors voted to adjourn to that location on September 16.

In related matters, the proprietors also voted at the August meeting to authorize the Executive Committee to spend up to $100 to repair cemetery fences (such as they existed), do any necessary clearing out (probably of unwanted shrubs and trees and the like) and to have the avenues and paths of the cemetery otherwise improved. The Committee was also authorized to purchase the six-acre plot owned by the heirs of J.P. Boyd "adjoining the cemetery to the North and East, provided the same may be procured as

specified on their report on file, for One Hundred Dollars, and to draw their order on the treasurer for the same."[57]

Discussions apparently continued at the September meeting and at one held in October, but the records for such do not survive—nor do any detailed records for any previous meetings, only the votes as passed by the proprietors. The next annual meeting saw Crosby again chosen as president, John Bright as secretary and Abner Taylor as treasurer.[58] The Executive Committee was comprised of James B. Fiske, Joseph Treat and George W. Pickering. Positions shifted somewhat during the early years, but the same individual members tended to be active on the cemetery board, although the proprietors did not yet use that term, and the same trend would continue into the twenty-first century.

The board called a special meeting for that November and voted to have the treasurer "sell and give a deed to John H. White of the interest which said Corporation has, in and to the Garden Lot lying between the County Road and their cemetery grounds, lately occupied by John Barstow and containing about five acres." This had been posted in the notice of the meeting; the resolve as voted was that that the land would "be used only for agricultural and horticultural purposes and for the erection of two dwelling houses and necessary outbuildings, for the term of fifty years, and a violation of this condition shall operate as a forfeiture of said lot to said corporation." The MHCC did not want any repeats of what had happened with Barstow as the designated initial lessee and then tenant. The proprietors next voted that a dividend be made of the money received from the sale or lease of the Garden Lot, to be distributed among the stockholders according to their respective interests."[59]

In spite of the attempts to clarify all lot owners and the exact location of their lots, as well as to properly survey and number all lots in the cemetery (seemingly both sold and unsold lots), problems still arose. In June 1846, the proprietors had to take a new action at the annual meeting regarding lot ownership—or rather lot occupation. They voted that "the Sexton Joseph Wing be instructed not to allow any lot in the cemetery to be occupied unless said occupant shall have a deed of the same, or shall be authorized by the treasurer to do so."[60]

In an effort also to clarify lot ownership and pay stockholders a dividend again, the MHCC voted in June 1846 to give each proprietor another lot, one in addition to that approved for distribution on June 11, 1844. Again, the grantee would be charged in "account of said share." The shareholders were granted yet another lot in the cemetery at the following annual meeting

in 1847, at which time John Crosby was elected president, Abner Taylor treasurer and John Bright secretary. Fiske, Treat and Pickering remained the Executive Committee. The same officers were elected the following year, and the Executive Committee gave a formal "annual report," a term just then adopted, and it was "read, accepted, and placed on file." Like earlier reports, given annually or not, this and subsequent ones did not survive.[61]

In other matters, the proprietors voted to "advertise and sell at auction twenty lots at Mount Hope Cemetery at a minimum price of thirty dollars, and the bid for choice of lots to be paid into the treasury." The treasurer would take charge of the auction. The proprietors voted again at the next annual meeting to sell an additional twenty burial lots, again by bid at auction. Still, in spite of all their efforts to sell and carefully identify lots sold and unsold, some people during that year had claimed to hold lots at Mount Hope for which they did not hold certification to prove ownership. The MHCC decided to handle the situation by having any person who made such a claim present a statement to that effect in writing and state "by his oath that he has lost his certificate and also that he has never sold, or in any way disposed of his interest in said corporation, but that he is at present the legal and equitable owner of the share claimed." This statement would be "deposited with the treasurer," after which time a new certificate *might* be granted. The proprietors also voted that day that Asa Davis would be allowed to give up the lot he had first purchased, and the treasurer would then "surrender the note given for the same," a vote the Corporation confirmed the following year.[62] Who owned which lots, what might be constructed on cemetery lots and how to ensure that no future mistakes were made in cemetery layout or lot sales and numbering remained concerns from the 1840s to the 1850s.

The year 1849 seems to have been a relatively quiet one for the cemetery in terms of issues requiring new resolutions, and the officers of the Corporation remained unchanged. However, the voluntary or involuntary changing of lot ownership and lots uses would be an ongoing factor for several years, as the MHCC seemingly struggled to determine just what ultimate form certificates and records should take. It would also examine the possibility of purchasing additional land so that it could increase its number of available lots.[63] The board anticipated holding a special meeting to discuss the possible purchase but apparently did not. The cemetery would, however, increase its landholdings in the future.

The year 1849 may not have been problematic in terms of administrative changes at the cemetery, but it was a trying time, to say the least, for the citizens of Bangor. A major cholera epidemic swept through the city, taking 161 people

Charles Stetson, like Samuel Veazie, is associated with a nearby town, and like Veazie, he proved an invaluable contributor to the local economy. *Courtesy of the Bangor Public Library.*

to their graves, many of them to Mount Hope. The number of deaths from contagious diseases in 1849 and over the next few years caused the city to examine its health statutes, including burial practices and site availability.[64]

The Corporation continued to meet at the offices of its members, especially the counting room of James Crosby, during the era, although Crosby did not always serve as president. This was true at the annual meeting in 1850, at which James Fiske was chosen president pro tem. Henry A. Head joined the Executive Committee, while George W. Pickering left it. The Committee that day voted to give each proprietor another lot, a fourth, adding to those granted on June 11, 1844; June 9, 1846; and June 15, 1847. The following June, MHCC voted to give proprietors a fifth lot "when called for."[65] Lots were worth money and were essentially replacing dividends.

In 1851, the annual meeting took place at the office of John Wilkins at the Strickland Block downtown. (The term "block" was used at the time to denote major buildings, generally in use for business and sometimes also for housing.) Wilkins swore in John Bright as secretary once more. Amos Patten became president and John Wilkins treasurer, while General Joseph Treat remained on the Executive Committee along with Henry Head; Fred Lambert also joined the group. The Committee made a report that no longer survives, but extant records show that there was a new development, in that the word "resolves" started to appear, as well as more details as to who made resolutions on which the board voted. In this initial case, acting on a subject raised the previous year, the Corporation "resolved" that it was the "duty of this Corporation to

procure more land and lay out the same into lots, thus, to provide funds for improvements of the lands and lots for our increasing population."[66]

Bangor's population was indeed increasing. The boom that began in the late 1820s and especially in the 1830s had continued, such that in 1850 the city had 14,432 residents and would continue to grow over the next few decades. Furthermore, disease was an ongoing concern in the city, and residents worried that another major outbreak of cholera might occur, causing large numbers of fatalities once again. Other diseases like tuberculosis, chickenpox and the measles also caused outbreaks during various years, and cemetery managers would have had a hard time predicting just when need for their spaces might suddenly increase.[67] Hence, concerns that they might need additional land in the future, even the near future, would have been quite reasonable. The cemetery would ultimately acquire enough land to meet its burial needs into the twenty-first century and beyond. In the short term, the Corporation authorized the Executive Committee to report on possible land purchases at the next annual meeting.[68]

Another issue the board revisited in 1851 was the matter of tombs. The Corporation voted in June that "the building of tombs on the Cemetery grounds" was prohibited. The following year, members upheld the prohibition on tombs, voted that no more tombs could be erected in the cemetery and, to that end, directed that the lots already surveyed and laid out for tombs on the south avenue be resurveyed and laid out for suitable-sized "grave lots and be sold for that purpose." Although it did not come into the discussion, Samuel Veazie already had his tomb erected, and quite likely a few other people had plans to build tombs in the future. Tombs would be major interest points for future cemetery visitors, yet at the time, the Corporation was concerned about their advisability. The Corporation decided in 1851 that any person who already had a claim to a "tomb lot" might, with the Executive Committee's approval, "reconvey" the lot back to the cemetery and be deeded another lot—or he might be required to give up his note for his tomb lots. No other provision was made for lot owners who simply wanted to build tombs as planned on their already purchased lots. They could simply choose to get either a new lot or their money back. It does not seem that they could even keep their original lot and simply use it for regular graves.[69] Within a few years, however, the Corporation would reverse its decision.

Albert W. Paine became treasurer of Mount Hope Cemetery Corporation in June 1852, a position that he held until 1902. His lengthy tenure overlapped with those of John Bright and John's son, Joseph M. Bright, both

of whom enjoyed long years in the position of secretary; it also overlapped with the tenures of a number of corporate presidents. Soon after his term as treasurer of the Corporation ended, Albert Paine published an account of the cemetery's history. In the meantime, there was much history yet to be made during the century.

Amos Roberts remained corporate president when Paine became treasurer in 1852, and Moses L. Appleton (who, along with George Pickering, former mayor Rufus Dwinel and a few other local men, was involved in establishing and developing the Penobscot & Kennebec Railroad during the same era) swore in John Bright as secretary. Henry A. Head remained on the Executive Committee, and John E. Godfrey, local attorney and writer, and Albert Emerson joined him. George Pickering, the local businessman for whom Pickering Square was named and who became mayor in 1853, was in attendance at the annual meeting and made a motion that the Executive Committee be empowered to settle "with the estates of the two late treasurers of this Corporation." Exactly what the settlements involved was not recorded in extant records—either the Corporation owed the treasurers money or the treasurers' estates needed to turn over money that the men were holding for the MHCC at the time of their deaths or leaving of office. The proprietors would make new regulations regarding the position of treasurer in the near future, perhaps as a result of this situation. Almost immediately, at the same meeting, the motion was made that when a person took the position of treasurer he should deposit with the secretary a $2,000 bond, with "sureties satisfactory to the Executive Committee." The motion passed, and following an additional motion by Pickering, the board voted that the treasurer "place on interest any amounts in his hands subject to…the best terms in his powers."[70] As MHCC would retain the same person as treasurer for fifty years, the issue would not need to be revisited for some time.

The Corporation also discussed granting additional lots to shareholders and voted that the Executive Committee "examine and adjust the accounts of General Treat—who had presented the Corporation with a bill the following year which the proprietors had since examined—with this corporation." No word was given as to whether all property payments had been made to Joseph Treat or if the funds involved another matter. The issue with the accounts of the two late treasurers still remained also, and they adjourned until June 22 to address that matter. At the adjourned meeting, the proprietors discussed the now resolved matter, still without recording any specifics in the very truncated records kept during the era. The proprietors also voted at the meeting to assign "to each share, one lot in Mount Hope Cemetery" and authorized the treasurer to convey to each

member the number of lots that he was deemed entitled to by the vote. Thus, all shareholders gained at least one additional lot.[71]

A new problem faced MHCC in 1852, one that the members would not be able to resolve in what they deemed the cemetery's best interests: an encroachment of modernity onto cemetery grounds. An agent of the Old Town Railroad Company had requested the railway be given a right-of-way over the cemetery grounds along the riverfront. The Corporation members discussed this and voted in June 1852 that it was not "expedient or advisable to grant such a right-of-way."[72] A railway would, however, soon be built along the Penobscot River and pass along the cemetery's river frontage. As some of the men involved with cemetery affairs were also involved in promoting railroads in Maine, this presented a rather unique situation.

Not being able to stop the railroad builders, Mount Hope tried another tactic. The MHCC entered an appeal to the county commissioner in the matter of the Corporation's "damages sustained by reason of the *Penobscot Railroad through the lands* of this Corporation." Unhappy that the railroad had won the day, the proprietors further authorized the Executive Committee in June 1853 to "compromise and settle the claim as they deem proper."[73] The railroad as built would follow the Penobscot River for some distance, ultimately be used by various railroad companies, form a major passenger and freight route for decades and remain in use along the waterfront well into the twenty-first century. And in the not-too-distant future from 1852, the matter of eminent domain would confront the cemetery again, on its back boundaries this time, and again the cemetery would find itself hard-pressed to fight the demands of modernity.

The cemetery board adjourned until July 9, at which time it voted (on Albert Paine's motion) that any still "unlotted" lands, and all lands purchased thereafter, be used for the "exclusive purposes of the Corporation and that no divisions be hereafter declared upon or from the property or land of the Corporation, nor any lots be divided among the stockholders, but that the proceeds be exclusively appropriated to the purchases of new lands and to the improvement of the grounds and other purposes connected therewith."[74] The officers clearly did not want any further issues with leasing the Garden Lot or other portions of the cemetery, with conflicting uses with the property, and preferably would have liked to prohibit any encroaches by the general public as well—although in cases such as eminent domain, they often could do little to stop "progress."

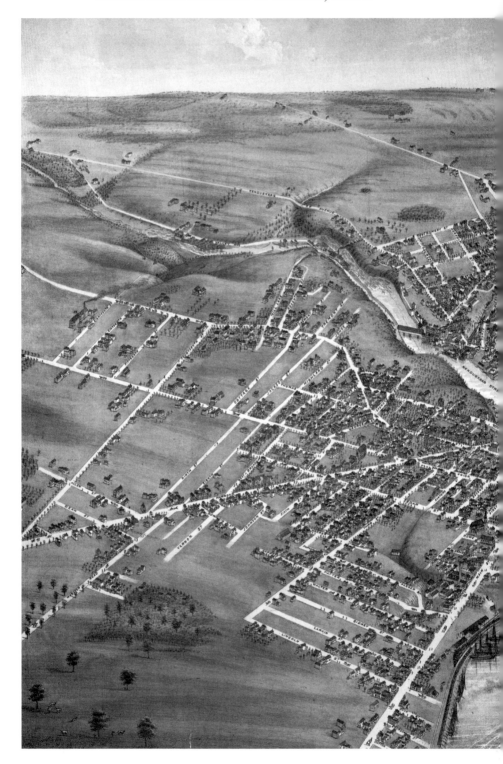

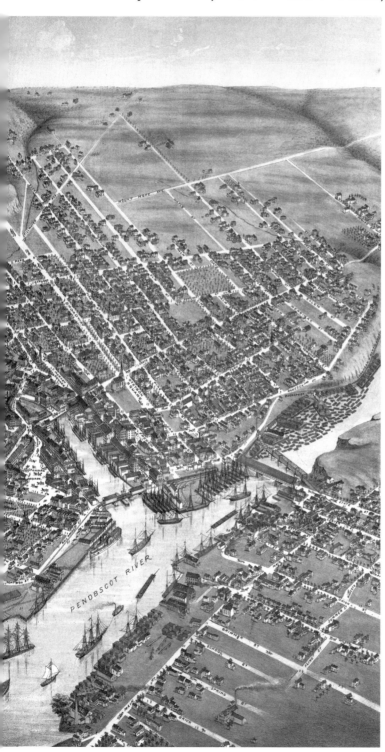

Bangor's busy river and growing economy is evident in this 1870s map, *A Bird's Eye View of the City of Bangor, 1875.* The map illustrates the city's houses, businesses and industries, which were already crowding the hills and shores of the Penobscot River and Kenduskeag Stream, as well as ships traversing its harbor. *Photograph by Trudy Irene Scee of 1875 map owned by Bangor Public Library.*

At the next meeting, the proprietors voted to "dispose of the dwelling house situated in the Garden Lot," another move toward creating the type of cemetery that they envisioned, and in June 1854, they voted "to sell the buildings on the lot purchased of J.H. White and have the same removed." They also voted that day to have measures taken as soon as possible "to have the Garden Lot laid into lots for burial purposes, provided the soil is found suitable for the purpose."[75]

Raising capital for civic improvements by subscription was very popular in Bangor during the 1800s, especially during the early decades of the century, and in essence Mount Hope Cemetery had been established through a subscription, albeit a limited subscription aimed generally at the higher echelons of local society. However, in 1853, Moses Appleton raised the idea of having a larger, more widely targeted, subscription drive—one that would appeal to the general public for the construction of an iron fence along the front portion of the cemetery. Besides opening up participation in the cemetery and its improvement to a broader portion of the community, building an iron fence would create a more substantial, durable and (depending on one's aesthetics) attractive way to protect the cemetery and separate it both from the public road and, now importantly, from the railroad just across the road. To augment the desired iron fencing, an ornamental entryway to the cemetery was advised. Other improvements might also be deemed appropriate, with the money expended on the various projects to be under the oversight of a committee of subscribers.[76]

The proprietors in the early 1850s began to refer to themselves as "members of the Mount Hope Cemetery Corporation." Readings of the annual reports of the Executive Committee, and those of the treasurer, became standard procedure at the annual meetings, although they were not recorded in the cemetery ledgers and did not survive into the twentieth cemetery. This, however, would largely change within the decade—after Mount Hope Cemetery underwent another incorporation.[77]

The members of the Corporation at the annual meeting in June 1854 chose the same roster of officers as previously. However, that September, following the death of James B. Fiske, the MHCC voted in Moses L. Appleton as president. Fiske does not seem to have been buried at Mount Hope, but his son, James R. Fiske, would be interred at the cemetery a few decades later, by which time most individuals involved with the cemetery would choose Mount Hope as their place of interment. Already by the 1850s, many local leaders would choose Mount Hope over other burial options. Perhaps in light of the increasing popularity of the cemetery, the board voted in 1854 to reverse an earlier decision and grant

permission to any person to "build a tomb on the front side of the hill of the cemetery grounds west of the Garden Steps, but the same shall be located and built to the satisfaction of the Executive Committee." (The exact date when these and another set of steps on the hill, Cemetery Hill, were constructed is unknown.) The 1854 change in policy regarding tombs allowed for the construction of the Blake Tomb, only the second tomb to be built by the turn of the century.[78]

Also in 1854, the "Members of the Corporation," using that name, voted to work in conjunction with the City "to prepare a new, suitable and appropriate entrance to the cemetery." Acquiring a suitable and attractive entrance to the cemetery would, however, take much time and effort. Appleton was reelected in 1855, as were Bright and Paine, giving the Corporation further continuity in addressing its goals, be they cemetery beautification or economic stability.[79]

In 1856, the treasurer reported that $1,340 was being carried over from 1855 and that twenty-six deeds to burial lots were made over the previous year, totaling $1,008. The board—consisting of the same officers, with John E. Godfrey, James B. Fiske and Arad Thompson as the Executive Committee—instructed him to invest the money at his best judgment.[80]

The following June, on June 23, 1857, Albert Paine motioned that a new method of conducting or managing the system be established. According to his proposed plan, "the stockholders or members of this Corporation should take measures to surrender the power held by them, or, take such course as will constitute the several and respective lot owners to be members of the Corporation and equally interested in the management of the 'Mount Hope Cemetery.'" For the purpose, the board appointed a committee to examine the matter and bring it into effect. The group then adjourned until June 30, a meeting to which lot owners were invited.[81]

James Fiske opened the adjourned meeting, and proxies were identified for several individuals, including Waldo T. Peirce, E.L. Crosby and John E. Godfrey. Albert Paine appeared with a proxy for A.W. Holden. All proxies were placed on file. A committee that had been chosen previously to investigate a change of management made several recommendations, and the Corporation voted to amend the corporate bylaws.[82]

The proposed changes would give voting rights to all lot owners (not just the original shareholders of the Corporation), would stipulate that all lands currently or in the future purchased by the Corporation be "appropriated to the sale and exclusive use of the Corporation" and would note that "no dividend or division shall ever be made of any such lands or of the money or

Albert Paine
served as a
longtime Executive
Committee
member and
treasurer of the
Mount Hope
Cemetery
Corporation. He
is shown here in
a photograph
included in his
1907 history of
the Corporation.
*Photograph from
Albert W. Paine,*
Mount Hope
Cemetery.

other value received thereafter among the shareholders or members of the Corporation." Rather, "the whole proceeds shall be exclusively appropriated for the purposes of the cemetery." With this change of bylaws, Mount Hope Cemetery would become a nonprofit cemetery, ready to serve the local community in a manner somewhat different than it had previously, although the change would not be immediately visible to the general public. The original shareholders had received compensation in the form of burial lots, but this would not be true in the future. In addition, according to the new plan, another bylaw would be amended such that a majority of members present at any meeting could make alterations as long as due notice were given of said meeting.[83]

To put its new goals into place, the Executive Committee was voted a committee to procure from the Maine State Legislature a new act of incorporation. The Committee was to do so at the legislature's next session. After a vote of those present and a tallying of the proxy votes, a total forty-five votes—a unanimous vote—was made in favor of modifying the bylaws and securing a new act of incorporation.[84]

The measures to reincorporate the cemetery continued, and on February 27, 1858, the Maine State Legislature approved the "Act to Incorporate Mount Hope Cemetery." President Appleton then notified the members of the Corporation that a special meeting would be held on April 17, 1858, to "see if they will authorize and empower their treasurer for such consideration as they think proper, to convey to the Corporation created by the Act of the Legislature of Maine…all the rights, title, and interest that this Corporation has in, and to, any real and personal property, wherever situated or however described, and all monies, demands, and securities," within the provisions of the act to incorporate, "and to take such measures and pass such other votes as under the acts of said corporation may be deemed requisite."[85]

President Appleton advertised the meeting in both the *Bangor Daily Union* and the *Bangor Daily Whig & Courier* for seven days prior to the gathering. The members of the Corporation met as scheduled, with those present being Moses L. Appleton, Albert W. Paine and James B. Fiske, with R. Prescott present for the heirs of one member named Rogers. Those assembled voted to have the treasurer "make, execute, and deliver" to the MHCC as incorporated by the state legislature "a quitclaim of all real estate and personal property, and all right, title, and interest in and to all real estate," and so on as had been proposed in the notice as posted in the newspapers. This would be done "subject to all Deeds and Contracts hereto for made by this Corporation whether the same be recorded or not, said conveyance to be also subject to the payment of said grantee of all debts, dues, demands, and the performance of all obligations and covenants now binding on this Corporation." Furthermore, to ensure that the new Corporation was "forever held harmless" from claims on the previous one, all such properties would "be held, devoted, and applied to the purposes and uses set forth and provided in and by said Act of Incorporation."[86]

After the April 1858 meeting and the acceptance of the proposed changes and the new incorporation act, the old Corporation executed a deed to the new Corporation, the deed being dated June 10, 1858. The MHCC started a new ledger of records, one in keeping with its newest incorporation. The roster of officers did not immediately change; in fact,

it did not change at all for some time. Paine, as mentioned previously, executed the deed of 1858 and served as treasurer until 1902, and Bright served as secretary until 1885.[87]

Newly reincorporated, Mount Hope Cemetery began to work on a new set of challenges while revisiting older ones. By the late 1850s, Mount Hope had become well known to the local community and had also begun to receive attention from afar. How to meet increasing demands for its interment services and please cemetery visitors—and sometimes protect the cemetery from them—would remain crucial issues over the next several decades.

Expansion and Development
in the Mid-1800s

The first regular annual meeting of the reincorporated Mount Hope Cemetery Corporation took place on April 4, 1859, at the Merchant Mutual Marine Insurance Company at 3:00 p.m. The corporate members had met the previous year on April 5 at the same place at 2:00 p.m. to recognize the newly passed charter, approved on February 27, 1858. When they met in April 1859, they voted to organize their new Corporation and elected Moses L. Appleton as corporate president pro tem, Albert W. Paine as treasurer and John Bright as secretary. They voted to have the Executive Committee "accept a deed of property of the old Corporation, to be made agreeably to the provisions of their charter." The meeting left no detailed records, but those present at the 1859 meeting recognized that under the new charter, all lot owners were now automatically members of the Corporation and had the right to vote at the meeting. Moses Appleton declined to stand for office again, and John E. Godfrey was elected corporate president in his place, an office that he held for several years.

The Executive Committee grew in size under the new system, having five members chosen in 1859 instead of three: Solomon Parson, Fabez True, Isaac G. Sprinth, Brad Thompson and F.M. Sabine. This new arrangement—in terms of a numerical increase in members and what would prove to be ever-increasing responsibilities—would last past the close of the century, with some variation.

With the president absent for the next annual meeting, held on April 2, 1860, Solomon Parson, a justice of the peace, served as "chairman" for the

meeting. This was the first located use of the word "chairman," although a reigning president had been absent at many meetings in earlier years. In such cases, a member usually stood in as president pro tem. The following year, as the record stated of the president, "John E. Godfrey [was] in the chair." Over the next few years, the president was sometimes referred to as the chairman of the meeting while still being recognized as the corporate president.[88] Little by little, changing terminology and business practices were making their way into the Corporation and its records.

At the 1860 meeting, the same board of officers was elected, and Samuel Jewitt and James B. Fiske joined True and Thompson on the Executive Committee. The Executive Committee and treasurer's reports were read aloud and accepted, as had become the general practice in recent years, and more details of the meetings made their way into company records. The Committee's report was a verbal one and may not have been written down at all. Certainly it did not get recorded in corporate ledgers—like others during these years.[89]

As the records indicate, the cemetery was doing fairly well financially. In early 1861, the treasury held $1,326, with $1,454 having been received over the previous year. Expenses had included fees for horses and for the undertaker, Chandler Cobb, who was paid $116 for his services, although the records did not specify that the sum was expressly for his work as an undertaker.[90]

As the balance exceeded that "ordinarily required for current expenditures," those present voted that the treasurer place some amount of it in the "Savings Bank," seemingly the Bangor Savings Bank—an institution established in 1852 that survived into the twenty-first century as the oldest local savings bank—"to the credit of the Corporation and subject to the order of the treasury." In 1864, the Corporation voted that the treasurer should place excess corporate funding specifically in the Bangor Savings Bank. The MHCC would maintain a working relationship with the bank throughout the century, although it would conduct business with other banks as well. In the meantime, as the duties of the treasurer had clearly expanded since earlier decades, the Corporation voted in 1862 to pay the treasurer, still Albert Paine, a salary of forty dollars per year.[91]

A change in the Executive Committee included a few new names, still ones associated with business and politics or leadership in the city. Charles Stetson, Charles Hayward and John B. Foster were elected to join Solomon Parsons and James Fiske on the Committee in 1861.[92]

During this era, the City of Bangor employed a city undertaker who worked with various cemeteries, primarily the public ones but also with

private cemeteries as needed. Chandler Cobb served as the city undertaker in the early 1860s and, as far as the private Mount Hope Cemetery was concerned, had "discharged" his duties of undertaker "in an acceptable manner," as the Corporation reported in 1861. The MHCC paid Cobb $116 for the previous fiscal year for his services. The city may have been assessing its options, however, as the board resolved that "a change in the office at this time is inexpedient" and thus instructed the secretary to furnish the mayor of the city "with a copy of this resolve." However, by the spring of 1866, a new city undertaker was in office, William Mitchell, one with whom the cemetery was well pleased. The Corporation voted to express its satisfaction with Mitchell's appointment, as well as "the hope that no removal of him from the office shall be made."[93] This was certainly a stronger endorsement than that previously given to Cobb. However, the situation would deteriorate in the future.

Like certain issues surrounding the duties of the city undertaker, collections for lot sales remained problematic after the cemetery reincorporated. In 1862, the members voted that the Executive Committee and the treasurer should actively "collect the sums due on lots bargained for," And the board instructed in instances wherein "such lots be not paid for in six months after notice by the treasurer, he proceed to sell such lots in the same manner as if no verbal bargains" had previously been made.[94]

Yet in spite of collection difficulties, the treasury continued to hold an excess of funds in the early 1860s, and the treasurer was instructed to invest any extra income. Furthermore, as had been under consideration for years but perhaps not previously feasible, in 1862 the board authorized the Executive Committee to purchase about five acres "lying northerly and easterly, and adjoining the grounds of cemetery, also [to consider purchase of] the lands of Mr. Pratt," northerly and easterly of the land presently under consideration. Both parcels might be purchased as soon as reasonable terms were arranged. The pursuit of additional lands for the cemetery would ultimately require many years to resolve, although during the following year, negotiations for the Pratt property proceeded. The Corporation agreed to give Pratt a deed to a Mount Hope lot, one not to exceed fifty dollars in value, with both parties yet to agree to the particulars.[95] The land would also cost the cemetery money.

The first of the two land parcels referred to in the 1862 records was conveyed to the Corporation in May 1862 by Salathiel Nickerson of Belfast, Maine. The parcel adjoined Lot 27 at the current property line on the east, started on the north side of "the County Road to Orono" (as described in

the conveyance deed), was 8 rods wide and extended north for 121½ rods (or was roughly 132 feet by 1,996 feet) and included a house (called the Barstow House) and a barn. However, according to the deed, Nickerson would have six months to remove the buildings for his own use or they would be forfeited to the Corporation. Nickerson's wife, Martha, cosigned the deed, and the sale was made for $1,200.[96]

The second parcel bordered the first, was deeded in early June, cost the Corporation $950, was the same length as the first and about 4½ rods wide (or seventy-four feet) according to cemetery records (or 8 rods according to the deed) and was conveyed to the MHCC by John Pratt. It bordered land then owned by the City as part of its municipal cemetery. These two purchases were formerly one tract of land, Lot 28, and indeed the line between the two spilt the aforementioned house into halves—the side used as a tenant residence was encompassed by the first deed, and the side occupied or intended to be occupied by the owner was encompassed by the second. Some change in the previous arrangement as to the buildings may have been made over the preceding month, as all buildings still on the property, including the "tenement house," were deeded to Mount Hope. The cemetery thus extended to the east, with the new lands bordered to the south by the County Road or State Street and to the west by the public cemetery, other corporate business continued.[97]

A change in the presidency occurred in 1865 when Charles Stetson was elected to the office. Paine and Bright retained their offices, but there were a few changes in the Executive Committee, as had been true over the past few years. In 1865, Moses Giddings, S.P. Bradbury and Samuel H. Dale were elected to the Committee, joining Arad Thompson and George Stetson.[98]

In 1865, in addition to depositing sums in the Bangor Savings Bank, the board having voted the year before that the treasurer might do so from time to time as designated by the Executive Committee, MHCC elected to purchase seven to thirty United States Treasury notes. The purchase of bonds or notes would become a central part of cemetery financing in subsequent years.[99]

During the Civil War, Mount Hope Cemetery donated land to what became a renowned veterans' memorial and become intricately tied to the project (discussed in a subsequent chapter). It also donated land to the new Home for Aged Women of Bangor and to the older Bangor Female Orphan Asylum. All three donations were for sites in the Garden Lot. At about the same time, another community need came to light: how to safely and securely store human bodies when necessary. After the war ended, the

cemetery helped undertake a crucial building project associated with that need. The Corporation and ultimately the City decided that Bangor needed a "receiving house," or a "receiving tomb" as it would eventually become known, and they decided that Mount Hope was the place to build it.

The City of Bangor still had various cemeteries scattered across the municipality, and during the 1850s, the private Mount Pleasant Cemetery opened on the opposite side of the city from Mount Hope, being located off Ohio Street and closer to the downtown area than Mount Hope. Mount Pleasant would serve primarily as a Catholic cemetery. The number of Catholics in Bangor had increased rapidly over the previous two decades, largely due to an influx of Irish immigrants, as well as the arrival of some other immigrant groups. The location of Mount Pleasant was contested initially by some members of the public who pointed out that other burial places and their occupants had already been pushed out by the increasing demands of the living in the downtown area, but the cemetery opened in 1855 just the same. It, like Mount Hope in previous years, received numerous reinterments, primarily Catholics who had been buried at Bangor's Buck Street Cemetery. In addition to the two major private cemeteries, the City continued to operate other burial locations in addition to its Municipal Cemetery at Mount Hope.[100]

Yet the private Mount Hope Cemetery remained crucial to the city and surrounding area, remaining nondenominational, increasingly known for its beauty and public endowments of land and important for its shared boundary and relationship with the adjacent public burial grounds. As MHC retained a vital position in the region in terms of its location, number of interments and significance on the cityscape, it was a natural choice, one might argue, to consider locating a significant mortuary structure. During the mid-1800s, it became increasingly clear that such an edifice was needed in Bangor.

Bangor needed a place to hold bodies in inclement weather until they could be interred. A receiving house or tomb would allow bodies to be stored inside a sanitary and perhaps psychologically comforting (for the living) facility over the winter or during other severe weather. In climates as northern as central Maine, frozen ground frequently precluded burials during the deep of winter or under other extreme conditions.

Members of the Mount Hope Cemetery Corporation voted in 1866 to build a receiving house on cemetery grounds and to draw from the treasury the necessary funds to design and erect such a facility. The following year, in April 1867, the Corporation decided to apply to the City of Bangor to erect the receiving house, either on "'Mount Hope' or on the public burying

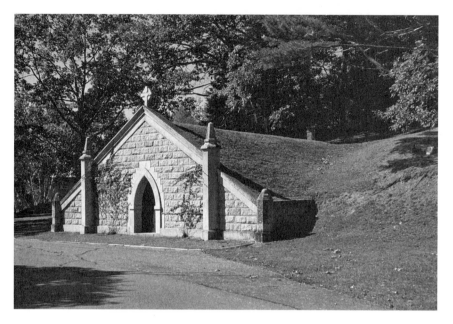

The City of Bangor Receiving Tomb, finished circa 1870, continued to serve the needs of northern Maine throughout the twentieth century, although its use was sharply curtailed by the early 2000s. *Photograph by Richard Greene, Klyne Studio.*

grounds thereto adjoining, and that the [Executive] Committee have full powers to unite with the City in such erection on such terms as they may think expedient."[101]

The tomb was ultimately built by the City in 1870–71. A newly organized city cemetery board reported in March 1871 that the Receiving Tomb had been completed "pursuant of the contract made" and "is a very handsome, convenient, and permanent structure costing within a few dollars of the five thousand appointed therefore."[102] The tomb was indeed all of these things, and it survived well into the twenty-first century with relatively little deterioration.

The roughly forty-five- by forty-nine-feet-square (depending on measuring points), granite-faced and brick-lined building was something of a masterful design and was a difficult project in several ways. All but the face of the building, adorned with a Presbyterian-style cross at its peak and large pillars at either end, was buried in the hillside on the boundary between the private and public sections of the cemetery, fronting on Western Avenue, still the main road through Mount Hope Cemetery. A chimney at the rear emerged from the ground to provide ventilation. Inside, a vaulted ceiling exhibited some

of the building techniques employed since the Late Middle Ages. Wooden shelves were added to hold caskets, the number of niches being fifty-nine plus a workspace to the rear in the mid-twentieth century. Earlier years may have seen more niches. The building had a shallow anteroom before the niche area, which could be used for services and such during inclement weather. During the era, a similar tomb was erected at Mount Pleasant Cemetery, with a Celtic cross adorning its peak, a reflection of its early Catholic and Irish beginnings.[103]

The Receiving Tomb built at Mount Hope was available for use by all sectors of the community. Religion and burial site were not qualifying factors, and the Receiving Tomb or house would come to serve

The inside of the City of Bangor Receiving Tomb in 2011, showing the racks used to hold caskets over the winter or during inclement weather or when, for whatever reason, remains could not be immediately interred. *Photograph by Trudy Irene Scee.*

surrounding communities as well as the immediate Bangor-Brewer area.

With all of its recent changes and additions, MHCC determined in 1867 that it was time "to procure a plan of the cemetery grounds for the use of the Corporation."[104] The Corporation would possibly still have had the older plan as originally drawn by George Bryant, but even if it retained that map, it had since reincorporated, revised its plans for the Garden Lot, added to its landholdings and anticipated adding yet more real estate, donated some land for benevolent purposes and so forth. A new plan would indeed have been advisable in the mid-1860s, some thirty years after the cemetery had opened.

After the Receiving Tomb had been locked for a few years, the author, the president of the Corporation and the superintendent examined it in autumn 2011. *Photograph by Trudy Irene Scee.*

While the new survey and other projects were underway, the Corporation—still under the presidency of George Stetson and with an Executive Committee comprised of Samuel H. Dale, S.P. Bradbury, Moses Giddings, J.S. Wheelwright and Arad Thompson—authorized the Committee in 1867 to enlarge the cemetery by purchasing additional lands "on such terms, and to such amounts, as they find expedient."[105] In other words, if any suitable lands were available nearby, or could be made available, that would satisfactorily augment Mount Hope, the Executive Committee essentially had carte blanche to obtain them. Specifically, the board wanted to obtain the balance of Lot 28, a few parcels of which had been obtained a few years earlier.

The members also voted in 1867 that the Executive Committee would petition the Bangor City Council "to cause to a new road to be made to 'Mount Hope.'"[106] The Corporation, however, would ultimately not be happy with such a road built a few years later.

Meeting as they had numerous times over the previous several years at Merchants Marine Insurance (the "Mutual" having been dropped from the company name), the corporate members convened there again on April 6, 1868. President Stetson served "in the chair" at the annual meeting (as was now standard in practice and language) and was once again voted back into office. The other officers remained the same, although Charles Hayward replaced Samuel Dale on the Executive Committee.

As the cemetery approached the close of the decade, a number of issues remained unresolved. The issue of fencing arose again, and indeed fence and gate construction and repair would remain issues into the twenty-first century, although not to the degree they had been for the 1800s. In April 1869, the MHCC simply voted that the Executive Committee would be empowered "to build such fences around the grounds of the Corporation as they may deem necessary and expedient." They also voted that the "superintendent" (an employee not previously referred to) would be instructed to keep the cemetery gates "open during the day, and closed at night during the spring, summer, and fall months." He was also henceforth empowered to have impounded any "stray cattle or horses found" on cemetery grounds. Animals on the loose were still a problem in Bangor in general, even though the town and later the city had passed ordinance after ordinance aimed at keeping animals from roaming the streets and yards of the community. Apparently, they also presented a problem to the cemetery, which is perhaps less surprising than the roaming of pigs in the downtown area, Mount Hope being surrounded for the most part by relatively undeveloped land in the 1800s.[107]

To resolve ongoing questions about what to do with excess monies in the treasury, the board in April 1869 empowered the treasurer, Albert Paine, to invest any corporate funds "in his hands in such way as he shall deem in the best interest of the Corporation."[108] Just as the Executive Committee was given more authority to make decisions about the grounds, so, too, was the treasurer granted more autonomy in his investment choices.

Of course, the same treasurer had been in place for well over a decade by 1869 and had proved his astuteness in business matters, and in 1870 and 1871, annual meetings were held in the legal offices of Albert Paine. In April 1870, the Corporation, on Paine's motion, voted to approve a land purchase—that of the property of Francis Hathorn (or Hawthorn) 2nd—the deed having recently been conveyed to the Corporation. Hathorn had deeded the property—which bordered the other recently acquired land, running twelve and a half rods (or about 206 feet) easterly along the river and extending northerly for one mile—to MHCC on March 29. This addition to the Corporation completed its ownership of all of the western portion of Lot 28 except for a thin strip of land on the shore of the river directly in front of the former Nickerson and Pratt lands; this small piece subsequently was deeded to the cemetery in May 1896 by Hathorn, whose conveyances also included a small wedge of land enclosed between the road and an upper entrance to the cemetery near the top of the hill.[109]

Although Edward Kent's remains were interred in Mount Auburn Cemetery in Cambridge, Massachusetts, his family had a memorial to him erected at Mount Hope Cemetery. Seen here in 2012. *Photograph by Trudy Irene Scee.*

At the 1871 annual meeting, Paine motioned, and it was so voted, that the Executive Committee be "authorized to exercise their discretion as to the removal of the 'Hawthorne House' and buildings, and repair the same as may be best in their judgment in every respect, placing the same as such part of the Corporation grounds as they may think best." Critically, although a superintendent had been briefly referred to in MHCC's 1869 annual meeting report, which like others of the era remained largely skeletal, it was only in 1871 that the Executive Committee was authorized "to exercise their discretion as to employing a superintendent of the grounds, or employing workmen as heretofore." The "superintendent" referred to a few years earlier was most likely a temporary employee or one of the "workmen" temporarily in charge of a few others. According to the 1871 vote, the "whole duty of taking care of the grounds" would now be "submitted" to the new superintendent or to the Executive Committee, the choice of which to fall to the Committee. The members could choose to have the superintendent oversee the day-to-day running of the cemetery

grounds or share some or all of that with the superintendent, making such decisions as they saw best.[110]

Although MHCC had petitioned that the City build a new road to Mount Hope Cemetery, when a new road was indeed planned, the cemetery did not find the road favorable to its interests. In 1871, after learning of plans for a new road to Veazie, a small town that the cemetery partially bordered and that had only in 1853 become independent from Bangor, the Executive Committee petitioned the City "to discontinue their road from the river road through Mount Hope so far as the road is embraced within the present limits of Mount Hope Grounds." No discussion regarding the road or other development issues was referred to in the 1872 records, which essentially just included the roster of elected officers and the swearing in of the secretary in addition to the notice of the meeting.[111]

George Stetson remained president, Joshua Bright secretary and Albert W. Paine treasurer over the next few years. The Executive Committee did vary in membership. The salary of the treasurer was raised to $100, and in 1876 and thereafter, the treasurer's reports were regularly printed in the ledgers of the Corporation in greater detail than seen previously. They provide glimpses into the daily expenses of running the cemetery.

In 1876, the cemetery had $6,148 on deposit at the Bangor Savings Bank, continuing its now well-established relationship with the institution. The bank would survive into the twenty-first century as the oldest local banking institution, enjoying almost as long a life in the community as the cemetery itself. In addition to the money on deposit at Bangor Savings, the MHCC held a $1,000 City of Bangor bond, as well as other assets, including $180 in cash in its treasury. The treasurer estimated that the Corporation had about 550 lots "unconveyed," although many of them had "been taken up and partially paid for." He also reported that of 383 newly plotted lots, only 3 or 4 had "as yet been sold."[112] Thus, the potential for increased income from lot sales was significant.

Reflecting its garden cemetery basis, the MHCC paid $173 for the planting of trees during the 1875–76 fiscal year, $67 for paving some of its walkways and $475 for unspecified grounds work. No matter its horticultural basis, it remained a business, and the Corporation spent $12 for printing meeting notices and related items and the $100 for the treasurer's salary.[113]

By early 1876, the Corporation held $1,650 of funds in trust, deposited at the Bangor Savings Bank, the interest on which was to be used for the upkeep of specific cemetery lots. Only a fairly limited number of families and individuals had made such arrangements for the care of their lots by

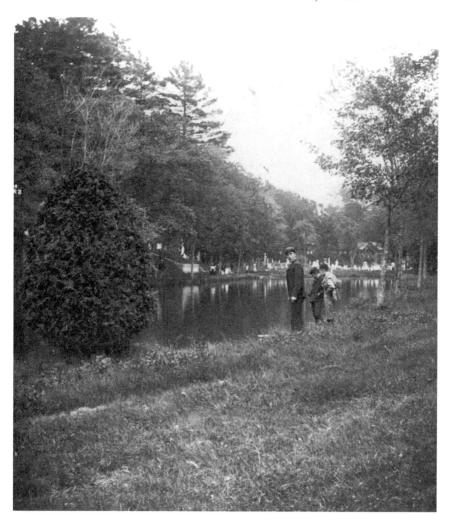

Office Pond, circa 1904, was always popular with cemetery visitors since its creation in the late 1880s. *Photograph by Mount Hope Cemetery staff.*

the mid-1870s, although the cemetery board clearly recognized the value of setting aside such trust funds so that lots would be given consistent care long after the deaths of those individuals who would occupy the specific burial lots. The Corporation had six enumerated trust funds listed in its 1876 records: those for or by Rufus Dwinel at $300, James Veazie at $200, Isabella E. Hitchings and Josiah Towle at $100 each, F. Cates at $50 and a $900 trust for the River Side Lawn Property, a small stone-enclosed area of about 150 feet and divided into six lots with as many owners. Riverside Lawn,

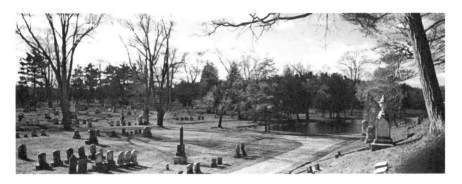

The view from Cemetery Hill showing the original Garden Lot and facing toward the Penobscot River in 1998. Cemetery Hill continued to be the center of interest in the late 1900s and early 2000s, just as it had been the focus from the 1830s into the early 1900. It encompassed the earliest land acquired for the cemetery, as well as some of the cemetery's earliest monuments, both public and private in terms of interest generated and monies raised. The Garden or Office Pond is seen to the right. *Photograph by Trudy Irene Scee.*

as it became known, would eventually hold the remains of, among others, Hannibal Hamlin, local native and first vice president to Abraham Lincoln. Riverside Lawn was located on a portion of the land in Lot 28 secured from Nickerson and Pratt in the 1860s.[114]

The Corporation was doing well financially, but the question arose on the part of Albert Paine as to the safety of its funds in the light of "the frequency of loss to keepers of funds from the danger of robber, fire, and insolvency." This, Paine posited, suggested "the propriety of the Treasurer submitting to the Corporation" a statement regarding "how its cash assets shall be hereafter invested." The treasurer believed that all its funds on deposit with the Bangor Savings Bank, where all its cash assets to date had been kept, were safe. So, too, did he believe that the City of Bangor $1,000 bond and similar papers were secure in the safe of the Kenduskeag National Bank. However, he reported that "a certain amount of danger ever hovers around all such investments," and he felt that he was "not at liberty longer to delay taking the instructions of the Corporation as to the whole subject" and therefore submitted his query to the board. The board then voted that Paine continue the deposits as they were, subject in future to "the written discretion of the Superintending Committee."[115] In future decades, the holdings of the Corporation would become increasingly diverse and investment strategies correspondingly complex.

In the mid-1870s, the annual reports of the Executive Committee finally made it into the regular ledgers of the Corporation, those that survived into the twenty-first century. They provide a wealth of information about the

cemetery. At the very outset of the first such extant report, that of 1877, the Committee reported that the members had toured the grounds during the spring of the previous year "for the purpose of seeing the condition of the avenues and paths, and also of the tress and shrubbery." As a result of that tour, the board decided to replace some dead trees with live ones and add three hundred additional trees to the cemetery. The members made a bargain with Lewis Kittridge to have him supply and transplant the trees, at a cost of "seventy-five cents for each maple, elm, and oak" tree and "forty-five cents each for cedar, fur [*sic*], and hemlock." Driving the bargain further, Kittridge was to ensure that each tree "live to the second year, and if any of them should die during that time to replace them without charge with a continued warranty." Kittridge accordingly set out a total of 345 trees for a total cost of $220. In another matter, the Committee reported that much work had been done to try to destroy anthills and that boiling water had proved "quire successful" in destroying "these little busy bodies" that had taken over some of the lots.[116]

Other matters were likewise addressed. During the 1876–77 fiscal year, the brook was "cleaned out and straightened, to protect the building at times from the washing of the waters of the brook, at an expense of about $14." The Corporation also had a pump placed in the well at the dwelling house on the grounds at a cost of $17.50. It was deemed a deep one, "well stoned, and with the supply of good water at all times—it will now serve not only as a protection to the building in case of fire, but be most useful to the inmates of the house who have heretofore had to resort to the brook when [not] dry, for their daily supply of water." Before the new installation, when the brook was dry, "they had to go to a long distance to the well at the lodge."[117]

The cemetery performed other grounds work during the 1876–77 year. Indeed, knowledge of this work comes from the fact that the Corporation finally decided to include an annual report in its permanent ledger by the Executive Committee, one that went into much more detail about the activities at Mount Hope than could be gleaned from the various votes and resolutions included from the past. This would be true for 1878 and subsequent years as well.

The nature of the site as a garden cemetery is also evident in the 1878 Committee report. As it stated at its outset,

> *Some additional trees have been set out and those that have died during the previous year have been replaced by others. The avenues have been kept in good condition and many of them newly graveled. The grass* [perhaps

for the first time] *has been cut over the past season, and all the grounds including the occupied lots and at no expense to the Corporation save what was obtained in the values of the grass to the person who did the work.*[118]

Essentially, it would seem, the cemetery had been hayed (the grass cut for hay) for use in local agriculture. Before this time, according to the report, "many of the occupied lots have had the grass cut two or three times during the season, leaving the others uncut, the grounds presenting an uncouth and unpleasant appearance."[119] This lack of care in many parts of the cemetery, including portions in which people had already been buried, was behind the drive to convince lot owners to invest funds with the Corporation for the continual upkeep of their lots. Known eventually as "perpetual care," it would take the cemetery many decades to integrate all of its grounds under a uniform care policy.

In 1877, the Executive Committee reported that a contribution had been promised, but not yet received, for building a pavilion or similar shelter to protect cemetery visitors from showers and "the hot summer sun." The cemetery had gone ahead and improved a ledge "on the side of the hill on the avenue passing around the southerly base of the hill." The cemetery had procured plans for the building and had already built "a granite bank wall," both at an expense of $550. Another $250 might be needed to finish the work. The board hoped that the promised contribution would come through, as a pavilion or similar structure would help beautify the grounds and add greatly to the comfort of visitors.[120]

The Corporation may well have received the donation, as by April 1878 it had completed a pavilion on "the southern, or river side of the grounds." The total cost of the pavilion would reach $741. The cemetery apparently had to bank part of the grounds nearby to have the pavilion located where it was. As the secretary recorded in the 1878 report, "As to the ornament and use of this erection, and finish of the grounds, there may be some difference of opinion. The future will better determine the fact." The portion of the grounds used for the structure was "a rough ledgy spot, wholly unfit for burial purposes." The area now presented "a tasteful and beautiful appearance, both as to the grounds and building."[121]

The new structure had been "covered with an ornamental slate roof," and the work had been done "in the best possible manner." The Committee anticipated that the place would "serve as a place of resort by visitors to the grounds, for protection from sudden showers and as a shade from the burning sun; and it will also provide a great convenience at any public

occasion which may be held on the grounds."[122] The Committee suggested that some suitable benches and seats be prepared to accommodate cemetery visitors.

There is some confusion as to whether there was both a new pavilion and a new "lodge" constructed, but the records refer to a back wall that had been constructed of an earth embankment and a stone wall in the "rear of the lodge, so called." There seems to have been two separate structures recently built, and a "lodge," a "pavilion" and a "chapel" were all referred to over the next few years, although identifying them specifically remains problematic. At least one survived into the twentieth century at the cemetery, but it was subsequently sold and removed.[123]

Other ongoing issues surfaced in the next Executive Committee report, included with the annual meeting of 1878. Over the years, several people had requested permission to have some of the cemetery's evergreens removed, those evergreens in particular that were dead or interfering—or so the members thought—with their tending of the lots they owned. Some of these requests were granted, but on a case-by-case basis.

In 1878, however, the Committee members questioned how wise such actions were, for, as they wrote, "The evergreens of our forest are the only things that in nature that speak of continued life during our long and dreary winters." Yet it had recently been "found necessary to remove one of the old settlers, a monarch of the forest." The handwritten report, as all reports at the cemetery were during these years and in a script often difficult for the modern reader to decipher, indicates that the ancient tree had white bark or was possibly a white birch tree. The rather eloquent report, perhaps penned by George Stetson, who signed the reports of the late 1870s and served as corporate president, or perhaps by John E. Godfrey, former corporate president and local writer, stated that the tree had "undoubtedly long since passed the three score years and ten allotted to man." It had "become so decayed that it was considered dangerous and unsafe to prolong its existence." This "monarch of the forest" was thereby "taken down with all due care and reverence for its age and respectability, and its body disposed of in the more modern way of cremation."[124] In addition to including a bit of anthropomorphism, this is the first reference to cremation located in cemetery papers.

Although such reports did not exist for earlier years, it is more than likely that some of the earlier managers of the cemetery, indeed its creators, felt similar bonds with nature. They did, after all, choose to create a garden cemetery and not just the type of dreary burial ground typical for their day.

By the late 1870s, numerous garden cemeteries had been created in the United States, some of them no doubt struggling with the same issues as did Mount Hope and others likely working on issues Mount Hope had already resolved or at least had learned to work with.

Mount Hope Cemetery was on good financial standing in the late 1800s, which in part allowed the Corporation to make some of the changes covered in the late 1870s reports. Appeals for subscriptions were not raised during these years in tackling various issues, as was true for earlier decades and in the creation of the cemetery, in part it would seem because earlier investments and current ones were providing the capital needed for most grounds improvements. In early 1878, the Corporation had funds totaling $8,095; $1,000 of it was invested in a City of Bangor bond at 6 percent interest, $6,487 was on deposit at the Bangor Savings Bank and the treasurer had more than $600 at hand. Among the other assets, the cemetery had received $17.50 from the sale of hay and $1,759.00 from the sale of burial lots. The pavilion, as previously noted, cost $742.00, and the Corporation paid William Lowney $50.00 for the care of the grounds. In 1879, Lowney was referred to as "the former city undertaker," and he probably held that position in 1878 when the report was submitted. There would be a distinct overlap between the cemetery staff, in particular the superintendent, and the office of city undertaker in the late 1800s. The cemetery paid Lowney a separate bill of $352.00 in 1877–78, perhaps for this overlap, and noted that he had been cultivating a portion of the northern grounds for several years; now that he was no longer the city undertaker, the Executive Committee in the spring of 1879 thought that he might "relinquish any further cultivation of these lands" and, if he did, that the lands "should be laid down to grass."[125] Executive Committee and treasurer's reports continued to provide invaluable information about cemetery doings throughout the rest of the century, even though in some instances further information would have been desirable from a historical vantage.

In June 1879, the Executive Committee noted that the grounds had been kept "in their usual good order and condition" over the past year. "The avenues and paths have all been well attended to," the report noted, and additional gravel had been applied to the same where needed. The Corporation had had the grass on all lots cut twice that year. The contrast between the lots whose grass the owner had had cut "many times during the summer" and those whose grass had not been cut was not as marked as in previous years. The Committee thus recommended that such double cutting be done in the future, especially when it could

be done "at so small expense" and give the grounds "a more uniform and beautiful appearance."[126]

Mount Hope Cemetery had more trees "set out" or planted during the upcoming year, in addition to replacing some dead trees with new ones. The Executive Committee recommended that more trees be planted where "they may be wanted in future, as it takes many years of growth of a small tree to become really useful and ornamental."[127] Such trees would indeed be planted.

Other grounds projects would be undertaken in the future, in addition to the continued planting of trees, building of new structures and the increased use of cemetery-wide grass mowing and perpetual care to create uniform grounds. One of the most important and perhaps ambitious projects undertaken in the late 1800s would be work on the brook, including building ponds, islands and bridges, and eventually creating, in a sense, a park within a park. When completed, these creations would make Mount Hope even more notable among New England cemeteries.

Continued Growth and Cemetery Beautification

Ponds, Ponds and More Ponds, 1878–1889

As Mount Hope Cemetery entered the last few decades of the late nineteenth century, it undertook several ambitious projects, in some cases undertaking them entirely on its own and sometimes in conjunction with other organizations or with governmental bodies. It still had to address the everyday needs of the cemetery, such as adding trees and removing dead or deceased ones, selling and collecting funds due on lot sales, working in tandem with the city government in some matters and, both as a necessity and as a matter of cemetery beautification, addressing its water needs and water ornamentation.

The Executive Committee report for 1877–78 referred to a "small artificial pond southerly of the house pond [created] some years ago" and stated that it "adds much to the beauty" of, primarily, its "immediate surroundings, but in a large degree to the whole grounds." Talk had arisen about the possibility of adding another artificial pond to the grounds, one on the "westerly and northerly side of the mount to provide water from the brook or from an 'artificial source,' as long as such a water supply could be acquired 'without too great expense.'" The board was also considering asking the City of Bangor to "improve a small portion of the unoccupied grounds adjacent to the brook where the pond would be located." This would be land on or near the borderline that the private Mount Hope Cemetery shared with the city cemetery. The addition of another pond and other improvements would "add to the whole property, not only [to] its picturesque beauty, but a large number of usable additional lots could be obtained."[128] Apparently,

the area under consideration was low lying and fairly wet and would need substantial earth work to be made usable for burial sites, and even then the board wanted to submerge the least desirable part of the location under water, turning an unusable space into a form of ornamentation.

Other construction and developments were underway or on the planning board. In addition to planning to put some of the most northerly portions of the property under grass or hay cultivation once the former city undertaker had taken his leave, the board considered adding a new avenue to one of the older (in terms of purchase date and occupation) sections of the cemetery.

Referring—for perhaps the first time in extant records—to the "soldiers monument," the monument erected during the Civil War to honor the fallen, the Executive Committee reported that a recommendation had been made "to preserve the vacant and unoccupied land north of, and contiguous to, the soldiers monument to be used on all public occasions, especially on Memorial Days, by opening an avenue next to the grounds now occupied, which may be done without much expense or disturbance of the occupied lots." One year later, the Committee was able to report that the cemetery had indeed opened a new avenue "on that portion of the grounds contiguous to the 'soldiers monument' and next to the lots, on the Northerly side." This would now leave "the unoccupied grounds south of the new avenue and the monument for public occasions in connection with that part of the grounds." According to the 1880 report, "this arrangement and great improvement" had "been accomplished through the kindness of Mr. Charles Collimore," who had agreed to exchange his original lot for another one—thus, it seems, opening up part of the space needed to build the new road.[129]

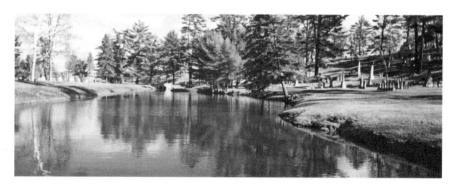

Tomb Pond in the early 2000s. Like other cemetery ponds, Tomb Pond would see some changes over the decades as the brook was rerouted; nature also made some changes. *Photograph by Trudy Irene Scee.*

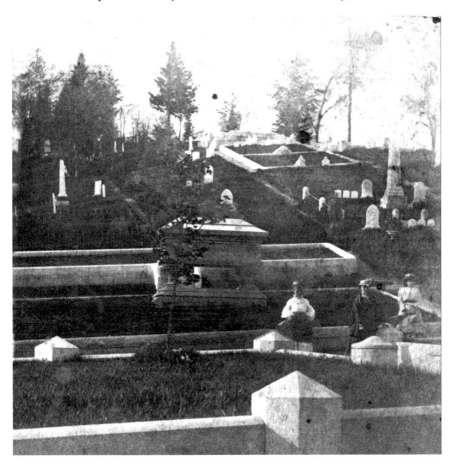

Riverside Lawn would from early on be a popular site at Mount Hope Cemetery, eventually being the resting place of, among others, Hannibal Hamlin. *Courtesy of the Maine Historical Commission.*

Other matters were perhaps more mundane, if still important. A barn connected to the dwelling house on the grounds had been leveled and reinforced during the 1878–79 year "with a good trenched wall." The roof of the barn still leaked, however, and needed to be shingled if, as the Executive Committee generally recommended for all improvements and purchases, it could be done at "no great expense."

How to best achieve smoothly functioning funeral operations was still an issue in 1879. The City of Bangor had a new undertaker, and the cemetery was trying to reclaim its property that the former undertaker had been cultivating (crops unspecified), but just as important, conflict existed between the cemetery superintendent and the municipal undertaker in terms of

the duties each performed. In 1879, the Executive Committee questioned whether some arrangement might be made with the City whereby "all internments not only those in the cemetery but [also] in the public grounds could be done by the superintendant of the Corporation grounds, letting the undertaker perform his duties only by taking the remains to the place of interment." In this way, the duties "could be better performed than at present." At the time, the undertaker and the superintendent were frequently in conflict, with both "digging graves, and after interment, in preparing the lots and clearing up the paths." And, the board opined, "if this whole business devolved upon the superintendant of the grounds, there could be no question as to the duty of each."[130]

Furthermore, the report of the Committee noted that "the qualifications of the person who attends the house of the mourners, and kindly attends to, and provides for, the special wants of the occasion, is a very different order than that of a man who does the manual labor of digging the grave and preparing the grounds after burial." The Committee thus suggested that it would be "better for the superintendant to have the charge of, and do all the work in building up and repairing the lots" after burials, provided that they could make proper arrangements with the lot owners, as "there have been some little complaint made by the owners of some of the lots for excessive charges when the work done by men employed in the grounds." They did not know how well founded such complaints were. However, no matter the degree of justification for them, "the superintendant is obliged to keep a crew of men, larger or smaller always on the grounds," and the Executive Committee believed that the superintendent was better qualified to have the work done than someone who was only "occasionally employed in that business."[131]

As it was, there were frequently problems in such conflicting interment cases with the "grounds [left] unfinished, and having dirt and materials in the avenues and paths, causing an obstruction to funeral processions and visitors to the grounds." The Committee needed to review the matter further and make the necessary decisions, especially the issue of fees levied for the cemetery to do all such work. The board did vote that year to have the Executive Committee "make such arrangements with the City of Bangor with relation to the undertaker and the superintendent of Mount Hope Cemetery Corporation as they see fit."[132] Of course, the talks would not necessarily go exactly as the Corporation hoped.

Another matter that involved the City undertakers, beyond exactly what their specific duties at Mount Hope should be, was that they apparently were, at least at times, collecting fees due the cemetery for lot payments. Lowney,

the former municipal undertaker, was out of town in June 1879 and had not turned over the money that he had collected for cemetery lots over the entire previous year. The superintendent had sold five lots and turned over the money for those ($675), but without the information and money from Lowney, the Corporation did not know exactly how much money lot sales totaled for the year. Plots marketed as single lots sold at a much lower rate during these years (often for $10) than did those designated simply as "lots," which appear to have been in choice locations and for multiple burials.[133]

Furthermore, in regard to lots, many had been "taken and occupied" but not paid for, "either in whole [or] in part, and that by persons who are amply able to pay; it seems their moral obligation ceases with their grief." George Stetson was the signer of the 1879 report and quite possibly the writer of the scathing commentary.[134]

One measure that the Corporation had already taken that would improve cemetery operations was to hire a new, permanent superintendent. The members did so during the 1878–79 fiscal year, employing Thomas Cole and indirectly, as it would turn out, his wife. Cole would remain in his position for several years, overseeing several projects at the cemetery, and he and his spouse both earned praise from the Corporation. Eventually, Cole would also come to serve as the city undertaker, helping to resolve some of the burial issues the cemetery and City experienced conflict over—or, at least, that their employees sometimes did.

One factor that also should be considered in assessing the situation is that by the mid-1870s Bangor had developed its own cemetery board, and it began submitting reports and suggestions. Unfortunately, reports included in the city reports varied from year to year, and details are often lacking in these reports, as with those of the Corporation. City records do, however, show that in 1875 and 1876 the Bangor Cemetery Board was composed of S.P. Bradbury, Albert W. Paine and John S. Wheelwright, all names associated with Mount Hope Cemetery Corporation. In 1875, they discussed a new hearse house being built, much as the MHCC had done. Apparently, a hearse house was built or repaired at this time, but not on corporate grounds. Lowney was still serving as city undertaker.[135]

In 1879, the Executive Committee made a recommendation that "the funds of the Corporation as well as those held in trust for owners of lots be hereafter loaned to the City of Bangor, subject to call, or withdrawal by the Executive Committee, provided an amicable arrangement for the safekeeping and payment for the use of it." Although its members did not discuss the purchase of the same in its records for either 1879 or 1880, the

Corporation held a $1,000 bond from the City of Bangor in the spring of 1880, hence this may have been a partial solution they arrived at for investing some of their funding. However, MHCC had tried to make arrangements over the year with the City to accept some its funds (the Corporation had a $12,767 balance in its treasury in April 1880), but no such arrangements could be made, and the money had been left on deposit in the Kenduskeag National Bank. This was not necessarily a satisfactory long-term solution, however, and the Executive Committee stressed that the Corporation still needed a solid investment plan for funds unneeded for its regular day-to-day expenses. The MHCC also had $7,852 on deposit at the Bangor Savings Bank, as well as $1,650 in trust fund monies, in April 1880. As money for lot sales continued to come in ($1,260 collected for the 1879–80 fiscal year and $1,380 for the following one), and as the emphasis on trust funds for ongoing care of lots increased, the Corporation would have to devote more attention to investment strategies as the decades progressed.[136]

The following year (the 1880–81 fiscal year), the Bangor Savings Bank—where the trust accounts continued to be kept "to the credit of the Corporation" as trustee of the respective designees—suffered some loses. The losses had actually started some years earlier, however, according to the bank's historian, Dean Lawrence, in *Here for Generations: The Story of a Maine Bank and Its City.* Following the recession in the United States during the mid-1870s, the European & North American Railway, or E&NA, defaulted on its loans and stopped paying interest due, and the Bangor Savings Bank held over half of its bonds. The founders of the bank were, in large part, railway promoters, as seen by the overlap in the bank's founders and early leaders and those of Maine railroad companies and as discussed in *Here for Generations* and in the author's *City on the Penobscot.* The European & North American Railroad had also gained control of many of the smaller roads by the mid-1870s, and it is the E&NA name that appears on cemetery and other maps of the era for the tracks running along the shore of the Penobscot River in front of Mount Hope Cemetery.[137] In spite of the bank's problems, the Executive Committee anticipated that all of the Corporation's accounts would eventually "be paid in full." Yet this would seemingly only add to the impetus for securing a strong investment plan. To date, the Corporation still listed trusts for River Side Lawn (the largest trust with $900), the Rufus Dwinel Lot, Isabella Hitchings, Isaiah Towle, Luther M. Pitcher, Ruth Emery and James P. Veazie.[138]

George Stetson remained corporate president as the 1880s opened and Albert W. Paine the treasurer of the organization, and at the annual meeting

Ducks, geese and other waterfowl add to the scenic beauty and the sense of tranquility that Mount Hope bestows on so many of its visitors and, indeed, are often a draw to visitors in their own right. Shown here is Office Pond with the foot of Cemetery Hill in the background. *Photograph by Trudy Irene Scee.*

of 1880, Joseph F. Snow served as secretary pro tem. The meeting saw the seating of J.S. Wheelwright, Charles D. Bryant, John Ricker and James Adams as the Executive Committee.[139]

The newly elected board of 1880 voted immediately, after Ricker made the resolve, that the Executive Committee confer with the city government "for a sale and transfer of the land near the brook for the purpose of making a pond or lake between the City Cemetery lot, and the Mount Hope Cemetery lot." If deemed advisable, the Committee would have a meeting called by the president to discuss terms of any such agreement.[140] This was apparently the same pond that had been under consideration a few years earlier.

The board also voted in April 1880 to have the annual report of the Executive Committee "published in the daily papers without charge." This would become the custom in following years.[141]

Although the members anticipated having the annual report published for free in 1880, the Corporation had paid $40 over the previous year for its advertising or notices. Other expenses included $216 for painting the fence and the lodge or office, $33 in pump expenses, $38 for trees and $4 in lot surveys. The Corporation also paid the secretary $10 for his services and the

Ducks in Stetson Pond. The pond was named after the death of the Corporation president Charles Stetson, who had during his tenure furthered the cemetery's beautification projects. *Photograph by Trudy Irene Scee.*

treasurer $100. These salaries would remain constant until the close of the century.[142] The rate of inflation was low during the late 1800s, so these stable salaries are not indicative of a sinking standard of living pay rate.

The board was pleased with the performance of the new superintendent, Thomas Cole, and reported in 1880 as it would in subsequent years that the grounds had been well tended over the previous seasons. Avenues and paths had generally been kept clean and gravel added where necessary. The fence on the "southern and river side of the grounds has been painted, mainly with two coats of good paint," the Executive Committee reported for 1879–80, and "the old well at the arbor at the front of the grounds has been thoroughly repaired, and a new pump and pipe have been added, and so arranged as to guard most effectively against the frost." Dead trees had been removed and replaced with new ones, and the cemetery had opened the already discussed new avenue by the Civil War monument.[143]

Money, in terms of investments and funds owed, continued to trouble the MHCC in 1880 and beyond. Although the cemetery sold $1,380 in lots for 1879–80, by the spring of 1880, only $760 for them had been collected, although another $475 had come in for lots previously purchased. These monies pertained to lots being paid for, however slowly, but many people still

simply did not meet their financial obligations. The Committee reported in 1880 that there were still "numerous cases in which lots have been taken, and some of them already occupied," yet in spite of numerous attempts to collect overdue payments, the persons involved "either decline or are quite indifferent to the demands. It is a delicate question to act arbitrarily in the matter, as would be done in ordinary business transactions." The parties involved, "in some cases at least, are able to pay for their lots, and they are persons who do pay their ordinary expenses of living" without such long, drawn-out entanglements. The cemetery did resolve in the future not to deliver any deeds for unpaid-for lots.[144] Clearly, cemeteries were in a unique situation when it came to bill collecting. Although it was discussed, the idea of repossessing already in-use property was indeed problematic. But Mount Hope was a private cemetery, gave generously to benevolent causes and sold low-cost single graves. The problem primarily seemed to involve the larger lots, ones people of at least some means had agreed to purchase and had reserved for themselves and their families.

Another problem in terms of managing the public and the relationship with the adjoining municipal cemetery was again at issue in 1880 and would take additional years to resolve. The Executive Committee stated in 1880 that there existed a problem with "the main entrance leading through the public grounds from Mount Hope Avenue [which was not yet a thoroughfare] to the Corporation grounds." The entryway and road as it existed was "a dangerous one at all times, and greatly more so in the winter and during the wet season of the year, and ought to be remedied." The MHCC expressed its hope that "the City will not defer the remedy which should be applied at an early day in the spring."[145]

The Corporation also still wanted, as discussed the previous year, to build a new pond. In order to do so, it needed to work with the City to secure a piece of its property (formerly MHCC property) near the site of the planned new pond, specifically land near the existing brook. Securing this property would allow the construction of the pond at "no great expense" to MHCC and would add "great beauty to the Corporation grounds, and quite much as to that of the public grounds and without any charge or expense to the City."[146] As it unfolded, much work would be done in the immediate area, work beyond the creation of a simple watering hole.

The board held a special meeting in July to discuss the land acquisition. The members met at Albert Paine's office at "nine o'clock in the forenoon," the time at which they had met for their April 15 annual meeting. They met to decide "[i]f the Corporation will accept the deed from 'The City of

Bangor' to the Corporation, of the swamp lands lying north of the brook between the lands of the City and Corporation, with the conditions therein specified." The conditions of the transfer were not transcribed into the report of the meeting, nor its advertisement, but the deed was presented to the meeting and read, and the Corporation voted to sign the deed—already signed by "acting Mayor Silas D. Jones and by John L. Crosby, treasurer of the city, on July 7, 1880." It was then placed on file at the Penobscot County Registry of Deeds, as had been all official deeds to date.[147]

According to the cemetery's newest deed, the City transferred to Mount Hope Cemetery Corporation and to its "successors or assigns forever" a tract of land extending from "the bridge near the receiving tomb to the point where said road [the road "laid down by Thomas W. Baldwin, dated 1880," seemingly the planned new entrance to MHCC and possibly including the Mount Hope Avenue Extension"] strikes the westerly line of said cemetery corporation grounds north of the brook." The transfer was conditional, in that for the deed to be permanently in effect, MHCC was required to build its proposed new road and to keep it in "good repair."[148]

Thus, Mount Hope Cemetery gained the land north and west of the brook, land it needed to proceed with its beautification and utilization plans for the northern section of the cemetery. This included both building a new pond and correcting problems with the entrance road from the public grounds.

The newly acquired (or reacquired) land, as well as being deemed swampy, was mostly flat and low lying and had served as the border between the private and public burying grounds. The main entrance to both cemeteries had been through the shared boundary, and now Mount Hope could extend "a new avenue to the easterly side of the Corporation grounds thence up to the main entrance from Mount Hope Avenue, thus avoiding the steep and narrow road and the dangerous pitch heretofore travelled." Of the new entrance envisioned and then built, the Executive Committee wrote, "This new and circuitous broad avenue adds much to the beauty and safety of travel both through the public grounds and the entrance" to Mount Hope Cemetery.[149]

The following year, the Committee reported, as did the treasurer, that the new boundary road to the brook had cost "$350 (including a bridge over the creek) as the consideration for the land conveyed." The transaction, the Committee noted, allowed the Corporation to gain "quite a tract of land of little value to the City, as the City would not deem it of sufficient importance to make such improvements as would be required to make it eligible for

burial purposes."[150] The MHCC, however, would over the next few years expend the funds necessary to build up the land.

Other costs during the 1880–81 year included $465.00 to the superintendent and others, it seems, in wages, and $4.50 in advertising. Of perhaps greater importance, the board voted that from that year on, the treasurer would be bonded for $10,000.00, and immediately after that vote, they voted that "the Executive Committee be authorized to make such improvements in the grounds as they deem necessary." This last decision would not be carte blanche for the future decades but rather for the upcoming projects.[151]

The private cemetery had only six or eight surveyed regular lots still available on the Penobscot River side of the grounds in the early 1880s; hence, building up the new lands near the boundary with the City had great appeal. The cemetery expected to create numerous "desirable lots" that would sell for desirable rates, the new pond—were it created—adding both to lot price rates and cemetery beautification.[152]

Meanwhile, the cutting of evergreens or of dying trees at the request of lot purchasers continued in 1879–80 and beyond but now required approval from the cemetery. After 1880, tree cutting also had to meet "a requirement that other suitable trees such as maples, elms, and other deciduous trees be set in their places." In some instances, the evergreens were apparently interfering with growing grass on the lots; in other instances, falling or water-saturated foliage reportedly caused problems with cemetery monuments, especially polished marble ones. The next year, further complaints about evergreens were voiced, and some people worried that the trees might fall over and damage monuments or buildings. The year after that, in 1882, the Executive Committee reported that lot owners complained that evergreens shed too much foliage and were thus "preventing the cultivation of open lawns and flowers." The current thought was that removing the trees would "let in the bright sunlight, making more cheerful the sad thoughts connected with the painful loss of dear relatives and friends." The cemetery over the previous year had set out numerous new trees, replaced several old and decayed ones and anticipated that each year would require more or less of the same. In 1883, similar thoughts were voiced, and so it would continue.[153] In later decades, disease would strike cemetery trees, necessitating new and often more aggressive action.

The fiscal year 1880–81 had clearly been a progressive one, and the Executive Committee recommended at the 1881 annual meeting that the Corporation continue to do what it could "to improve and embellish the grounds" and also pointed out recent improvement to its lots by the lot

owners. Some were adding flowers to their sites, flowers being the "poetry of life." Lot owners also seemed to be improving the current situation in terms of paying owed monies, and the Corporation let the public know about its recently acquired land from the City and set out trees on both sides of the new avenue, as well as made other improvements. Soil gained from digging out a new pond could be used to build up the surrounding area for burial lots and beauty spaces.[154]

In October 1881, the cemetery gained a small parcel of land in Lot 26, which would have been on the eastern side of the grounds (the western boundary of Lot 27) near the later-day site of the cemetery lodge, land just north of the brook. It was just about 66 by 82 feet in size. Mr. and Mrs. George W. Herring conveyed the land to MHCC on October 17, 1881, and twenty years later, on October 8, 1901, the Corporation would secure another small piece of property contiguous to that one from R.W. Parker and his sister, land located about 660 feet from the highway and extending back from that point about 412 feet and again being about 66 feet wide, to meet—or border—the other parcel of land. The land was secured primarily for use as work and storage space, not for burial purposes.[155]

By the spring of 1882, the proprietors of Mount Hope Cemetery had agreed to proceed with building the new pond at the northern location, and work on the same was underway. Excavation was nearly complete, and a dam had been constructed with an iron gate at the pond's outlet to regulate water flow. The cemetery had built two new bridges by that spring, both having stone abutments. One had been built just below the new dam and the other "at the head of the pond." Avenue construction seems to have continued, with a new avenue connecting the grounds on the northern side via the main avenue leading from the entrance from the public ground to Mount Hope. This, it seems, would have included the newly constructed area by the pond. Still needed was a large amount of fill to finish building up the area around the pond, soil in addition to that gained from the excavation. Extra fill was being obtained from "a neighboring lot obtained from Mr. Herring: the purchase was made for an ample supply of dirt to complete the filling, having three or more years for removing it" from Herring's property. The soil cost the Corporation $150, and $1,200 had been spent to date on the entire project. The cemetery anticipated the creation of another forty desirable lots as a result of these expenditures and the new land.[156]

The new lots took some time in creating, however, as various delays and difficulties arose. During the 1882–83 year, much work had to be done on and around the new pond. The cemetery rebuilt the dam "in a more

substantial manner." The members also did some work on the new bridges and in "elevating the grounds around the pond, preparing them for lots." However, even with the work of two years and with the outside soil already added, the Executive Committee reported that "considerable more filling will be required to make the lots eligible for burial purposes, and when completed a carriage road on the margin of the pond and ornamentation with trees, it will furnish some forty or more desirable lots, greatly beautify that portion of our cemetery, which is, and should be the pride of [our] City where so many dear and lost relatives and friends repose."[157]

The cemetery had obtained during the 1881–82 year, with the soil purchase, a small parcel of land near the lodge, currently used as a temporary storage for rubbish and carts. It might, however, be better used, the Executive Committee reported, to construct a "Hearse House"—the presently used one being some two and a half miles away. The Corporation planned to approach the City about sharing the burden of building a hearse house on the property. The hearse house, were it built, might be constructed on the public grounds, near the "tomb." This seemingly referred to the recently constructed Receiving Tomb, built just on the dividing line between City and MHCC property. A few years later, a fence was built near the lodge "screening the rubbish and carts." The hearse house had apparently not been built.[158]

All in all, things were progressing nicely at Mount Hope. George Stetson, or another Committee member (although Stetson was corporate president and signer of the report), had written of the cemetery in 1881, "Well may we feel a just pride in that City of the Dead, to which all will sooner or later be called, to join departed friends, as our final home."[159]

The board in the 1880s was quite pleased with the work of the superintendent, Thomas Cole. The Executive Committee noted in 1882 that he had proved "very efficient and devoted" for the previous three years. He had "given his services to the care of the grounds and other duties pertinent" to his position. He had "employed a good and efficient force in the care and improvement of the paths, avenues, and lots, and with his good wife much is done in decoration by the cultivation of shrubs and flowers." The Committee recommended that the care of all buildings also be given to the superintendent, as well as the repair of lots, the second to be done as far as possible after "consulting with lot owners" so that "there may be no deformity in the general appearance of the grounds. [As] now practiced, every owner of a lot claims the right to employ whoever he pleases, and it is often the case that with the hope of saving a small sum in the expense,

an irresponsible person is employed to do the work."[160] Having dealt with the issue of an undertaker versus a superintendent preparing and repairing graves before and after burial, the board wanted to resolve the issue of different people being in charge of day-to-day maintenance of cemetery graves. It seems likely that Cole had taken on the job of the municipal undertaker or superintendent by this time, as friction between the respective duties of the city undertaker and the superintendent of Mount Hope seem to have become much less extensive.

The cemetery spent a relatively large amount of money during the 1881–82 fiscal year on maintenance and improvements, but in April 1882, it was proud to state that it still had cash assets of almost $11,203. Along with its $1,000 City of Bangor bond, the Corporation held a $1,000 bond from the Town of Bucksport. The corporate trust fund maintained for individual lots now reached $2,000. The Executive Committee advised that individuals make such trusts, "leaving a suitable sum that will insure the proper care of their lots for future time. The living pass away, and the dead are forgotten as evidenced by the dilapidated conditioned and uncared for appearance of many a lot in our cemeteries occupied by those who once were among our most wealthy and respected citizens."[161]

Although the Executive Committee in early April 1882 referred to American cemeteries in general when members wrote of untended graves, the Corporation met again a few weeks later to consider revising its bylaws. It specifically wanted to change one section of them to read:

> *All improvements and work in the grounds shall be done by the superintendant of the Corporation unless a written permission is granted to the owner of the lot by the Executive Committee to do his own work, and in that case the superintendant shall have the immediate supervision of the same, and in all cases, the work is receive the approval of the Executive Committee.*[162]

However, an opposing "remonstrance signed by members of the Corporation" was presented "in opposition to a change of the By Laws."[163]

The special meeting adjourned until May 20. At the special meeting, which a later report said was widely attended, the Corporation decided to form another committee to investigate the proposed bylaw revision. The new or special committee was composed of John E. Godfrey, Joseph F. Snow, Joseph Carr, Irving W. Coombs and Albert Wakefield. The committee was to report at the next annual meeting, hold a public meeting or hearing and publish notice of the time and place of the same one week before it

The chapel or another outbuilding constructed in the late 1880s, as printed in Paine's monograph, 1907. A number of lesser cemetery buildings or structures were built, with the details being lost to time, but some of them apparently served more than one function during their existence. *Photograph from Albert W. Paine,* Mount Hope Cemetery.

convened. No record of such a meeting has been located, and none was recorded in cemetery ledgers.[164]

Seemingly, no action was taken regarding the proposed revision in the months following the two 1882 special meetings. Then, at the annual meeting in April 1883, the board voted to indefinitely postpone the issue of revising the bylaws. It also voted to have the treasurer's report published in the Bangor daily papers. It adjourned for a few weeks, met again at the Common Council Room at the city hall and voted then to hold all future annual meetings in the Common Council Room. In addition, the Corporation voted that any authorized representative of a lot owner would have a vote at the meeting. Those present also elected J.S. Wheelwright to the Executive Committee when Abram Moore resigned from his seat and also elected the officers for the upcoming year.[165]

By early 1884, work on the new pond and the surrounding area had been completed and the nearby grounds seeded with grass. In addition, a "carriage way" had "been made and graveled on the margins of the pond." In the near future, the now improved grounds would be divided into lots in such a "tasteful manner" as to "command good prices." Most of the lots in the then central and front part of the grounds had already been sold by 1884, according to the Committee members, thus increasing sales potential

for the new area; the group anticipated that such sales would more than pay for all the work in the northern section: the pond, avenue, bridge, dams and other construction. The bridge crossing the brook at the upper end of the pond had been finished that year with "good stone abutments, and railed and painted, [and] a good substantial walk" had been built "on the small island in the pond." A few other improvements would be made in the upcoming year to finish off the project.[166]

Also by 1884, the Corporation had added $6,000 in water bonds from Stillwater, Maine, to its two separate $1,000 bonds from the City of Bangor and the Town of Bucksport. Its $8,000 in bonds were augmented by $1,869 on deposit in the Bangor Savings Bank and $544 in the hands of the treasurer. Lot sales had hit their highest level in terms of incoming money (in spite of comments that most lots in the front and central portions had already been sold) in the 1883–84 fiscal year. Sales of lots fell a bit the following year, but still brought in $1,535 along with some payments on lots previously sold. Another $1,500 was overdue, and the Executive Committee commented that this was "a large sum for charitable purposes, especially so when the parties are apparently able" to make the payments due.[167]

By the spring of 1885, MHCC had $3,527 in trust for the care of individual lots, and the Executive Committee recommended that the treasurer open separate accounts for the individual trusts, "crediting the deposits and the yearly income from the same, and charging what may have been expended from time to time for the purposes intended by the owner and approved by the Executive Committee, thus clearly defining the interest in the fund rather than keeping the individual accounts with the bank as now practiced." The Committee was not finding fault with past practices but instead wanted to initiate the changes to keep the trust accounts in a more "mercantile manner so that anyone may at a glance see where the several interests of the Corporation and of individuals consist."[168]

The following spring, as the treasurer reported on April 5, 1886, MHCC had $4,227 on deposits at Bangor Savings Bank "in separate books, one for each separate fund." Total corporate assets at the time were $17,521. At an adjourned meeting held on April 18, the Corporation voted to secure "suitable account books for the use of the treasurer" and, at another adjourned meeting on April 19, discussed further just how the various accounts might be best maintained. At that meeting, the special committee previously appointed recommended that the proposed bylaw amendment be made, with the Corporation being responsible for all monies reserved for trust purposes, and that the proposal should be amended to add that MHCC

"will guarantee 4 percent interest on the same, until otherwise voted by the Corporation." Specific requests by investors as to how their money might be invested could still be made under the proposed changes, but if accepted, such funds "shall be governed by the direction of the giver in writing."[169] In other words, individuals could choose their own investment strategy, but they would have to do so in writing and probably at their own risk.

Another problem had confronted the MHCC in the spring of 1885. At that time, a case that concerned the board was pending before the Court of the County Commissioners. A petition existed to extend Mount Hope Avenue from its current endpoint near the back entrance to the cemetery to pass through both the public and the private portions of Mount Hope Cemetery. Understandably, the board had no desire to see the grounds broken in two by a major public road. Many proprietors also voiced their objections to the road extension and thought that it would be "detrimental to the interests of the Corporation, requiring fences to be built on the side[s] of the avenue."[170] And, of course, the cemetery had also just recently put so much time, effort and money into building the new pond, carriage road, bridges and such in the northern section of the grounds, in an area that would be close to the new public road.

Opponents further argued that dividing the cemetery would make the section north of the proposed road "of little value if any for burial purposes, requiring ere long the purchase of contiguous land for the enlargement of the Corporation grounds."[171] Indeed, the Corporation would buy more lands in the future.

Proponents of the road argued that extending Mount Hope Avenue to "Veazie" (the name of the town perhaps in quotes as the town had only in 1853 separated from the City of Bangor, before that date having been Ward 7 of the city) was a safety issue. Proponents, or some of them, apparently had concerns that the new railway built along the river bank and the engines traveling the route presented dangers to people using the existing road to travel to Veazie.[172] The Corporation had fought to keep the railroad from being built along its front border; now it was threatened on its current back section. Eminent domain confronted the cemetery once again. And once again, the cemetery lost the battle.

Yet the issue of the road was not a new one in the mid-1880s. The then newly formed City Cemetery Board had discussed and recommended the road extension a decade earlier. In 1875, the board, composed of S.P. Bradbury, Albert W. Paine and J.S. Wheelwright, each associated with Mount Hope Cemetery, had voiced its support for extending Mount Hope Avenue

to the town of Veazie. The board argued that it would make operations easier for the public cemetery at Mount Hope and allow people to use the road year round for travel. It anticipated that the road might be built during 1876 and noted in March 1876 that plans had been drawn as to its general layout. The only problem with the project, according to the cemetery board's annual report, was that Veazie was not quite ready to proceed.[173]

But protest did arrive, and quite likely slowed the project. However, by 1886, the road had been formally surveyed and laid out; as planned, it would cut through "the back or middle part of the grounds" of the Mount Hope Cemetery. The Corporation expected it to be built by the City during the coming year. The Executive Committee therefore recommended buying land north of the new road instead of purchasing other available or potentially obtainable lots.[174] Securing land north of the new road was currently of greater import than that of other nearby properties that might become available.

In another matter, the Corporation did want to utilize urban progress and to bring that progress right to its grounds. The City of Bangor had recently put its "Holly Water System" into operation, utilizing a dam on the Penobscot River, new turbines and an extensive piping system to supply water to residents and businesses alike. The system had been started in the mid-1870s, and the city had focused much of its development initially on providing fire suppression needs and safe drinking water; thus far, the system was not available everywhere and was optional where it was available. But the system promised to supply Bangorites and industry with all their water needs in future years.[175]

In 1885, the Executive Committee reported the introduction of the "Holly Water so called, would be a great acquisition in supplying a needed want for the ponds in dry season, as well as for fountains, and watering shrubs and flowers." The Committee anticipated raising enough money through subscription "from those who take an interest in the beautiful grounds of Mount Hope Cemetery for laying a main pipe from the waterworks [on the Penobscot River at the dam], the city might furnish the water free to all cemeteries. The Corporation should then make the distribution in the grounds." George Stetson still headed the Executive Committee and served as corporate president, and he hoped that the system as they envisioned it would indeed make it to Mount Hope.[176]

However, the Holly Water System had not reached the cemetery by the following spring. The Committee, still showing great interest in the water supply system and its possible uses, expressed the hope that "those who may think it of importance for embellishing the grounds…may in the near future open their hearts and purses to the cause."[177] Some people may indeed have

done so, but it would take several years to establish a water supply system at the cemetery, and then it would not be the one envisioned in 1885–86.

During 1885–86, Mount Hope lost two of its active board members, Executive Committee member John S. Ricker and corporate secretary John Bright. At the outset of the 1886 annual meeting, the proprietors resolved that in Ricker's death the Corporation had "lost the services of one who has for the past ten years been an honored, faithful, and efficient member of the board of directors, and we are pleased to place upon our records, an expression of our appreciation of his 'services.'" Besides expressing their appreciation of Ricker's and their loss in his passing, the resolve is perhaps the earliest surviving use in the corporate records of the term "board of directors," or simply "the board," although quite likely they had used the term verbally in the past. Perhaps the new secretary was the critical factor in putting the term into corporate records.[178]

John S. Bright had been involved with the Corporation for more than forty years at the time of his death, and the MHCC, as would become its custom, also posted a resolve honoring Bright. The board resolved that members of the Corporation "fully appreciate the long and faithful service which he has performed…and desire hereby to testify to our high regard for his memory." They therefore also resolved to "tender to the family of the deceased our sincere sympathy with them in their bereavement." The board then voted to publish its resolves in "the papers of the city and a copy of the same attested by the President, be presented to the widow of the deceased."[179]

Only after passing their resolves regarding Bright and Ricker did the Corporation members present that day move on selecting their officers for the following year. George Stetson continued as president and Albert Paine as treasurer, while Joseph M. Bright, son of the late John S. Bright, became the new secretary. He, too, would enjoy a long career with the Corporation. J.S. Wheelwright, Charles D. Bryant and James Adams served on the newly elected Executive Committee.[180] The writing style of corporate records changed a bit with the election of the younger Bright as secretary, and the records became somewhat more detailed.

Lots sales had increased again during the 1885–86 year, for a total twenty lots selling for $2,545, up from nine lot sales during the previous year at a total of $1,035. Some money was still owed in spring 1886, but deeds were not being given out until all due funds were collected. During the 1886–87 fiscal year, sales were again brisk: seventeen for a total of $2,075, plus thirteen single lots for $130 total. Still, collecting monies owed remained a problem, and the area around the new pond had not been

divided into lots, although brisk sales were still anticipated for such as they would be made available.[181]

Still, monies in the trusts for individual lots had increased. In the spring of 1886, the Corporation had $4,227 in trust funds on deposit at the Bangor Savings Bank in the names of several individuals to care for their lots "for all time." According to the current bylaws, the trust money had to be invested in "United States or some State bonds or City script of undoubted ability." The Executive Committee recommended that such funds be assumed by the Corporation, merging them with corporate funds by keeping a "distinct and correct account of them…and paying a fair rate of interest yearly, to be added to the accounts of each individual deposit."[182]

An amendment was made to the bylaws in 1886, stating that by the following spring the accounts were to be kept as proposed, and a new system of bookkeeping was adopted in 1887 to reflect the amendment. By 1888, the Corporation had a combined fund for the trusts totaling $6,057, with other corporate assets of $18,506.[183]

The Corporation continued to express its satisfaction with Superintendent Cole in the 1880s, noting its gratitude for his services overall and for his "polite attention" and "gentlemanly deportment to all visitors to the cemetery grounds," and also with his wife, whom they thanked in 1883 as Cole's "good wife" for her "services in the cultivation and arrangement of beautiful flowers which add much to the adornment of the grounds." In 1884, Cole completed his ninth year of consecutive service, and the Executive Committee noted that as he continued to do the fine job he had done thus far, it was "of greatest importance that he should be retained."[184]

As the decade and the various cemetery improvements progressed, Mr. and Mrs. Thomas Cole remained integral to the cemetery, and in 1887 the Executive Committee again specifically noted the work of Mrs. Cole, pointing out her endeavors of many years in cultivating flowers, "decorating the grounds" and in "showing polite attention to lady visitors." In light of her service, they deemed it "not only an act of kindness, but as a testimonial of our high regards that some suitable [measure be given] to her for such valuable services." Members voted to have a suitable present, and the expense thereof, to be given at the discretion of the Executive Committee. The Committee continued to compliment both of the Coles in following years.[185]

By early 1887, the "Highway to Veazie" (a small back road by twenty-first-century standards) was complete. The Executive Committee recommended removing some of the existing evergreens, which were in poor condition, bordering the main avenue in the cemetery leading to the new road and

"replacing them with standard elms and maples." Furthermore, the group still anticipated having to fence the border of the roadway, and at a special meeting held on August 21, 1888, the Corporation authorized the president to have a fence constructed "from the river road to the new road, through the grounds to the Town of Veazie, the same as the fence now built on the west side of the grounds." By mid-November, the superintendent had contracted for the fence construction.[186]

At the special meeting of August 1888, the board voted that the president "procure a good and sufficient deed to the Lowder farm, so called, containing about one hundred (100) acres" at a price of up to $3,000. George Stetson did do so, for the price of $3,000 plus the property taxes due for 1888. Stetson secured the deed, dated October 26, 1888, from Almira L. Spier, who had gained the land in 1873, it having previously been owned by William Lowder. Lowder had lived on the property for some fifty years, having purchased it from John B. Boyd in 1823. The land currently fell inside the boundaries of the town of Veazie. The Honorable A.J. Wakefield served as agent for Spier during the land's most recent sale. The property was leased to George M. Fogg in November 1888 for the coming year. The board soon reported that the new land would not only provide burial space for years to come but that it would also provide sand and gravel for such purposes as maintaining walks and avenues, as well as for building up lots as needed. The City of Bangor, via the Maine State Legislature, annexed the property on January 29, 1889, such that all of the cemetery's land remained within Bangor boundaries. The Town of Veazie did not object to the land transfer.[187]

The cemetery received $100 in rent from its newest acquisition during its first year of ownership from George Fogg, while the tax paid to Veazie as agreed as part of the purchase amounted to $49.50. The lease was assigned to MHCC on March 30, 1889. By the early 1900s, no portion of the property had been lotted or used for burial purposes. That, however, would occur in the future.[188]

In the summer of 1887, the last original signer and stockholder of Mount Hope Cemetery died. Albert Paine had submitted a notice to the *Bangor Whig & Courier* about the death and noted that for several years Calvin Dwinel had been the sole survivor of the purchase agreement of April 23, 1834, arranged between General Joseph Treat and John Barstow—who originally had control of the Garden Lot—and that obligated the signers to purchase one share at $100 and to thereby form a corporation. L. Dwinel had also signed the initial document, and several other men had signed it a few months later. Paine posited that the fact that so many prominent businessmen had signed the early document, and that the last one of them "is now gone," was "most surely an impressive if not a most

suggestive circumstance." So Paine ended his article, without further explanation or clarification. However, he would certainly seem to have meant that Mount Hope's success, and the fact that so many prominent businessmen (prominent either in 1834 or in subsequent years) had been involved in the cemetery's establishment, were closely intertwined.[189]

Mount Hope had grown in physical size, personnel, management style, funding and income since the 1834 land purchase, and it had, indeed, totally reorganized and reincorporated itself. Yet the core of its mission had not changed. It still geared itself toward ensuring a burial place for the dead that would offer a calm, comforting beauty for the living. It had donated

Monuments for children have often been of interest to cemetery visitors. Seen here is a child's "crib" monument of the 1800s, captured on film in 2011. *Photograph by Trudy Irene Scee.*

land to some people and to organizations that could not afford burial spaces and had made itself the cemetery of choice for many financially secure and politically or socially connected individuals and families. Visitors to the region now frequently came to Mount Hope Cemetery to visit its monuments, explore its walkways and avenues and enjoy its waterways. That would remain unchanged into the twenty-first century, even as the Corporation itself and the grounds evolved over time. And, of course, yet another pond would come into existence as the cemetery neared the close of the century, as would a regular water supply for the cemetery. Other developments would occur, such as the preparation for building another major war monument in Mount Hope Cemetery. In the meantime, there were places to visit and people to bury.

CORPORATE BENEVOLENCE

Mount Hope Donations to the Broader Community, 1860–1900

Just as important, and perhaps integral, to the personnel changes, land acquisitions and cemetery beautification projects of the era was the fact that the Mount Hope Cemetery Corporation contributed to benevolent and patriotic causes during the 1860s, as it would do in subsequent years. The Corporation's gifts allowed for the burials in the cemetery of veterans, orphans, elderly women and other people—many of them poor and perhaps forgotten even in their own time and many who would not otherwise have been buried in such a scenic and soon-to-be historic place.

Probably the most well-known (although not necessarily the most important) gift of the Mount Hope Cemetery Corporation of the 1860s was that of a site for a veterans' memorial. Early in the American Civil War, while the war was still being waged, Bangorites—spurred on by the death of Maine's Colonel Stephen Decatur Carpenter in Kentucky on December 31, 1862—decided that they wanted to create a memorial to those who had given their lives to the cause of the nation. To that end, a group of citizens began discussing a possible veterans' monument, and their dialogue became public over the following months. There was some question as to where such a monument might be constructed, as at the time Bangor had five active municipal cemeteries: Glenburn Road, Levant Road, Pine Grove Cemetery, Orono Road Cemetery and at Mount Hope, as well as the private Mount Hope and Mount Pleasant Cemeteries. Bangor also had a number of public squares and parks in the 1860s. There was also some discussion as to exactly what type of

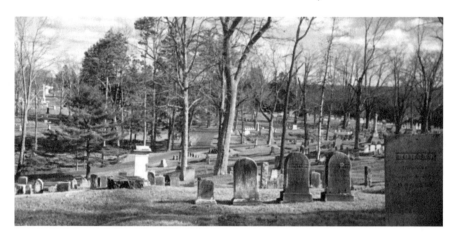

The overall setting of Mount Hope remained that of a garden cemetery in the late 1900s and early 2000s, demonstrating the care that generations of cemetery officers, superintendents and staff gave to the organization and its grounds. *Photograph by Trudy Irene Scee.*

memorial the city should build, even as locals started a subscription drive for the memorial.[190]

In 1863, Mayor Samuel H. Dale stated that the memorial should be erected "on consecrated ground by which the names of our own Jameson, Pitcher, Carpenter, Dean, Chamberlain, Ayer, and other brave officers and citizen soldiers, may be handed down to the last days of posterity." He furthermore stated that such a memorial would serve to "all honor to the brave dead, 'who die for their country,' and to the living, that such a privilege is granted them of erecting their monument."[191]

Some 115 Bangorites would die in the Civil War, with more and more dying even as plans progressed—although the local troops were generally spared during the first years of the war. By early 1863, members of the local cemetery board had determined that any monument constructed to honor the fallen should be built in "a public cemetery under the care of our City." Otherwise, the memorial might be seen as representing "only as an expression of individual feeling, while it should represent the patriotism of our entire City." Their first recommendation was that the memorial be built in the Pine Grove Cemetery, but this recommendation did not rule the day, and within the year the Soldier's Monument Association determined that the Mount Hope Cemetery should be the chosen location.[192]

It was the private section of Mount Hope, not the city section, that would become home to the Civil War Memorial. The Mount Hope Cemetery Corporation donated a large lot in the former Garden Lot for both the

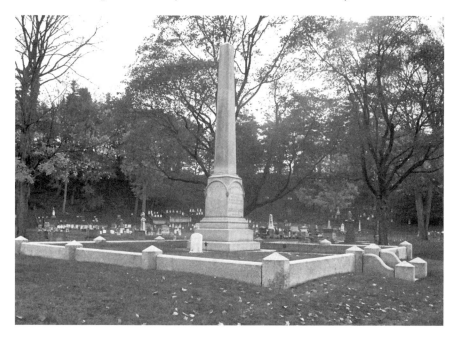

Built while the War Between the States was still ongoing, Mount Hope's Civil War Memorial remained a popular site from its 1860s dedication to the early 2000s. *Photograph by Trudy Irene Scee.*

memorial and for graves for some of the fallen. A Soldiers Cemetery Corporation, headed by Mayor Dale, was established to assume future care of the memorial. The subscription drive by the community had raised all but $150 of the $3,490 cost of the proceeds for the memorial and other stone, and Charles P. Stetson, "chairman" of MHCC, covered the balance, as well as having contributed earlier to the cause. As Albert Paine, corporate treasurer, described it, "Stetson, who had already subscribed very generously, remarked that he had paid the bills and no further discussion needed to take place." Mayor Dale presided at the opening ceremonies and religious consecration for the monument at Mount Hope Cemetery on June 17, 1864, and local newspapers covered the event.[193]

The names of fifty-five fallen military troops appeared on the obelisk-shaped memorial, and white granite enclosed the space with a small set of steps leading up to it. The lower portion of the monument had four faces or sides. The side facing the steps and the Penobscot River was inscribed with "In Memory of Our Citizen Soldiers Who Died for Their Country," and below that, "Consecrated 1864." The first face of the stone, clockwise from the "front" of the memorial, held twenty-one names, headed by Major

S.D. Carpenter, for war hero Colonel Stephen Decatur Carpenter. The second face listed thirteen names, headed by Major William L. Pitcher, and the third face listed twenty-one names, headed by General Charles D. Jameson. Jameson and Pitcher, like Carpenter, were notable local men and heroes of the war.[194]

In addition to the main memorial, two separate small stone monuments were placed at the site. One was for Captain John Ayer, whose name was also listed second on the first face of the main memorial and whose individual stone stated that he "Died in Libby Prison" in Richmond, Virginia, "February 22, 1863," at age thirty-five years. The lowest portion of Ayer's monument was inscribed with "Brave Soldier Rest." The second individual gravestone memorialized Reverend Henry C. Henries, who died in 1865 and had "served for nearly four years [as] Chaplain of the U.S. General Hospital, Annapolis, Md."[195]

The Civil War Memorial would become one of the most frequented locations in the cemetery, as would another lot granted to veterans and developed in the 1890s and 1900s. Stephen Carpenter was originally buried at the Civil War Memorial site, as its promoters had desired all along, but in 1881 his family moved his remains to their family lot. The Mount Hope Cemetery Corporation deeded the memorial lot, measuring 2,300 square feet, to the City as trustee on August 29, 1864.[196]

Although better known and more visible to the casual visitor, the 1860s gift to the Civil War Memorial was not the only critical gift of the decade. In 1864, the Corporation discussed a lot deeded to the Bangor Female Orphan Asylum free of charge. The Executive Committee and the treasurer had already appropriated and deeded a lot to the institution on September 23, 1863, so the asylum may have actually received the land in 1863. The asylum had been established in 1835 on Fourth Street to care for indigent girls, as discussed by the author in *The Inmates and the Asylum: The Bangor Children's Home, 1835–2002*, and the lot given to the organization would be invaluable to the home, especially during the years before 1869, when the asylum, run solely by women, had to struggle almost day to day to keep the institution going. After 1869, the home would move to a new and much grander building—donated in part and in part financed through a major subscription drive. In order to receive a land donation and much of their construction costs, the female board agreed to admit men to the board and allow boys to stay at the home on a regular basis. (The home had taken in boys from time to time before 1869 but usually placed them elsewhere fairly quickly.)[197]

The Bangor Female Orphan Asylum utilized the 1863 MHCC lot donation almost immediately after receiving it, having eight bodies disinterred from their original resting places and reinterred—complete with small, new, seemingly granite stones—at Mount Hope. The reinterments included those of the first child to die at the home, in 1850, and of Alice Stone, an infant of unknown origins who had been found in a stone doorway in 1856 and had died soon thereafter. The women raised funding for the reinterments and the new markers from a subscription drive. They also had a larger monument placed in the center of the girls' lot.[198] The site granted to the home was located in the Garden Lot and situated between Western Avenue and the Civil War Memorial.

The next series of burials for the home came after it moved and transitioned into the Bangor Children's Home, a much larger facility on Ohio Street. The first death at the new home was that of an orphan baby who died in 1872. The following year, Lillian Collins was buried at Mount Hope after she died from whooping cough on Christmas Day. The board of managers of the home had already determined that it needed additional burial space by the time of Lillian's death, and so the members had petitioned Mount Hope for an additional grant of land.[199]

In 1873, the Bangor Children's Home requested additional burial space. Sarah E. Sabine, president of the home, and its secretary, Mary L. Patten, wrote to the MHCC on behalf of the Bangor Children's Home Board of Managers. According to the letter, the "Lot at Mount Hope devoted to this institution is very limited, and [other] lots are being taken up in its immediate [vicinity]." The managers "would therefore request that an addition be made to the lot of such size as the needs of this institution will probably require." As the homes would take in children into the 1970s, such need could indeed be significant, although relatively few children died while living at the home over the course of its history.[200]

The board of the Mount Hope Cemetery Corporation acted on the home's request for additional burial space and in 1873 voted to convey to the Bangor Children's Home "free of charge, such lot or lots adjacent to its present lot as the Executive Committee may think proper to direct." According to records of the home, it was George Stetson, who was involved with both institutions, who presented the new deeds, seemingly in 1874.[201] The cemetery granted the home three more burial spaces—and eventually a fourth.

The Bangor Children's Home soon made use of its burial lots. In 1877, the body of Louisa Boston was buried in the Children's Home Lot. Boston

As one of its many benevolent acts, Mount Hope Cemetery granted a large burial site—later augmented—to the Bangor Female Orphan Asylum, later the Bangor Children's Home. Burials would be made at the site for roughly one hundred years, although overall the home had few deaths in terms of numbers of children who stayed long-term or short-term at the facility. *Photograph by Trudy Irene Scee.*

had had a troubled life, having entered the Bangor Female Orphan Asylum in 1856 as a sick infant who remained an invalid as a young girl. She was sent out to a few residences and then returned from each, only to die at the Bangor Children's Home. Soon after Boston's death, in 1878, Myra Murray, who had first come to the Female Orphan Asylum in 1865, died of consumption and other illness and was buried at Mount Hope. In both cases, members of the community donated caskets and services for the girls. In the early 1880s, diphtheria claimed the lives of two of the inmates of the home, and both were buried at Mount Hope, again with caskets and services donated to the home. Then, in 1893, one small girl succumbed to the measles and membranous coup, but before her burial, another community organization requested burial space from Mount Hope Cemetery. The Bangor Children's Home lot in the twenty-first century would hold seventeen small individual gravestones, dated into the early 1900s, as well as a larger stone for the home.[202]

In 1892, the cemetery approved another arrangement for the good of the public. The MHCC voted to donate several lots to the Home for Aged Women. The home had opened in 1874 as the result of a group of women organizing into a formal organization in 1869, timing their group's official establishment to coincide with the community's centennial celebration. The organization's establishment also coincided with the opening of the Bangor Children's Home at its new Ohio Street location. Some of the same

women were involved with both the Home for Aged Women and the Bangor
Children's Home, and they used some of the same fundraising techniques
to finance construction and operation of their institutions. The managers
of the Home for Aged Women requested burial space from the MHCC in
1876, two years after the home opened. The MHCC board met several times
and in 1877 reported that "the majority of the lady managers expressed
a preference for a lot on the flat grounds near to that of the Children's
Home lot." They were then given three more lots such that in 1877 they had
"a large commodious and beautiful lot which will meet the needs of that
charitable institution for a long time, a pride to our city and highly creditable
to the lady managers."[203]

To meet the request of the Home for Aged Women, the cemetery decided
to have a new avenue opened on the "westerly border of the grounds parallel
to the main avenue leading to the Receiving Tomb." The decision was also
made to "lay out a large and appropriate lot by taking a portion of the
grounds not before lotted out and rearranging some of the adjoining lots
not occupied." The cemetery also had to do some rearranging to enlarge the
space allotted to the Bangor Children's Home a few years earlier. The new
arrangement resulted in a lot "some 70 feet long, and 60 feet deep bordering
the new avenue and having 8-feet walks around the remaining three sides."
The managers of the home had conducted a subscription drive and by that
had their lot prepared "for burial purposes." By early 1877, it had "one
or two occupants." Indeed, the first stone was dated 1876. The MHCC
gave the lot to the Home for Aged Women without charge, and the board
thought that the new avenue and recent work helped beautify that part of
the cemetery grounds as well as having provided increased convenience, and
would soon lay out more lots in that area. In 1892, the cemetery enlarged
the lot for the home. The lot would eventually hold one main stone inscribed
"Home for Aged Women" and, below that, "Founded 1872," as well as fifty-
three individual stones, the last seemingly for a woman who died in 1971,
although an unmarked and apparently newer stone would remain undated
and simply read, "Ida."[204]

One benevolent contribution that the cemetery also made during the
1800s, but one that was ultimately almost lost to time, involved a lot conveyed
to the Maine Charity School in 1836, at roughly the same time the cemetery
sold thirty acres to the City for the establishment of a public cemetery. The
school would soon be renamed the Bangor Theological Seminar and would
become a key part of the cityscape and culture. The cemetery decided soon
after its 1836 dedication ceremonies to sell a four-hundred-square-foot lot to

The Home for Aged Women requested burial space in the late 1880s, just after its incorporation, which the Mount Hope Cemetery Corporation, as it had to the Female Orphan Asylum, readily gave the home. *Photograph by Stephen G. Burrill.*

the trustees of the Maine Charity School for fifty dollars, a price well below what it might be expected to receive at auction due to its prime location on Cemetery Hill, as other such lots often sold for much higher prices.[205]

Early cemetery records are scarce, and the sale was not discussed in extant records. However, the relevant deed on file at Penobscot County Registry of Deeds indicates that the plot was located near or in the Garden Lot of the cemetery. The Corporation gave the school permission to erect stone monuments, as well as "special school" or "church" "structures." The property was to be used for burial purposes, and the school was free to build a fence or a wall around the lot. Indeed, the school or seminary was required to establish—if not a fence or wall—some type of "border" so that the lot would be easy to identify. The school could also cultivate trees and shrubs, although no trees in the lot "or garden" were to be "cut down or destroyed" without the consent of Mount Hope's Executive Committee. The school was, in general, required to keep the lot in "good repair." The deed specified that it pertained to a "conditional release," although no conditions beyond those mentioned above were enumerated.[206]

Corporate records are limited to one line in a ledger regarding the site. The school did, however, use the site, although it may have used it only to

reinter a few individuals when it first secured the site and essentially left it alone thereafter. It is also possible that the site described in the original deed was replaced by another one, as the existing plot is located near the top of Cemetery Hill but below the peak and situated more to the rear of the hill, not facing or close to the Garden Lot as suggested in the deed. Be that as it may, seven stones existed on the site in the early twenty-first century and that would seem to have been the case for many decades, if not longer. Two of the stones were apparently memorials for one individual, two more were likely memorials for a second person, two others may have been for a third individual (however, one of the stones has weathered too severely to decipher any of the inscribed lettering) and another memorial, the most notable on the lot, is for one of the earliest ministers in the area. None of the individuals is recorded in extant cemetery ledgers.[207]

A distinctive tabletop memorial on the theological lot honors the life and death of "The Reverend John Smith, D.D." The monument consists of what appears to have been an original large grave marker, or it may simply have been a large slab used to form the tabletop when the minister was reinterred (or simply memorialized) at Mount Hope Cemetery, the date of his death being still legible as 1831 and inscribed on the marker in Roman numerals. Six smallish pillars resting on a base the size of the rectangular top support the slab. Smith served as a minister both in the Bangor area and in other locations, seemingly ending his life locally and having taught or worked with the Maine Charity School or Bangor Theological Seminary. As with the other markers on the site, the lettering in places is difficult if not impossible to decipher with great confidence as to accuracy.[208]

James H. Upham likewise has a stone on the seminary's lot in his memory. Again, the circumstances of the markers and the remains are unclear. It is unknown if Upham was originally interred at Mount Hope, or if his remains were moved there at a later date or even if he simply had a marker placed there in his honor. The primary stone notes Upham as having been a "Member of the Theo.-Sem., Bangor, Me." and as having "Exchanged Earth for Heaven." The date of death on Upham's stone is unclear, and a second small stone, bearing the initials "J.H.U.," is located at the foot of the immediate grave site, a situation that is also present for Sarah Richardson. Richardson's stone identifies her as the "Wife of Rev. Alvand Bond," having, it seems, been born in 1791 and having died in 1834.

The remaining stones at the Bangor Theological Seminary site consist of a small marker inscribed with the initials "W.S.W." and a larger stone at what might be the head of that grave, whose surface has weathered so

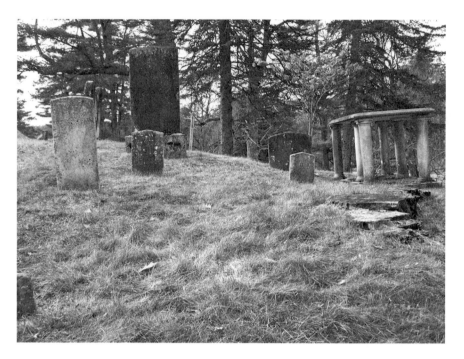

The Bangor Theological Society purchased a lot on the back of Cemetery Hill soon after the cemetery opened. However, it appears to have used the site only for a few initial burials or reinterments. Seen here in 2011. *Photograph by Stephen G. Burrill.*

much as to make the inscription illegible. As appears to be the case with Richardson and Upham, it may well be that both stones mark the grave or would-be grave of one individual.[209]

The seven stones on the seminary's lot seem to have been left after the early years of the cemetery to weather as they might but with the site likely tended to some degree in terms of lot maintenance. The stones seem not to have been augmented by later burials or memorials, and the existence of the lot as one purchased by the local seminary was essentially lost over the course of the following century, only to reappear in one brief notation on the cemetery's enumerated lots in the mid-twentieth century as belonging to the Maine Charity School, which the ledger keeper may or may not have associated with the Bangor Theological Seminary.[210]

While its other benevolent contributions were being put to use, Mount Hope Cemetery continued serving the local community, and during the 1890s, it made another gift of land and aid to veterans of the American Civil War, one that augmented the cemetery's earlier help in creating the

1860s Civil War Memorial. The cemetery built a new pond in the 1890s in a continuation of its cemetery beautification program, a pond located on the opposite side of Cemetery Hill from the lots earlier deeded for the older Civil War monument, the Maine Charity School, the Bangor Children's Home and the Home for Aged Women, and located near the new Mount Hope Avenue extension. As work on the pond progressed, it became apparent to the Corporation that veterans of the American Civil War—veterans who had survived the war but were now, in increasing numbers, aging and dying of natural causes or, sometimes, natural causes worsened by old injuries—needed additional

Like the child's crib monument located in the same area of the cemetery, this "dove" monument was dedicated to a child. As shown in 2011, the monument had suffered some deprecations by time but was still well maintained. *Photograph by Trudy Irene Scee.*

burial space; the original Civil War Memorial Lot was largely filled to capacity. An earlier land gift to the veterans had seemingly been arranged for another location in the cemetery, but both parties determined in the mid-1890s that the area near the newest cemetery pond would be a more suitable location.

The proprietors discussed the need for further veteran burial space on a few occasions during the 1890s before the new pond was finished, and on October 23, 1897, the proprietors authorized the Executive Committee to deed, as much as it deemed appropriate, land "to be used and appropriated for the burial of the bodies of soldiers who served in the War of Rebellion—including those who shall die hereafter." The treasurer was to ensure that a proper deed to the land was conveyed for

the "perpetual title or use of the land." He was to "make, execute, and deliver a deed of said lot to Hannibal Hamlin Post #165 G.A.R. and B.H. Beale Post #12 G.A.R." The deed would be subject to the same conditions and restrictions as were other such lots in the cemetery.[211] Work on the Grand Army Lot would continue into the new century. In the meantime, the cemetery continued work on the surrounding area, and the Grand Army of the Republic and Mount Hope Cemetery Corporation continued formulating plans that would come to fruition after the new century opened.

Other Burials of the 1800s

During the first decade and more of the establishment of Mount Hope Cemetery, not all of its founders or board members, nor all local dignitaries, chose to be buried there. However, as the decades progressed, an increasing number of them did. The grounds became more landscaped, flora became more decorative and changes in the brook and the construction of ponds, islands and walkways appealed to more and more people. As soldiers' monuments were added and members of various families were buried at the cemetery, Mount Hope's overall appeal only increased. The addition of a working water system at the end of the century, although still rudimentary in some ways, added to the attractiveness of the private, still nonsectarian, Mount Hope Cemetery. So, too, did burials in the nearby City and, later, the Jewish sections increase as more and more people found it appealing to secure burial sites in or near the private Mount Hope. While most people buried at Mount Hope purchased their sites in advance or their families or associates did so near the time of their death, other people were buried at the cemetery as charity cases, and some people who received interment at Mount Hope Cemetery did not receive burials there at or near the time of their death, but rather their bodies were moved to Mount Hope from another cemetery.

After Mount Hope opened, and especially after the city section opened, numerous people previously buried in other burial locations were reinterred at Mount Hope. Bangor's first known Caucasian murder victim was one such person.

Frenchman Joseph Marie Junin (or Junion) had come to Kenduskeag Plantation sometime before it was incorporated as the town of Bangor. Junin made his living trading furs, and probably other goods, with the local Native Americans, and during the winter of 1790–91 he had a nephew, Louis Parronneau, staying with him. On February 18, 1791, Parronneau burst into the home of a neighbor, yelled that there were Indians in the area and that they posed a threat and then dashed back out of the house. Soon thereafter, at least one shot was heard. Parronneau was arrested after Junin was found dead in his own bed with two bullets holes in his brain and no evidence of an intruder—Native American or not—present. A local inquest determined that Junin had been murdered, most likely by his nephew. However, the French consul in Boston secured an acquittal for Parronneau. No other suspect was ever prosecuted. Local authorities continued, it seems, to consider Parronneau the murderer.[212]

Junin was moved to Mount Hope from his first burial site at the corner of Oak and Washington Streets in 1836 and reinterred near the site of the present-day Receiving Tomb, just inside the city section. A slate tombstone seemingly went with him. It reads:

> *Here lies the remains of Joseph Marie Junin*
> *of La Rochelle in France,*
> *who departed this Life*
> *the 18th Feb AD 1791*
> *In the 32nd Year of his Age*
> *& the Second Year of the*
> *Era of the French Liberty,*
> *Carrying with him*
> *to the Grave*
> *the sorrows of all*
> *who knew him.*
>
> *May his Soul Rest in peace.*

Other people were also reinterred at Mount Hope, particularly in the 1830s and 1840s as the newly incorporated city decided to use a few older burial sites for other purposes. And in the 1850s, after the Bangor Female Orphan Asylum received a gift of land from the Mount Hope Cemetery Corporation, it removed eight children's bodies to its new burial grounds.[213] Some other people were moved to Mount Hope by

family members. In the more unusual case of Civil War hero Stephen Decatur Carpenter, his body was moved from one Mount Hope gravesite to another.

One of Bangor's most well-known civilian citizens to be buried at Mount Hope in the 1800s was Rufus Dwinel. Dwinel made a fortune in the lumber industry early in the century, as well as became involved in transportation and other local business and in politics. Dwinel served as Bangor's third mayor during 1838, promoting local education among other things but also raising concerns about the extent to which the impoverished deserved financial and related aid. With Ira Wadleigh and Milford P. Norton, Dwinel organized the Bangor & Old Town Railroad in 1832, which stirred up some controversy among the proprietors of the MHCC, as the line would ultimately run inside cemetery boundaries. The line was opened for business in 1836. Dwinel also became embroiled in a battle over canal and river use in northern Maine in the 1840s and served on the board of directors for the Penobscot & Kennebec Railroad in the early 1850s. He was on the Penobscot & Kennebec board at the time the City provided the railroad financial aid, which became especially controversial when the line was unable to meet its obligations to the City of Bangor in subsequent years, an issue that would not be resolved for some time.[214]

Dwinel died on September 29, 1869, at age sixty-one, and was interred at Mount Hope soon thereafter. His monument would inspire interest and speculation into the twenty-first century, and as with some of the other people noted herein and in the next section, it would be a regular stop for local historical society tours in the late 1900s and beyond.

Dwinel had a sarcophagus built in his memory, an outsized one that is roughly the size of a large casket with associated accouterments. The sarcophagus is raised on granite legs or feet and sits atop another massive stone slab. As the sarcophagus is clearly large enough to hold Dwinel's body, speculation arose as to whether his body was in it or, if not, where Dwinel's remains might be.

Two major stories arose about Dwinel's monument and interment. According to both, Dwinel indeed had his casket and remains placed inside the raised section of the elaborate gravestone—essentially just the whos and whys of the interment stories varied. As one story had it, Dwinel, a millionaire, supposedly said that as long as he was above ground his wife would not inherit a single cent of his fortune—hence he chose to be interred above ground. According to the second version, Dwinel had asserted that as long as he was above ground he would continue to

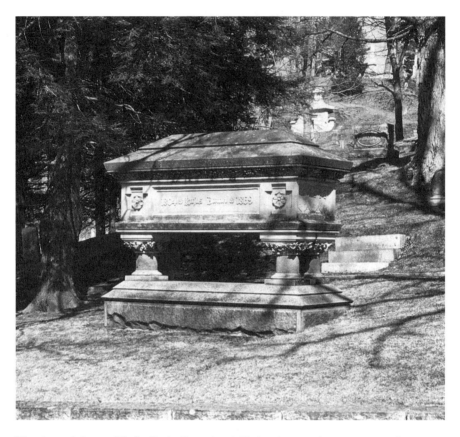

The size and shape of Rufus Dwinel's tomb would give rise over the years to questions as to exactly where Dwinel's body had been interred—above the ground or in it. *Photograph by Stephen G. Burrill.*

support his beloved mistress. The hitch to either story is that in spite of its size, Dwinel's sarcophagus is made of solid stone, and Dwinel was buried below it, not in it. Furthermore, Dwinel had not been a married man, also ruling out the first version. Dwinel had, however, left a fair sum of money to his housekeeper of many years, perhaps supporting the second version to some degree, although no details of any possible romance exist, and of course, his actual burial location ultimately rules out that version also.[215]

The monument built in remembrance of Edward Kent has also given rise to misunderstandings. Kent served his city and state in numerous ways during his life, although he originally came "from away." Born in 1802, Kent came to Bangor early in his career and opened a law firm in

the town in 1825. Soon thereafter, Kent was elected captain of one the town's small engine (or fire) companies. He had the distinction of being Bangor's second mayor after it was incorporated as a city in 1834, and he later became governor of Maine, elected to that position in 1837 and 1840. Kent was the mayor (elected in early 1836 and 1837) who spoke at Mount Hope's dedication ceremony. Like Dwinel, Kent would also be associated with promoting local education for city youth, and he tended to encourage separating the issues of poverty and shame, although he did link poverty with intemperance. As mayor, not surprising in light of his earlier experiences, he also promoted enlarging the fire services in the city. When Kent died, he had a memorial built in his honor at Mount Hope. However, Kent was interred not in Bangor but in Massachusetts.[216] Neither Dwinel's nor Kent's remains are where many people continue to expect them to be.

The body of General Samuel Veazie, for whom the town bordering Mount Hope Cemetery was named, did eventually make it to the exact place it might be expected to be, but not before a few other bodies spent some time there. Veazie, like Dwinel, was a local lumber baron of the early to mid-1800s. Along with seven other men, he organized a local canal company in the late 1820s, but he found his forte—beyond his massive lumber interests—more in the management of railroads, owning and operating the Bangor & Old Town Railroad from 1854 until 1868. Veazie died on March 13, 1868, and was buried two days later at Mount Hope. Veazie, and in particular his wife, was a supporter of the Bangor Female Orphan Asylum. It was Veazie who had had the first tomb erected in Mount Hope Cemetery, and according to superintendents of the 1900s and 2000s, his tomb was used as a holding site for bodies until the City built its own receiving tomb, essentially at the time of Veazie's death, when his tomb was needed for its intended purpose.[217]

Another key player in the local economy and in Mount Hope's early history, George W. Pickering, was born in September 1799 and went into business as a merchant at an early age. He soon became involved in the banking business, being one of the creators, in 1832, of Bangor's Kenduskeag Bank and then, two decades later, of the Bangor Savings Bank. He served as presidents of both institutions and for a time served as such simultaneously. Pickering was involved in other banking concerns as well and acted as president of the Bangor Fire and Marine Insurance Company—the first in that role, starting in 1833—and also served for a time as the president of the Merchant's Marine Insurance Company, where many early MHCC meetings were held.[218]

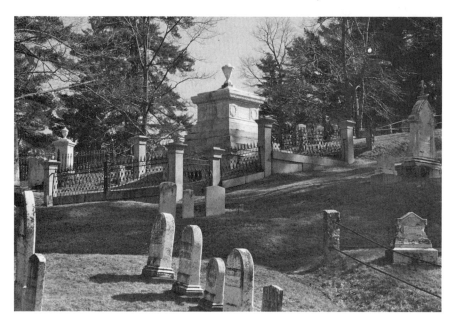

Another photograph of the Veazie Tomb, emphasizing the tomb itself rather than the "mount" on which it rests, Cemetery Hill. *Photograph by Stephen G. Burrill.*

Pickering purchased key downtown properties, entered the shipping industry in the 1830s and served as Bangor's twelfth mayor from 1853 to 1855. He also sat on the Penobscot & Kennebec Railroad board of directors after it was reorganized (due to an internal territorial battle) in 1853, serving on the then all-Bangorite board with Rufus Dwinel, Moses L. Appleton, William Cutter and Samuel Farrar. He had earlier helped establish the company in 1850 with Maine railroad promoter Alfred W. Poor and Bangorites Moses Appleton, Wyman B.S. Moor and Samuel P. Strickland, as well as a few non-Bangorites. In addition to the Penobscot & Kennebec, Pickering was also involved with the European & North American Railway and the Maine Central Railroad, all three of which would overlap in service and eventually ownership as the century progressed. Pickering participated in various other economic and civic endeavors and died at age seventy-seven on September 28, 1876. He was buried at Mount Hope sometime later. As was true for most such influential men, other family members were also buried on his lot. For example, George C. Pickering, the son of George W. and Lucy F. Pickering, died in 1891 at age sixty-four and was buried near his parents, as were other relatives.[219]

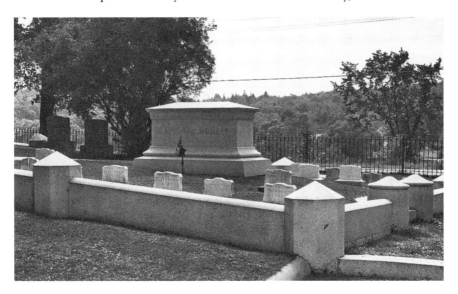

Hannibal Hamlin served as President Abraham Lincoln's first vice president, as well as a Maine senator and governor. His memorial is a well-frequented Mount Hope site. *Photograph by Frederick Youngs.*

Another influential local man died in 1891 and was interred at Mount Hope Cemetery. Hannibal Hamlin was eighty-one years, ten months and seven days old when he died on July 4, 1891. Hamlin was born in Paris, Maine, and died in Bangor. Four days later, he was buried in the Riverside Lawn Lot, where other relatives were and would be interred. Hannibal Hamlin was one of the city's most illustrious members, having served as Abraham Lincoln's first vice president, their joint ticket widely supported in Bangor on the eve of the Civil War, as well as serving as a Maine senator and governor. Hamlin also acted as a president of the Bangor & Piscataquis Railroad in the 1860s—after his time as vice president—and was, along with many men associated with the cemetery during the era, involved in the Bangor Mechanic Association and later the Bangor Public Library. Hamlin also served as the first president of Bangor's prestigious Tarratine Club, where he was playing cards at the time of his death. Thousands of people came out to the streets to mourn Hannibal Hamlin's death as his funeral carriage passed by en route to Mount Hope. His burial lot overlooking the river remained one of the most visited sites in the cemetery into the twenty-first century.[220]

Once again, a number of family members would be buried nearby. Hamlin's older brother, Elijah L., had served as the city mayor as the

1850s opened. He generally spoke positively about the Irish community that was quickly growing in Bangor (soon leading to the establishment of Mount Pleasant Cemetery), as well as stressing the need to clean up the city after its recent deadly cholera outbreak. Another relative of Hannibal Hamlin buried at Mount Hope, Augustus C. Hamlin, served as an assistant surgeon in the military during the Civil War (along with surgeon and city physician Samuel B. Morrison) and would later serve as mayor.[221]

In many ways, it would be easier to list the mayors, business leaders, civic reformers and such who chose *not* to be buried at Mount Hope after the mid-1800s than to list those who did. More than 70 percent of the mayors of the 1800s chose to be buried at Mount Hope Cemetery, and the percentage is even higher for those who died after the cemetery became well established. The high percentage of Bangor's political leaders choosing Mount Hope as their place of interment would continue in the 1900s and beyond.[222] It is hard to quantify just who qualifies as a civic or business leader outside of political office, but in many cases, including those mentioned, they were one and the same. The same could be said for such mayors as Charles Fred Bragg of N.H. Bragg & Sons, started in 1854 and surviving into the twenty-first century as a secure leading business in the region, as well as others like Isaiah Stetson, Bradford Harlow, Henry E. Prentiss, Joseph Wheelwright, Lysander Strickland and Flavious O. Beal.

As Mount Pleasant Cemetery became more established, many Catholic leaders—political and civic—would choose it as their interment location, and some of Bangor's leading Jewish politicians and businessmen would choose burial in one of the Jewish cemeteries. Mount Hope continued to receive burials of people of various faiths, however. As the cemetery grew in size and in financial stability and skill, it would be involved not just in burials at its own property but also with those at the city cemetery at Mount Hope and, later, at a few of Bangor's Jewish cemeteries As Bangor superintendents of burials, some personnel would serve at virtually all of the Bangor cemeteries, private and public, regardless of faith. Other cemetery associates would become involved in maintaining other cemeteries and still others in planning for the same.

Some people associated with the cemetery through their other, outside activities also chose to be buried at Mount Hope in the 1800s and beyond. For example, Mrs. Horatio (Anna) Pitcher died in 1897 after working with the Bangor Children's Home for many years as a very active member of

its board of managers. Other members of her family were also closely associated with the institution and its move to Ohio Street. After her death, Mrs. Pitcher's daughter requested (acting on her mother's wish) that the children of the home sing at her service. Twelve children did so, singing at Mount Hope Cemetery at Mrs. Pitcher's burial service in July.[223] Many other regional women were quite active in civic and reform activities and would be buried alongside their often more well-known husbands or male relatives at Mount Hope.

Some individuals, of course, were buried at Mount Hope Cemetery as, essentially, a gift. This included not only war veterans but also children who had been at the Bangor Children's Home or Female Orphan Asylum at the time of their death (in addition to those whose bodies had been reinterred at Mount Hope in the 1850s), elderly women from the Home for Aged Women and also a number of people for whom the cemetery, eventually, simply forgave their debts. The issue of lots not being paid for was an ongoing problem in the 1800s, and in some cases the cemetery eventually wrote off the debt.

Other people would be buried free of charge by the City as the decades passed. This was true for many residents of the Bangor Almshouse (or Poorfarm) from the time the Mount Hope Municipal Section opened into the twenty-first century. Those who were buried with no one to help pay for their burials or to purchase a gravestone were buried in the 1800s in unmarked graves in essentially a small-city version of the "Paupers Field" found in numerous large American and European cities. (By the twenty-first century, small markers would be used for even "pauper" funerals in the city section to identify which site which person was in.)

However, Mount Hope Cemetery kept track of pauper burials as best it could even in the mid-1800s and even for the city section. For example, James Babcock entered the Bangor Almshouse in late 1868, probably in November. Babcock was twenty-eight years old, but he found himself in the poorhouse on lower Main Street in Bangor after his feet froze, quite likely while he was logging, working on the railroads, farming or performing other manual labor. Babcock stayed in the almshouse, classified as "lame" and "sick," for all of 1869. There is no indication that Babcock had issues with alcohol or mental health problems or was unwilling to work. His condition worsened, and he died at the almshouse in late 1870. There the record on Babcock, scanty as it is, might have ended, except for one short entry in the Mount Hope interment records for the city section. According to the records, Babcock was buried in 1870

in the Strangers Lot in an unmarked grave at age thirty. No information on his birth or death place or family ties was recorded. Babcock was buried in a long row on the southern portion of the city section, along with many other people, all in unmarked graves and without specific records as to their relative locations at the site—although they were supposedly buried roughly according to date of death, so a general time period might be roughly estimated.[224]

Yet problems identifying exact locations of buried individuals who had enjoyed more economically comfortable lives also occurred. As the superintendents of Mount Hope Cemetery began to serve as official City of Bangor undertakers in the late 1800s, and eventually become known as superintendents of burials, Mount Hope became increasingly involved in burials in the city portion of Mount Hope, that section of land that Mount Hope Cemetery had earlier deeded to the City.

Disagreements as to the responsibilities of the municipal undertaker and Mount Hope's board, including issues concerning who should dig graves, close the graves and take care of the new grave sites—apparently in both the city and the private sections, with the latter being of particular concern to MHCC—had caused conflict for a number of years before the Corporation decided to hire a permanent superintendent. The members hired one during the 1878–79 fiscal year, employing Thomas Cole, whose wife would aid him in his work, in particular in the growing of ornamental plants, flowers and shrubs, as well as in greeting cemetery visitors. Cole would remain in his position for the rest of the century, overseeing several projects at the cemetery, and he and his spouse both earned praise from the cemetery board and the Executive Committee. Eventually, in 1885, Cole would also come to serve as the city undertaker, helping to resolve some of the burial issues previously of great concern.[225]

In December 1898, the board discussed the "matter of records to show where the known graves are located at Mount Hope Cemetery," such records being inadequate or even nonexistent in some instances. Superintendent Thomas Cole informed the group that as far as the city section was concerned (graves in the corporate section seem not to have been as much a concern, as the cemetery had been keeping fairly close records since at least 1861, initially kept by William Mitchell, who would later, if not already doing so, serve as a city undertaker), City records generally noted on which municipal lots people had been buried, but not necessarily in which grave. Cole said that the only way to determine the exact grave in question as to occupant at present was through his own

knowledge of where people had been buried. As he was now serving as city undertaker as well as superintendent at Mount Hope, the Committee discussed how to have corporate records indicate which person was buried in which particular grave, "as far as the knowledge is obtainable." To this end, they appointed Cole and Charles Bartlett, secretary of the Executive Committee, as "a committee to examine the City records and report what records it was necessary for the Corporation to keep to effect the purpose."[226]

Seemingly in spite of such a plan, according to cemetery oral history, in the 1900s Superintendent Reuben E. Hathorn, as the last "private contractor" (although records show that he did indeed receive a salary from the cemetery, he may well have financed some particular projects and later been reimbursed) to serve as the cemetery's superintendent, informed the board that he had put together a substantial body of records indicating who was buried where, according to cemetery oral history. But, he argued, he had made interment maps and the like on his own time and thus should be paid for them—otherwise he would not release them to the board. Then, before an agreement could be reached, the massive Bangor Fire of 1911 destroyed his property, including the burial maps and records.[227]

It seems more likely, however, that if such an incident occurred, it would have been Thomas Cole who had been the party involved, as Cole was just leaving his position at Mount Hope and had had time to assemble such records. Indeed, even then it would remain a mystery as to why he would try to extract payment for them, in view of the board's and superintendent's discussions on recordkeeping during the 1890s. Perhaps an agreement had not been formally reached and the superintendent involved saw it as his personal work rather than his work as an employee, and so he offered it for sale. The possibility also exists that the records were actually those pertaining to the city section, which MHCC would come to manage in some aspects.

The City of Bangor began reporting general burial locations—in terms of cemeteries used—in an organized manner just as the 1870s opened. The "Mayor's Annual Report" for the 1869–70 municipal year—during the construction of the Receiving Tomb at Mount Hope—noted there had been 299 deaths in the city (some of locals, others of visitors) and classified 190 of the deceased as Americans. The year 1870 saw the city undertaker (or rather undertakers, for there were two of them that year, Charles F. Mitchell and James Mitchell) submit perhaps the first undertaker's annual report. The undertakers reported that there had

The early history of Mount Hope Cemetery is largely contained in the fading ledgers maintained by Corporation officers from 1834 into the 1900s. Details are sometimes scarce, yet the work of generations of secretaries and others did preserve much of what might otherwise have been lost. *Photograph by Trudy Irene Scee.*

been 282 deaths in Bangor over the previous municipal year, with 163 burials at Mount Hope Cemetery (seemingly both sections), compared to 93 in Mount Pleasant Cemetery, and 4 people were buried at Pine Grove Cemetery, 5 at Maple Grove and 4 each at the Levant Road and Crosby Farm cemeteries or graveyards. There was no identification of any of the deceased being Jewish that year in the undertaker's report,

although during some surrounding years the board reported on burials in the Jewish Cemetery at Webster Road. In addition, some people (often about twenty to thirty of them) were regularly brought into Bangor for interment, while others (often numbers greater than those brought in) were taken out of the city for interment elsewhere.[228]

The following municipal year, ending in March 1871, also showed Mount Hope Cemetery, as in all years of the era, receiving the most interments: 151 of them compared to 109 at Mount Pleasant, 6 at Pine Grove, 4 at Maple Grove and 2 at the cemetery at Levant Road. The cemetery board, when it delivered its report that March, was composed of Henry R. Prentiss, Isaiah Stetson and S.P. Bradbury. The following March, the city undertaker's report would again appear with the municipal reports and would show a new municipal undertaker, one with whom the private Mount Hope Cemetery would soon experience some difficulties: William Lowney. Lowney also included information on the causes of death in Bangor: of 251 deaths in the city, consumption claimed 42 lives, followed by "fever" at 21. More people were taken out of the city for burial than were carried in for interment.[229]

After the Mitchells and Lowney, J.C. Lane would serve for a brief period as city undertaker, starting in the late 1870s, and in the mid-1880s, Thomas Cole of Mount Hope Cemetery would take over the position, easing some of the tension previously felt between the municipal undertakers and the superintendent and staff of Mount Hope.

After the turn of the century, Reuben E. Hathorn served as the superintendent of the Bangor Almshouse and City Farm. Hathorn worked in that capacity until he left and became both the superintendent of Mount Hope Cemetery and the city undertaker, serving as such from 1908 to 1930. Burial rates at Mount Hope Cemetery remained high during his double tenure at Mount Hope and for the city.[230]

Superintendent Harold S. Burrill served as city undertaker in the 1930s, having replaced Reuben Hathorn, with the decade opening like previous ones: in 1930, of 302 interments in the city itself, 252 were at Mount Hope, including, it seems, both the public and private sections, with the city section now formally known as the Mount Hope Municipal Cemetery (it would undergo a major repair and beautification process late in the decade, augmented significantly by the public works funding of the Great Depression). The totally private Catholic Mount Pleasant was generally not included in the reports for this period. Harold Burrill would be the last superintendent at Mount Hope to serve as the

municipal undertaker, or superintendent of burials as the position was sometimes called.[231]

In addition to the grave sites of rich and poor, some people simply had an interest in visiting the graves of their loved ones or, as the cemetery aged, their ancestors. Other notable people in addition to those discussed earlier were also buried at the cemetery in the 1800s, such as Park Holland, whose surveying work had helped lay out the cemetery and whose efforts in America's Revolutionary War had led to a donation of a monument in his honor by the Massachusetts Society of Cincinnati; Peter Edes, who had edited Bangor's first newspaper and enjoyed a long career in journalism; and John and John E. Godfrey, noted educators and writers of the era, one of them also being a judge and involved with Mount Hope Cemetery.[232] As noted, most of the people involved with the cemetery would, especially as the decades passed, choose to be buried at the cemetery they had helped found or had proved instrumental in developing. This would also prove true for the twentieth and early twenty-first centuries.

New Roads, New Water, New Construction

Mount Hope Approaches the Twentieth Century, 1887–1900

While the staff at Mount Hope Cemetery provided burial and other services as best they could to the public, so did cemetery improvement and beautification proceed and the day-to-day work of the Mount Hope Cemetery Corporation continue at the close of the nineteenth century. The Corporation's elected officers and the Executive Committee remained key to the long-term financial and cultural success of the Mount Hope Cemetery, and while some remained seated throughout the closing decade of the 1900s, others entered or left offices or the board during these years.

After being nominated to the office, George Stetson declined to serve as corporate president in April 1887. The other members present at the annual meeting decided to reconvene in one month to respond to Stetson's decision. They met on May 4 but had no quorum, a recurring problem in recent years, and so they adjourned again. Stetson, having already been chosen president for the year, may have decided to serve the term after all, although he missed some subsequent corporate business. J.S. Whit served as chairman at the 1888 annual meeting, yet Stetson was again chosen president.[233]

At the 1888 annual meeting, the Corporation made a point of thanking Charles Bryant for his "faithful and valuable services," no direct statement of said services being provided. Quite likely Bryant had aided the cemetery in its grounds improvement plans. This may have been Charles H. Bryant, who had served in Maine in the military among other older local leaders like Norris E. Bragg, Hannibal Hamlin, Llewellyn Morse and George H. and Charles H. Stetson.[234]

The Executive Committee noted the increasing popularity of the cemetery in its 1888 report. "The beautiful grounds at Mount Hope are becoming more and more attractive each year, and we are frequently visited not only by our own citizens but by strangers," the Committee reported, adding that "the scenery and ride along the margin of the river is very attractive." Perhaps partially in view of the increase in the cemetery's appeal to visitors, and in view of years of frustration in trying to collect overdue monies from lot sales, the Committee in 1888 noted that "any parties" who had "held [a lot] (but no deed given) for some years, the lots still unoccupied, and nothing paid for them," should be "notified at once that unless the lots are paid for immediately, they will be sold to any other person who shall want them."[235]

Perhaps some of those unpaid for, unoccupied lots were indeed sold, but either way, lot sales rose once more over the following year and reached reportedly the greatest annual number to date: 18 regular lots for $2,540 and 3 single graves for $30, making a total income of $2,570 from lot sales. Since 1880, the cemetery had sold 162 regular lots and 31 single graves, for a total of $19,716 in sales. Thus far, $19,028 had been collected—although there does seem to have been some minor discrepancy in bookkeeping—so collection rates do seem to have improved. Unsold lots in the established areas, the Committee reported, were becoming scarce, and the board planned on having lots near the new pond laid out during the current season to meet anticipated demand. The new fence on the eastern side of MHC to the new road was completed by the close of 1888, with painting underway in 1889.[236]

In 1889, the Corporation held its regular meeting at the Common Council Room of the Bangor City Hall. The existing municipal building was quite old and had at one point been relocated. In 1893, the building would be replaced by one funded by a bequest from General Samuel F. Hersey. The project was a controversial one, as discussed by the author in *City on the Penobscot*, but it would result in an impressive structure—classified as Flemish Renaissance Revival—used for municipal affairs, public and private meetings and even musical performances into the 1960s. In the meantime, the MHCC used the older building for several of its meetings. The Corporation again chose George Stetson as president in 1889 and Albert Paine as treasurer, and Isaac H. Merrill was chosen as secretary pro tem. Lysander Strickland—Bangor mayor of 1881–83 and advocate of railroads, canals and temperance—along with Joseph S. Wheelwright, a former Bangor mayor, and James Adams and Ivan W. Coombs were selected as the Executive Committee. Improvements and expenses over the preceding year had included building a new fence for $794.00, $691.00 paid to

Superintendent Cole, $1.50 for advertising and the acquisition of the Lowder farm for $3,000.00 plus $49.50 in taxes.[237]

Corporate assets in 1889, which did not include land, were calculated at $16,797, a substantive increase from the $9,946 of 1880, in spite of its having recently built the new pond, new avenues, new fencing, having acquired new land and having met other recent expenses. The Corporation's bonded securities were kept in a safe deposit box at the Kenduskeag Bank. The Corporation also held $6,976 in trust funds—a significant increase of more than $5,226 since 1880—and the funds were held still at the Bangor Savings Bank in a separate account. [238]

The transactions of the MHCC indicate some of the growth and changes in the local economy since the 1830s. Over the century, new banks and businesses had opened in Bangor, which continued to be a bustling harbor town, although some of its transportation focus had switched to train traffic. Some businesses lasted only a short time and others for decades or longer. As a corporation, Mount Hope Cemetery would be one of the oldest in existence by the early twenty-first century.[239]

In 1890, the MHCC advertised its annual meeting in the *Bangor Daily Whig & Courier* and in the newer *Bangor Daily Commercial*, which would remain in circulation until the mid-1900s, when it was taken over by the *Bangor Daily News*. The Corporation met again at Bangor City Hall, and George Stetson

An 1889 receipt for N.H. Bragg & Sons, a local business that would survive and flourish into the twenty-first century. In addition, generations of Braggs would serve on the Executive Committee and as corporate presidents, to an extent unmatched by any other family. The receipt is a partial payment of $100 for a family plot. *Scan of receipt held by N.H. Bragg & Sons.*

was again chosen president and Albert Paine treasurer. The minutes of the previous annual meeting were read as accepted, as were the reports of the Executive Committee and the treasurer, as had by now become customary. The new Executive Committee for the upcoming years was composed of J.S. Wheelwright, Lysander Strickland, James Adams and Ivan W. Coombs. C.L. Marston would join the Committee in 1891 when Wheelwright left it, and then Marston became corporate president when George Stetson declined the position for good. The secretary swore an oath of office before Paine, and the board then adjourned, the various reports having been approved.[240]

The 1890 Executive Committee report intimated some of the changes that would be of great interest during the upcoming decade. George Stetson, or whoever authored the report, again waxed a bit flowery, noting that many "estimable and lamented citizens have from the busy scenes of life, taken their abode and last resting place, in the city of the dead, our beautiful Mount Hope Cemetery." The author noted that "many have contributed to the city of the dead, with their hopes of a final resurrection in some form or manner." Nonsectarian the cemetery was, and nonsectarian was the comment.[241]

The 1890 report referred to "Mr. Thomas J. Cole, our most faithful superintendent," and to "his good wife" and her "kindness," as well as to the couple's "cultivation" of the needs of the cemetery. All was kept as should be, older evergreens were still being replaced with young trees— many of them elms—and the grounds around the new pond had been partially surveyed although not yet marked for burial lots but supposedly would be soon. The old gravel pit, "which had been used to provide gravel for cemetery walks and avenues, might be filled and used for burial lots," the Executive Committee suggested. The Committee reported that the new Lowder property had a good deposit of gravel that might be used for cemetery needs, and the farmland also had a quantity of sand that could be sold. In the past, the City had purchased sand from the previous farm owners, and the Corporation anticipated the City as being a likely purchaser of sand from the Corporation. Furthermore, as the new property would be "held for a cemetery," it would not be taxed. No lotting had been done on the property, however, and it was still leased to George Fogg. It might be lotted in the near future, or some portion of it, for burial sites.[242]

Beautification of Mount Hope remained possible due to the work of board members like president George Stetson, soon to be lost to the board, and longtime treasurer Albert Paine. As the new decade opened,

"Ponds and Islands," as seen at Mount Hope Cemetery at the close of the nineteenth century and as printed in Paine's work of history. *Photograph from Albert W. Paine,* Mount Hope Cemetery.

the Corporation still held its $1,000 City of Bangor bond, a $1,000 Belfast bond, a $2,000 Bucksport bond, a $6,000 bond from Stillwater Water, $5,000 in bonds from the Nelson Lumbering Company, $3,254 on deposit in the Bangor Savings Bank, $486 in the treasury and $7,306 on deposit at the Bangor Savings Bank in its trust funds in the spring of 1890. Altogether, the Corporation claimed $19,420 in available assets. Two years later, in 1892, the Executive Committee referred to the lots endowed with trust funds as "lots perpetual," not a far step from the term "perpetual care," which would be used later in the twentieth century. By 1892, the Corporation held $9,440 in trust funds, and only the interest on the deposits was used for the appropriate lot upkeep.[243]

The year 1891 opened with a special meeting held on February 4 at the offices of George Stetson. The meeting was held to discuss a possible property purchase. The board ultimately voted that day to purchase the Forak property owned by Edward H. Blake and others, at the price of $2,000. The property lay between the existing main grounds of Mount Hope Cemetery and the Lowder farm and hence would be an invaluable addition to the cemetery. The Executive Committee reported later that year that the MHCC had long desired to purchase the property, owned by Edward

H. Blake. However, the price had been previously set at $4,000, which the board deemed "very exorbitant." Blake had reconsidered the price, and hence in February the purchase had been agreed on. The property deed was dated February 5, just a day after the board voted to take action. After the purchase, Mount Hope Cemetery owned three hundred acres, sufficient, the board would opine in 1892, to serve local burial needs "for generations to come," although some portions of the Blake and Lowder properties might be disposed of and the front or southerly sections kept for burial purposes. The entire property was retained, however, and some of the Lowder property was lotted, graded and well into use by the turn of the century. Before then, however, the Corporation would bury one of its own, and that even before the 1892 meeting at which the board commented so favorably on the recent land purchase and other matters.[244]

George Stetson, after fifteen years as president, declined to stand for the office in 1891. He submitted a formal note of resignation:

Declining years and declining health remind me that there is a time in this life when active operations may well take some rest. Thanking you cordially for your kind and generous support for the last fifteen years I have held this place as President of the Corporation, and with my associates it has afforded me much pleasure during that time. I now feel it is my duty to decline holding the place longer.

Very truly yours,

Geo. Stetson
April 4, 1891.[245]

The board therefore passed a resolve—which it had published in the local papers—expressing its gratitude for all his work over the years and crediting Stetson "in large degree for the most important improvements with which the cemetery is now ornamented, and which form the principle attraction of the place." The members also expressed their wish that "long may he live to enjoy the fruits of his labor." Sadly, he would not. George Stetson died on June 15, 1891, and was buried at Mount Hope two days later.[246] In some ways, his death marked a crucial passage for the cemetery and the city, both of which he had contributed to substantially during his life.

The Executive Committee report for 1891 did reflect much of the intense work that Stetson as president, the board and Superintendent Cole had

recently undertaken. The Committee thanked both Cole and his wife for their efforts and noted that the "heretofore unoccupied ground north of the pond" had been "raised and properly drained" and then divided into twenty-seven lots, and the new lots were expected to be in high demand by the public. Even more notable, the cemetery had just completed "an ornamental and thoroughly finished building in every respect" located "in the center of these grounds." The building had been designed "not only as a place of rest and resort, but may at times be used as a chapel and place for burial purposes." The structure would also be referred to as a pavilion by the Executive Committee, and it had cost $1,107.[247] This seems to be the chapel later referred to in fleeting comments.

In the spring of 1892, with little further work having been done in the northern area, the board voted to dedicate an area between the new pond and an existing path and the pavilion as a public park to be known as Stetson Park, named for the late George Stetson. It had been Stetson, during his tenure as corporate president, "at whose suggestion and under whose supervision the low-ground was filled, the pond constructed, and the pavilion erected," according to his peers on the board.[248]

The association of Stetson with the major recent improvements continued for some time, as Stetson had remained active in the planning stages up to the last days of his life. According to the Executive Committee report of 1892, George Stetson would, weather permitting, visit the grounds daily during the last few years of his life. He had served on the board for fifteen years. Moreover, with Thomas Baldwin (serving as secretary pro tem), aiding him, Stetson had sat up in his bed just two or three days before he died and "with hardly the strength to do it, [drew] a plan and advising work to be done in the future" at his beloved Mount Hope Cemetery.[249]

Work proceeded on the park, and the associated grounds were essentially completed in late autumn 1892. Superintendent Cole had put much work into the project, concentrating on "the upper part of the brook" during the 1892–93 fiscal year, working without a plan, according to an Executive Committee report, to form "the brook islands, bridges, etc." (It would seem that Stetson's plans were left incomplete or were simply not sufficiently detailed regarding the work undertaken by the superintendent.) By the spring of 1893, the bridging, sodding and transplanting of shrubs and flowers had been finished on the "islands." The work added great beauty to the park, such that it was "pronounced by the strangers visiting our grounds among the handsomest in our country."[250]

J.S. Wheelwright, corporate president, signed the 1893 Executive Committee report, which started out as something as an ode to America's cemeteries, seemingly referring specifically to those with a horticultural origin or focus. "There is nothing in this country to which foreign visitors give more praise, than to our cemeteries," the report opined. "There is a constant and growing interest in them. Most of us remember when a cemetery would have been the last place to visit for pleasure." Furthermore, "The care and neatness with which they are kept up in foreign communities are points in which they would do well to imitate us."[251]

Moving on to the issue of perpetual care, the report noted, "The system by which all lots may be cared for, under one management, is very desirable—ensuring uniformity, and avoiding sameness." An odd juxtaposition perhaps, but likely the author meant to say that caring for all plots in the same manner would keep a certain cohesiveness to the grounds while allowing the cemetery to landscape the properties to create various settings as appropriate to the topography. The author or authors seemed to refer partially to the practice also of enclosing individual lots, stating, "In most modern cemeteries, fences, hedges, and copings are dispersed with." In conclusion, concerning perpetual care, the report noted, "We can but recommend the practice of making a deposit with the treasurer for the purpose."[252]

The Committee recommended in 1893 that some of the Blake property should be lotted and work undertaken at the Lowder farm. In June 1894, the board voted to have the barn at the Lowder farm moved. The ensuing year saw the layout of streets and drainage pipes and the grading of lots on both the Blake and Lowder properties. The next year saw further work on the two newer properties, along with some avenues being laid out next to the hill east of the new pond; several cemetery streets and walks were also graveled. The Corporation sold the Lowder house for $125 during the 1894–95 fiscal year, and the purchaser removed it from the property. The granite on the property was reserved, however, and a portion of it was sold for $78. The barn had been moved and reconstructed on the east side of the road at a cost of $312, and it was to be used to store hay and various materials. Grass or hay had been harvested or sold during the year from the Lowder farm for $100. In addition, about six acres on each side of the Veazie Road had been plowed and seeded. About fifty acres of good pastureland remained north of the new road and had been fenced in.[253]

Gating and fencing were issues once more in the early 1890s. By the spring of 1893, the gate at one entrance was in poor condition, deemed "rotten" and

needed replacing. The Executive Committee suggested—or desired—much more substantive gates, advising "the use of iron and granite posts" and noting that it might "be well to rebuild the gates and both entrances." The board left the matter with the Committee for further study and action.[254]

Later that fiscal year, the proprietors had part of the problem resolved. They had "the old wooden gate at the main entrance" removed and replaced with "beautiful and substantial granite," the description seemingly referring not to the swinging portion of the gate but rather to the pillars built on either side.[255]

The gate situation had improved by 1894–95, and with the work on Stetson Park essentially completed, the MHCC turned its attention to another part of the cemetery, a swampy area near the center of the burial grounds. The cemetery approached the newest project by "removing clay to make a pond, and placing the clay upon the hilly streets, thereby greatly improving said streets, and the pond surrounded with a thick growth of evergreen." These changes in place, the board deemed the area now "one of the [most] attractive spots in the cemetery."[256]

Progress was truly being made at MHC in terms of grounds beautification and in making plans for the future needs of the cemetery and the community in the early 1890s, but the cemetery still did not have a regular water supply beyond that provided by the stream running through the cemetery and its on-site domestic wells. The anticipated municipal or Holly Water supply had not been obtained as hoped, and in 1892, the board decided to try another option: it voted to authorize the president and two other members of the Corporation to consult with Electric Power Company about the best terms for supplying water for cemetery use. For many years, the power company and the water company functioned as one department, with the dam supplying the electricity used by the city departments and offered for sale.[257]

The Corporation held a meeting on September 1, 1892, and the special committee reported its findings on the water supply. The members reported that they had "invited proposals from the Public Works Company to furnish and lay such pipes, and furnish such quantity of water, for the use of the public and private grounds as would be satisfactory to your Executive Committee." They had received proposals and seemingly discussed and recorded them in their report, which does not survive. They decided that the Executive Committee could have a water supply made available either by digging wells or having water supplied "by the Veazie Water Works, or otherwise."[258]

The group met again the next week, on September 7, having received a "proposition from the Public Works Company to supply water and lay pipe

for $1812 with water rates of 10¢ per 1000 gallons." No action was taken, and the following spring, the board discussed the terms and conditions once more and voted to leave the matter with the Executive Committee.[259]

The cemetery still did not have a regular water supply by 1896. However, over the 1896–97 fiscal year, the cemetery would acquire a system via another route. It would spend $2,200 installing the system, which included, the board reported the following year, "a large steel tank placed upon the highest bluff, which is filled by power from the windmill on the shore of the river"; water was "piped to all parts of the cemetery." [260]

The Executive Committee during 1896 underwent something of a revitalization and began meeting monthly and keeping records of those meetings. Having met with failure in its other approaches, it voted on May 27, 1896, to form a committee to have a water tower erected at Mount Hope along with a windmill and a pump, as well as to have pipes laid to supply the cemetery with water. The results of this vote led to the 1897 report. The Executive Committee also authorized the secretary to obtain a conveyance of "the 12½ rod strip on the shore in front of the cemetery grounds, for the sum of ten dollars." This would have been the small piece of property about 206 feet wide that completed the Corporation's ownership of the western half of Lot 28, augmenting its 1870 purchase, its ownership now going one mile north from the river.[261]

On May 18, 1897, the Executive Committee "made a tour of inspection of the grounds, examining the new windmill, standpipe, and the lots." Such tours were standard in the late 1800s, but the inspection of the new water system seems to have been a stressed and especially pleasing inspection to make in May 1897, as well as the now complete ownership of the old Lot 28 surveyed by Park Holland almost one hundred years previously.[262]

In 1898, the Executive Committee voted to have the superintendent purchase twenty-four "galvanized iron pails" and have the words "Mt. Hope" painted on them. He was then to have them hung on the water faucets, which the cemetery had apparently had constructed at various locations, "for the use of people desiring to water their lots." Water was now available throughout the grounds, but watering individual lots was, in most instances, still left to the individual lot owner. The new system apparently worked quite well during its first few years, and in 1899 the Committee expressed its great appreciation of it.[263]

The Executive Committee gave Superintendent Cole credit in 1894 for his "great skill and artistic ability in the work of laying out the [Stetson] Park, and for all the beauty and attractiveness; he was its designer." The

next year, 1895, the members again noted how Cole was indispensable to the cemetery, "having from the first taken great interest in all aspects of his job and the grounds, and exhibiting courteousness to all." The Committee also noted the efforts of Mrs. Cole in aiding visitors and in tending flowers and other ornamentals, showing "excellent taste in her arrangements of the same."[264]

Two years later, in 1897, still quite pleased with the work of the couple, the board voted to present Mrs. Cole with $100 in "appreciation for all her efforts and successes in beautifying they grounds." Interestingly, as published in the newspaper, the $100 was noted as going to "Mr. Cole for his services… per vote of Co." Perhaps the newspaper assumed that the gender of the recipient had been a mistake as submitted, as it also included Mr. Cole's salary of $500 as usual in the account. Mount Hope Cemetery's Executive Committee would compliment Mrs. Cole further in coming years, and as the new century opened in 1900, it would vote to pay her $50 for her "excellent" work. Mr. Cole's salary would remain $500.[265]

Another ongoing issue, one that was voiced before that of a water supply system, was that people were still not always paying for their lots. In 1892, the Executive Committee acknowledged that some people had already been buried in unpaid-for lots and recommended that the treasurer should give deeds to these lots as he saw fit. Yet resolving the issue did not come easily, even after decades of the same problem occurring again and again. In 1894, the board again discussed the matter of bodies being interred in partially or totally unpaid-for lots and determined that the cemetery needed to decide "whether to remove the bodies, cancel the debtness, or adjust the matter in some other way." Nothing was done, it would seem, in the way of removing dead bodies for reinterment elsewhere (although as some bodies had been moved from older cemeteries to Mount Hope, the idea was not unheard of during the century), but in 1895, the board did vote to cancel the debt of George W. Snow on his lot and to present him with the relevant deed.[266]

In 1895, the Committee report was deferred until the following year, perhaps because the president, Wheelwright, was absent from the annual meeting. He had sent in a message, however, telling his peers that "on account of declining years and ill health" he declined to "be a candidate for re-election to office." Those present voted James Adams to the office of president, with Bright and Paine remaining in their respective positions. James Adams, Ivan W. Coombs, Charles H. Bartlett and Manley J. Trask were elected to serve as the Executive Committee for the upcoming year. The board resolved to send a letter to Joseph S. Wheelwright thanking

him for his nine years on the Executive Committee and for his services as president. The board also sent Wheelwright its "ardent wish that he may live to enjoy a long continued life here." The members then voted to have a copy of their resolve published in the local papers. Wheelwright, however, did not long survive his retirement. He died on October 27 of that year and was buried at MHC two days later.[267]

Later that fiscal year, the Corporation lost two other members. Charles Marston died in early December and was buried at Mount Hope a few days later, and a resolve was passed in his honor at the 1896 annual meeting. Then, less than one month later, Lysander Strickland died on January 4, 1895. He was buried at Mount Hope Cemetery on January 6. As the Corporation described its loss a few months later, Strickland was "suddenly called from these earthly scenes to a higher life. We miss his genial presence and wise counsel—his interest in everything connected with the welfare of this corporation was increasing." The board not only noted Strickland's death in the annual report but also passed a resolve to honor his passing and services as corporate auditor and corporate member: "By his death the company has lost a highly valued, competent, and faithful officer—one upon whom all felt they could implicitly rely for the complete performance of all duties devolved upon him." They also expressed their "high regard for his character as a worthy citizen and useful member of society." They had the resolve published in the local papers and "a copy given his wife." H.O. Pierce served as auditor after Strickland's death.[268]

Meetings and procedures became a bit more formalized as the decade progressed. In 1894, the board dealt with an issue, one that—from the number of adjourned meetings in the past—may have been an ongoing concern. The board voted to have the Executive Committee examine the bylaws to see if there was "any provision by which a less number than a majority of members constitute a quorum for the transaction of business." If no such provision existed, they might consider adding one.[269]

In 1896, the proprietors elected James Adams president once more and Bright and Paine as secretary and treasurer, respectively. The Corporation also voted James Adams, Ivan Coombs, Manley Trask, Charles Bartlett and Augustus Farnham as its Executive Committee. The same group of men would serve until the close of the century and hold its annual meetings at city hall, although city hall itself would change. The salaries of the treasurer and secretary remained $100 and $10, respectively, in 1900.[270]

Also in 1896, the Executive Committee met and voted to have the secretary secure a "suitable record book" and in it be required to "keep

a true and correct record of all proceedings and doings of this board." The Committee seemed to undergo something of a transition in how its members viewed it during the late 1800s, and from 1896 on, the Committee maintained records of its meetings that greatly supplemented the annual reports of the group as previously recorded as part of the Corporation's annual meeting reports. The first ledger of the Executive Committee meetings would begin with May 1896 and contain reports up to May 1964. The first years would be handwritten, with entries for later decades being typed and pasted into the ledger.[271]

The Executive Committee during May 1896 also voted the corporate president, James Adams, to be president of "the board," as the Committee now actively and specifically called itself, as well as elected a secretary of the board, the first being Charles H. Bartlett. Adams called the initial May 9, 1896 meeting, and before the election of officers that day, he was "in the chair." The Committee appointed Thomas Cole superintendent for "one year or until another is appointed in his stead," and in subsequent years during the decade, he would also be "elected" superintendent, the use of the term being new for the era. The group also voted to hold meetings on the first Monday of every month at the office of the president.[272]

Interestingly, plans were currently underway for the construction in Bangor of an Insane Hospital, as it was called for many years. At its first regular monthly meeting as adopted in 1896 (the meetings would not, however, prove to be monthly as planned, but rather annually and as needed), the board voted to sell to the hospital contractor "all the sand he requires for the building." The price was set at "twenty-five cents…for each two horse load," an account for which would be rendered every Saturday night to the cemetery superintendent, with payment on demand. The contractor would also be responsible for the costs of building a road to the bank from which the sand would be removed, as well as to "uncover the bank."

The Insane Hospital, later known by various names and eventually becoming the Dorothea Dix Hospital (or Center) after a local Civil War reformer and crusader for the mentally ill, would survive into the twenty-first century. Located just down the road from Mount Hope Cemetery on a hill off State Street overlooking the Penobscot River, the hospital would become a major part of the cityscape. Before its construction, the mentally ill would often be tended at the Bangor Almshouse or sent to the Augusta Insane Hospital. Mount Hope's Executive Committee would later vote that the superintendent could sell sand and gravel not only to the new hospital but also "to such parties as he deems advisable at not less than…25¢ per two horse load."[273]

In another matter, also a timely one, the Executive Committee voted in May 1896 to have Bartlett, an attorney, collect fifty dollars per year from the Bangor Boom Company for the rent of its shoreline, collecting that year for both 1895 and 1896. Lumbering was slowing down during the 1890s, but operating a boom on the river was still profitable and renting the shoreline for that purpose gave MHCC another opportunity to increase its coffers and meet its operating expenses. The Corporation would continue to lease the property to the boom company into the early twentieth century.[274]

In a matter that would be revisited almost a century later, the Committee voted in May 1896 to prohibit dogs in the cemetery and to have the superintendent post a sign to that effect. Dogs would be permitted in the cemetery again in the twentieth century and then forbidden once more when some of their keepers failed to keep them leashed and out of trouble.[275]

During the late 1890s, the cemetery continued to add trees (planting one hundred elm and maple trees during the 1898–99 year alone), grade lots on the main hill—which had had most of its lots already sold, except for the new ones being created—and sell lots throughout the main grounds. Lot sales dropped for a bit, then rebounded and in the last year of the century reached $3,120 on the sale of nineteen regular lots and two single ones.[276]

During the late 1890s, Mount Hope also repaired damage from heavy spring storms and sometimes winter ones, seeded some areas, removed brush and graveled roads and walkways. During 1897–98, the cemetery had some 3,080 feet of fence along the road painted; shingled and painted the lodge house; had the exterior of the Hathorn house on Mount Hope Avenue painted and the inside refurbished; clapboarded and painted part of the Hathorn garage; and painted the stable. The cemetery also started to pave some of its roadside gutters to better catch and drain heavy precipitation (this also probably worked in conjunction with the new water system) and leveled and filled in what had been the basement of the Lowder house. It continued to grow and sell hay, or extra hay, as well as some extra sand and gravel. During 1899–1900, sales of hay, sand and gravel, as well as the renting of pastureland, brought in $312. The Corporation rented out its shoreline and the nearby house, which brought in $95 for 1898–99 and $105 the following year. During these years, the cemetery received much positive feedback from lot owners about the state of the grounds.[277]

During the 1895–96 fiscal year, the cemetery added bushes and alders at the foot of the hill, and the Corporation discussed adding a small pond in that area. Seemingly the one under discussion was the one on which work

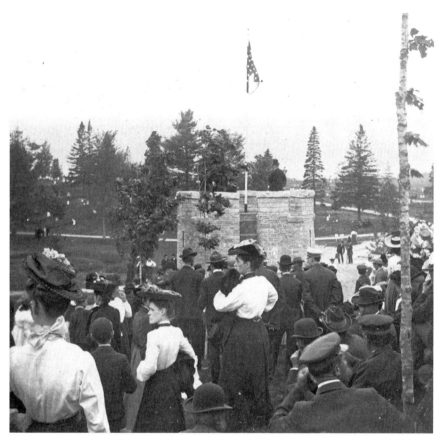

Memorial Day at the newly completed Grand Army of the Republic (GAR) Fort, showing the crowd assembled for the festivities, circa 1904. *Courtesy of the Maine Historic Preservation Commission.*

started the following year; it was about 50 percent complete by early 1898, and the Executive Committee referred to it in 1898 as being located on Mount Hope Avenue. The cemetery did not name its ponds as it constructed them during the 1800s, rather it generally simply referred to each as "the new pond" during the time of its construction and seemingly up to the construction of the next one. The newest 1800s pond was to extend from the existing lodge to the avenue, as the records described it. Introducing an entirely new project or co-project, the Executive Committee reported in the spring of 1899 that what had been the "gravel bank" was now "surveyed and lotted to the new pond, including that part donated to the Grand Army, and soon will be added to our plan."[278] This would embrace the pond later known as Fort Pond or sometimes the Grand Army Pond.

The "Grand Army" referred to in the report was the Grand Army of the Republic, which had fought on the side of the North during the American Civil War. As the older area around the Civil War Memorial at the river side of the cemetery became congested, the cemetery realized that it needed further space for Civil War veterans, particularly those who died after the close of the war. The Grand Army Lot, planning for which began in the mid-1890s, would become one of the most noted spots in the cemetery in the twentieth and twenty-first centuries, although the records of the cemetery—as had been true for the original Civil War monument—once again had little to say about this project. The cemetery in the 1800s and beyond generally tended to simply donate burial space as it felt was needed to worthy causes and did it in a matter-of-fact way, not inviting any particular fanfare. It posted notices of the passing of

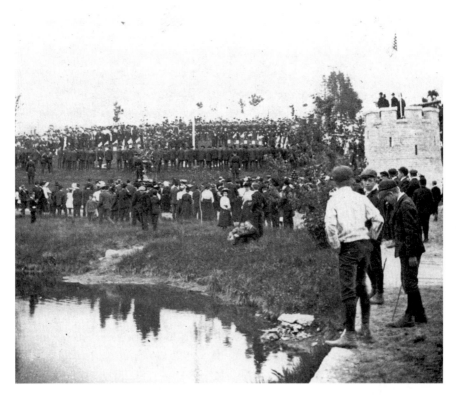

Memorial Day at the Grand Army of the Republic Fort, circa 1904, showing the crowd from another vantage point and boys standing on the most northern bridge over the brook. *Courtesy of the Maine Historic Preservation Commission.*

its board members to let the city know of its good works and the loss its deaths represented, but it generally did not seek out any press for any good works the cemetery and Corporation as a whole undertook.[279]

The new pond was almost finished by the spring of 1899, planning for the Grand Army of the Republic Lot was well underway and more trees were planted to beautify the cemetery. The board noted that the new water system, with its holding tank and windmill on the shore, "worked to perfection and at all times has furnished an ample supply of water, which has been a great convenience." The cemetery completed the new pond during the next season, 1899–1900, including grading and seeding the nearby grounds. The gutters that brought water from the hill to the pond were paved and the avenue around the new pond completed. The cemetery also set out fourteen granite posts with chains for the safety of the "teams"—the horse teams "driving around the pond"—and planted shade trees on the hill above the pond.[280] Motorized vehicles would come to Mount Hope, but not quite yet.

During 1897, the same year in which work began on the newest cemetery pond, the Executive Committee recommended something totally new. In light of all the visitors coming to the cemetery, the Committee posited that the Corporation might wish to employ a special policeman. A private policeman, the Committee suggested, might be placed on duty during Sundays and during evenings throughout the summer season. No records have been located suggesting that a guard was hired.[281]

The Corporation was on a steady footing financially during the close of the century. A large share of its assets continued to be invested in bonds. In the spring of 1899, the MHCC held $2,000 of Bucksport town bonds, $2,000 in Anderson city bonds, $2,000 in Toronto city bonds, $1,000 in Galveston city bonds and $1,000 in Austin, Texas water and light bonds. Mount Hope would vary its bond holding somewhat over the following few years. The Corporation also had almost $2,250 on deposit at the Bangor Savings Bank, $1,150 at the Penobscot Savings Bank, $1,130 in the Eastern Trust and Banking Company and $158 on deposit in the corporate treasury in the Kenduskeag Bank. Total cash assets were $18,085 in early 1899 and would reach $21,389 in early 1900. In addition to its bonds and funds on deposit at the various banks, in 1899 the Corporation held close to $22,000 in perpetual-care trusts and nearly $24,500 at its 1900 annual meeting. Clearly, MHC had added significantly to its assets since its 1834 incorporation, and it would continue to do so during the 1900s. In 1899–1900, the cemetery surveyed parts of what it called its "Eastern Division," ensuring that it would have lots readily available for

sale during the coming century; planning for the new veterans' memorial continued into the 1900s.[282]

In closing one century and opening another, the Executive Committee stated that with the improvements made during the previous years, "We hopefully look forward to the time when Mount Hope may rank among the finest cemeteries in New England, not only in its situation, which nature so richly provided, but under the careful supervision of our faithful superintendent, it may each year be beautified by fine walks, flowers, trees, and shrubbery."[283]

Superintendents in the twentieth century continued to add to the beauty of Mount Hope, and as it would seem by most standards, Mount Hope Cemetery would clearly "rank among the finest cemeteries in New England" in the twentieth and twenty-first centuries. Indeed, it was well on the way to becoming one of the finest cemeteries in the nation by 1900.

A Twentieth-Century History of Mount Hope Cemetery

AN INTRODUCTION TO
MOUNT HOPE CEMETERY

At the close of the twentieth century, in the year 2000, Mount Hope Cemetery officially turned 166 years old. Established in 1834, concurrent with the incorporation that same year of Bangor, Maine, the cemetery's host city, the Mount Hope Cemetery Corporation, beginning with 50 acres, owned roughly 264 acres of land by 1996. Mount Hope, recognized as America's second garden cemetery, also managed the adjacent cemetery holdings of the City of Bangor during the nineteenth and twentieth centuries. In total, Mount Hope by 1995 owned or managed some 300 acres, property visited by the general public for educational and recreational purposes; it also provided local—and in some cases nonlocal—citizens with burial, crematory, mausoleum and related services.[284]

Several of Bangor's leading citizens selected the present site of Mount Hope Cemetery in the 1830s after the City had unsuccessfully, in terms of longtime community satisfaction, established cemetery lots at a few other locations. Located on the north bank of the Penobscot River and largely bounded by what became Bangor's State Street and Mount Hope Avenue, the new site ultimately exceeded nineteenth-century community needs and criteria. To finance the purchase of the original fifty acres from Bangor's General Joseph Treat, local citizens circulated a subscription sheet, eventually receiving thirty-one subscribers. Thirty of the subscribers each paid $100 for their share. The thirty-first paid $50. The total amount raised, $3,050, fell short of the $3,500 purchase price, and Treat agreed to become a subscriber for the balance.

Those involved in the purchase agreed to divide the property according to a plan drawn by prominent Bangor architect and civil engineer Charles G. Bryant. A portion would be set aside for horticultural purposes, with the rest of the land designated as burial grounds. This would create, as did other such cemeteries, a place of tranquility for the living, as well as lots for burying the dead. The preliminary plan divided the burial portion into thirty-five shares, each selling for $100 and held as part of a corporation under the recently passed "Act to Incorporate the Bangor Horticultural Society," to be managed by said society. The garden portion would be deeded to John Barstow, who would act as purchaser for the entire fifty acres. Barstow would enjoy use of the garden area for horticultural purposes in return for specified services such as maintaining hedges and fences surrounding the cemetery.[285]

The "causeway" at Mount Hope Cemetery helps direct and contain the brook, especially during periods of high water levels and during the spring runoff. Originally built with granite blocks, the causeway was redone in concrete after a hurricane destroyed the original one in 1958, and portions of the newer structure were rebuilt in the early 2000s. *Photograph by Trudy Irene Scee.*

As envisioned in the early 1830s, the new cemetery would reflect trends seen elsewhere in the nation, particularly the Boston area with which Bryant was familiar through his visits to the region in the 1830s, according to architectural historian Deborah Thompson. Bangor looked to Boston for cultural standards or trends during much of its early period. In 1831, the Massachusetts Horticultural Society laid out in Cambridge the Mount Auburn Cemetery, which would serve as a model to some degree

for Mount Hope Cemetery and subsequent garden cemeteries, such as that established at Lowell Hill, Philadelphia, in 1836 and at Greenwood, located in New York City's Brooklyn borough, three years later. Such cemeteries served essentially as parks, some of America's earliest, as well as memorials to the deceased, and they have been seen as part of an overall garden cemetery movement.[286]

Before the purchase for Bangor's new cemetery had been made, however, the Mount Hope subscribers drew up a new petition for incorporation. The Bangor Horticultural Society had not survived its formative stages. The petitioners met on September 24, 1834, and again two days later, and at the second meeting they adopted a set of bylaws. The new entity, the Mount Hope Cemetery Corporation, had an Executive Committee charged with effecting the land purchase and instructed to "lay out the grounds for a cemetery into lots, make a lease of the land not intended for a cemetery, and expend such sums as may arise from the sale of lots and income from the cemetery grounds in fencing and ornamenting the grounds, as may be directed by the proprietors."[287]

Although several specifics had changed, the basic plan and purpose for Mount Hope had not. The Executive Committee continued to perform the same basic duties specified above throughout the nineteenth and twentieth centuries. The Corporation elected officers and an Executive Committee and adopted a corporation seal bearing the "Emblem of Hope" and the words "Mount Hope Cemetery Corporation 1834."[288] The cemetery retained the emblem, an anchor, and the wording throughout the twentieth century.

The Corporation deeded twelve acres, including the so-called Garden Lot— located between Cemetery Hill (the hill located at the front or southeastern portion of Mount Hope) and State Street—to Barstow in December 1834 for a designated period of one thousand years with the condition that "faithful performance" of the agreement be made. Barstow paid no rent but remained responsible for maintaining hedges and fencing around the cemetery and for the general care of the premises. However, only two days after receiving his lease, on December 22, 1834, Barstow transferred the lease—with the Corporation's consent—to Philip Coombs for consideration of one cent. (Some of the property was later conveyed to the City and then reconveyed to Mount Hope.) Yet Barstow did occupy the grounds as a lessee. He did so until 1845, at which time the Corporation—after repeatedly requesting that Barstow improve his care of the premises—had him legally evicted. At that point, in October 1845, Coombs's interests in the premises were also legally terminated. The lease passed to another person, John H. White, for $500. White held the lease until 1852. In

1852, the Corporation paid $1,200 in consideration for the lease and proceeded to drain portions of the Garden Lot for burial grounds. The Corporation did not drain the Garden Lot pond, and it remained a well-frequented site throughout the nineteenth and twentieth centuries.[289]

After completing the 1834 purchase, establishing an Executive Committee, electing officers and doing the basic layout of the grounds, the Corporation held a dedication ceremony in July 1836. Ministers from three local churches spoke at the ceremony, as did Bangor mayor and later Maine governor Edward Kent. Kent presided at the 1836 ceremony and would later have a monument built in his honor at Mount Hope. His body was interred at Mount Auburn Cemetery in Massachusetts.[290]

During autumn 1836, the Corporation initiated sales of an original two hundred lots, the proceeds to be used to pay existing debts, meet current expenses and provide for any cemetery improvements endorsed by the Executive Committee. At a public auction soon thereafter, the Corporation sold some eighty lots for a total sum of $3,688.50. The Corporation had designated a $25.00 starting price per lot, with higher bids taken depending on site location. The first burial occurred that same year. Samuel Call, who had died on July 9 and whose brother, Henry, purchased the lot, was buried at the top of Cemetery Hill.

The cemetery sold additional lots for some time after the 1836 sales, and in 1844, the Corporation voted to give each shareholder one lot as a dividend. Subsequent dividends were made such that the shareholders each ultimately received six lots in payment for their original subscription. A payment from White for the Garden Lot was likewise distributed to the shareholders. In 1853, the Corporation voted to pay no further dividends but instead to use any proceeds to purchase new land, initiate improvements and so forth.[291]

In 1857, the Corporation again addressed the shareholder issue, voting that it would be in the best interests of the cemetery for Corporation members to surrender their titles and property or to have all lot owners made equal members of the Corporation with a resulting interest in Mount Hope's management. Soon thereafter, the Corporation petitioned the Maine State Legislature to make all lot owners members of the Corporation with "rights, privileges, and powers," equal to those of the shareholders and with each person "entitled to one vote." All future land purchases would be "sacredly appropriated to the sole and exclusive use of the Corporation." No future dividends or divisions of such lands or any proceeds would be made among Corporation members or stockholders. All proceeds would instead

be "exclusively appropriated for the purposes of the Cemetery." The state legislature enacted the Corporation's "Act of Incorporation" and Governor Lot M. Morril approved it on February 27, 1858.[292]

Via the new legislation, the old Corporation conveyed all real estate, property, funds, rights of action, debts, demands and the like to the new, nonprofit Mount Hope Cemetery Corporation through a deed dated June 10, 1858. The re-formed Corporation assumed its duties before June, however, meeting in April and adopting a new set of bylaws at that time.[293]

The re-formed Corporation, now with a five-person Executive Committee instead of the original three-person Committee, continued to make land purchases. The disbanded Committee had made purchases periodically during its twenty-four years of existence. As the Corporation enlarged cemetery borders, resurfacing was performed in some places, various improvements made to buildings and grounds, a few structures removed and, in January 1889, a portion of the town line of neighboring Veazie relocated so that a newly purchased lot would be legally part of Bangor. The state legislature passed the pertinent act to relocate the town line at the Corporation's request.

In addition to extending Bangor's borders, Mount Hope also undertook care of the city burial grounds adjacent to Mount Hope, land along Mount Hope's western border. Mount Hope did so in the nineteenth century and remained manager of the city's cemetery under a contract system into the 1990s. Management concerns did arise from time to time regarding the city premises, but for the most part, the arrangement proceeded smoothly.

Bangor's Jewish cemetery (or cemeteries, depending on the date) located on the north side of Mount Hope Avenue also adjoined twentieth-century Mount Hope. These burial grounds were separate entities, however, under the management of local synagogues, and except for a small area the city had devoted to its Jewish population when it opened, Mount Hope did not manage Jewish burial property. Nonetheless, Mount Hope Cemetery remained nonsectarian, open to members of the Jewish faith as well as of others.

The City of Bangor, in addition to contracting with Mount Hope for its maintenance needs, also entrusted Mount Hope with the management of the City's Receiving Tomb. The tomb provided a place for storing human remains during the winter until burial was possible and would serve as the primary receiving tomb—purportedly first an original tomb and later the tomb built, and finished circa 1870, at the boundary of the private and public sections of Mount Hope—for northern Maine throughout the period.[294]

Care for the day-to-day management of Mount Hope and the care of the municipal cemetery and the Receiving Tomb fell to Mount Hope's superintendent. The lease system having failed in the first decades of cemetery operations, the Corporation elected to have a superintendent charged with the supervision and care of the cemetery premises, including attending burial and other services and tending lots, grave markers, plants, roads, buildings and so forth. Throughout the early decades of the twentieth century, the superintendent would also monitor the planting, care and harvesting of hay, oats and other products raised on cemetery property and used for cemetery horses, as well as sold to meet expenses or other needs.[295] Farming would become obsolete in cemetery management by mid-century, but additional superintendents' duties would be added with the passage of time.

Mount Hope Cemetery Corporation made several charitable contributions of lots in the nineteenth century and would do the same in the twentieth. Nineteenth-century donations included burial lots given to Bangor's Home for Aged Women and the Female Orphan Asylum—later known as the Bangor Children's Home. Twentieth-century donations of lots or greatly reduced fees for lots and care included donations to the Good Samaritan Home of Bangor (for the burial of children born to poor young women), the Maine Charity School (later the Bangor Theological Seminary), the Home for Aged Women and the Home for Aged Men. (In 1985, the Corporation voted to offer the successor to the Home for Aged Men a perpetual-care contract in recognition of the company's having returned to Mount Hope the unused portion of its lot.) Most of the direct work with the various agencies occurred during the first half of the century, as changing social and economic practices subsequently led to changing burial practices and policies in many public or charitable institutions.[296] In addition to donations to charities and various institutions, the Corporation also established one of the nation's earliest memorials to the military casualties of America's Civil War in the nineteenth century and made similar donations of lots in the twentieth.

In early 1863, following the 1862 death of Maine's Colonel Stephen Decatur Carpenter in Kentucky, the City of Bangor, desiring to show due respect to the fallen soldiers and after considering the suggestion of the Corporation's treasurer, decided to accept a burial site at Mount Hope Cemetery for Civil War fatalities. The veterans would also, the City and cemetery decided, have a memorial erected in their honor. The plan proved popular with the local community, and a subscription drive raised all but $150.00 of the $3,489.94 estimated project cost. Charles P. Stetson,

Mount Hope's first Civil War memorial and lot, consecrated in 1864, was one of America's first memorials to the fallen soldiers of the War Between the States. Shown here in the early 1990s. *Photograph by Frederick Youngs.*

a future Corporation president, quietly covered the balance, doing so in addition to previous contributions he had made. Interested parties formed a "Soldiers Cemetery Corporation" that consisted of the Bangor mayor as ex-officio president and three local citizens. The new corporation was charged with the future care of the premises. Mount Hope held a consecration ceremony in June 1864 for the lot, located in the Garden Lot portion of the cemetery. The family of General Carpenter later, in 1881, had his remains moved to their family lot. In the meantime, the number of war casualties necessitated that additional space be provided, and Mount Hope proved willing to provide it.

The cemetery established its second Civil War burial and memorial site just south of Mount Hope Avenue. It became known as the Grand Army Lot and in the future would receive probably more attention from the general public than did the original lot. A small fort was constructed on the Grand Army Lot in the early twentieth century, with cannons and other

ornaments added in memory of the soldiers. The twentieth century would see additional memorials erected at Mount Hope in honor of America's military, such as the Peirce Memorial honoring Civil War veterans during the 1960s and the Korean War Memorial in the 1990s. The newer memorials would prove as popular as the earlier ones with cemetery visitors and with others who desired suitable memorials to Maine and American male and female veterans.[297]

Other major construction projects of the twentieth century included the building of an administrative facility in 1909 to replace the original "lodge" built in 1874, the addition of a crematory to the administrative facility in 1972 and of a subsequent independent crematory structure in 1992 and the construction of a community mausoleum in 1986. The new facilities offered points of interest for some cemetery visitors, as well as provided additional services to the community. They added to the efficiency of cemetery operations and generally made its activities more economically viable. Other major twentieth-century undertakings included completing cemetery fencing, paving roads and developing new burial divisions. Cemetery beautification or improvement was a crucial goal of twentieth-century projects and included close attention to mowing cemetery lawns, planting ornamental shrubs and trees and undertaking or selecting suitable flower arrangements. The grounds themselves as well as any monuments or structures erected on them were the primary focuses of cemetery care.

Although new buildings were constructed and various changes made, Mount Hope retained much of its nineteenth-century heritage in the twentieth century. Furthermore, some of the additions made to Mount Hope in the early 1900s—such as the ornamental fencing around the cemetery and the stucco and timber administrative building—would serve as examples of period architecture and design by the mid- to late 1900s. Added to Mount Hope's status as the second-oldest garden cemetery in America was its repository of nineteenth-century craftsmanship and artistry and its interest quotient as the burial place of numerous leading Maine and American citizens—such early twentieth-century developments helped make Mount Hope both a scenic and an historic asset to Bangor and New England. Well-known persons interred at Mount Hope during its early decades included Hannibal Hamlin, best known as Abraham Lincoln's first vice president but also a Maine senator and governor; his daughter, Sara, who witnessed Lincoln's assassination; later (1938) his son Hannibal E. Hamlin, attorney and member of the Maine Senate and House of Representatives; General Samuel Veazie, a lumber magnate for whom the town of Veazie was named;

Frederick W. Hill, regional lumberman and philanthropist; and Rufus Dwinel, one-time Bangor mayor, lumberman and bank and railroad owner. Formal recognition of Mount Hope's historic status came in the 1970s.

In August 1974, the Maine Historic Preservation Commission informed Mount Hope superintendent Harold S. Burrill Jr. that the Commission was considering the cemetery for nomination to the National Register of Historic Places. Inclusion on the register, according to Commission documents, would not affect the autonomy of the Corporation but would rather simply recognize the cemetery—as was true for any corresponding "building, structure, or site" so designated —as being "an important historic resource that should be preserved as an integral part of Maine's heritage and

Trees contribute enormously to the setting of Mount Hope Cemetery but require continual attention, from pruning as a method of disease treatment to leaf gathering in the autumn. Shown here is a scene from autumn in the mid-1900s. *Photograph by Harold S. Burrill Jr.*

environment." Inclusion on the register would protect the cemetery from any "detrimental impact that might occur" as the result of municipal, state or federal agency projects using federal funds.[298]

The Commission reviewed Mount Hope's case, forwarded its recommendation to the National Park Service as required for approval and then had Mount Hope's name added to the register in December 1974. The cemetery's resulting certificate as signed by Maine liaison officer James M. Mundy identified Mount Hope as "a part of the historical and cultural heritage of our nation" that "should be preserved as a living part of our community life and development in order to give a sense of orientation to the American people."[299] Possibility existed of funding for restoration work, but as of 1999, in spite of applications submitted for memorial restoration work, the cemetery had received no such funding.

Mount Hope became a focal point of the Bangor Historical Society's historic tours of the city during the late twentieth century, tours that provided interested persons with a tour of the grounds and discussion of its design, buildings and monuments. The cemetery cooperated with the Bangor Historical Society and even underwrote the cost of printing a tour pamphlet in the mid-1990s.[300]

Clearly Mount Hope had fulfilled its early goals. In the late twentieth century, the cemetery continued to meet community needs for burial and other associated services while continuing to develop its potential as a place where people could contemplate the beauty of nature and humanity's role in it, sentiments expressed at the cemetery's 1836 dedication ceremony. Not only did Mount Hope officers, Executive Committee members and staff recognize the value of Mount Hope as an institution and a place, so, too, did members of state and federal organizations devoted to historical preservation, as well as members of the local historical society, and, judging by the many recreational visitors of the cemetery, members of the general community.

MOUNT HOPE GROUNDS
AND BUILDINGS

M ount Hope entered the twentieth century as a well-established, well-run cemetery. Yet Mount Hope officers, Executive Committee members and employees worked as determinedly in the early 1900s as they had in previous years to enhance the cemetery's efficiency and beauty. The process continued throughout the century.

Horticulture remained an important aspect of cemetery maintenance and beautification. Superintendents from 1900 to the 1990s recognized the need for constant vigilance in properly caring for the flowers, shrubs and trees integral to Mount Hope's identity as a garden cemetery. An interest in keeping the grounds as appealing as possible appeared again and again. In 1900, the minutes of the Mount Hope Cemetery Corporation's annual meeting recorded that the Executive Committee was looking forward

> to the time when Mount Hope may rank among the finest cemeteries in New England, not only in its fine situation, which nature has so nicely provided, but under the careful supervision of our faithful Superintendent, it may each year be beautified by fine walks, flowers, trees, and shrubbery.[301]

Walks, flowers, trees and shrubbery—along with other changes or improvements aimed at increasing visitor comfort or cemetery beauty, such as work involving roads or avenues, bodies of water, bridges, seating and ornamental fencing, as well as major structural additions—garnered Executive Committee and superintendent attention throughout the twentieth century.

In 1900, those attending the annual meeting acknowledged part of the role that Mrs. Thomas Cole, wife of Superintendent Cole, played in cemetery operations. The officers present resolved that

> *Mount Hope Cemetery Corporation is under obligation to Mrs. T.J. Cole for her continued and successful efforts in beautifying the grounds at Mount Hope with flowering plants and shrubbery, arranged in such pleasing and happy designs—adding so much to the pleasure of a visit to the silent home of our dear departed.*[302]

The Corporation offered Mrs. Cole "hearty thanks" and authorized the treasurer to pay her fifty dollars for her work.[303]

The Corporation continued to recognize Mrs. Cole for her work in following years, voting to pay her fifty dollars year after year until 1908–9, when the Coles were replaced by the Hathorns. Mrs. Reuben Hathorn then received both the fee and the recognition for the work performed. As other improvements were made early in the century, horticulture remained vital. In 1907, for example, the Executive Committee's report noted that

> *more than usual has been done in the past year in the way of flower beds and ornamentation on the several lawns. About one hundred new shade trees were set out, and many old trees, which by reason of decay had become a menace to headstones and monuments, were removed.*[304]

As indicated by the Committee, planting trees was one focus of cemetery improvement early in the century, with more than one hundred specimens planted in the 1900–1901 fiscal year and roughly the same number of trees and shrubs planted the following year. In 1903, the cemetery planted fifty poplar, twenty-three maple and five elm trees. Newly planted trees did not always flourish. In 1908, newly planted trees died from a summer drought and had to be replaced the following year—fortunately, for Mount Hope, at no cost to the cemetery.[305]

Old and newly planted trees required more than drought protection. In 1909 and 1910, the Corporation elected to hire forester John Appleton to tend to trees in need of pruning and surgery of one type or another. Appleton and another forester, Mr. Sewall, trimmed, patched, bolted and pruned cemetery trees, and the Executive Committee, believing that it had saved many trees, hired the men to treat the balance the following season.[306] Tree treatment continued to be a factor in future operations. Cemetery

personnel or contracted labor planted and pruned trees as needed from the 1910s to the 1990s. In addition, changes in cemetery bylaws affected trees and all other cemetery flora.

In 1932, the Corporation amended its bylaws such that all lots sold from February 1932 forward, with the exception of five specifically identified lots, had to be sold to include perpetual care. Before this, although many lot purchasers did provide funding for the future care of their lots, some lot owners did not do so and therefore held the responsibility for maintaining their owns lots, both in terms of monument upkeep and flora care. Making all lots perpetual-care premises meant that the Corporation and Mount Hope superintendents gained the responsibilities of perpetual care and could begin to make grounds care more uniform. Perpetual-care contracts also served as a hedge against inflation: investing funds wisely and spending interest carefully allowed the. Corporation to meet annual cemetery needs while ensuring income for future grounds care.

As part of the change to virtually all perpetual-care lots, the Corporation specified in 1932 that "as the Corporation maintains its own landscape department, no trees within the said lots or margins should be cut down or destroyed, or new cultivation of trees allowed, except by direction of the Superintendent when so ordered by the Executive Committee." The Committee would, however, cooperate with lot owners as far as possible concerning decorations, lot improvements, markers, monuments or memorials. In any event, the right to make any changes regarding cemetery trees had clearly been recognized as the Corporation's right. As a further testimony to the importance of trees in a cemetery envisioned as a place of beauty to be enjoyed by the living as well as providing interment for the dead, the cemetery conducted a survey in 1932 to determine the number of trees growing on the premises. There were 2,066.[307]

The 1970s and 1980s saw a special emphasis on tree replacement as Dutch elm disease destroyed numerous elms and other older trees in the cemetery. At the close of the 1930s, the cemetery had elected to spray its elms on State Street and prune elms on Central Avenue, as well as to remove all poplars on Poplar Avenue, such poor condition were those trees in. In 1940, the Corporation again sprayed elms, this time all of those within cemetery grounds, and repaired trees where possible. During the mid-1970s, the Executive Committee voted to allow the University of Maine to conduct tests at Mount Hope on the treatment of Dutch elm disease. In the 1980s, when the disease hit full force, the City of Bangor stated that all affected trees had to be removed at roughly the same time, but Mount Hope was

able to circumvent this and instead budget money annually for tree removal and replanting. At the end of the 1980s, the cemetery planted numerous maples to fill voids left by elm disease and other factors. According to the superintendent and his assistant at the time, the effects of the disease lasted for roughly a decade. Problems surfaced during the same period with oak trees that likewise needed attention.[308]

Drought, disease and other natural developments were not the only challenges to cemetery flora or property. Vandalism sometimes occurred. In 1904, for example, the minutes of the annual meeting noted that the Corporation was "glad to say that the practice of stealing plants and flowers and committing other misdemeanors, so prevalent a few years ago, has been practically stopped."[309] Vandalism would at times occur elsewhere in the cemetery, occasionally setting back the grounds beautification that the Corporation so wished to further, but for the most part it remained the "misdemeanors" experienced early in the century.

While flora of all types added to the beauty of the cemetery, other improvements also enhanced the garden cemetery aspect of Mount Hope. One important feature of the cemetery was that of water. When the land was originally purchased, a brook wound through Mount Hope, in some places contributing to undesired runoff and swampy areas. During the nineteenth century, the Corporation had portions of the brook rerouted, creating three ponds by the early 1900s. At the turn of the century, the Corporation completed construction of North Pond (later known as Fort Pond) south of Mount Hope Avenue. The area around the pond was graded and the surrounding area seeded. The Corporation also had a street constructed around the pond, complete with "fourteen granite posts with chains...for the safety of teams driving around the pond." To finish the project, the Corporation had set a "large number of shade trees" on the hill above the pond.[310]

Other grounds improvements involving cemetery waters included the regrading of the area around Blue Pond—Mount Hope's middle pond in terms of north–south location. Blue Pond, like the Garden Pond (later known as Office Pond), is separate from the brook. The 1914 regrading of Blue Pond was accompanied by the removal of "small brush and superfluous trees" such that the pond and the project received "much favorable comment" at the time and subsequently became increasingly popular with cemetery lot owners and visitors. Wooden bridges connected walkways over the brook—three such bridges would be rebuilt in 1930.[311]

During the 1928–29 fiscal year, the Corporation "directed" the overflow of Garden Pond, located south of Cemetery Hill, by sending it across a

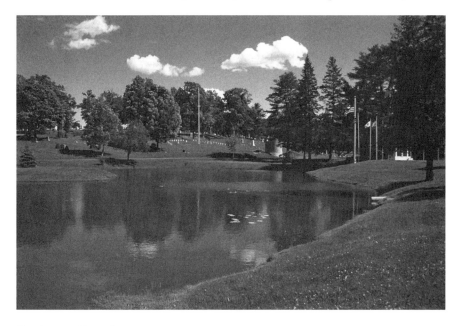

Fort Pond or North Pond, created by rerouting the cemetery brook in the nineteenth century, shown here roughly one hundred years after its creation. *Photograph by Richard Greene, Klyne Studio.*

field then owned by Mrs. Alice Buck and channeling it from there directly into the Penobscot River. This lowered the level of the pond "considerably," "thereby remedying a bad condition that had existed for several years." Earlier, the Corporation had Superintendent Hathorn and an engineer from the state place culverts where needed to help prevent flooding when the State made changes in the layout of State Street.[312]

Rerouting and otherwise managing the water flowing through Mount Hope such that three separate ponds existed, as well as free-flowing channels of water, both increased the appeal of the cemetery in the eyes of many people and reduced flooding and other problems. Later in the century, the brook would be reinforced with concrete in places, referred to as a canal or causeway, and a wide area of the waterway would become known as Tomb Pond. Adding sewers and securing municipal water in the 1910s likewise contributed to cemetery efficiency and appeal, just as fencing in the cemetery during the same era provided functional and ornamental value.

Fencing on the grounds had begun in the nineteenth century for visual impact and security reasons. Work on fences and gates continued in the twentieth century. In 1904, the Executive Committee under Corporation president James Adams, who had succeeded Joseph S. Wheelwright in 1895,

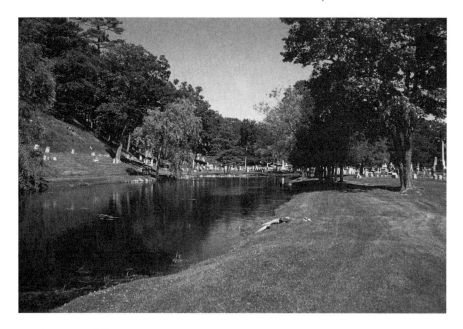

The Garden or Office Pond, as photographed in the 1990s, provides a haven for ducks and geese and remains a popular site for human cemetery visitors as well. *Photograph by Mount Hope Cemetery staff.*

had investigated the possibility of constructing "an iron fence on the rear of Mount Hope Cemetery Corporation grounds on the south side of Mount Hope Avenue," as well as that of adding "a gate on the river side." The Corporation would request the City to help meet the associated expenses. The cemetery worked to the same end the following year.[313]

No appreciable progress on fencing occurred from 1904 to 1906, but about 4,500 feet of fence located along the road from the upper entrance on State Street around to Mount Hope Avenue were painted during the 1906–7 fiscal year. During that same year, Mount Hope installed iron gates at the cemetery's three main entrances and erected "very substantial gate posts at two of them" under the supervision of Superintendent Cole. The Executive Committee, now led by President Manley G. Trask, believed that the iron gates and new posts added greatly to the cemetery's appearance, as well as allowed cemetery personnel "to close the grounds at night against intruders." The Corporation contracted for the gates and posts. Substantial foundations were laid for them according to cemetery records.[314]

In 1907, the cemetery requested that the local electric company remove a few electric poles to allow the "placing of [a] new fence on Mount Hope Avenue." The "new fence" apparently referred to some 450 feet of iron

fence erected along one of Mount Hope's entrances during the 1907–8 fiscal year. Perhaps not all fencing goals of the early 1900s had been met, but with new and ornamental fence, gates and posts, as well as repairs to older sections, fencing progress had definitely been made by 1908.[315]

The 1910s and 1920s saw further additions and changes in Mount Hope's fencing and entrances. By the 1910s, cemetery fencing once again needed attention in regards to appearance, and during the 1914–15 fiscal year, more than four thousand feet of fence surrounding the cemetery, primarily along State Street, were painted. This, like related projects, was deemed a "great improvement," and the Executive Committee recommended that painting be done as often as once every three to four years. The next painting did not come until seven years later, however.[316]

In the early 1920s, iron fencing was added to the cemetery along State Street between the upper and lower gates, a gift from Franklin R. Webber of Boston, formerly of Bangor. Webber had offered, and the Corporation accepted, the gift of fencing in 1921. The new fence extended "from the lower to upper gates on the main road." The old fence was subsequently moved to a section on Mount Hope Avenue, "thus completing the fencing of the grounds" by 1923. The Corporation, led since early 1914 by President Edwin A. Cummings, was so pleased by the gift of iron fence that it stated, "We think the thanks of the whole city is due Franklin R. Webber for his generosity in this respect." And the whole city could read that statement in the Mount Hope annual meeting minutes as published in the *Bangor Daily News* should it have so desired.[317]

Frederick R. Webber and his wife, Martha, gave the city and the cemetery another cause for gratitude the following year. The Executive Committee decided during the 1923–24 fiscal year to move the existing upper gate to a position opposite a barn on Mount Hope Avenue. The granite posts, as well as the ironwork, would be moved to the new location. The former entrance was then to be used only as a foot entrance. The three entrances were thereafter to be identified as the "lower, middle, and upper" gates. The Webbers volunteered to extend the iron fence to Mount Hope Avenue. The Corporation then planned the necessary grading for the new fence, as well as for relocating the old fence from State Street to the upper boundary of the cemetery's landholdings. An abandoned sandbank was in the process of being filled for additional burial lots north of Mount Hope Avenue, and the Corporation wanted the northern boundary fenced.[318]

By early 1925, the iron fence skirting the "Federal Highway [State Street] side of the cemetery" was complete, but the Executive Committee had

The Lower Gate, showing the ornamental fencing donated by Martha and Franklin R. Webber and erected in the late 1920s. *Photograph by Mount Hope Cemetery staff.*

more to thank Mr. and Mrs. Webber for than the new fence. The Webbers had also donated iron gates, and the Executive Committee reported that although the project had required "considerable filling and grading," "we now have an entrance [on State Street] second to none in appearance and ease of access," and it thanked the Webbers for "extending the iron fence" to a most gratifying and artistic completion. The Corporation resolved in April 1926 to "extend to Mr. and Mrs. Webber most hearty thanks and appreciation for their generous gift of the handsome iron fence and gates extending along the lines of the State Highway [Mount Hope Avenue], which adds greatly to the charm, beauty and dignity of Mount Hope." Then, at a special meeting held in August 1927, the Corporation similarly voted to extend the Webbers "hearty thanks and appreciation for their generous gifts of the ornamental wrought iron entrance which they have caused to be installed on the so called upper or northerly gateway from the State Highway to the cemetery grounds adding greatly to the beauty and dignity of Mount Hope." The Corporation clearly appreciated the Webbers' contributions of recent years.[319]

The Webbers helped beautify more than just the cemetery holdings situated along the public roadways. Early in 1927, the Executive Committee reported that the Webbers were to fund the placement of a new iron fence "from the lower gate to the administration building," the fence to be "put in place as soon as conditions allowed." The fence as completed in 1929 actually extended to the brook as located behind the administrative building.

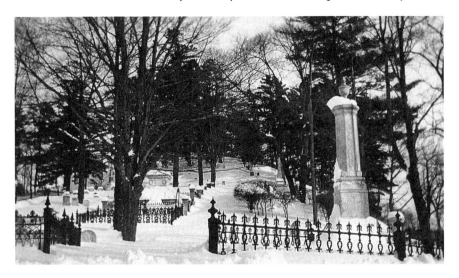

Ornamental iron fence in front of the lodge, facing Cemetery Hill, as seen in the 1930s or 1940s. *Photograph by Mount Hope Cemetery staff.*

The Webbers also donated temporary wire fencing to denote the southwest boundary of the cemetery as established by a recent survey.[320]

The Corporation had good reason to appreciate the gifts of fencing and gates made by the Webbers and the fine work of all those involved in building and placing the fence and gates: cemetery visitors would comment throughout the century on the decorative ironwork, and the 1920s additions clearly did help control access to Mount Hope. In April 1927, the Executive Committee—referring to both the ironwork and to other cemetery improvements and repairs such as painting the grounds and tool building, grading and filling in the upper grounds and applying calcium chloride to the main avenue—stated that in the opinion of the Committee, "Mount Hope Cemetery never looked better than at present time."[321] The Committee clearly recognized both the value of the fence and gates and the fact that regular maintenance work, along with various improvements throughout the grounds, added to Mount Hope's appearance and its functioning.

Gravelling or otherwise treating walkways and avenues received a great deal of attention in the early twentieth century and, like fencing, proved to be an ongoing process. The Corporation began having walks and roads treated regularly in the 1900s and 1910s, especially after Superintendent Hathorn had a two-thousand-pound roller built in 1911 for keeping travel ways properly rolled. Before this, during the 1909–10 fiscal year, the Corporation had the drive areas around the new office building and the old

carriage houses—which had been "moved across the brook"—filled in and graded, a process that required more than "1,300 loads" of stones, gravel and loam. In addition, the cemetery had been using granite blocks to pave gutters during the first years of the century, with some five thousand blocks laid by April 1901. Granite steps had also been added on the "bank leading to the northern part of the grounds" in the 1904–5 year that "proved a great convenience to lot owners in that vicinity." One year earlier, the cemetery had experimented with "cementing some of the steep hillside walks, which proved so successful" that during 1904–5 the cemetery "treated several more in the same manner." The cemetery continued to add Portland cement to walkways during the first decade of the century, especially on the hillsides in order to prevent "washing," a problem previously experienced during heavy rains. Only Portland cement would be used after 1904, reflecting a decision that year to that effect.[322]

New roads were also constructed during the era to provide greater access to various portions of the cemetery, and bridges underwent regular repairs. By 1924, automobiles made regular appearances on the roads or avenues of Mount Hope, necessitating "a good amount of gravel to keep the roads in good condition." The Corporation purchased a "half-ton auto truck" during the 1921–22 fiscal year for cemetery purposes. The Executive Committee stated in April 1922 that the truck had "proved a valuable addition, as a great deal of time is saved in taking men and tools about the grounds, and

Mount Hope's first new dump truck: a 1946 Dodge, shown here with cemetery staff. *Photograph by Mount Hope Cemetery staff.*

in showing many strangers the lots they wish to visit." The cemetery truck and the use of automobiles by visitors did not yet curb horse use but did foreshadow things to come. When the cemetery initiated developments in the Eastern Division during the 1930s, new roads would be laid out with the use of automobiles in mind.[323]

In the mid-1960s the Corporation began paving cemetery roads under the supervision of Superintendent F. Stanley Howatt. During the 1965–66 year, the two main entrance roads were paved for some distance, and in 1966, Howatt suggested that another section of roadway, the one connecting the two main entrances, be paved as well. Additional cemetery roads were paved in following decades under Superintendents Harold S. Burrill Jr. and his son, Stephen G. Burrill. Harold S. Burrill Jr. stepped up the paving process soon after replacing Howatt as superintendent in 1969, and by 1996, all existing roads had been paved except for a small stretch near the State Street side of the cemetery. Located in the original Garden Lot, the Corporation planned to leave that section of the road surfaced with gravel. Elsewhere in the cemetery, roadwork would be focused on maintenance except, perhaps, for any construction on future burial sections.[324]

With the increase in the numbers of occupied burial lots and in cemetery visitors, and with the modernization of the cemetery from its nineteenth-century origins, the Corporation felt a need for new structures to increase visitor comfort and cemetery operations. During the first half of the twentieth century, construction of such concentrated on public waiting rooms, a new office and chapel building and a storage facility.

The Corporation recognized the need for an office building by the early 1900s if not sooner. In 1900, the Executive Committee voted to redo the existing clerical space and carriage building as an office for the superintendent and purchased a safe for cemetery "plans, records, and other papers." (The Corporation also voted to construct a new stable that year.) The revised office arrangements were only a make-do affair, however, and during the 1901–2 fiscal year, the Corporation purchased land on the present-day west side of the cemetery that would, the Executive Committee reported, serve as both "a valuable addition to the grounds" and "provide ample room for a much needed office, which we hope will be built in the near future." The Executive Committee voted in May 1901 that President Adams and Committee member A.B. Farnham "constitute a committee to consult with Mr. [Wilfred E.] Mansur…in relation to the design and probable cost of a building to be erected near the waiting room and to be used as an office." Wilfred E. Mansur was a well-known local architect who was involved in numerous

cemetery projects, and he served on Mount Hope's Executive Committee from 1908 through 1920. The newly formed building committee was to "report the results of this investigation to the full board." The Committee continued to function the following year, apparently with the new property as the intended building site. Before building the new office, however, the Corporation erected two public waiting rooms.[325]

The two public waiting rooms were built at the main and upper entrances. Wilfred E. Mansur designed the buildings, apparently wooden, and J.T. Young constructed the facilities. The Executive Committee voted to contract with Young with the stipulations that the waiting rooms be erected for $430 each, be constructed ready for painting and be completed on or before August 1, 1903. Mansur would have the right of approval.[326] The waiting rooms allowed cemetery visitors to rest while awaiting companions, services or transportation. The Corporation expressed satisfaction with the waiting rooms and stated in 1904 that they filled "a long-felt necessity," calling them the "most important improvement made during the past year." At that time, in addition to horse transportation in the area, the Bangor Street Railway and Electric Company, established in 1889, linked nearby Old Town to Bangor via trolley car, passing Mount Hope on its route. The trolley company was one of the earliest in the United States and also connected Bangor with Hampden, Winterport and Charleston. At least one of the waiting rooms survived until the late 1920s and was thereafter replaced.[327]

The cemetery supposedly erected a gazebo for visitor comfort a few years later. Purportedly constructed in about 1906, the structure has been credited to architect Mansur. The so-called gazebo was later removed—dragged by horses—from the cemetery grounds in the 1950s or earlier and taken to the Bangor Floral Company for its use. The structure remained in existence in the late 1990s, occupied by Growing Fun Daycare. The structure may actually have been one of the waiting rooms designed by Mansur in 1903, or perhaps it (or one of Mansur's rooms) may have been the "old waiting" building moved in 1909–10 to a location near the brook, as indicated by Corporation records for that year.[328] For the early twentieth century, as in the mid- to late nineteenth, identifying the specifics of the smaller structures built by or for the cemetery remains problematic.

After constructing the public waiting rooms and possibly a gazebo, the Corporation contracted for the construction of an office or administrative building, doing so during the 1907–8 fiscal year. The plans called for an office, "a waiting room where funerals can be held if desired" and a fireproof vault for cemetery records and maps. The Executive Committee

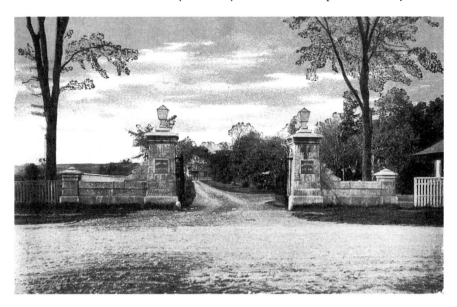

A postcard, mailed in 1910, of the lower entrance on State Street. One of two waiting rooms constructed in 1903 is visible in the lower right corner, as is a small portion of the old wooden fence in service before the 1920s donation of iron fencing by Martha and Franklin R. Webber. Postcard circa 1910.

anticipated a total cost of roughly $10,000 for both the building and its furnishings as designed by Wilfred E. Mansur. The Committee had contemplated such a building for several years but had delayed the project for some time, as other matters had been deemed more pressing. By 1908, however, "the necessity for such a building was so great that we did not consider it wise to delay it longer, as the Corporation had no place in which to keep its maps and papers safe from fire or other loss." Not only would the planned building be functional, the Committee stated that it would also "be an adornment to the grounds."[329]

By early 1909, the new building was finished and furnished. Described as exemplifying "the felicitous use of domestic Old English design for an institutional purpose" by architectural historian Deborah Thompson, the half-timbered stucco building had already hosted a number of funerals in its waiting room or chapel by April 1909. A "women's waiting room" had been built off the chapel and "provided with a convenient toilet." A cellar would provide a place to store plants through the long Maine winters, and a furnace provided heat for people during those winters—supplemented by fireplaces in the office and chapel. A large room that occupied most of the second floor would probably be "used for a drafting room at no distant date." The Executive

The new lodge or administrative building, designed and constructed in 1908–9 and photographed here in 1972. The lodge underwent only a few modifications during the twentieth century. *Photograph by Frederick Youngs.*

Committee reported in 1909 that the building—soon known as the Lodge—and its furnishings would "be ample to supply all demands for many years."[330]

The Executive Committee's conjecture about the second floor proved correct, as did its prediction that the Lodge would meet cemetery needs for years to come. At the close of the twentieth century, the second-story room still served as a drafting area, as well as provided storage space for cemetery records. Changes would occur in the functions of the other rooms, except for the restroom, which would remain just that but become available to both genders. The original office area become a reception area and served as a work area for the assistant to the superintendent (or assistant superintendent); the chapel served as an approach to a crematory (for which an addition was made, retired after a few years and, in 1996, converted into a meeting room) and then became the office area for the superintendent, as well as the meeting area until 1996; and a small area off the former chapel served as a work area at the end of the century.[331]

The vault, so needed in the 1800s and early 1900s, continued to store cemetery records throughout the twentieth century, fortunately never having to fulfill its duties in keeping safe from fire the interment records, Executive Committee and Corporation minutes, maps and numerous other materials. Further testifying to the foresight and solid workmanship involved in creating and furnishing the building, the original oak tables, chairs and a recently refinished bench, as well as the original fireplaces, continued to provide both utility and dignity to the structure at the close of the twentieth century. Some

repairs would be made to the Lodge over the years, such as redoing the stucco on the south side of the building due to a crack that allowed water seepage, but all in all the building held up quite well indeed.[332]

A few other projects likewise modified the structural landscape of Mount Cemetery in following decades. The old chapel, badly in need of repairs and no longer vital to cemetery purposes, was sold for $150 during the 1924–25 fiscal year and subsequently removed. Moreover, a barn used for grain and equipment storage burned down, as did the so-called Watson house. However, the Watson dwelling, previously used to house a staff member, was in a decrepit state and was no longer in use; the Corporation approved it being burned down during the 1966–67 fiscal year. Another barn, located on State Street, had been disposed of in 1935 or thereabouts.[333]

The Corporation approved the addition of two new, or replacement, projects in the early 1930s that would have a lasting impact on the cemetery grounds. The Corporation accepted the gift of a new waiting room and allowed Superintendent Harold S. Burrill to build a new bridge by the GAR Lot near Mount Hope Avenue. Both would survive and continue to draw favorable comments into the closing years of the century.

The new waiting room as constructed in the 1930s was donated by Mr. and Mrs. Franklin R. Webber, the same Webbers who had earlier donated iron fencing and gates. The Webbers offered in 1928 to erect a permanent stone waiting room to replace the wooden one constructed earlier. The Executive Committee voted to accept the offer that year and to use the lot, enlarged and regarded, to "provide for the proper setting and use of such a building," "always…for the purpose of a waiting room building only." The cemetery would maintain the lot. The cemetery board also elected to lay out a new permanent walk for the middle gateway and provide "suitable pathways at this point." Three years later, the Corporation had papers drawn and signed to confirm the 1928 decisions.[334]

Known as the Webber Waiting Room, the granite and bronze circular building was designed by George I. Mansur. George Mansur had replaced his brother, Wilfred Mansur, on the Executive Committee in 1921 after Wilfred's death. Neither George Mansur nor Mrs. Webber lived to see the waiting room completed. During the 1930s, the *Bangor Daily Commercial* highly praised the new structure, dated 1932 on its bronze plaque but not finished until 1935 or later, as a fine example of Mansur's work, calling it "an everlasting monument to his genius." The waiting room measured fifteen feet in diameter and roughly twenty feet in height. Its thick walls, made of Marshfield pink granite, a Maine product, were constructed by Fletcher and Butterfield and left an inside diameter of ten

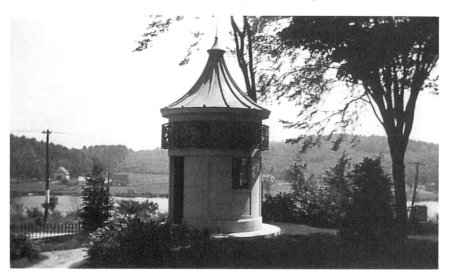

The Webber granite and bronze waiting room, as photographed in the 1930s or early 1940s. The circular waiting room is shown from the rear or Mount Hope side, with State Street just barely visible behind the waiting room. The small facility served as a place for visitors to await an electric trolley car. The Penobscot River is visible in the background. *Photograph by Mount Hope Cemetery staff.*

feet available for those persons who wished to sit on the stone bench or stand on the stone floor and admire the bronze ceiling and electric chandelier (moved to the administrative building in 1975) or look through the bronze window work. The door was also constructed of bronze, and a framework of bronze—complete with scrolls and various figures—surrounded the structure, as did a granite footing at the base of the walls. The Acme Manufacturing Company of Bangor supplied the decorative bronzework, while William Wall did the roof and set the grills.[335]

The *Bangor Daily Commercial* noted that the waiting room, located just off State Street near the old upper entrance (south of the new one), had been built for "the convenience of the public" and was open each day for its use. For the convenience of cemetery staff, the electric light could be turned off and the door locked from the administrative building. A release mechanism located inside the waiting room door ensured that people would not get locked inside. Echoing Corporation sentiments, the *Daily Commercial* stated that

> *Bangor is fortunate, through the munificence of Mr. and Mrs. Webber, in having added to the beauty of the cemetery such a building of distinctive type and notable design and it has been admired by countless thousands passing on the busy thoroughfare close at hand.*[336]

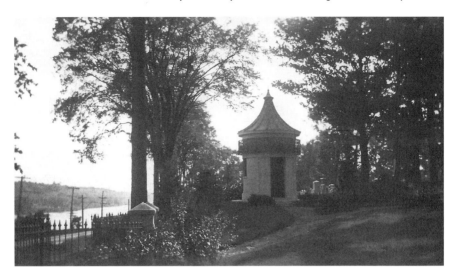

The Webber Waiting Room, from a vantage point parallel to State Street and the Penobscot River. The walkway maintained by the cemetery as part of the original agreement is visible, as is the room's bronze entrance. *Photograph by Mount Hope Cemetery staff.*

The paper also noted the Webbers' generosity in having donated more than four thousand feet of iron fencing over the years, as well as having had the "artistically designed" Webber Mausoleum constructed. The mausoleum had been built in 1922.[337]

As "artistically designed" as were the Webber additions—and also with lasting presence in Mount Hope—was the rebuilding of the bridge leading to the GAR Lot from the west. Superintendent Harold S. Burrill designed the stone bridge, and he and his crew constructed it seemingly before the completion of the Webber Waiting Room. Made of stone, the bridge replaced an older wooden one built in the nineteenth century. The new bridge measured five by fourteen feet, with an arched culvert running through it through which the brook passed. The other bridges in Mount Hope had also been recently rebuilt, with a second stone bridge, similar to that leading to the GAR Fort, being credited to Burrill. The *Bangor Daily Commercial* praised the Fort Bridge in the 1930s and ran a photograph of it next to one of the new waiting room.[338]

In the late 1940s, the cemetery erected its last major structure built before the 1970s. Once again the structure replaced, with a definite upgrading, an existing one—or, in this case, a number of existing ones. In 1950, during the last year Franklin E. Bragg served as corporate president (Bragg had succeeded Edwin Cummings in 1931), the Executive Committee voted to construct a new workshop and storage building. The

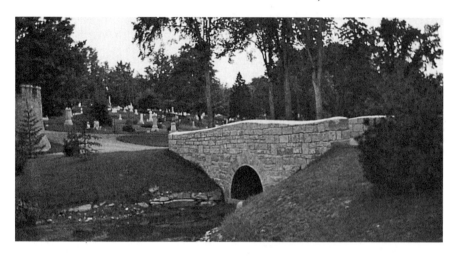

Fort Bridge, circa late 1930s, designed by Superintendent Harold S. Burrill and built by cemetery personnel. The bridge replaced an older, nineteenth-century wooden bridge and survived past the close of the twentieth century. *Photograph by Mount Hope Cemetery staff.*

building would also function, according to the plan, as men's quarters and would allow for the removal of "existing obsolete buildings." After discussing the project, the Committee voted to have Superintendent F. Stanley Howatt contract for the purchase and erection of a metal building with a cement foundation. The size should be thirty-two by eighty-four feet and the cost not to exceed $16,000.[339]

With the increasing use of automobiles and automated equipment, the cemetery needed additional space to house vehicles and equipment when not in service. By the 1940s, Mount Hope was using automobiles almost exclusively for cemetery tasks and had acquired such other mechanized tooling as automated lowering devices for placing caskets in the ground. Automated lowering devices were some of the first pieces of mechanized equipment purchased in the twentieth century. The Corporation had voted to purchase its first one—a National Improved Adjustable Lowering Device—in 1903 as long as the company provided a sixty-day trial period, and in 1909, the Executive Committee voted to buy a second. By the mid-1970s, machine-driven lawn mowers, leaf vacuums and the like would also require storage space, as well as a place for undergoing necessary repairs. The shop, built in an unobtrusive location slightly to the rear or northwest of the administrative building and behind the Receiving Tomb, served these needs into the 1990s.[340] Other structural projects would be initiated and completed from the 1970s to the 1990s.

Work on various tasks continued in the mid- to late twentieth century, with development of the Northern Division a primary focus. In 1955, Superintendent

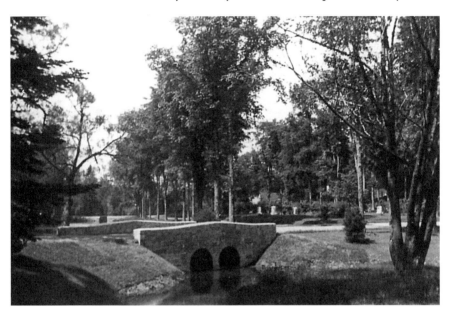

The Cut or Office Bridge, circa late 1930s, was constructed at the same time as Fort Bridge and was likewise designed and constructed by Harold S. Burrill and his crew. *Photograph by Mount Hope Cemetery staff.*

Howatt laid out the land north of Mount Hope Avenue as a "memorial park," a section of the cemetery to have only flat memorials, memorials flush with the surface of the earth, in order to keep grounds maintenance as simple as possible. Prices per lot would be the same as those for lots located elsewhere in Mount Hope. People apparently did not favor such cemetery design, or perhaps they did not find it worthwhile to purchase such lots at the same price as for those in the more traditional portion of the cemetery, with its plain and ornate monuments as well as tombs and mausoleums.[341]

None of the lots in the Northern Division had sold by the time Harold S. Burrill Jr. became superintendent in 1969. The only portion of the cemetery sold for flush marker use by 1969 was Section H in the Eastern Division. Burrill therefore recommended that the Northern Division plan be revised, a recommendation the Executive Committee voted to accept in 1970. The superintendent had met one of the architects from Greever and Ward, a New York firm, at a regional cemetery function and, in 1971, arranged for the firm to redesign the section. Greever and Ward followed its standard procedure and designed the section free of charge as a promotional and public relations service for the granite industry: above-ground markers demand more stone than do flush or flat ones, and they redesigned the section to include above-ground monuments.

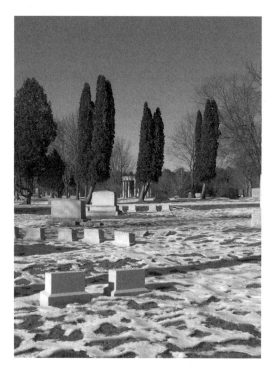

Trees remained an integral part of Mount Hope Cemetery and would change in variety over the years due to cemetery design, disease and simply the passage of time. Seen here in 2012 is a central section of the cemetery with its cedars and the Amanda Skofield Memorial visible in the background. *Photograph by Trudy Irene Scee.*

The firm continued to design sections for cemeteries at a cost or value of up to $1,500 to help promote granite late into the century. Prentiss and Carlisle of Maine did the actual surveying of lots at Mount Hope, with follow-up conducted by cemetery staff. Lot sales proceeded in a satisfactory manner after the Northern Division's redesign. In 1984, Greever and Ward would be asked to prepare a detailed plan for Section B of the "New Northern Division."[342]

Additional modifications in approach to cemetery management accompanied the 1969 change in superintendents. Probably the most important of these was a reemphasis on cemetery beautification. Superintendent Howatt had apparently been quite frugal in his management style, spending only funds deemed absolutely necessary for upkeep, whereas some superintendents had placed greater importance on beautifying and updating the cemetery. By 1969, the cemetery had operated on as low a budget as possible for many years, according to Superintendents Harold S. Burrill Jr. and Stephen G. Burrill. Harold S. Burrill Jr.'s tenure placed more emphasis on the late nineteenth- and early twentieth-century goal of making Mount Hope as beautiful and appealing as possible. For example, for some time before the change in superintendence, lots had been mowed on a rotating basis. With a new dedication to cemetery improvement, and with the purchase of a motorized mower and related machinery such as vacuuming equipment purchased in the mid-1970s, all lots and lawns could be mowed at the same time and leaves and debris removed on a regular basis.[343] Other improvements accompanied the increased care of cemetery grounds during the 1970s, 1980s and 1990s.

Mount Hope Twentieth-Century Land Transactions

M ount Hope Cemetery grew substantially in terms of its landholdings, as well as in its developed divisions and utilized burial lots, during the twentieth century. From its original 50 acres, Mount Hope had grown to encompass some 264 acres by the 1990s.[344] Several parcels of land accounted for the change.

Although City of Bangor tax records and Mount Hope documents remain vague in several respects, by 1900 the cemetery had grown to include well over two hundred acres of land. This included land west of the municipal cemetery between State Street and Mount Hope Avenue (the original purchase plus a number of additions); well over one hundred acres of land north of Mount Hope Avenue (divided into woods and fields); and several acres of fields along the Penobscot River to the Bangor-Veazie town line. The cemetery had begun to develop its Eastern Division on land east of the original fifty acres by 1900 and utilized some cemetery land for purposes other than burials. Mount Hope rented shore property to the Bangor Boom Company for use in its logging operations for fifty dollars per year until at least 1917, after which time mention of the company disappeared from the annual records. In addition, the raising of oats, barley and hay for sale, as well as for cemetery use, occupied field land through the late 1920s.[345]

As discussed previously, the first twentieth-century land purchase involved a small (less than one acre) triangular parcel located just west of the existing boundary during the 1901–2 fiscal year. The cemetery purchased the land, situated roughly halfway along its holdings between State Street and Mount

Hope Avenue, from Robert W. Parker and Esther W. Crombie on October 8, 1901, and intended to erect its administrative building on the property at a future date. Subsequent purchases and various property transactions occurred during the twentieth century. A majority focused on land west of the original nineteenth-century holdings.[346]

In 1902, the Executive Committee authorized President James Adams and Committee member I.W. Coombs to investigate purchasing property west of the new cemetery boundary from Augustus D. Prescott. Apparently, nothing came of the talks, but six years later, on May 12, 1908, the cemetery did secure from Prescott a small triangular land parcel located directly west of the 1901 purchase from Parker and Crombie. The Executive Committee had offered Prescott a twenty- by twenty-foot burial lot, $100 worth of perpetual care and an additional $50 for the strip. The addition proved crucial to the ongoing administrative building project. The Corporation had the parking area to the rear of the new lodge and a small portion of the building constructed on the recent land acquisition. Still desiring farther western expansion, the Committee authorized President Edwin Cummings in 1916 to visit the now widowed Mrs. Prescott to ascertain what price she might accept for her property. No records exist to indicate progress in securing the land.[347]

The Executive Committee continued to view the property adjoining Mount Hope's western boundary—land running roughly north and south—as a valuable addition to the cemetery. In 1927, the Committee authorized member Donald Snow, an attorney, to negotiate with Mrs. Alice Buck, then owner of the former Prescott property, and purchase the land if he could obtain it for $5,000 or less. If necessary, Snow could grant Buck a lifetime lease so that she might continue to live on the premises. This attempt at purchasing the property also came to naught. The Committee, now under the guidance of President Franklin E. Bragg, made a fourth approach in 1940 by offering Miss Alice Buck a maximum of $3,500 and life tenancy for the real estate. This time, after some negotiation, the Committee met with success, and the purchase finally transpired in 1947.[348]

Through the 1947 purchase, the cemetery gained 14.5 or 15.0 acres along its former western boundary just beyond the existing administrative building, land on which the cemetery would soon erect a maintenance and storage facility. The purchase included the Buck House, so-called, which the cemetery utilized as staff housing throughout the balance of the studied period. The irregularly shaped land parcel ran from State Street to Mount Hope Avenue, measured 170 feet along its southerly side and 264 feet on

The Alice Buck property, as purchased in 1947, provided housing for cemetery personnel into the late twentieth century. *Photograph by Mount Hope Cemetery staff.*

its northerly side and contained a number of turns and angles. The land ultimately cost $5,500 and included property occupied by the Bangor Automatic Sealing Vault Company—property that the cemetery requested the company to vacate by December 1, 1947. The vault company still owned property adjoining the newly expanded cemetery, however, and Mount Hope would also seek to purchase this.[349]

In the meantime, the Corporation—under Presidents Cummings and Bragg, respectively—attempted to secure additional land in 1927 and 1932 on the southern side of State Street near the cemetery's lower entrance. The property included the Penobscot Homestead and the land and buildings of the Penobscot Granite and Marble Company. A purchase offer of $3,000 for the latter was arranged in 1932, but it appears that it was not finalized.[350]

The Mount Hope Cemetery Corporation contracted with David J. Nason of Bangor in October 1930 to survey current Mount Hope property lines and establish any necessary monuments. Nason's resulting map, as drawn in December 1930, indicated total acreage as 218.94. At the time that Nason developed his map, the cemetery, in addition to its own landholdings, managed 26 acres of cemetery property for the City of Bangor. Charles V. Chapman, a civil engineer and instructor at the University of Maine, had his students revise Nason's maps in 1948 but did not have them update the maps so as to indicate the recent property acquisitions. The revised maps did not indicate the 1947 Buck property purchase nor the May 1943 conveyance from Alvah Towle of a small (a fraction of 1 acre) triangular piece of property along the boundaries of Mount Hope Avenue and the Bangor-Veazie town

line. The Towle parcel was situated at the northern side of the junction of Mount Hope Avenue and State Street and was located east of the former cemetery boundary within the town of Veazie. The Committee had elected to purchase the Towle property with a $250 payment at a special meeting of the Executive Committee held on June 23, 1943, the Corporation having already voted its support of the Committee's intentions.[351]

In 1931, the Executive Committee voted to have Nason develop a contour map of portions of cemetery land north of Mount Hope Avenue, land encompassing the new Northern Division. Later surveys likewise tended to focus on specific portions of cemetery grounds. For example, during the 1985–86 fiscal year, the cemetery resurveyed Section B of the Northern Division to facilitate relotting the area. In this instance, cemetery staff received aid from the Penobscot County Roads and Mapping Department. Ten years later, in 1996, the Corporation had the Northern Division resurveyed by the James W. Sewall Company for a contour map indicating two-foot intervals of changes in elevation, Nason's 1930 map with five-foot intervals no longer being sufficiently detailed for cemetery planning.[352]

In June 1982, the Executive Committee considered another property transaction. In this instance, the Committee elected to swap small parcels of land with Guy M. Flagg and Bruce H. Flagg of the R.M. Flagg Company, neighbors to the cemetery. The exchange—handled by President Charles F. Bragg 2nd, who had replaced his father, Franklin E. Bragg, as corporate president in 1951—deeded the land conveyed in 1943 by Alvah Towle to the Flaggs, along with another, somewhat larger, triangular parcel bordering the western side of the Towle parcel. The second parcel extended some 221 feet north of Mount Hope Avenue on the Bangor-Veazie town line, in comparison with the Towle parcel's 50 feet along the town line. Altogether some 170 feet along the roadway, plus an area of well under half an acre, were deeded to the Flaggs. In return, the Flaggs deeded to Mount Hope Cemetery a parcel of land located east of the cemetery's then current holdings on the north side of Mount Hope Avenue. As surveyed by the James W. Sewall Company, the irregularly shaped parcel contained 4.7 acres of land located just within the town of Veazie. Bragg signed the appropriate quitclaim deed on January 5, 1983, before a notary public.[353]

In 1982, President Bragg and Corporation treasurer Charles V. Lord had also polled the Executive Committee by telephone in late July and secured an agreement by all members to approve the purchase of a lot of roughly 1.2 acres adjoining the former Buck property for $1,000 from American Concrete Company—previously the Bangor Automatic

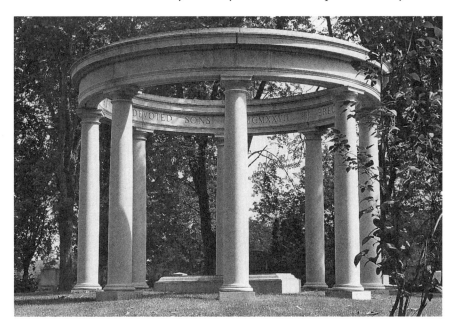

The Amanda Skofield Memorial, built in 1927 in honor of her death and probably Mount Hope's most photographed memorial, is seen here in 1972. *Photograph by Frederick Youngs.*

Sealing Vault Company. The land—situated on the north side of State Street with 65 feet of road frontage and extending north for over 600 feet in an irregular shape—was held then by Petgre Realty Company, having been acquired by Petgre in 1963 from Harold S. Burrill Jr. Before 1959, the year Harold S. Burrill Jr. acquired it, the property had been owned in common by Mattee Getchel, Albert K. Watson Jr. and Bertha D. Burrill. The 1982 transaction between Mount Hope and Petgre Realty occurred on September 8 and brought land long desired by the cemetery under Corporation management.[354]

A few years later, in 1990, the Corporation sold a portion of the land received through the Petgre purchase. Frederick P. Gallant of Massachusetts offered first a land swap and then a purchase offer for land along the cemetery's relatively new western boundary. The Executive Committee refused the land swap offer, as well as Gallant's original purchase offer, which would have included all of the former Vault Company/Petgre property. The Committee did agree to sell a smaller parcel, a 20- by 606-foot strip, for $5,000, subject to Gallant's securing City permission to build a multifamily housing unit partially on the parcel. The Corporation extended a ninety-day offer to Gallant and his partner, Mike McLaughlin, in February 1990 and

then extended it for another ninety days in September 1990. The sale was complete by February 1991.[355]

Mount Hope Cemetery Corporation made one final land transaction in the twentieth century. In October 1995, the Executive Committee voted to grant Bangor Hydro-Electric Company a purchase option for a strip of land along a currently held right-of-way as granted in 1951. (The company had also secured a more limited easement in 1941.) The 70-foot strip of land (about 7.7 acres in total area) was located along the Bangor-Veazie town line and bordered the 80-foot existing right-of-way. The electrical company would pay $2,980 for consideration of the option and an additional $26,820 if the consideration were exercised. Superintendent Stephen G. Burrill advised the Committee that the property "was not needed or desirable for cemetery purposes," and the Executive Committee expressed its agreement through its actions. The electrical company ultimately did elect to exercise its purchase option in 1996. Through the agreement dated September 6, 1996, Bangor Hydro-Electric agreed to combine its 80-foot right-of-way granted by Mount Hope in 1951, containing 9.0 acres, with the new 70-foot strip for a total width of 150 feet. The land would be used for "transmission of electricity or intelligence," with full access and construction rights granted by the cemetery. Mount Hope retained the right to use the land except for the construction of buildings or for burials. Should the company or its successors or assigns abandon use of the land, the property and all associated rights would revert to the cemetery after allowing five years for the removal of poles and other apparatus. Under the 1951 agreement, the cemetery retained the rights to all timber cut, along with a payment of not less than $40.00 per acre for the easement itself. By an agreement concerning the 1995–96 purchase, the cemetery retained half of the stumpage value of any timber cut. By late 1996, Mount Hope had received $4,031.76 in stumpage payments.[356]

In addition to purchasing, swapping and selling property, Mount Hope Cemetery Corporation also elected not to sell or to swap various pieces of property in the twentieth century. For example, in 1946, the Coca-Cola Company made a purchase offer for cemetery land, seemingly on State Street, which the Executive Committee rejected. Likewise, in 1958, the Executive Committee considered, and declined, a purchase offer made by Blotner Trailer Sales, Incorporated, to lease land at the Bangor-Veazie town line opposite the main cemetery grounds for use as a mobile home sales lot. The company requested a five-year renewable

More land often meant more work. Cemetery personnel had to keep major roads passable throughout the century, even when snowfall proved plentiful. Shown here is a "typical" snowy winter day in 1967, with elm trees destroyed in the 1970s by Dutch elm disease lining the road. *Photograph by Harold S. Burrill Jr.*

lease with an option to purchase or the option of first refusal. The company stated that it would operate the business so as "not to create any unsightly condition." The Committee voted to refuse the request "in accordance with the established policy of the Trustees of Mount Hope Cemetery Corporation which is to retain the land opposite the cemetery on State Street for cemetery use only." In 1982, the Executive Committee voted to deny another purchase offer, this one from Steve Crichton of Unlimited Property Service, for $4,000 per acre (for a total of roughly $50,000) for State Street land, giving basically the same reason. Crichton

also suggested the possibility of trading the land for another piece of property bordering Mount Hope. In 1987, in a final transaction denial, the Committee declined a request by the R.M. Flagg Company—its owners the individuals with whom the Corporation had earlier swapped land north of Mount Hope Avenue—to sell or lease land adjoining the company to the company. The Corporation did so at Superintendent Harold S. Burrill Jr.'s recommendation.[357]

LATE TWENTIETH-CENTURY MODERNIZATION

Mount Hope Crematory, Mausoleum and Related Developments

Changing demands for interment services created the impetus for the two most important new cemetery structures of the century after the 1950s: Mount Hope's crematory and its Community Mausoleum. Much of the driving force behind both projects came from Superintendent Harold S. Burrill Jr., as did the creation of an urn garden and the purchase of a computer system.

The Mount Hope Executive Committee first discussed the possibility of building a crematory and an above-ground mausoleum, as proposed by Superintendent Burrill, at its 1971 annual meeting. After due discussion, the members asked Burrill to look into the matter, including formulating estimates of local demand.[358]

Burrill reported his findings in April 1972 and stated that installing a cremation retort—the actual apparatus for cremating human remains—would provide "a further service of the cemetery and...add further income to the cemetery." Based on an informal survey that he and his assistant (his son, Stephen G. Burrill) had conducted by contacting crematories and Maine governmental agencies, Superintendent Burrill expected Mount Hope to initially perform about one hundred cremations per year should the cemetery add a crematory. Charges would run roughly eighty-five dollars per cremation, plus the cemetery would realize income from container sales. Only two crematories existed then in Maine, one of them having been built just the previous year. Permission from

the State to amend Mount Hope's charter to include cremation services should be secured, according to cemetery attorneys, as well as permission obtained from the Maine Health and Welfare Department. Burrill asserted that building a crematory should be one of the Corporation's "prime objectives" as "sooner or later a crematory will be built to service this area and Mount Hope should be the one to offer this profitable modern burial method."[359]

The following month, the Executive Committee heard testimony from Attorney Merrill R. Bradford that changes to federal tax laws in 1969 "appeared to make it possible for a crematory to qualify as an activity in which a non-profit organization might engage" and that Maine law "confirmed the propriety of a cemetery's operating a crematory." The Committee voted to have Bradford "apply for a ruling from the Internal Revenue Service confirming the tax exempt status with respect to a crematory," thus the process would already be started should Mount Hope proceed with building a crematory. Senator Margaret Chase Smith of Maine subsequently informed Superintendent Burrill that the pertinent federal legislation had not yet been introduced into the Senate, although the House of Representatives had approved it (H.R. 16506). The law or a modification of it eventually did make its way through Congress.[360]

By May 1972, the Executive Committee had received a proposal from J.J. Dunn, Incorporated, of Veazie to construct an addition to the chapel portion of the administration building to house a cremation facility. The proposed cost was $14,000. The Committee voted in May to ask the company for a revised cost estimate to include a slate roof comparable in style to that on the existing building in lieu of the proposed addition with asphalt shingles. The cost of one retort chamber, according to figures Burrill had received, would be roughly $12,500 to $15,000.[361]

The Executive Committee voted in late July to proceed with the project. It voted to develop a construction contract with the Dunn Company for the proposed nineteen- by twenty-one-foot addition. The Committee compiled a list of criteria that Dunn had to meet. The Committee also voted to purchase and have installed a retort at the price of $15,000 to $16,000.[362]

Within a year from the Executive Committee's voting to proceed with the project, the addition was essentially complete. In July 1973, the Committee considered the superintendent's proposal that an urn garden be developed in the new Northern Division in an area unsuitable for regular burials due to the presence of underlying drainage tile. The proposed plots for cremated remains would measure two feet by two feet. The Committee also considered Harold Burrill Jr.'s proposal that a display

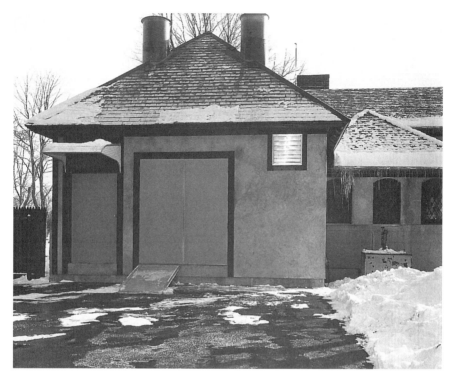

The crematory facility, as added onto the administrative building, added a whole new area of services available at Mount Hope, and it was the only such facility in northern Maine during the era. Photographed soon after construction, in 1972. *Photograph by Frederick Youngs.*

unit for urns available for sale be purchased, along with an urn storage unit capable of holding eighty-three variously sized urns. The Committee voted to proceed with the Urn Garden (or Urn Garden Section, as the site became known), sized for 441 plots under perpetual-care regulations and restricted to the use of uniformly sized bronze markers, and to inventory an assortment of cremation urns. The Committee resolved that "the crematory at Mount Hope be used for cremation of humans only." Mount Hope had recently been asked by the Bangor Humane Society whether or not a St. Bernard dog too large to cremate in its own equipment might be cremated at Mount Hope. Earlier in the century, the Corporation had voted to reject requests to bury dogs or other animals with their human companions, although the Corporation acknowledged that such interments had occurred in the past.[363]

Although the concept of an urn garden quickly evolved into the reality of one, Mount Hope never required that clients purchase urns from

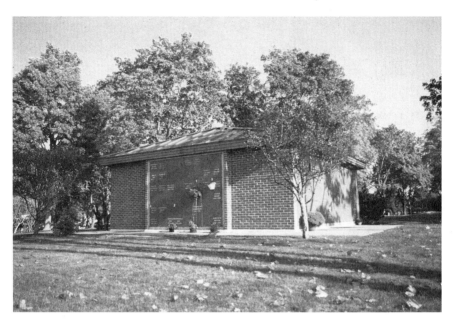

Mount Hope's Community Mausoleum, built in 1985–86, was the culmination of lengthy research and planning and, like the crematory, offering a new service to the broader community. *Photograph by Richard Greene, Klyne Studio.*

Mount Hope's inventory for interment or cremation at the cemetery, and indeed it did not require the use of a permanent container for holding cremains. The Corporation did eventually revise its bylaws to include the statement that, concerning cremains, "a permanent container is advised (but not required) in case a later removal of the cremains should be desired."[364]

The matter of supplying additional interment options for cremains remained an active one, even after the associated decisions had been made and the Urn Garden developed. Superintendent Burrill stated once again in 1973 that in the future the cemetery should develop a columbarium for above-ground interment of cremains, and he designated a location adjacent to the chapel as being suitable. Discussion of a columbarium continued the following year. Burrill proposed in 1974 both that a second retort be purchased—primarily as a backup unit—and that the Executive Committee consider building a combination mausoleum and columbarium, one with eighty full-size crypts for regular above-ground interments and 160 cremation niches. The proposed structure would cost under $35,000 and "take up less than twenty regular grave spaces." This would be a "feature mausoleum," with all crypts and niches on the exterior. A second option

would be a "community mausoleum," with crypts and niches both interior and exterior. A detailed feasibility study and proposal could be requested of Milne Mausoleums. A third option, should the others not be adopted, would be to purchase a less expensive unit with forty-five niches for $2,640 plus expenses. This unit could be placed in the chapel until the construction of a separate facility. The first two facilities could be constructed in the "large oval in the Eastern Division." On a related matter, Burrill proposed that some decorative feature be purchased and added to the new Urn Garden, perhaps the commercially available "Open Bible" or the forty-eight-inch diameter "Sundial."[365]

The Executive Committee voted to purchase the second retort later in May and also to purchase and install "an appropriate feature" to the Urn Garden after further study. The members also voted to postpone a decision on a combination mausoleum and columbarium until further study. The Committee stated that "there is an interest in such a facility in our area," but as "any decision made now might shape the direction of the cemetery's development along these lines in the future," further study was necessary.[366]

The following year, Superintendent Burrill recommended that if the financial aspects of the combination columbarium prevented its being approved, a "feature mausoleum" with forty full-size niches and some cremation niches might be considered for placement in the Eastern Division oval for about $20,000. The structure could be centered on the oval such that room would remain for two additional units to be added in the future, one on either side of the first unit. He also suggested that, if need be, the Corporation delay purchasing the anticipated bronze sundial for another year and instead have the Urn Garden Section professionally landscaped.[367]

The Executive Committee took no action on the mausoleum matter when it met in June 1975 but did authorize the superintendent to obtain cost estimates for the landscape work, with the treasurer and president of the Corporation able to approve the work at their discretion. The Committee again tabled talk of a "feature mausoleum" in May 1976.[368]

Although discussion of erecting a mausoleum lasted for a number of years, not all cremations performed at Mount Hope or elsewhere resulted in interment. When originally investigating the feasibility of a crematory for Mount Hope, Superintendent Burrill toured numerous New England crematories, some with his wife and some with his assistant, and was shocked to discover crematories stockpiled with cremains that relatives or others had failed to collect. One crematory in particular had hundreds of remains still on its premises from years earlier and advised Burrill to avoid the same.

Burrill determined that Mount Hope would not become involved in the "storage business." Mount Hope, therefore, began its cremation services with a policy of shipping cremains as soon as they were ready unless other arrangements were made and promptly executed. The system worked well and avoided problems seen elsewhere.[369]

Although cremains did not become a storage problem at Mount Hope Cemetery, records associated with cremations did demand permanent storage space. The State of Maine required that the Corporation retain cremation forms, and these became increasingly detailed as the decades passed.

In 1972, cremation forms consisted of half a standard-size page stating the name, cremation number, date of birth, date of death, city of death and city of previous residence of the deceased. The form included a signature of the deceased's "relative or legal guardian" and one of the funeral director, as well as a designated "disposition" for the cremains. Attached was a brief "Medical Examiner's Permit to Cremate a Dead Body" and a certificate of receipt of the remains by Mount Hope, as well as, where applicable and reflecting the cemetery's decision not to store cremains, a U.S. Mail delivery receipt.[370]

By the mid-1990s, the length of the cremation forms had increased substantially. The length of the basic form, now called the "Authorization for Cremation and Disposition," had roughly doubled. It included a "Policies, Procedures, and Requirements" page, photocopies were added and much more legal and medical information was given, including whether a body contained any "pacemakers, prostheses, [or] silicone and radioactive implants," which could be damaging to the crematory. Mount Hope required that such implants or devices be removed before the delivery of the remains to the cemetery. The Medical Examiner's Report had likewise become more detailed, and a certificate of death, as well as a U.S. Postal Service receipt, accompanied the other forms. State law required Mount Hope to retain cremation forms indefinitely.[371]

Mount Hope performed four cremations when it initiated crematory operations at the close of 1972. The cemetery performed the first free of charge as a form of goodwill and as a promotional measure.[372] Cremation numbers rose rapidly thereafter, such that they totaled 158 in 1973, 249 in 1976, 337 in 1980, 649 in 1985, 895 in 1990 and 1,281 in 1995. Cremations proved increasingly profitable as well as popular, quickly becoming a major source of revenue for the cemetery. By 1980, the ability of cremation services to significantly augment cemetery income had become apparent. During

the 1979–80 fiscal year, the cemetery attributed $39,397 of its $93,495 gross income to cremations and urn sales, an amount more than twice the $18,872 income from burials. (Foundations associated with burials did account for another $4,083, however, but some of this may have included interment work in the Urn Garden.) The economic impact of cremations and associated services would remain vital in subsequent years.[373]

With the number of cremations continuing to rise, and bringing with it an increase in cemetery revenue, Superintendent Harold S. Burrill Jr. continued to ask the Corporation to consider adding to the available space and the type of structure available for cremain interments. Burrill made inquiries with a number of firms concerning mausoleums, and in 1980, he proposed that Mount Hope purchase a cremation cabinet with forty-eight niches for $6,611 and locate the structure near Office Pond or elsewhere. He also asked the Executive Committee to consider erecting a 144-crypt mausoleum by Granit-Bronz, Incorporated.[374]

The following year, the Committee again deferred plans for a mausoleum or cremation niche but did vote that Burrill continue to make inquiries and record them as received. Burrill had included a mausoleum proposal again in his superintendent's report, stating that a mausoleum with about forty crypts plus niches for cremains would make Mount Hope "a full service cemetery offering ground burial, cremation with urn burial, and a community mausoleum, the first such cemetery north of Lewiston." He had recently visited Laurel Hill Cemetery in Saco, Maine, where a forty-two-crypt and twenty-four-niche mausoleum was under construction at a cost of $42,000. Acme Marble and Granite Company of New Orleans, Louisiana, creators of the Laurel Hill Mausoleum, had submitted material to Mount Hope stating that it would design a mausoleum, generate enough sales in the region to cover construction costs, build the facility and "leave a profitable inventory for our future." Other sizes and types of facilities might also be considered.[375]

In late November 1983, the Executive Committee met with a representative from Acme Company about the possible construction of a mausoleum at Mount Hope. The representative, Martin De Laureal, presented illustrations and discussed feasibility studies and market surveys as conducted by Acme. Burrill suggested the possibility of building a mausoleum on either side of the Peirce Civil War Memorial near the cemetery's main entrance, a location that De Laureal later wrote would be an excellent setting as it "not only provides the desired visibility but also benefits from its physical association with the memorial." He noted that Mount Hope might build one unit initially and add a second later. De Laureal referred to the mausoleum at Laurel Hill and indicated to

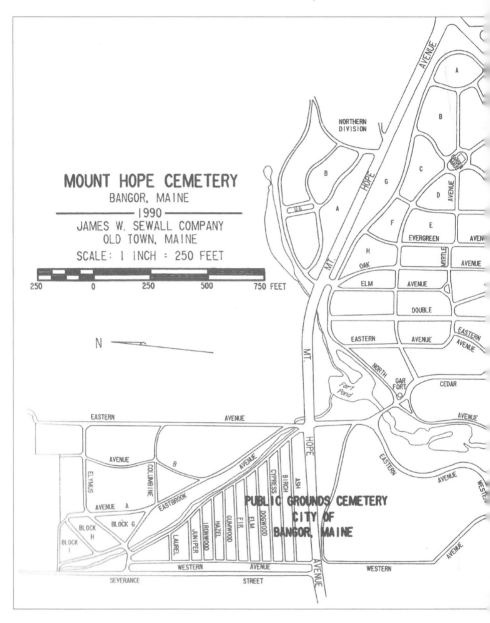

Corporation president Charles F. Bragg 2nd that the company thought that Mount Hope would also want to start with a relatively small mausoleum, making for a relatively high price per unit but preventing the cemetery from becoming overextended while "testing the waters." He recommended a garden (all exterior) mausoleum with about one hundred casket spaces.[376]

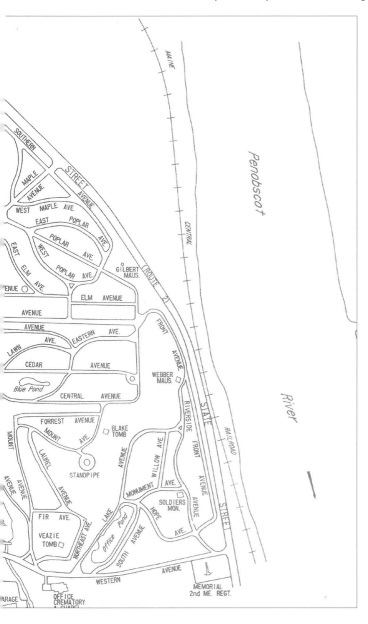

A basic map of Mount Hope Cemetery, showing the brook and the main roads, ponds and sites. *Map by the James W. Sewall Company, Old Town, Maine.*

The Executive Committee discussed De Laureal's suggestions in January 1984 and voted to have the superintendent request from Acme Company "a specific proposal and cost estimates for a seventy-two crypt mausoleum, including 'presale survey,' design, and construction costs." The Committee also requested the names of New England cemeteries that had similar

facilities constructed by Acme and could be contacted for references, and it asked Burrill to obtain warranty information concerning the mausoleum after construction.[377]

Acme subsequently submitted a proposal to the Corporation, and in June, the Executive Committee agreed that if the demand existed in the area, Mount Hope "should be prepared to make such a facility available." The group deferred making a decision until a later date. Burrill, in the meantime, spoke with local funeral directors and determined that although relatively few inquiries had been received in recent years, the funeral directors believed that "the existence of a suitable mausoleum at Mount Hope Cemetery would, in their opinion, stimulate an active future interest." Burrill's report having been received, President Bragg and the Executive Committee as a whole agreed in October 1984 that Mount Hope should provide a mausoleum. The Committee voted that the superintendent would seek a contract with Acme for the "construction of a seventy-two crypt mausoleum as outlined in their proposal of April 30, 1984," but with one major modification: the mausoleum would include forty-eight instead of twenty-four columbarium niches. After such a contract was drawn, cemetery officers (after due review) could enter into contract with the company. In the meantime, Superintendent Burrill could seek ideas concerning pertinent brochures, press releases and public relations in general from Cardin Advertising concerning the project.[378]

The Corporation ultimately decided to conduct a less extensive publicity campaign than originally suggested by Cardin, but it did have brochures printed for distribution to area clergy and funeral directors and agreed to have a story published in the business section of the *Bangor Daily News*. The cover of the brochure as prepared featured a small color photograph of the "Garden Mausoleum at Mount Hope." Inside was a lead statement: "Mount Hope is pleased to announce that it has become the first full service cemetery in northern and central Maine with the addition of a garden mausoleum." The small brochure also included information about mausoleum interments available at Mount Hope and assured readers that "the concept of mausoleum entombment is not new" but rather "is as old as recorded history," and it mentioned cave dwellers, Egyptian pharaohs and other people associated with above-ground interment. The brochure script ended with a simple statement: "Ask your funeral director to tell you more about the mausoleum or, if you prefer, stop by our offices at the cemetery for further information."[379]

Superintendent Burrill made his pleasure with the Committee's vote apparent in his next correspondence with De Laureal. He called De Laureal the morning after the vote, and in a letter that same day he stated that "it was nice to report

the approval of the mausoleum by my Executive Committee at last." Discussion of the mausoleum and the additional cremation niches continued thereafter, and a projected construction date of the spring of 1985 was established.[380]

The Executive Committee reviewed the contract submitted by Acme Company and had the firm of Eaton, Peabody, Bradford and Veague prepare amendments so as to better protect the Corporation's interests. John Conti ultimately made the revisions, and President Bragg reported construction developments at the annual meeting in May 1985, at which time expected costs were $80,000 to $85,000.[381]

As constructed, all cremation niches were located at one end of the mausoleum, with regular interment niches opening off either side. The "shutters" for the crypt and niche fronts were stone panels in "capao bonito," and the trim was done in "Spanish rose." Niches and crypts were scored for identification purposes. The cemetery had the mausoleum constructed on the oval in the Eastern Division, as previously suggested by Burrill, the unit being placed to one side of the oval so that an additional unit could later be added, with the combination facility centered on the lot. By 1996, the need for an additional unit had not yet been realized. The new mausoleum was the cemetery's fourth mausoleum to date—the Franklin R. Webber, Frederick W. Hill and Charles W. Gilbert mausoleums predating it—and was Mount Hope's only community mausoleum.[382]

After considering charging uniform rates for all levels of the new mausoleum, the Executive Committee, on the advice of Acme, decided to vary niche and crypt pricing. The highest rates would be charged for interment in the center level of the three levels of crypts and the center two levels of the six levels of cremation niches. The Committee also decided to make both singles and side-by-side companion memorials available. Purchases could be made on installment plans, much like that available for below-ground interments, and similar charges as for ground burials would be levied for opening and closing niches and crypts.[383]

In May 1986, Bragg was able to report that the mausoleum had been completed and that the first niche and the first crypt had sold within a few days of the completion. The Corporation had consulted with De Laureal about "an appropriate newspaper [advertisement] or other means of attracting public attention to the new mausoleum during the Memorial Day season."[384] De Laureal had responded with advertising data, and Superintendent Burrill ran, accompanied by a photograph taken by *Bangor Daily News* staff, the following during Memorial Day Weekend 1987:

Mount Hope Cemetery, Bangor, Maine is now offering an alternative to ground burial in the new Garden Mausoleum where single, double, and companion crypts, as well as cremation niches, are available. Decisions about burial space should not be left until the last moment when families are under emotional stress and are coping with new financial concerns. You and your family should consider now the benefits of meeting this most important obligation.[385]

The addresses (street and post office) and telephone numbers for the cemetery accompanied the newspaper advertisement. The cemetery received two inquiries during the first business day after the advertisement appeared and anticipated more in the near future. Additional inquiries and sales did occur, but making the general public aware of the facility remained an issue. The following year, the cemetery considered, but rejected, the idea of using an outside salesperson "to sell mausoleum units or lots." In the long run, niches and crypts did not sell as quickly as anticipated. To date a second facility has not been added.[386]

Another need experienced by the cemetery and its staff, and partially associated with the increase in cremations and related services, was that of a quicker and more efficient method of maintaining cremation and other cemetery records. As records continued to accumulate year after year, the staff needed an easy way to access and manage them. In 1987, in response to cremation and burial record needs—and with the intent of eventually having the Corporation's payroll and accounting systems (currently maintained by the firm Brooks and Carter) managed at the office by cemetery personnel—the Executive Committee began to consider, as suggested by the superintendent, purchasing a computer system.[387]

The Executive Committee considered two computer systems and ultimately decided on an IBM system from Val Coin Computer Center. Not only would the system allow for the already anticipated functions, it would also allow historical data to be updated and replace the more than $3,000 annual fee paid for contractual computer services. The Executive Committee committed itself to the $6,000 system in March 1988. When Superintendent Harold S. Burrill Jr. retired in 1992, the Corporation acknowledged Burrill for "persistently urging the Mount Hope Executive Committee toward new and important steps." One such step was the purchase of the computer system, which by then was handling the cemetery's "accounting as well as the efficient recording and storage of all the cemetery's burial lot and cremation records, which are constantly referred to by the public."[388]

Meanwhile, cremations continued to increase yearly, stressing current operations. In February 1987, the Committee agreed with Superintendent

Burrill that it should consider a third retort for the crematory, an addition that would require enlarging the existing facility. No such action was taken for a number of years, however. Repairs and revisions were made on the older retorts to keep them operating efficiently and according to state and federal regulations, yet the demand for greater capacity remained through the end of the decade.[389]

In the 1990s, substantial changes occurred with the crematory and its ability to meet increasing demands. In 1991, the Corporation purchased a "new 'All' Cremains Processor" for $2,750 to use in treating cremains for interment or other disposition. At the same time, the Corporation decided to explore the feasibility of staffing the existing retorts for additional hours each day, thereby increasing the crematory's capacity without an immediate need for another retort. Additionally, the Corporation considered expanding the crematory and office by eliminating the seldom-used chapel portion of the administrative building, a possibility that had also been discussed in 1990. In January 1992, Superintendent Harold Burrill Jr. and his assistant, Stephen G. Burrill, again brought to the Executive Committee's attention the need for a third retort and for an enlarged crematory. The Committee agreed to have the two men obtain proposals for a new retort from both the Jarvis Company and the All Company and to secure a preliminary estimate of costs for either expanding the present crematory space or having an appropriate building constructed to house a three-retort crematory.[390]

Stephen G. Burrill become superintendent in July 1992. He reported in writing that August that the present crematory—the addition made to the administrative building years earlier—was becoming too hot and noisy for good working conditions, partially due to the Environmental Protection Agency's having raised the required operating temperature from 1,600 degrees to 1,800 degrees, a 200-degree increase per retort. The existing units, moreover, had been installed in December 1972 and August 1974 and had a maximum potential of three cremations per twenty-four-hour period under perfect conditions. The two retorts also needed maintenance work—should one of them break down or be taken out of operation for an extended period, the cemetery would have no backup in place.

Cremations and sales of urns and trays had brought in $162,513 as opposed to having cost the cemetery $52,946 in expenses for the first nine months of the current fiscal year. In addition, income from cremations and urn and tray sales totaled $1,632,739 to date. The use of the crematory had increased sixfold since operations started. Keeping up with demand might necessitate that a half-time employee be hired. The superintendent proposed an addition measuring roughly thirty by fifty feet. Such an addition would

allow for installation of a third retort as well as a future fourth one and provide desired processing and storage areas. The crematory was currently housed in the twenty-two by twenty-foot existing addition along with some use of the chapel portion of the administrative building. The cemetery could either add a new building or augment the existing crematory area.[391]

The Executive Committee voted in August to adopt the first option and add a new building. Two proposals had already been received, and the Committee voted to proceed with the process. Later in the month, the Committee examined the two bids—both for preengineered steel buildings—and voted to retain the services of Richard H. Campbell of Construction Coordinates. Campbell would work with the superintendent, Committee member Robinson Speirs, various subcontractors and Downeast Associates to develop a price estimate and design for a masonry building. Downeast Associates had submitted one of the proposals for a steel building, but Campbell had stated that a more durable masonry (cement block) facility more in keeping with current cemetery buildings might be constructed instead and possibly at a lower cost than that for a comparable steel building. In the meantime, the Corporation authorized the purchase of a third retort from All Corporation.[392]

As subsequently constructed, the crematory measured 30 by 60 feet for a total area of 1,800 square feet, a tremendous improvement over the old facility. Construction was complete by early 1993. The Environmental Protection Agency delayed operations in the new building for about two months while it conducted various tests. Testing the retorts for temperature and pollution levels remained integral to future operations.[393]

In 1995, President Charles Fred Bragg 2nd identified the use of the crematory, which had witnessed an expansion the previous year, as being responsible for "the significant increase in revenue from cemetery operations" in recent years. Furthermore, the cemetery's budget, as prepared by Superintendent Stephen Burrill, projected a "continuation of the positive trend."[394]

Clearly, the crematory at Mount Hope Cemetery, both in the original location off the administrative building and in the new building, provided welcome income from the early 1970s to the mid-1990s. It also served the needs of the regional community, as did the associated Urn Garden and Community or Garden Mausoleum, while the computer system helped to manage cremation and other Mount Hope records. Mount Hope had adapted to changing burial needs and desires in a positive manner, and its solid financial status at the close of the studied period attested to its success in so doing.

Twentieth-Century Monuments
and Memorials

In addition to working to maintain and beautify cemetery grounds and construct buildings, both functional and aesthetic, the Mount Hope Cemetery Corporation erected new memorials with lasting significance in the twentieth century. Three of these honored the memory and commitment of America's veterans and fallen soldiers.

The Hannibal Hamlin and H.H. Beal Posts built the Grand Army of the Republic (GAR) Fort on land donated by Mount Hope for that purpose in the late nineteenth century. Situated off Mount Hope Avenue, the memorial was to supplement one erected during the Civil War. The area surrounding the GAR Memorial served as burial grounds for fallen Maine Union soldiers, those whose numbers had increased during the war to such an extent that the initial plot consecrated in the early 1860s near State Street proved too small for their interments. By 1901, the lot on which the memorial would be built had been graded by the local GAR Post, and a masonry fort or tower had been erected and cannons and flags installed. The Mount Hope Cemetery Corporation reported in 1901 that the area was a most fitting place for the burial of the loyal soldiers. The Corporation acknowledged that "much credit is due to the posts for their success in carrying out their carefully projected plans."[395]

Much of the GAR Fort planning and construction had been completed by 1900. However, the fort would receive much attention during the course of the twentieth century. In addition to some improvements made to the lot in the early 1900s, a dedication ceremony was held on October 7, 1907. The

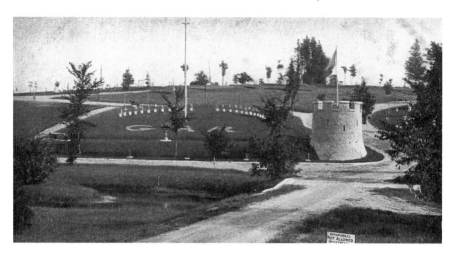

The Grand Army of the Republic Lot, as seen in a postcard produced circa 1910.

ceremony attracted a great number of visitors in spite of inclement weather. The Maine Central Railroad ran a special train in honor of the occasion so that those seeking transportation would find it more readily available.[396]

Numerous organizations participated in the dedication ceremony. The Hannibal Hamlin and B.H. Beal Posts took part, as did the GAR of Bangor. Their extensive roles in establishing the fort made these organizations and their members obvious participants. Other groups also played roles. These included the Frank G. Flagg Post of Hampden; Company G, Second Regiment; and the Daniel Chaplin Camp Sons of Veterans. Captain Frank A. Garnsey directed the paraders, who rode to Mount Hope on special trolley cars.[397]

Once those participating in the ceremony had arrived at the cemetery, a group of policemen and the Bangor Band led the military groups to the GAR Lot. There, General Joseph S. Smith, chairman of the project's board of trustees, acted as master of ceremonies. Smith had played a significant role in the building of the fort. Smith told those attending the October ceremony:

We are assembled upon this sacred ground this Sunday afternoon, a most appropriate day, for the purpose of dedicating this beautiful burial lot to the memory of our fallen dead. There are twenty-five veterans of the Rebellion at rest here now and many more to come. May their ashes rest in peace.[398]

The chaplain of the Hannibal Hamlin Post—Reverend John S. Sewall of the GAR—then led those assembled in prayer. After the close of the prayer, the Apollo Quartet sang "Honor to the Nation's Dead."[399]

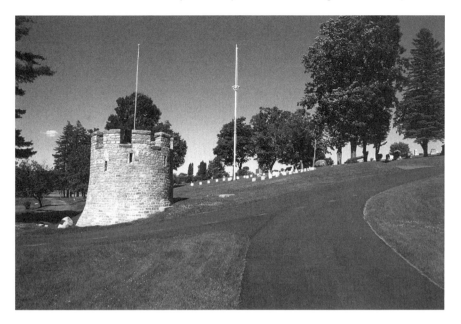

The GAR Fort, as seen in the 1990s. With its masonry tower, cannons and flag, the fort was as popular a site at the close of the twentieth century as it was at the century's beginning. *Photograph by Richard Greene, Klyne Studio.*

General Joshua L. Chamberlain, arguably Maine's most famous Civil War veteran and hero, was to deliver an address, but was unable to attend the ceremony and was "detained at home." Proceeding with the schedule, the flag donated by the widow of General Charles W. Roberts was raised to the accompaniment of "The Star-Spangled Banner." A number of speakers addressed the crowd, including Governor Llewellyn Powers, General Augustus C. Hamlin of the Second Maine for All Maine Veterans, Bangor mayor Arthur Chapin and Professor Allen E. Rogers of the University of Maine. Veteran John F. Foster, secretary of the project's board, read the list of those who had subscribed $100 each for beautifying the lot and that went toward the future care of the "soldiers and sailors lot."[400]

By 1924, thirty-nine Civil War veterans had been interred at the GAR Lot. During that year, Captain Garnsey—as the sole remaining trustee of the GAR Lot—turned over the sum of $1,400 to the Mount Hope Cemetery Corporation for the perpetual care of the soldiers and sailors memorial and lot. The Corporation accepted the funds, and according to the cemetery trustees, as reported in the *Bangor Daily News*, "The lot will be forever maintained in the condition appropriate to its purposes."[401] Although the fort did go through a period of disrepair later in the century and was

subsequently restored, the lot remained a peaceful, well-maintained and regularly visited feature of Mount Hope Cemetery in the 1990s and beyond.

The successful construction and dedication of the Grand Army of the Republic Memorial did not mean that the Mount Hope Cemetery Corporation had finished building memorials to Civil War veterans. Another major monument, one to the Second Maine Regiment of Volunteers, was erected in the 1960s. A bequest made by Colonel Luther Hills Peirce of Bangor provided the impetus and the means for the project.

Luther Peirce was born in 1837, graduated from Yale University in 1858 and served in the Second Maine from its 1861 establishment through its early Civil War battles.[402] Known as the Second Maine, the regiment was actually the first Maine regiment to leave for military engagement. It served for two years and fought in eleven battles—Bull Run, Yorktown, Hanover Court House, Gaines's Mill, Malvern Hill, Manassas, Second Bull Run, Antietam, Shepherdstown Ford, Fredericksburg and Chancellorsville—as well as engaged in a number of skirmishes. A total of 1,228 Maine men served with the Second Maine at one time or another, although when the regiment originally left the state, it had only 772 men instead of the standard 1,000. Some members of the Second Maine eventually transferred to the Twentieth Maine or to other units. Nicknamed the "Bangor Brigade," some 123 towns were actually represented among the Second's original members, who "rendezvoused" at Bangor. The regiment included several men from well-established families from the Bangor area, families whose members served Mount Hope in one official capacity or another during the nineteenth and twentieth centuries.[403]

Peirce served with the Union army throughout the war and until he entered the real estate business in Chicago in 1868. He visited Bangor frequently and discussed with other Second Mainers the possibility of erecting a monument to the regiment. Peirce died in 1915, and his will specified Mount Hope Cemetery as his chosen site for a memorial to the Second Maine.[404]

In June 1960, the Mount Hope Executive Committee voted to

> accept the bequest under Clause Eleven of the will of Luther H. Peirce… [the proceeds of which are to be used] *for the erection of a memorial in Mount Hope Cemetery, Bangor, Maine, to the Second Maine Regiment of Volunteers in the Civil War.*[405]

The Committee thereafter discussed the memorial and the possible "retention of a Maintenance Endowment for the care of the proposed memorial." The members later elected to include Waldo Peirce, a relative

of Luther Peirce, in their discussions. As approved by the Committee, Corporation president Charles F. Bragg 2nd conferred with Vernon (O.V.) Shaffer of Beloit, Wisconsin, about a suitable design for the memorial. Bragg had earlier encountered Shaffer's work and felt confident of Shaffer's ability and suitability. Shaffer submitted his plans in late 1961, and the Executive Committee voted in December to enter into a contract with him to proceed according to his submitted proposal for a fee of $6,500. Shaffer was to design and create the sculpture of "materials which will withstand weather and time," deliver the sculpture to the site and supervise its installation. Costs for the granite work, the foundation and a partial fence were allocated separately, with Mount Hope retaining the right to contract all work.[406]

When completed, Shaffer's bronze sculpture measured some fifteen feet in height and was mounted on a white granite setting. The impressive sculpture depicted an angel, or the symbol of an angel, faceless, bearing aloft in a compassionate embrace a wounded man, with the man's head thrown back, his arms and legs bare and his body rounded in death or repose. In regards to the memorial, Shaffer stated:

> I tried in this sculpture not to design just another heroic war memorial but at the same time wanted to show that heroism existed, but not without pain. The face and figure show pain and yet the wings express glory. I hope I have succeeded.[407]

The sculpture was indeed striking and promised to remain that way. A Public Broadcasting Systems program called the memorial "one of the most artistic war memorials anywhere."[408] The memorial's location is also commanding, situated as it is near the main entrance of the cemetery and just off Main Avenue. A walkway leads from the avenue to the memorial, and a low semicircular brick wall encompasses the statue and sets it off quite effectively.

The memorial bears the inscription "Not Painlessly Doth God Recast and Mold Anew the Nation," a quotation from John Greenleaf Whittier's antislavery poem "Ein Feste Burg Ist Unser Gott," more widely known in the United States as "Luther's Hymn." Also inscribed on the memorial are the battles engaged in by the Second Maine from July 1861 through May 1963. A granite slab at the base of the monument is inscribed "In Memory of the Second Maine Regiment of Volunteers, Gift of Luther H. Peirce, a Member of That Regiment." A flowerbed and flag were later added to the monument.[409]

After the Luther H. Peirce Monument was completed, the Executive Committee under President Bragg and composed of Donald J. Eames,

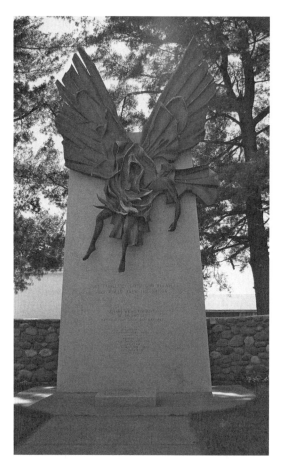

The Luther H. Peirce Memorial to the Second Maine Regiment of Volunteers was Mount Hope's third memorial to Maine's Civil War soldiers. *Photograph by Stephen G. Burrill.*

Franklin W. Eaton, Charles V. Lord and Donald S. Higgins prepared and had printed (with the aid of the Tom Kane Agency) a booklet containing a brief biography of Luther Peirce, photographs and related descriptive information about the monument and a chapter from *Maine Troops in the Civil War* recounting the history of the Second Regiment. While the Corporation intended the memorial itself to "perpetuate the name and record of the regiment among those who have occasion to visit the premises," it hoped the booklet would "reach a larger audience and thus carry out the intent of the donor Luther H. Peirce to honor in the highest degree the comrades with whom he shared the fortunes of war." The Executive Committee credited Superintendent F. Stanley Howatt for planning and directing the installment of the memorial.[410] Memorial gates and fencing along Mount Hope Avenue likewise provided testimony to Peirce's generosity and his high regard for the Second Regiment, and his memorial fund would later help in the restoration of the GAR Fort and in other cemetery projects.

A few decades later, Mount Hope Cemetery took another opportunity to honor American veterans. Superintendent Stephen G. Burrill learned that the Maine Veterans Cemetery in Augusta had elected not to allow a memorial to Korean War veterans to be located on its grounds. Burrill contacted the Maine Korean War Memorial Fund to inquire about the memorial and ask if the

group would be interested in locating the memorial in Bangor. On August 3, 1994, Ken Buckley of the memorial fund wrote to Burrill, stating that his organization wanted to establish a monument in honor of Mainers killed or classified as missing in action in the Korean War. The count totaled 233 Maine men and women. The proposed monument would bear the names of all 233 persons (much like the Vietnam War Memorial built in Washington, D.C., in the early 1980s) and would measure four feet wide, fourteen feet long and fifteen feet high. The monument would include a lengthy approach or walkway bordered on both sides by flags from each of

Luther H. Peirce (1837–1915), member of the Second Maine Regiment and benefactor of the Luther H. Peirce Memorial to the Second Maine Regiment of Volunteers, as well as other cemetery improvements. Photograph of painting on display at the Bangor Public Library. *Photograph by Frederick Youngs.*

the twenty-one nations that participated in the conflict on the side of South Korea as part of the United Nations military force.[411]

The Executive Committee voted in October 1994 to provide a setting for the memorial. Later that month, the Corporation reached an agreement that perpetual-care financing would be provided by the Korean War Memorial Fund, with the amount to be agreed on before beginning construction at the Mount Hope site.[412]

The cemetery provided a site for the new memorial on Mount Hope Avenue, near the GAR Fort and close to a small pond. The monument itself arrived at the cemetery in June 1995 and was covered until the site was fully prepared and a dedication ceremony held. In the meantime, the Maine Korean War Memorial group sold commemorative stones for its "veterans walkway," allowing for individual memorials recognizing veterans from "several Wars."[413]

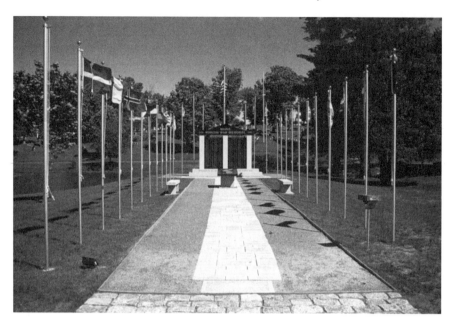

The Maine Korean War Memorial, constructed in 1995, bears the names of the 233 Maine men and women who died or were listed as missing in action in the Korean War. Flags of all the countries that participated in the United Nation's military force fly along the approach to the memorial. *Photograph by Richard Greene, Klyne Studio.*

The memorial as constructed included the white granite walkway and the twenty-one national flags located on either side of the approach. The monument itself, inscribed with the 233 names on either side, was made of black granite and framed by white columns set on a white granite platform. Steps leading to the monument were inscribed with dates of the conflict and with the name of the memorial on a shaped back crosspiece. The impressive memorial was dedicated to Maine's Korean War veterans on July 29, 1995, at a candlelight ceremony, with a reading of the 233 Maine citizens killed or classified as missing in action in the Korean War.[414] Subsequent ceremonies were held at the monument, and the State of Maine recognized the importance of the memorial by informing travelers on Interstate 95 which exit to take to reach it.

The various memorials to America's fallen military men and women continued to receive public attention at Mount Hope Cemetery throughout the twentieth century. Well cared for and remembered by veterans organizations year after year, the memorials—from the first memorial to honor Civil War casualties built in the 1860s to the Korean War Memorial built in the 1990s—promise to remain important to the cemetery and its visitors well into the twenty-first century.

Protection, Repair and Restoration of Mount Hope Monuments

The Mount Hope Cemetery Corporation worked to improve and beautify Mount Hope throughout the twentieth century. Along with cemetery grounds upkeep and the construction of new monuments and memorials, older monuments and memorials also needed maintenance and repair in order to keep them—and therefore the cemetery in general—in optimum condition.

Vandalism in some cases created a necessity for repairs that might not otherwise have been needed at the time. In 1905, the Corporation had cause to write to University of Maine president George E. Fellows about the possible involvement of university students in an attempt to steal one of the cannons from the Grand Army of the Republic Lot one November night in 1905. The vandals had ripped up two planks on a bridge leading to the GAR Lot to use in their endeavors and had removed the cannon from its mounting and moved it several feet. The vandals left behind, besides the damage, a beam believed to be property of the university. President Fellows assured the Executive Committee that he would try to find the guilty parties. In the meantime, the Corporation ran an advertisement offering a $100 reward for information that would "lead to the detection and conviction of the party or parties" responsible for the vandalism.[415] The guilty parties were apparently never apprehended.

The GAR cannons continued to attract attention. During the 1950s, for example, according to later superintendent Harold S. Burrill Jr., some person or persons managed to knock one of the cannons off the top of the GAR Fort. The

cannon weighed more than three thousand pounds. In 1965, the Executive Committee again dealt with acts of vandalism at the GAR Lot involving the cannons, as well as vandalism at the Hill Mausoleum (erected in 1917–18). The Executive Committee discussed possible alterations at the fort to help avoid problems with vandalism in 1988, but vandalism involving the cannons occurred again in 1990. For the most part, however, vandalism did not present a major concern for Mount Hope Cemetery. On occasion, flowers or plants were stolen and trespassing occurred in spite of posted hours and fencing, but these generally did not involve destruction of property.[416]

Employees of Jerry Hannebury, Incorporated, and Mount Hope Cemetery return a gravestone to upright position in 1997. The gravestone was probably knocked over by vandals, although time and weather do take a toll on cemetery monuments. *Photograph by Jerry Hannebury.*

A unique form of trespassing did occur in 1995, however, when one of the GAR cannons was used as a letterbox of sorts. Superintendent Stephen G. Burrill, while giving the author a tour of the premises, discovered a folded message slipped into a cannon. The note, seemingly part of a game of one type or another, read:

Don't worry[,] don't fret
There's nothing in store
That could maim or hurt you
It's a game nothing more.
Now you can see

Cannon number two
Inside is a surprise
And a message for you.

A game player had apparently found the note nearby and placed it in "cannon number two" after finding the "surprise." No further notes were located on or near the GAR Lot.[417]

One of the major concerns of the late twentieth century was not vandalism but simply the need to keep monuments in good repair. Cemetery staff had to concentrate more on how to best counteract the effects of nature and time than on how to remedy acts of human disrespect. The cemetery made allotments for cleaning a certain number of gravestones annually. Chemicals used to clean the stones varied over the years. From roughly the 1940s to the 1980s, the cemetery staff primarily used B.B. Granite Crystals, manufactured in Rockland, for general cleaning, augmented by ZIT (another commercial preparation) for removing more difficult stains. Changes in federal legislation required changes in cleaning substances. The cemetery used sodium hydrochloride, a bleach, during part of the 1980s and then switched to sodium hypochlorite, a basic chlorine bleach, during the 1990s. Chlorine bleach had also been used to some degree in earlier decades. The introduction of pressure washers in the late 1970s greatly aided staff efforts in keeping stones clean.[418]

The GAR Fort continued to attract both law-abiding and not so law-abiding citizens over the years, but its condition became an increasing matter of concern in the 1970s and 1980s, primarily because of the cumulative effects of time and weather. By the early 1970s, the mortar on top of the fort had deteriorated to such an extent that water was leaking into the structure. Nearby bridges also needed repair.[419]

The Executive Committee considered rebuilding the fort in 1972 but decided to defer until a later date as more pressing concerns existed. Initiating crematory operations were also demanding staff attention. The following year, Superintendent Harold S. Burrill Jr. proposed that the Executive Committee again consider the condition of the fort, as deterioration was evident about four and a half feet above the ground. No permanent measures were taken, and conditions continued to worsen.[420]

In May 1977, Superintendent Burrill suggested that the Corporation contact the Local 7 Bricklayers and Masons of Bangor regarding a program that the union offered to nonprofit organizations. The union might be willing to employ its apprentice program for repairs on the GAR Fort and on the

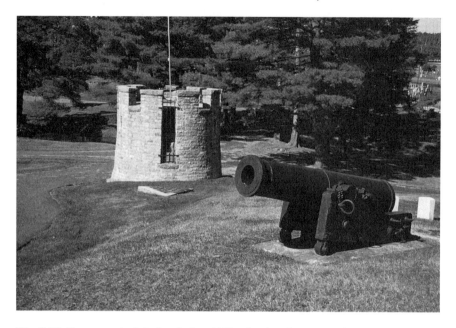

The GAR Fort as repaired during the late 1980s, showing the cannon (foreground) used as a mail drop by unknown "game players" in 1995 and otherwise the subject, along with the other fort cannons, of public attention. *Photograph by Richard Greene, Klyne Studio.*

two bridges (built circa 1930 by Burrill's father) in need of attention. The Executive Committee authorized Burrill to proceed with the idea.[421]

The 1977 idea came to naught, and in 1978, the Executive Committee authorized the superintendent to secure firm cost quotations for repairing the fort. In 1979, the superintendent, as authorized by the Committee, proceeded to apply for funding from the federal government for 1980 for repairing the fort and the two bridges. All three structures were part of Mount Hope's historical landscape, as reflected in the cemetery's listing on the National Register. Any grants received would be matching ones wherein the Corporation would be matched dollar for dollar by the government for any approved repairs or restorations.[422]

Unfortunately, funds—matching or otherwise—through the Maine Historical Preservation Commission were not forthcoming. The 1980 request was rejected due to an almost 40 percent reduction in restoration funds from the federal government that year. Earle C. Shettleworth Jr., the State Historical Preservation officer, sent the cemetery a 1981 application should Mount Hope decide to reapply. Funding for Maine for 1981 remained unknown at that point, but Shettleworth wrote that the administration of President Jimmy Carter had impounded $16.5 million of the 1980 funds

and reduced 1981 funding from $45.0 million to $25.0 million. Competition for grants would be fierce. Shettleworth nevertheless encouraged Mount Hope Cemetery to submit a grant application. Superintendent Burrill asked the Executive Committee if the members wanted him to obtain a second quote for masonry work or proceed with the grant application,[423] or just what they wished him to do. The Executive Committee discussed the issue in May 1980 and voted that Burrill should reapply for a grant.[424]

The Preservation Commission denied Mount Hope's second application but once again encouraged the Corporation to reapply. The most recent quote for the repairs indicated the Corporation's share of the matching funds, should they be received, as $8,037. As the quote was now one year old, Superintendent Burrill asked if he should secure an updated quote and reapply for funding. The Executive Committee instructed him to do so, but the results for 1982 remained the same, seemingly due to governmental funding cuts.[425]

The Corporation applied in 1982 for a 1983 grant, at which time the cost of repairs to just the fort, as quoted by Louis Silver Construction Company, was $10,000. The Finance Committee at this point, however, decided to proceed with reconstruction of one of the bridges for a cost of $8,700, as quoted by the Louis Silver Company. Louis Silver's crew repaired the bridge in the "cut," while Mount Hope awaited funding for "Fort Bridge."[426]

Mount Hope once again had its grant application rejected, this time "due to a Congressional stipulation that the limited funding approved not be used for acquisition or restoration projects." Deborah L. Thompson, architectural historian and former member of the Maine Historic Preservation Commission, suggested that Mount Hope seek funding through local veterans organizations. In the meantime, Burrill suggested that the Fort Bridge be repointed to prevent deterioration of the masonry and hopefully stave off major repairs for several years. Cemetery personnel ultimately made the necessary repairs to the bridge at the approach to the GAR Fort.[427]

The Corporation continued to seek funding from various organizations for repairs for the GAR Fort itself, including the local Grand Army of the Republic organization, but to no avail. In March 1985, Superintendent Burrill reported that the fort had finally collapsed. He had received two quotes for rebuilding the fort, one for $14,000 and one for $15,850, as well as an estimate for $850. The quotes included using Philippine mahogany to build new carriages for the fort's four cannons. The Executive Committee discussed the matter, and one member pointed out that the reserve set aside for maintaining the Peirce Memorial had grown to more than $100,000. He

suggested that a portion of the reserve might appropriately be used to make the necessary repairs to the fort and cover refurbishing the cannons. The Committee voted to proceed as suggested.[428]

The Corporation solicited bids for the repair work and received four bids ranging from $9,889 to $15,850. The highest bidder, Louis Silver, was invited to rebid with different specifications, as he had contemplated more extensive repair work than had the others. Silver did not rebid, and the job went to Donald Hamilton of the James Hamilton Masonry Company, the lowest bidder. The GAR Fort repairs were completed by early 1986 without government funding. To date, no funding has been received by Mount Hope from the Maine Historic Preservation Commission for any cemetery project.[429]

The Executive Committee elected to have the Peirce Memorial Gates repaired during roughly the same period as the fort. Rogan Memorials erected new granite posts on the existing foundations and topped them with the old granite caps during the 1989–90 fiscal year. The company sand-blasted the old wording onto the new posts. The cost for the project totaled $5,067. President Bragg and Superintendent Burrill developed a bronze plaque with appropriate wording to acknowledge "the financial support afforded by the Luther Peirce Fund for the recent restoration of the fort."[430]

The new plaque read:

> *This fort was built by patriotic donors in 1907. It was rebuilt in 1985 with funds bequeathed by Luther H. Peirce, a member of the Second Maine Regiment of Volunteers in the Civil War.*[431]

The Corporation had the plaque mounted on a boulder near the GAR Fort. The repairs to the gates and the fort, as well as the new plaque, were charged to the Peirce Memorial Fund.[432]

Following the gate and fort restoration projects, the Executive Committee again reviewed the Luther Peirce Memorial Fund. The unspent principal of the fund had grown from $36,589 following the construction of the Peirce Memorial in 1964 to $174,984 by the close of March 1989. Capital appreciation and unexpended income explain the growth. The terms of the Luther Peirce bequest regarding a memorial to the Second Maine Regiment of Volunteers, and the desirability of establishing a policy regarding the management of the fund, led to the Executive Committee voting on policy issues in early 1990. President Bragg had sent the Committee a letter about the matter, as well as made available copies of Peirce's will to guide the

Committee in its decisions. The Committee discussed the proposals and the will in January and voted to maintain a minimum fund balance of $75,000 at all times; to apply amounts deemed necessary from the unspent income to the "maintenance and repair of the Shaffer sculpture and the other memorial sculptures" on an annual basis; and to use, with the Executive Committee's approval, "any part of the remaining available income, from time to time…for special projects undertaken for the benefit or improvement of the cemetery."[433]

Even with the new policy, the Peirce Memorial Fund maintained a much higher than minimum balance in subsequent years. On March 31, 1993, the fund had a balance of $112,154; on March 31, 1994, the balance was $109,468; and on March 31, 1995, the balance totaled $119,430. During these years the Peirce Fund was the largest single donor fund held by the cemetery, followed distantly by the Webber Fund.[434]

Continued upkeep of lots and memorials—the new as well as the old—demanded cemetery attention throughout the twentieth century. Two of the most significant private monuments that required attention, and had funds set aside for that purpose, were the Hill and Webber Mausoleums. Both were constructed in the early twentieth century.

The Hill Mausoleum was built in 1918 to hold the remains of Marianne Hill, her mother, Nancy O. Egery, and, upon his death, Frederick W. Hill. Frederick Hill had the mausoleum built following the death of his wife, Marianne Hill, in accordance with her will. In her will, Marianne Hill had left provision for the erection and perpetual care of a tomb at Mount Hope to hold herself, her mother and her husband. Her mother's body would be moved from Mount Auburn Cemetery in Cambridge, Massachusetts, in late 1917. She had died in 1899. Marianne Hill bequeathed $3,000 to be "invested and re-invested" for perpetual care of the tomb and made provisions to keep the tomb supplied with "flowers and other plants in season." She likewise bequeathed $1,000 for the perpetual care of the Thomas N. Egery Lot at Mount Hope. Frederick Hill purchased a lot in Mount Hope Cemetery following Marianne's death on August 15, 1915, and had the mausoleum constructed.[435]

Frederick Hill died on April 10, 1920. Under the terms of his will, the mausoleum and its lot were given in trust to Mount Hope Cemetery. The cemetery was charged with keeping the glass door to the tomb open from May 1 to November 1 each year "except during storms," while the outer grill was to remain closed. Hill had created a trust of $50,000, bequeathed to the Eastern Trust and Banking Company of Bangor, for the care and upkeep of the mausoleum and to provide funding for a dozen roses to be

placed in the tomb in a special vase twice per week from the first of May to the first of November, as well as on Christmas Day, Memorial Day and Easter Sunday. The trust fund was to be invested in United States, municipal or state bonds.[436]

According to Frederick Hill's will—which also bequeathed more than $2.5 million to a number of charities and institutions, including the Bangor Public Library, Eastern Maine General Hospital (later renamed the Eastern Maine Medical Center), the University of Maine, the Young Men's Christian Association and Bangor's Home for Aged Women—the Hill Mausoleum was to be examined twice each year by a "competent person to ascertain what repairs may be necessary to keep it in perfect order." Special attention would be paid to all joints, which were "to be kept at all times thoroughly pointed." A written report was to be submitted to the trustees following every inspection. All examinations and any necessary repairs, as well as the cost of the floral arrangements, were to be paid for from the net income from the trust. When the net income was not expended for care and upkeep, and when any major repairs did not cause the balance of the principal of the trust to fall below $50,000 (major repairs if necessary could draw on the

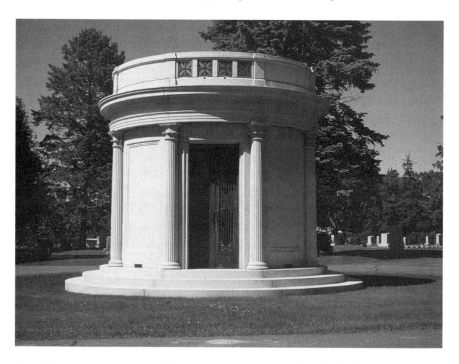

The Hill Mausoleum, built in 1918, holds the remains of Frederick W. Hill, his wife, Marianne Hill, and his mother-in-law, Nancy O. Egery, 1972. *Photograph by Frederick Youngs.*

principal), the net income for any given year could be given to the University of Maine in Orono.[437]

The Webber Trust, created to provide for the care of the Webber Mausoleum (built in 1922) and other structures built or donated to Mount Hope by the Franklin R. Webber family, was administered differently. Mount Hope administered the Webber Trust. Under the terms of the trust, the Corporation had to invest principal such that it continually increased and use a portion of the interest to maintain the Webber Mausoleum, as well as the Webber Waiting Room built in the early 1930s and the iron fence donated in the 1920s by the Webbers.

The terms of the Webber Trust made for fairly straightforward trust management and maintenance of the mausoleum and other structures. The cemetery oversaw investments of the trust and used its income to make repairs

Built in 1922, the Webber Mausoleum holds the remains of Franklin R. Webber and Martha Webber. The Webbers made possible several early twentieth-century improvements, including iron cemetery fencing and the Webber Waiting Room. *Photograph by Stephen G. Burrill.*

as necessary. The trust grew throughout the decades after its creation. The Corporation received $20,000 minus any inheritance taxes under the will of Franklin R. Webber in 1950. (Webber died in January 10, 1949; his wife, Martha, had predeceased him in 1934.) By March 31, 1970, the trust fund had grown to $33,522, and it had risen to $43,408 by the close of March 1995. The trust's peak balance of the century exceeded the March 1995 balance.[438]

The Hill Mausoleum underwent extensive restoration in the mid- to late 1950s involving primarily the internal walls. The marble interior walls had deteriorated significantly. They had turned an orange-rust color and had flawed surfaces. The trustees, on the advice of cemetery staff, therefore engaged Italian marble cutters to replace the walls. Additional repairs to the mausoleum were made in following years, including attention paid to the structure after it experienced vandalism in 1965.[439]

During the mid-1980s, both the Webber and Hill Mausoleums required extensive repairs, restorations overseen by Superintendent Harold Burrill Jr. In both cases, the structures needed their exterior joints repaired. The joints were pressure washed, repointed and redone with a pliable latex or other synthetic compound. The refurbishings proceeded without event. The cemetery withdrew funds as needed from the Webber Trust for repairs to the Webber Mausoleum, and Eastern Trust and Banking Company submitted the appropriate funds for repairs to the Hill Mausoleum. Such arrangements were in accordance to the wills of Franklin R. Webber and Frederick W. Hill, and in most years, the arrangements worked as originally intended by the grantors of the trusts. Eastern Trust and Banking did challenge the cost of the repairs to the Hill Mausoleum yet was ultimately satisfied with the cemetery's accounting and paid the submitted bill.[440]

Not all monument or lot upkeep involved expensive or time-consuming restoration work such as that involved in replacing marble walls or redoing a miniature fort. In some cases, as with cleaning gravestones, the approach proved more direct and the results more immediate. In 1962, for example, the Executive Committee toured the cemetery grounds and decided to authorize Superintendent Howatt to remove sections of old iron fencing surrounding certain individual lots, fencing deemed beyond repair. Such fencing could prove dangerous, as well as being aesthetically unpleasing to many people. In some places, the fencing had rusted away at its base and fallen over. Five years later, the Committee authorized Howatt to dispose of more iron fencing and to realize what he could from the same. The proceeds were to go into the general fund.[441] Hence, cemetery maintenance during the era ranged from costly restorations to simple repairs to removing no longer serviceable ornamentation.

The Famous and the Infamous

Films and "Glamour" Surrounding Mount Hope Cemetery

While Mount Hope Cemetery maintained its historic legacies and met modernity through such acts as constructing a crematorium, paving roads and installing a computer system, modernity met the cemetery in other ways, some of which brought a bit of glamour—if it may be called that—to the cemetery and in some instances brought a glimpse or two of Mount Hope to the nation. The motion picture industry proved one such catalyst, while the interment of certain famous and infamous people—along with stories rooted in the nineteenth as well as the twentieth century—helped retain a sense of mystery about the cemetery in the eyes of some local citizens and to link the present with the past.

In 1982, the Mount Hope Cemetery Corporation Executive Committee voted to reject a request to use Mount Hope as a setting for a motion picture. The members did so reasoning that the Corporation had to protect the privacy of its lot owners.[442] In 1988, however, the Executive Committee voted to grant another such request. Bangor author Stephen King secured permission to have portions of his movie *Pet Sematary*, based on his 1983 novel of the same name, filmed in Mount Hope Cemetery. Pet Film Productions, Incorporated, managed the film and secured the location agreement. King had insisted that the movie be filmed in Maine, this being the first time that he had done so.[443]

The location manager of Pet Film Productions, Mary Thomas, contacted Superintendent Harold S. Burrill Jr. via the telephone after touring the region and requested permission to film at Mount Hope.

She stated that Paramount Pictures had the support of the governor of Maine and of the City of Bangor for the film and assured Burrill that the company would furnish its own security and leave the premises in the same condition it found them.[444]

Burrill secured permission to proceed with the request from the Executive Committee, and Pet Film Productions drew up a contract with Mount Hope Cemetery. According to the agreement, the Corporation granted the company the right to use the premises for about eight days beginning on September 11, 1988, or, in the event of undesired weather or personnel problems, "until completion of photography" of the proposed scenes. The agreement freed the cemetery from any damage or injury claims, as well as noted that the production company would leave the premises in the same condition as found. Also crucial, and an indication that the Committee had not abdicated its protective role as stated in its 1982 decision, the Corporation agreed not to "assert or maintain" any claims against the use of photographic images *except* the agreement stated that the company was "not in any way depicting or portraying me [us] in said motion picture photoplay either directly or indirectly."[445]

Attorney M. Ray Bradford Jr., an Executive Committee member, reworked the original document to add further protective clauses for Mount Hope, such as assigning an end date of December 31, 1988, versus leaving the closing date open. Leaving the end date unspecified might have left the cemetery open for possible future use in the form of movie sequels and the like. A second modification ensured that the superintendent and his assistant would be consulted on scheduling matters. A third change specified security needs. As Bradford noted in a letter to the superintendent, the cemetery "should anticipate added traffic and crowd gathering when this is being filmed. Also, there tends to be many production people going all over the place."[446]

Pet Film Productions had already typed and signed the first agreement; it agreed to draw up and sign the second also. It modified the new contract to read, "You are not in any way depicting or portraying our cemetery in said motion picture either directly or indirectly," thus clearly stating that staff, officers or the grounds itself would not be identified or represented as such. The new agreement also incorporated the other changes requested by Mount Hope. The company then submitted a certificate of insurance, and filming plans proceeded.[447]

Most of the filming took place in the front portion of Mount Hope, on the grounds facing State Street. Mount Hope was used in a few scenes

Portions of the film *Pet Sematary*, based on Stephen King's best-selling book of the same title, were filmed at Mount Hope below Cemetery Hill, shown here in 1998 with State Street and the Penobscot River in the background. *Photograph by Trudy Irene Scee.*

shot over the course of three days. The filming at Mount Hope did not portray the actual pet cemetery depicted in King's novel and movie—an isolated cemetery to which generations of children had journeyed to bury their pets—nor the ancient Micmac cemetery beyond, a cemetery capable of returning to life, or some semblance of it, animals and humans interred therein according to certain rituals. The film did depict Mount Hope as Mount Hope, burial place for one of the story's female characters. The production crew created a mock grave for the scene, Stephen King appeared as the presiding minister and Fred Gwynne—well known for his role as Herman Munster in the 1960s TV sitcom *The Munsters*—talked with the main character (played by Dale Midkiff) in front of the stone steps leading up Cemetery Hill. A second scene filmed at Mount Hope showed Midkiff, in his role as Louis Creed, jumping the fence near Hannibal Hamlin's grave, followed by him lugging his shovel up Cemetery Hill and lastly capturing him digging up his dead son so that he might rebury him—and hence bring him back to life—at the Micmac burial grounds. In the novel, this occurred not at Mount Hope but at the fictional Pleasantview Cemetery, seemingly based on the Catholic Mount Pleasant Cemetery located on Bangor's Ohio Street. Most filming at Mount Hope was done after hours, and during the filming of the disinterment, the crew waited until 2:00 a.m. for the moonlight to be just right.[448]

The production company fed the cemetery staff during their three days at Mount Hope. They worked daily from noon until early morning and did not cause any problems at the cemetery. About 100 to 200 people entered the cemetery to watch the filming, and the film crew itself numbered close to 150 at times. The cemetery only received two complaints from lot owners about the filming.[449]

The city blocked off traffic between the intersection of State Street and Mount Hope Avenue, as well as the intersection of State Street and Hogan Road, for the three days of filming, September 27–29, 1988—all were weekdays—so that equipment and production crews could be moved safely. The city did so between the hours of noon and midnight and posted notices to that effect in the *Bangor Daily News*, as well as using other forums to advise citizens of the roadblock. Filming took place, in terms of camera setups, both within the cemetery and on State Street.[450]

The closed streets may have inconvenienced some people, but the film did aid the local economy. The *Ellsworth American* estimated the economic boost to neighboring Hancock County, in which various scenes were also filmed, as being $1.5 million in goods and services, as well as noted that the film had provided a memorable experience for the locals, who supplied everything from custom furniture to work as "extras" on the set at $40 per person.[451] Bangor may not have benefited quite as much financially as the Ellsworth region, as filming days were more limited in Penobscot County, yet filming in Bangor certainly provided local citizens with a rare chance to watch a film being made, as well as see a bit of their town in a nationally, and even internationally, distributed movie.

In terms of Mount Hope's experience, Superintendent Burrill later reported to the Executive Committee that the movie "had been completed without difficulty or financial burden to the Corporation." One minor problem had arisen, as Burrill informed a reporter in early October, concerning water. The extensive cast, with its campers, dressing rooms and cooking facilities, drained the cemetery's well, Mount Hope's only water source during the cooler months when the surface piping carrying city water is shut off. However, within a few days after filming had ended, the problem had essentially corrected itself.[452]

In May 1989, Burrill reaffirmed at the annual meeting of the Corporation how smoothly the filming had gone overall and stated that "the crew carefully observed all the conditions laid out for them by the Executive Committee and shared lunches provided by their rolling kitchen with the Mount Hope crew." More than seven years later, Burrill and his son, currently superintendent, still remembered those meals with fondness.[453] Clearly the goodwill shown by the production company in this matter, as in others, had a beneficial effect, and the experience did not leave the Corporation with a negative reaction or an antipathy toward future films.

The crew of *Pet Sematary* likewise carried away a good impression of their hosts. Pet Film Productions wrote to the superintendent in November 1989 that "the movie is in the can and on its way to the editing room and we couldn't

have done it without your hospitality and help." The company also stated that "your efforts and competence will open the doors to more movies being produced in Maine."[454] While this may or may not have been a standard letter sent to any institution or group involved with the film, it did express courtesy and satisfaction with the company's experience in Maine. In addition, while at Mount Hope a number of crewmembers stated that the cemetery was the most beautiful cemetery they had ever seen. They expressed their appreciation of the cemetery and its hospitality to cemetery personnel.[455]

The filming experience at Mount Hope likewise may or may not have been instrumental, but more screen adaptations of Stephen King's books were indeed made in Maine. In the 1990s, a movie version of *The Langoliers* was filmed in Bangor, and in 1990, a production team discussed the possibility of filming King's *Graveyard Shift* at Mount Hope but ended up filming it elsewhere. The production company did, however, rent or purchase some of Mount Hope's iron fencing that had previously been removed from service.[456]

When Pet Productions wrote to Superintendent Burrill in November 1988, the company requested that Burrill send any negative or positive comments to Richard Rubinstein of Laurel Entertainment, Incorporated. In March 1989, Rubinstein formally invited two members of the staff (or one staff member and a chosen companion) to a preview of *Pet Sematary* at the local cinema on Stillwater Avenue in Bangor on April 10. The preview was by invitation only, so the invitation was not transferable. Paramount Pictures released the movie nationally on April 21, 1989, and Mount Hope made its national debut.[457]

National, state or local headlines came to Mount Hope Cemetery in a different manner and medium through a few of its interments in the twentieth century. Such interments included a gypsy princess, a nationally sought mobster and an infamous Bangor madam.

During the boom years of Bangor as a nineteenth-century lumber and shipping town, one woman came to the forefront as Bangor's most notorious madam. Nancy (or "Fan" or "Fannie") Jones operated a bordello on Harlow Street for several decades and became something of a local legend, known as one of the "madams with a heart of gold" and as a shrewd businesswoman. Folk songs and ballads arose about the woman and her boardinghouse/bordello, depicting the company a sailor or woodsman might find there. Many have been collected at the Northeast Oral History and Folklore Center at the University of Maine under the directorship of Professor Edward "Sandy" Ives, as have several interviews with people who remembered Bangor's illustrious madam. Legal records, as researched by local historians such as Richard Shaw and Wayne Reilly, attest to the more concrete aspects

Part of the burial lot of Bangor madam Fannie Jones (or Thomas). Jones was buried without a gravestone, just to the left of two young children. The children were probably borne of Jones's adopted daughter. Doves originally graced both of the children's nineteenth-century headstones pictured here. Lilies are carved into one side of the children's stones along with inscriptions. The stone that still retains its dove (for Harry Irvin Robinson, who died in 1883) is inscribed "Waiting for me in that bright land to come." The other (for Charles Earl Graffam, who died in 1889) is inscribed "Of such is the Kingdom of Heaven." Jones's one-time consort or husband, John Thomas, is buried to the right of Jones. His gravestone is not pictured here. *Photograph by Trudy Irene Scee.*

of Fan Jones's life, including her numerous run-ins with the law. In addition, a novel by Adreana Hamlin Knowles, *Pink Chimneys* (1987), presented a feminist portrayal of Jones and two other main female characters.[458]

Fan Jones—born in Brooksville but a resident of Bangor for sixty years—died in 1917 at the age of eighty-seven and was laid to rest at Mount Hope Cemetery. The lot belonged to Jones, and during her life, according to Richard Shaw and Wayne Reilly, Jones had chosen to share it with three men: John Thomas, her one-time consort; Edward (or Edwin) Lake; and John Lyons. Mount Hope interment records support Shaw and Reilly's assertion that Jones had shared her lot with Thomas, Lake and Lyons. However, Jones, buried under the name Fannie N. Thomas, also shared her lot with seven other people: five children and two women were also buried on the premises before Fannie Jones or Thomas died. Jones was the third woman and eleventh person interred on the lot, and in 1926, a fourth woman was also interred there.[459]

Two of the children buried on Jones's lot appear to have been children born to her adopted daughter, Caroline or "Caddie" Graffam (née Dudley), although Caddie was not buried on the lot when she died in 1896 at age thirty-two. (Jones's property later passed to a son of Caddie's.) A third child was likely

Caddie Graffam's by a previous liaison. A fourth baby did not have any parents listed, and the fifth shared the same last name and was probably the sibling of the fourth. Fan Jones died of tuberculosis, as did three other persons buried on her lot. Cause of death was vague or unlisted in Mount Hope and City of Bangor records for three of the interred persons, while one person seemingly died of heart problems, one committed suicide and another died of diphtheria. Contagious disease accounted for at least seven or eight of the deaths, perhaps indicative of crowded living conditions where contagious diseases were common throughout America during the era, or perhaps indicative of congenital and sexually transmitted disease. Several of the adults buried on the lot either died in their prime during the heyday of the bordello or would have been in their prime at that time. Two of the children died in Boston.[460]

Fan Jones may well have given burial space to those she loved or befriended or sold or otherwise provided lots to neighborhood acquaintances or business associates. According to City of Bangor Registers concerning those persons for whom residences are identified before their death or the death of their parents, they were indeed from the Harlow Street neighborhood where Jones conducted business. Some had lived at the house at one time or another. Either way, the possibilities are intriguing and add something to Jones's dual reputation as businesswoman and compassionate person.[461]

Twenty years after Jones's death, a nationally known criminal made local and national headlines, but his life of crime generated much less sympathy at the time or in handed-down stories than did Fan Jones's. In autumn of 1937, Alfred "Al" Brady and a few of his cohorts in crime came to Bangor. At the time, the Federal Bureau of Investigation (FBI) had Brady listed as Public Enemy No. 1. Brady's gang was most known for committing robberies and police murders in the Midwest, supposedly having stolen $100,000 in jewels and having killed at least three people. They had been jailed once and absconded and had also escaped a police sting in Pennsylvania a year before they came to Bangor. Brady allegedly bragged that he would make gangster John Dillinger "look like a piker," but in Bangor, Brady met essentially the same fate that had befallen the more famous criminal.[462]

The FBI laid a trap in downtown Bangor on October 12, 1937, and Brady and two of his associates walked right into it. Brady and his men had given away their whereabouts by purchasing several rounds of ammunition at Dakin's Sporting Goods store one day, returning for three Colt .45 automatic guns and extra clips a few days after that and asking the store's proprietor to secure machine guns for them. The store owner, Everett Hurd, told one of Brady's men that Dakin's did not handle such weapons, but the gangster insisted that Hurd try

Clarence Lee Shaffer, sidekick to Al Brady, "Public Enemy No. 1," was gunned down in the streets of Bangor on October 12, 1937. *Courtesy of the Bangor Police Department, supplied to Mount Hope by Robert Welch.*

to get one or more and said that he and his men would come back the following Monday or Tuesday. Hurd then called the police, who in turn called the FBI. The FBI came to Bangor en masse and set up cars and agents surrounding the store, stationed agents in windows of nearby buildings and positioned a few agents inside the store.[463]

Brady and his two men returned on Tuesday as promised. The FBI agents or "G-men" captured one of the gang, James Delhover, inside the store. Brady and Clarence Lee Shaffer, Brady's right-hand man, soon appeared on Central Street, Brady supposedly exiting the gang's car—still with its Ohio license plates attached—firing at FBI agents. Shaffer fired into the store, apparently trying to help free Delhover. Gunfire erupted on Central Street, with G-men shooting from cars and windows and along the street. Brady and Shaffer were shot down. Some observers stated that Brady was cut nearly in half by the wounds he received. He died almost instantly. Shaffer, in spite of being riddled with bullets, survived for at least eight minutes. Brady's and Shaffer's blood ran together in the street, where the bodies and blood remained for some time after crowds

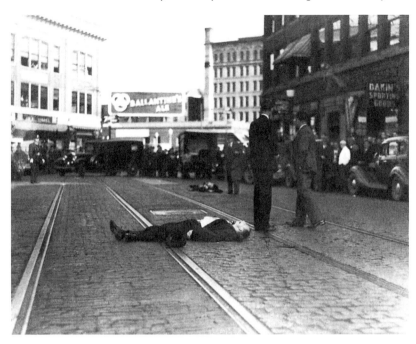

Crowds watch while FBI agents and other law enforcement officers finish business following the shootings of Al Brady and his associate Clarence Lee Shaffer. Dakin's Sporting Goods, where the Brady gang attempted to purchase machine guns, is visible to the right. *Courtesy of the Bangor Police Department, supplied to Mount Hope by Robert Welch.*

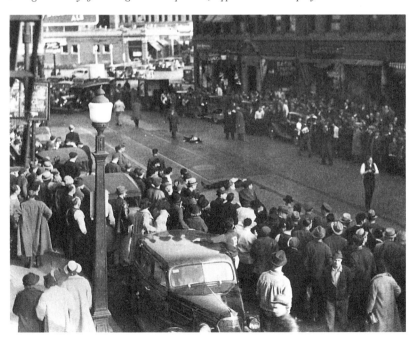

began to descend on the spot. The FBI had blocked off nearby streets as much as possible when the gang's Buick had appeared on the scene.[464]

The FBI returned thirty-year-old Delhover to Indiana to await trial for murder and other crimes. The body of the twenty-year-old Shaffer was shipped to Indianapolis for burial. Brady's remains stayed in Bangor.[465]

Although his family was contacted, no one claimed Brady's body, and it was interred at Mount Hope without a headstone. Twenty-six-year-old Brady seems to have had only one close relative, an uncle, who said that he could not pay burial costs. The City paid for the disposition of the body but was repaid later from money found in Brady's pockets. The *Bangor Daily Commercial* summed up the burial day in its headline of "No Escort, No Mourners, No Sun as Man Who Fought Law Is Lowered into Ground Begrudged Him by Natives." The *Bangor Daily News* reported that "there were no mourners, no flowers, no crowds, no ceremonies." Only Mount Hope superintendent Harold S. Burrill, his assistant Stanley Howatt, a gravedigger, funeral home personnel and a few newspaper men attended the burial. Bangor natives at the time might have denounced Brady being buried at Mount Hope. As the *BDN* noted, "The city that repudiated Alfred Brady in life was forced, by ironic circumstances, to receive him in death." Yet the story of Al Brady and his Bangor death became almost a local legend, and Brady's interment spot north of Mount Hope Avenue was deemed by some as "Mount Hope's most talked about grave."[466] It would remain without a marker until early in the twenty-first century, at which time a local group raised funding for a gravestone to be added to Brady's grave in the city section of MHC.

Two years later, a gathering of gypsies for an interment at Mount Hope again brought the cemetery into the spotlight. While traveling to her wedding in late October 1939, "Gypsy princess-elect" Katie Marks became ill, and her entourage had to stop in Bangor. There the Romany or gypsy group parked its limousines and camped on outer Essex Street in the hopes that the eighteen-year-old would recover. She died of pneumonia two days later, however, in a Bangor hospital. Relatives reported that she had suffered from an asthmatic condition for some time. The *BDN* reported that Marks was soon to have been formally inducted "as princess of the tribe."

A large gathering of gypsies arrived from throughout the nation to attend her funeral. The assembled group reportedly included members of the most prominent Romany families in the nation. After the traditional dirge or mourning ritual and her funeral on November 2, the young woman was buried at Mount Hope Cemetery. Her grave, located near the south side of Mount Hope Avenue, is marked with a simple headstone. Some members of

The interment of Al Brady. *From left to right*: Unknown, possible FBI agent; Geannie Mean, Mount Hope; reporter, name unknown; unknown, possible Sheriff's Department representative; Malcolm Hayes, funeral director; reporter, name unknown; F. Stanley Howatt, Mount Hope; and Harold S. Burrill, Mount Hope. *Photograph by Mount Hope Cemetery staff.*

the Marks family stayed in Bangor for a lengthy period, as custom prohibited a member of her status, even a deceased member, being left alone. (According to the *BDN* at the time, however, Marks did have one relative living in Bangor already.) One of those persons who stayed, Herman Frederick Marks, later entered a life of crime and served as Fidel Castro's chief executioner for two years following the 1958 Cuban Revolution.[467]

While Bangor saw other colorful characters interred at Mount Hope in the twentieth century, tales about some of the older interments continued to circulate. The most talked about has probably been that surrounding the burial of Rufus Dwinel.

Rufus Dwinel died in 1869 and was buried at Mount Hope. One-time Bangor mayor and a millionaire lumberman, Dwinel had a large rectangular stone monument or sarcophagus raised several feet above the ground on granite columns at his grave site. Two tales soon arose about Dwinel and the marble encasement. Both tales had Dwinel interred in the stone monument. According to one story, Dwinel supposedly stated that as long as he was above ground his

wife would not inherit one penny of his fortune. The second story had Dwinel declaring that as long as he was above ground he would support his beloved mistress. The trouble with both stories is that although the monument is large enough to hold human remains, it is solid stone, and Dwinel is buried below it and not inside it. Moreover, Dwinel had not been a married man, although he did leave a fair sum of money to his housekeeper of many years. According to Maine folklorist and professor Sandy Ives, both types of stories are associated with similar monuments in other cemeteries. Certain types of structures seem to lead to flights of human fancy wherever they might be found.[468]

A similar tale, although one not tied to a particular burial, is that concerning an interred infant. According to the story, a young couple lost a baby or young child. Unwilling to place the child where they would never see him or her again, they had the baby buried above ground—or flush with the ground, depending on the particular version of the tale—with a glass window built into the child's casket such that they could look in and see the remains. The story came to the attention of Professor Ives when his young daughter brought the story home from school, and Superintendent Stephen Burrill reported that over the years numerous women have asked to see the baby. No such baby or child or casket exists, however.

Burrill responds to any inquiries about the supposed windowed casket by directing visitors to one of three graves—the first located on the Atwood family plot on the eastern side of North Avenue near the south bridge over the brook or canal, the second on the Kinney family plot at the Mount Hope end of Double Avenue and the third on the Webber family lot located near Myrtle Avenue north of the Garden Mausoleum. The three lots each have monuments with marbleized statues encased in glass. A fourth lot was also similarly endowed at one time. The G. Peirce Webber Lot at the State Street end of Double Avenue once contained a marbleized statue enclosed in a wooden frame with glass, but over time the wood disintegrated and the protective structure was removed. Of the possible sources for the story of the buried baby or child, perhaps the most likely is that of the 1876 death of two-month-old Charles Howard—a member of the Atwood family, on whose lot one of the statues is located.[469] Legends can indeed be enduring.

Movies, colorful characters and local legends all added something to the mystique of Mount Hope Cemetery in the twentieth century. None of them contributed significantly to the development of the cemetery, yet together they serve to remind one that in the eyes of many people, cemeteries are indeed mysterious places, places holding potential beyond that of normal, everyday occurrences.

MOUNT HOPE TRUSTEES
AND PERSONNEL

Long Tenures and Lasting Links

M ount Hope Cemetery benefited from managers and administrators of long and productive tenures during the twentieth century. During the century, Mount Hope had only five presidents as of 1999, but from 1834 to 1900, it had twelve. Also during the 1900s, the Corporation had six secretaries, five treasurers and six superintendents, numbers roughly comparable to those for the nineteenth century. At the same time, twentieth-century members of the Mount Hope Cemetery Executive Committee tended to serve for long tenures, tenures frequently one to several decades in length. In addition to long formal associations with the cemetery, family continuities remained a noticeable feature in Mount Hope's management. While corporate officers, Executive Committee members and superintendents brought experience and continuity to the cemetery, workers hired either seasonally or permanently to help meet the needs of the growing cemetery likewise contributed to the successful operation of Mount Hope during the era.

James Adams served as Mount Hope's president—charged with presiding over all meetings of the Corporation and the Executive Committee if present—at the turn of the twentieth century. Adams had filled that position since 1895 and was replaced just before his 1907 death by Manly G. Trask in 1906. Trask had served on the Executive Committee for many years and brought a strong knowledge of Mount Hope with him to his new position. This would prove to be a standard trait of twentieth-century Corporation presidents.[470]

Franklin E. Bragg, president of Mount Hope Cemetery Corporation, 1931–51. *Courtesy of the Blank and Stoller Corporation.*

Charles F. Bragg 2nd , president of Mount Hope Cemetery Corporation, 1951–2007. Just as Charles Bragg replaced his father, Franklin E. Bragg, as corporate president, he would in turn be replaced on the board by his son, John Woodbury Bragg. Seen here in 1953, two years after he became corporate president. *Photograph by Bill Perry, Bel-Air Studio.*

Edwin A. Cummings replaced Trask upon the latter's retirement in 1914. Cummings had served on the Executive Committee since 1901. Cummings remained president until 1931, at which time Franklin Everett Bragg acquired the position. Bragg differed from his predecessors in that he had served on the Executive Committee for only one year before becoming president, a trait that his son, Charles Fred Bragg 2nd, the final president of the century, would share. Charles F. Bragg 2nd became Mount Hope's president in 1951. Like their predecessors, both Braggs were prominent local businessmen and continued to serve the community and participate in financial concerns during their years of presidency. Charles F. Bragg 2nd stayed in office past the close of the century and would have the longest term to date in the office since the establishment of the Corporation, with his father's twenty-year term being the second longest. By 1999, the two Braggs had filled the presidency for well over one-third of the cemetery's existence.

Joseph M. Bright was the twentieth century's first secretary of Mount Hope. Bright had filled that position since 1886 and would continue as secretary until his death in 1931, his forty-five-year tenure

being the longest one for the office. Bright served as the Corporation's fourth secretary, charged with keeping records of MHCC meetings and advertising the regular and special meetings in at least one local paper before the meetings. Bright had been involved with Mount Hope for many years before becoming secretary. Carl E. Danforth replaced Bright and was, in turn, replaced by Charles V. Lord in 1947, Harold S. Burrill having served as secretary pro tem for a time in 1946.

Charles V. Lord had served as Mount Hope's treasurer since being elected to that position in late December 1945, as well as to the Executive Committee. Lord remained secretary for only five years, but he remained actively involved with the cemetery until his death in August 1983, serving throughout the period on the Executive Committee. Lord resigned as treasurer only in May 1983 and only did so then because his health prevented him from continuing to fill the office. This was a common feature of Mount Hope officers, Executive Committee members and superintendents in the twentieth century: many served until declining health or death itself forced them to leave their posts. Mount Hope, understandably, was the choice for interment for many of these individuals.

Following Lord as secretary was Horace S. Stewart Jr., who entered the office in 1951. Stewart also served on the Executive Committee until he left the secretary's office in 1961. His father, Horace S. Stewart, had served on the Committee from 1919 until 1951, at which time he resigned.

In 1961, Donald J. Eames, brother-in-law to President Charles F. Bragg 2nd, became corporate secretary. Eames served in that position until 1965, at which time the Executive Committee elected Franklin W. Eaton to the office. Eames remained on the Committee until 1981, while Eaton remained in the position of secretary until 1998, at which time M. Ray Bradford Jr. replaced him as secretary.

The treasurer of Mount Hope has the responsibility for the cemetery's money, collecting and disbursing funds according to the directions of the Executive Committee. The treasurer is also responsible for reporting corporate finances—funds received and expended—as well as the number of lots sold and the proceeds from them, at the Corporation's annual meetings. The treasurer, as is also true for the secretary, is compensated with a relatively small annual fee; the salary recognizes the work performed by the individual while at the same time ensuring that the position is largely a voluntary one performed by an individual truly interested in the welfare of the cemetery. After 1930, the treasurer gained responsibility for executing contracts for the perpetual care of cemetery lots as approved and authorized

by the Executive Committee. In 1945, the Corporation amended its bylaws such that in the event that the treasurer is unable to perform his duties, the superintendent and a member of the Executive Committee can endorse checks to meet current needs.

Charles V. Lord, as previously noted, served as the Corporation's treasurer for thirty-eight years, from December 1945 until August 1983, as well as serving as secretary for five years. Lord held the longest tenure as treasurer of Mount Hope in the twentieth century. In a similar manner, Franklin W. Eaton held dual offices as treasurer from October 1983 and as secretary from 1965, serving in both capacities until 1998, at which time M. Ray Bradford Jr. became secretary and John M. Lord became treasurer.

At the beginning of the century, attorney and *Mount Hope Cemetery* author Albert W. Paine served as treasurer until 1902, having been treasurer for some fifty years. Paine had become the Corporation's treasurer in 1852, serving the longest tenure for a treasurer to date. Paine remained active in cemetery affairs after he left the office, spending much time writing his brief but important history of the cemetery. Henry O. Pierce followed Paine as treasurer and retained the position until the Executive Committee elected Richard H. Palmer in 1930. Palmer served on the Committee over the following years and remained treasurer until his death in December 1945. Charles V. Lord then replaced Palmer. By that time, the work of the treasurer had become increasingly sophisticated, and Lord upon his retirement would be credited with having "not only directed fiscal policy and record keeping" but also for having "served as investment manager of the Corporation's securities portfolio and coordinator of every significant expansion of property and plant during these years." During Lord's tenure, the trust funds of the Corporation had increased fivefold. Lord died soon after retiring as treasurer.[471] Franklin W. Eaton replaced Lord in 1983, and in 1998, the dual position was once again divided.

During the twentieth century, MHC also had an auditor or auditing firm review the Corporation's financial records, starting the practice in 1894 with Lysander Strickland. Following Strickland was Henry O. Pierce from 1895 to 1902, Horatio W. Blood from 1902 to 1913, Victor Brett from 1913 to 1930, Richard H. Palmer from 1930 to 1945, Clarence N. Holden from 1946 to 1959, Brooks and Carter from 1959 to 1986 and Kenneth Foster (later Foster, Carpenter, Black and Company) from 1987 to the close of the century. Palmer was the last volunteer auditor to examine Mount Hope's fiscal records. The transition to professional auditors at Mount Hope reflected changing fiscal policy elsewhere in the nation during and after World War II.

Corporation officers are elected annually by ballot and have been since the nineteenth century. Executive Committee members are likewise elected, and their numbers have increased. Until 1858, three people served on the Committee. In 1858, the number increased to five, with the president ex-officio as chair. Committee members, like the elected officers, tend to be "leaders" in the region and have especially included a large number of attorneys and businesspersons. As such, the Committee has been able to contribute substantially to the successful management of cemetery funds and to keeping the cemetery operating with a noticeable absence of legal problems. As with presidents, treasurers, secretaries and superintendents, Committee members from the 1800s through to the 1990s were all males.

The Executive Committee has the responsibility for "the general superintendence, direction, and control of all matters and things relating to the Corporation and its property," except as defined otherwise in the Corporation's bylaws and charter. A majority can act in the absence of members as long as a majority of the Committee agrees before the act is deemed "passed and binding." The Committee reports at the Corporation's annual meetings and meets as necessary to address various issues that might arise. The Corporation likewise can be called to special as well as annual meetings.

In 1930, the Corporation elected to create a Finance Committee composed of three individuals appointed annually by the Executive Committee. The Finance Committee received the responsibility for "investing and reinvesting funds of the Corporation, including Trust Funds, subject to control of the Executive Committee."[472] Established in the early days of the Great Depression, the Finance Committee, with the aid of Corporation officers and wise cemetery management on the part of superintendents, has done remarkably well. Finances have varied over the years, but the Corporation, although nonprofit, has greatly expanded its revenues since the 1930s.

Members of the Corporation also appoint a superintendent to care for the cemetery grounds and oversee its various operations or services. The superintendent's responsibilities include a multitude of disparate tasks, such as attending funerals and various ceremonies, ensuring that trees and flowerbeds are in good health and form and determining future cemetery needs. In addition, during the early decades of the twentieth century, Corporation officers frequently noted the work of superintendents' spouses and awarded them small fees in appreciation of their efforts.

The first superintendent at Mount Hope in the twentieth century was Thomas J. Cole, who served until 1908, having by then worked at Mount

Poplars along the avenue leading to the Hill Mausoleum, seen here in the late 1920s or early 1930s. Years later, the poplars would be killed by disease. *Photograph by Mount Hope Cemetery staff.*

Hope for about thirty years. Reuben E. Hathorn succeeded Cole and maintained the position until 1930. Upon Hathorn's death that year, Harold S. Burrill assumed the position. Harold S. Burrill was the first of three Burrills to hold the job over the course of the century. He was also the first superintendent to serve as a so-called elected employee. The previous superintendents—although salaried—had served largely as private contractors, a position that Burrill was economically unable to assume when he took over the duties of superintendent.[473] Burrill had served as Hathorn's assistant for some seventeen years before 1930 and essentially took over Hathorn's duties as of December 1929 when Hathorn became seriously ill.

Harold S. Burrill was succeeded in turn by his former assistant, F. Stanley Howatt, in September 1946, the month in which Burrill died. Like Burrill, Howatt had served as the superintendent's assistant from June 1944 (although officially the position of assistant superintendent was only created in April 1945) before becoming superintendent and had worked as the cemetery's bookkeeper from April 1930. Howatt held the position of superintendent until 1969, at which time Harold S. Burrill Jr., son of former superintendent Harold S. Burrill, secured the position.

Harold S. Burrill Jr. enjoyed a long tenure at Mount Hope, holding a variety of positions. He started doing summer work in 1937 and continued in that

Harold S. Burrill, superintendent of Mount Hope Cemetery, 1930–46. Photographed in the Lodge just before his retirement. *Photograph by Mount Hope Cemetery staff.*

fashion on and off for a few years, rotating his time at Mount Hope with time at The Citadel and with military service during World War II. After the war, he became Mount Hope's bookkeeper and then assistant to Superintendent Howatt. Although the title would change to assistant superintendent, Burrill served in basically the same position for some twenty-three years before becoming superintendent. He then served as superintendent until his retirement in 1992 and remained active in cemetery affairs until his death in February 1999.[474]

Harold S. Burrill Jr. was succeeded by his son, Stephen G. Burrill, who remained superintendent through the close of the studied period. Stephen G. Burrill had served as assistant superintendent under his father since April 1969.

By early 1999, the three Burrills had together served as Mount Hope superintendents for forty-six years and had worked as assistant superintendents for roughly sixty-six years. Like Presidents Franklin E. Bragg and Charles F. Bragg 2nd, who together had served as presidents of the Corporation for more than sixty-eight years by early 1999, the presence of the Burrills cannot be overlooked as an important factor in Mount Hope's twentieth-century history and beyond.

Mount Hope's superintendents oversaw the hiring and work of various employees engaged to keep cemetery operations running smoothly and to

Harold S. Burrill Jr., superintendent of Mount Hope Cemetery, 1969–92. *Photograph by Mount Hope Cemetery staff.*

keep the grounds in good condition, with various improvements being made over the years. The number of such employees hired seasonally or year round increased over the century, but not to an appreciable degree. In the 1940s, the cemetery generally employed four full-time persons and fifteen seasonal laborers. The number of workers remained fairly constant over the following decades in spite of the cemetery's growth—in terms of lots developed and sold and a few land purchases—as increased mechanization allowed grounds work to be performed with fewer worker hours per task or per acre. In the mid-1990s, Mount Hope generally employed twelve to eighteen seasonal workers depending on ongoing projects and labor demands. The first permanent full-time employee increase since mid-century occurred in the early 1980s to allow for a full-time crematory operator when demand proved such a position necessary. The addition of a full-time crematory operator brought the full-time total to five persons, where it remained into the late-1990s.

Men continued to hold most Mount Hope jobs during the second half of the century, just as they had before 1950. The wives of superintendents continued to help out as needed through the 1970s, especially during holidays. The 1970s saw probably the first "regular" Mount Hope female employee, a seasonal worker. Then, in the 1990s, Emily Burrill, daughter of

Stephen G. Burrill, superintendent Mount Hope Cemetery, 1992 to present date. As with the Bragg family of corporate presidents, three consecutive generations of Burrills would serve as superintendents to the present day. *Courtesy of the* Bangor Daily News.

the current superintendent, Stephen G. Burrill, worked for the cemetery as a seasonal worker.

Mount Hope benefited from the long careers officers, Committee members and employees pursued at the cemetery. Most officers and superintendents came to their positions with previous experience at the cemetery, as well as having had experience in the local community. The many years most then gave to the cemetery meant that Mount Hope gained the additional advantage of maintaining employees and advisors as their experience and knowledge increased.

The Corporation regularly acknowledged the contributions of officers, Committee members and superintendents upon their retirements or deaths. The first such twentieth-century recognition came upon the retirement of Treasurer Albert Paine. At its 1903 annual meeting that year, the Executive Committee noted that Paine's last account was read by President Adams "in the absence of Mr. Paine, for the first time since the Corporation has had an existence." (The Committee was seemingly referring to the cemetery's 1858 reincorporation.)[475] Likewise, when I.W. Coombs retired from the Executive Committee the following year, the Corporation called attention to his service to the cemetery since 1888.[476]

Retirements of superintendents elicited comments and concerns similar to those for officers and Committee members. In 1908, the Committee reported that Superintendent Thomas Cole had turned in his resignation, which came "as a great surprise as we had expected to have his valuable service for many years to come." Cole had insisted on tendering his resignation, and the Committee reported that the superintendent of thirty years "was associated with Mr. Adams in all the great improvements which were made under his supervision." The Committee assured the Corporation, however, that concerning the newly elected Reuben E. Hathorn, "we feel confident he will prove a worthy successor." The following year, the Corporation reported that Mr. and Mrs. Hathorn were indeed proving worthy successors to Mr. and Mrs. Cole. In this the MHCC both confirmed its faith in cemetery personnel and showed its appreciation for the work that a superintendent's spouse could and did provide Mount Hope.[477] The retirements of superintendents in years following that of Cole would also result in resolutions concerning the services they had provided and encouragement over the work thereafter displayed by the succeeding superintendent.

Death would also receive attention in the Corporation's annals. In 1908, the Corporation had two deaths to acknowledge: President James Adams and Treasurer Albert Paine. The official recognition given them would find similar expressions on the occasions of future deaths. In the death of Adams, the MHCC resolved the following:

> *Mount Hope Cemetery Corporation loses one of the ablest and most efficient officials. He always gave to the Corporation the same business ability and deep interest that made him successful in his private affairs. We sincerely mourn his loss and join with a host of others in a tribute of honor and respect to his name and memory.*[478]

Similar sentiments were expressed about Paine. The Corporation acknowledged his fifty years of service to Mount Hope. This included his safeguarding cemetery funds, issuing deeds for lots, performing various other tasks and "making his influence felt for the good of our enterprise." The Corporation further resolved that "we rejoice that he was permitted to live to such a good old age, and in the name of our beautiful city of the dead, we would remember and cherish his name and work." The board resolved that the resolutions concerning Adams and Paine become part of the permanent record and that a copy be "furnished the daily papers" of Bangor for publication.[479] Later resolutions of this type would also result in copies being sent to the families of the deceased.

Later in the century, the board remarked on the long career of Harold S. Burrill at Mount Hope and stated that in Burrill's 1946 death the Corporation had "sustained a severe loss." Throughout his seventeen years as superintendent, Burrill had "faithfully and conscientiously" filled the position, "untiring in his friendly advice and cooperation." Late 1945 had seen the death of another longtime friend of the cemetery, Treasurer Richard H. Palmer, whom the record also indicated had given "friendly advice" as well as sound counsel and whose death had caused Mount Hope and the Executive Committee a "severe loss."[480]

Expressions of sympathy changed in style over the years, with similar expressions found for people who died during the same period. Resolutions tended to be more flowery during the earlier years, but expressions of sympathy seem sincere for all deaths in all decades. Four years after cemetery records contained the previous resolutions, the Corporation dedicated a lengthy portion of its 1951 record to the memory of President Franklin E. Bragg, who had served as president for twenty years. The Corporation expressed its "sorrow" in different terms, befitting a different time and a different person. Noted were Bragg's "keen mind" and "keen interest" in MHCC affairs, as well as his being "devoted to his family, charitable, and loyal." The resolution included more information about Bragg's affairs outside the cemetery than had most earlier ones, listing Bragg's positions of president of N.H. Bragg & Sons, president of the Bangor's Home for Aged Men, president of the Bangor Mechanic Association and director of Merchants National Bank in Bangor.[481]

The role of family service appeared in resolutions marking the deaths and the retirements of those involved with the cemetery. In 1932, for example, the death of Secretary Joseph M. Bright occasioned a lengthy inclusion in the Corporation's records. The board noted that Bright had served as secretary "for all the years from 1886 to 1931, inclusive, succeeding his father who had served in the same office from the organization of the Corporation in 1858.[482] In a second example, upon the 1992 retirement of Harold S. Burrill Jr., the Corporation noted that, as Burrill himself had stated, Mount Hope was in his blood at an early age since his father, Harold S. Burrill, had earlier served as superintendent.[483]

National events exerted direct effects on Mount Hope and its labor needs. During World War I, the cemetery felt the effects of a general labor shortage on the homefront. In 1918, the Executive Committee reported that, combined with poor weather, "the high price of labor made an added expense of no small amount. Our Superintendent, however, has been able to keep up his reputation of past years." The superintendent continued

to do so throughout America's involvement in the war and during its aftermath. The Committee report regarding the 1919–20 fiscal year stated that "owing to the increased cost of labor it has been an expensive year, but our Superintendent has kept up the grounds in the usual good condition." A similar statement appeared in the following annual report, a report that also touched on another effect of the war: "the high demand for lots."[484] Cemetery records gave less attention to World War II labor shortages and pay rates, although they were mentioned during at least one Executive Committee meeting. A shortage of workers later in the 1960s may have been an indirect effect of the Vietnam War and the associated drafting of large numbers of young men.[485]

In 1929, Mount Hope Cemetery Corporation president Edwin Cummings noted that "Mount Hope is fast growing and the amount of work increases every year. Although this is plain to be seen, comparatively few people realize the fact."[486] The effects of the Great Depression would also be plain to be seen in following years, although due to the continual need for labor and the secure investments of cemetery funds, Mount Hope workers were not as severely affected as were many other American workers.

In April 1933, the Executive Committee voted to reduce by 10 percent the salaries of all personnel except for that of the "Clerk of the Corporation." Four months later, the Committee met to discuss President Franklin Delano

Albert Watson, a Mount Hope employee for more than seventy-two years, many of them as grounds foreman. He worked for the cemetery from about 1885 to 1957 and died just a few years after his retirement at age ninety-three. *Photograph by Mount Hope Cemetery staff.*

Roosevelt's National Industrial Recovery Act and the president's Reemployment Agreement. Following discussion of these Depression-era measures aimed at helping the country recover financially, the Executive Committee voted to reduce the daily hours of all regular employees from nine to eight. The change would take effect immediately and was planned to end at the close of that working season. The following year, the Committee voted to "retain all salaries and hours of labor to agree" with those before the April and August 1933 decisions. The Corporation issued Christmas gifts to each of fifteen employees in 1937 to help them through the difficult times. No other measures seem to have been taken, and wage increases were not noted again until the close of World War II, by which time the national economy was once again on sound footing. The cemetery does not seem to have laid off any workers due to the Great Depression or to have greatly cut back on their remuneration, but instead strove to keep wages and hours fair while still cooperating with federal measures.[487]

Employees tended to stay with the cemetery for long periods, and the Corporation regularly expressed concerns over their well-being, noting in annual and special meetings any sicknesses or other problems that had come to their attention. As far as can be ascertained, the MHCC treated workers more than fairly in terms of duties required and remuneration provided. The Corporation kept up to date in terms of pay rates and benefits, increasing both as the century progressed. Housing during the first part of the century was also provided for the person responsible "for the care of the grounds at night," a dwelling house

The crew at Mount Hope Cemetery as seen circa mid-1920s. *Photograph by Mount Hope Cemetery staff.*

being "given in payment of this service."[488] Although the residence changed, Mount Hope continued to provide such housing in later years to the person filling the position of general foreman, using a rental agreement signed by the Corporation and the foreman to set the appropriate terms.

The Corporation and the Committee regularly thanked superintendents for the care they gave the premises, with the wives of the superintendents likewise receiving recognition during the first half of the century. Thanks were also regularly given for the work performed by the general cemetery crew or personnel. The Corporation in the mid-1940s set pay rates to be in accordance with city rates, increased wages through the 1950s and 1960s and, in 1969, adopted a standard forty-hour workweek, making certain that full-time employees did not lose any remuneration through the change. In 1970, the Corporation initiated payroll checks instead of making cash payments, as had previously been standard policy. That same year, the Executive Committee approved a new pension plan for employees (earlier, the Corporation had given money to employees upon their retirement or for the duration of their life). Somewhat later in the century, the MHCC initiated Christmas bonuses and Blue Cross and Blue Shield medical insurance for permanent employees, with other plans available for those over age sixty-five.

The Corporation often provided special funding or offered special thanks in a material manner upon the retirement or illness of an employee. For example, when one longtime employee (a general foreman) became ill, likely with Alzheimer's disease, in the early 1990s, the Executive Committee voted to continue paying him his regular salary—even after utilization of unexpended sick leave and vacation pay—until such time as his Social Security payments from the government might commence, as well as to cover his health insurance costs until Medicare benefits became available to him. In a similar but happier show of appreciation, when Harold S. Burrill Jr. retired as superintendent, the Committee voted to convey to him for his personal use and ownership the cemetery-owned vehicle previously assigned to him. The Committee had done the same thing upon the 1969 retirement of Superintendent Stanley Howatt.[489]

Although Mount Hope was not immune to basic personnel problems seen elsewhere, the cemetery did experience overall sound employee-employer relations during the course of the twentieth century and reaped the benefits thereof. This mirrored the benefits gained by having committed, long-serving officers and Executive Committee members. Solid management combined with capable supervisors and a devoted staff resulted in a minimum amount of problems and a well-run, financially viable corporation and cemetery.

MOUNT HOPE IN THE 1990s

As noted near the outset, at the annual meeting of the Mount Hope Cemetery Corporation in 1900, the Executive Committee reported:

> *It is with satisfaction that we review the work of the past year, as we cannot fail to notice the improvements that have been made in various ways, and we hopefully look forward to the time when Mount Hope may rank among the finest cemeteries in New England, not only in its fine situation, which nature has so nicely provided, but under the careful supervision of our faithful Superintendent, it may each year be beautified by fine walks, flowers, trees, and shrubbery.*[490]

Although the town of Veazie and the outskirts of Bangor have grown since 1900, encroaching to some extent on the beauty of the area, nature continues to provide Mount Hope with a fine situation. Hills, ponds and a brook provided by nature and maintained by cemetery personnel add to the riverside setting and view of the cemetery. "Walks, flowers, trees, and shrubbery" provided by successive superintendents and staff continued to make Mount Hope a beautiful cemetery, as have other "various improvements" made during the twentieth century. Monuments, fencing, bridges and buildings such as the administrative facility and the Webber Waiting Room have augmented the historic value as well as the scenic interest of Mount Hope. Paved avenues have provided easier access for burial services, visiting graves or simply enjoying both the natural and the

Mount Hope Cemetery served the local community in numerous ways during the nineteenth and twentieth centuries, and various celebrations or memorials to and of life were held within its gates. Photographed here is the Bangor Police Department in a Memorial Day parade in Mount Hope, circa the late 1950s or the early 1960s. *Photograph by Mount Hope Cemetery staff.*

human-enhanced or designed environment. In the late 1990s, the 264-acre cemetery maintained, and perhaps exceeded, the pastoral, garden and park-like aspects envisioned by its founders in the 1830s.

One of the last improvements made to Mount Hope during the studied period was the addition of carillon bells, an electronic system capable of playing an unlimited number of hymns, carols, anthems and other musical selections. Galen Cole of the Cole Land Transportation Museum offered the gift of the carillon to the cemetery in 1994, and the Executive Committee later voted to accept the donation. The system could be used for funeral services and special occasions, as well as be set to play at specified times during the day. The four-hundred-watt Novabell Carillon—made by Schulmerich Carillon of Pennsylvania—was installed in a wooden tower supplied by Mount Hope and erected on Cemetery Hill. Speakers carried the electronically produced music throughout the cemetery and, playing at one-half capacity, to nearby areas.[491]

The cemetery started its carillon system with sixty songs recorded on computer chips donated by Cole, and subsequently added others. By August 1995, the system was playing three times daily, as well as during funerals and other occasions. The cemetery later decided to play the bells only twice daily and then adjusted the times to 7:30 a.m., 11:30 a.m. and 4:30 p.m. to correspond to cemetery work hours, adding 7:30 p.m. during summer hours to reflect the later closing hour for cemetery gates. The cemetery held a dedication in early September attended by Cole and numerous comrades of his from World War II. Cemetery visitors who heard the system commented favorably on its use and sound, and indeed one family donated $100 to Mount Hope to secure additional music after hearing the carillon during a funeral.[492]

Visitors in the 1990s came to see the geese inhabiting the Garden or Office Pond, tour the historic monuments, enjoy the trees and walkways, rollerblade or gain other exercise such as skating on frozen ponds in wintertime and visit the graves of loved ones. Although Mount Hope offered a peaceful atmosphere for the living, it continued to be in demand for interment and cremation services. However, burials actually decreased overall during the century.

Recordkeeping varied somewhat over the years, but according to the Corporation's computer records, from the 1860s to about 1900, the cemetery generally saw between 140 and 180 burials per year. In 1900, 180 people were interred at Mount Hope. Figures tended to range between 200 and 250 from the 1910s to about 1960, after which time burials each year decreased to roughly between 130 and 180—figures similar to those for the late nineteenth century. Records kept by Superintendent Harold S. Burrill for 1911 to 1944 show somewhat higher burial figures; for example, computer records show 249 interments for 1923, whereas Burrill recorded 282, with a peak in 1919 of 310. World War I figures were the highest on record, reflecting not only the direct casualties of war but also a worldwide influenza epidemic, with 1918 and 1920 seeing the second-highest burial statistics, according to Burrill's records. The early 1990s saw the low point in terms of interments, with 1994, according to computer records, seeing only 110 and 1995 only 109. The reason for the decrease may involve an erroneous assumption that Mount Hope had few lots left for sale, as well as an increase in the number of cemeteries in the Bangor area. Mount Hope's interment prices and cremation rates remained competitive.[493]

In addition, the increase in cremations may account for part of the decrease in Mount Hope burials. By 1992, Mount Hope was providing more

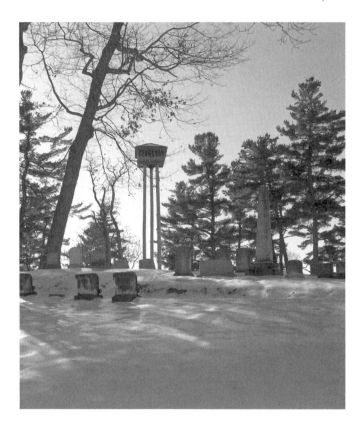

Mount Hope's carillon tower, built during 1994–95. Galen Cole of the Cole Land Transportation Museum donated the music system. *Photograph by Trudy Irene Scee.*

than one thousand cremations per year. Only a small percentage of the cremains received interment at Mount Hope. Cremains are often scattered at designated locations or kept with the deceased's family.

A reduction in interment services did not mean a reduction in Mount Hope finances. Cremations brought new funding to Mount Hope coffers, supplementing the successful investments of perpetual care and other funds. The Finance Committee of the Executive Committee became increasingly sophisticated in its investment approaches over the decades. Members offered advice in their own areas of expertise and consulted other professionals to secure investment and management advice when necessary. In 1901, the Corporation treasurer reported cemetery assets as being $22,638. By 1920, the value of Mount Hope's assets had increased to $37,044. The value of the cemetery's assets continued to increase—although some years showed limited downturns—such that by 1963 assets totaled $1,209,225 and in 1980 reached $1,920,259. By March 1995, cemetery assets had reached $833,232 in unrestricted assets and $4,620,115 in restricted assets. Subsequent years would see similar growth. Financial progress can be measured by various other

Right: Mount Hope Cemetery remained a peaceful haven at the end of the twentieth century. Seen here is a gravel road that runs parallel to Main Avenue and passes by the Home for Aged Women Lot. Avenues in the Old Garden Lot area will remain gravel to better preserve the nineteenth-century atmosphere of a portion of the cemetery once referred to as "our city of the dead." *Photograph by Richard Greene, Klyne Studio.*

Below: The Lodge, built in 1908–9, remains the center of Mount Hope operations and a fine example of Old English architecture in the early twenty-first century. *Photograph by Richard Greene, Klyne Studio.*

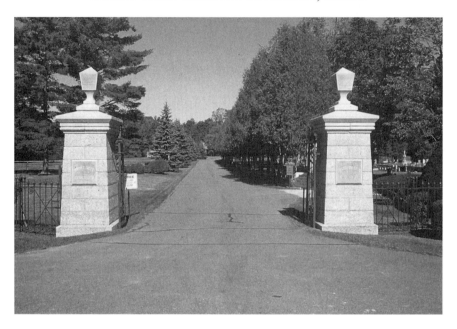

The main or lower entrance to Mount Hope Cemetery in the late 1990s. The entrance has remained essentially the same since 1930. *Photograph by Richard Greene, Klyne Studio.*

means or statistics, but by any standard, Mount Hope officers and Executive Committee members proved able stewards of cemetery finances during the twentieth century.[494]

Numerous suggestions by Mount Hope superintendents aided the financial progress of the Corporation. Especially important late in the century were the establishments of the crematory and the computer system. Superintendents offered suggestions throughout the century, but major policy and economic decisions remained in the hands of the Executive Committee, as led by the Corporation president.

Economically secure and well managed, Mount Hope had become—by almost any criteria available—one of the "finest cemeteries in New England" by the late twentieth century, just as the Executive Committee had anticipated in 1900. Known for its natural beauty and its graceful architecture and ornamentation, Mount Hope draws visitors from throughout the region. Hundreds of people visit the cemetery each year, and local papers and publications frequently mention the allure of the cemetery. Mount Hope has retained the appeal of a garden cemetery as envisioned by nineteenth-century cemetery and urban planners at the same time as it has successfully made the transition to a modern nonprofit—yet financially astute—organization.

MOUNT HOPE CEMETERY IN THE LATE 1990s AND THE TWENTY-FIRST CENTURY

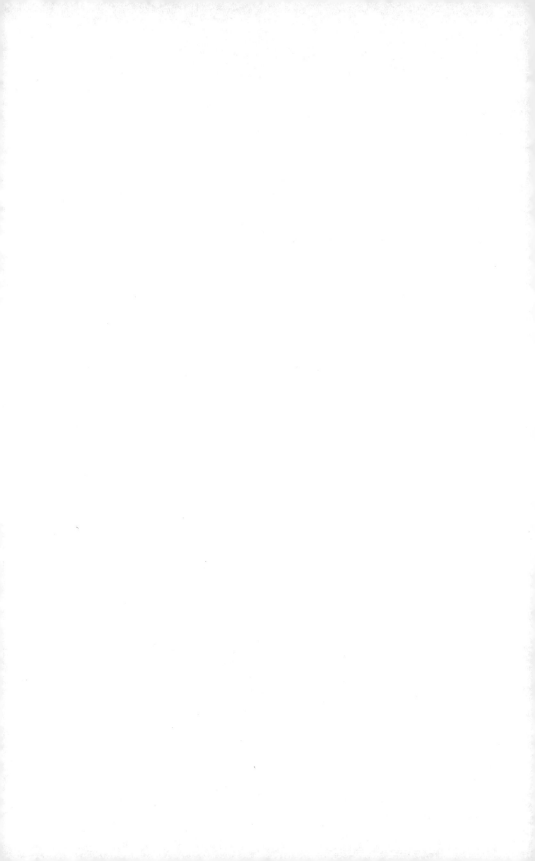

Sequel, 1999–2012

Mount Hope Cemetery closed the twentieth century much as it had the nineteenth: a prosperous, land-wealthy, well-landscaped site popular as a burial location; a place of remembrance of loved ones, ancestors, dignitaries, war veterans and the odd infamous character; and, often times, a spot for casual visits by local and nonlocal persons alike. The actions the Mount Hope Cemetery Corporation, its board and its superintendent and staff would take during the early twenty-first century would only add to the legacy of the earlier centuries and ensure its continued prosperity in following years.

However, a few projects and challenges undertaken in the mid-1990s required further attention as the 1990s progressed and the new century opened. These ranged from adjusting the volume of the new carillon bells to paving roads, updating the crematory, laying out new burial sites and dealing with trust fund issues.

The matter of the carillon bells was quickly and easily resolved. The cemetery received some complaints soon after installing the system donated by Galen Cole in 1995, the same year in which the Korean War Memorial was dedicated (having been attended by close to 1,500 people) and the writing of *Mount Hope: A Twentieth-Century History* was undertaken by the author. The bells were playing a variety of tunes, sounding twice daily initially and then three times per day during the winter months and four times daily during Daylight Savings Time. Cemetery staff also played the bells for three minutes when funeral processions entered the grounds

and were ready to depart for the graveside service. The system proved able to withstand a rough windstorm during its first year of operation, with the speakers on their wooden platform surviving unharmed while roughly a dozen large trees nearby were blown over. Storms, like other acts of nature, continued to affect the cemetery in the late twentieth and early twenty-first centuries, but in this instance at least, it was nature itself that needed cleanup and repair after the storm rather than the new musical system.[495]

Most of the surrounding community enjoyed the carillon bells, but by late 1997, the board had received one or two complaints of the system being too loud. However, the problem may really have been that the bells were ringing too loudly too early. The cemetery fixed the problem by simply turning the volume down.[496]

The carillon system would not have another problem for well over a decade, and then it appeared to be a problem of the opposite extreme. During the winter of 2010–11, the bells stopped tolling. The system continued to indicate that the bells were playing normally, and did indeed play at the systems control box in the Lodge, but the bells were simply inaudible outside.[497]

Superintendent Stephen G. Burrill contacted the manufacturer of the bells, a company located in Pennsylvania. The company could not attend to the problem right away, however, as it only had one technician to service the entire Northeast. The technician was able to get to Mount Hope in July, sooner than the anticipated date of August or September, after finishing work at another Maine location. The technician fixed the problem within an hour. The problem was a broken four-hundred-watt amplifier. The replacement of the amplifier with an updated and improved one, plus cleaning the system and downloading additional musical selections, cost $995. That money represented the entire expense to the cemetery for maintenance (which it had agreed to cover when it accepted the carillon gift) for the fifteen years of the system's operation. The cause of the failure was likely an electrical surge, either from a lightning storm or through the electrical power supply company itself. When restored, the carillon rang out with a volume and clarity not seen in some time, if ever. The bells could once again be heard throughout the cemetery, in the local neighborhood and even across the river in adjacent Brewer.[498]

The cemetery began to hail the outside world in another way in 1997 besides the ringing of its bells. The year saw the beginnings of a website for Mount Hope Cemetery. This move toward modernization started with the superintendent's

request to purchase a new computer for the crematory, one to be tied into the system used by the superintendent and assistant superintendent in the Lodge. At the same meeting at which the Executive Committee approved the purchase, it also authorized Stephen Burrill to move forward with the creation of "a Home Page to present Mt. Hope Cemetery, its Services and Products, to the public via the world-web" at a cost of $750, including a two-year contract. The expense of creating the website was actually rather inexpensive in terms of other expenditures for the year. For example, $2,750 was budgeted for the new computer and $8,349 for a new riding lawn mower, while rebricking the third retort or cremation chamber, installed in 1992 and having provided 1,628 cremations since that time, was to be undertaken at an estimated cost of $7,000. A three-year program of tree pruning and, in some cases, tree replacements (an estimated 169 of the first and 9 of the second) was approved at a cost of $7,360 for the first year alone.[499] The new homepage would soon prove popular and, over the years, would become increasingly in-depth and eventually include interment records for all known burials in MHC.

As the new century opened, MHCC made a new decision as to allowable use of the cemetery. People still came to enjoy the park-like environment for walking and strolling, as they had for more than one hundred years, but lately new use had been made of the cemetery. In the late 1900s, rollerbladers and skateboarders had come to enjoy the paved roads of Mount Hope, and the board voted in June 2000 that this would no longer be allowed. Some skaters and skateboarders had abused the privilege previously granted them, or at least allowed to them. In several instances, individuals had skated right through the middle of groups assembling for funerals, and in one case, an entire hockey team had commandeered a section of cemetery road. The cemetery subsequently posted signs forbidding the use of rollerblades and skateboards, and also during the era, again due to the abuse of cemetery lands, the board banned dogs from the property.[500]

Some people, however, really wanted their pets to have a place at Mount Hope, not just in terms of walking them there but in terms of burying them there. Several requests for pets or their ashes to be interred where their keepers were buried or would be buried came in over the years. Just after the turn of the twenty-first century, however, the cemetery received a request regarding establishing a separate pet cemetery at Mount Hope. The board discussed the matter in 2001 and decided to take no action on the matter.[501] A portion of the film adaptation of Stephen King's *Pet Sematary* had been filmed at Mount Hope in 1989, but that did not mean

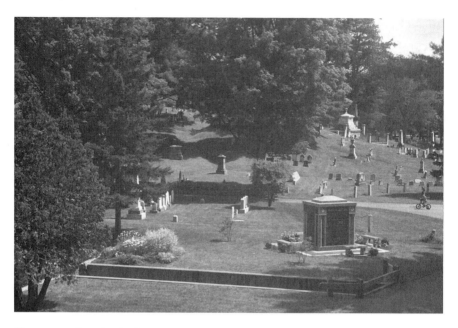

The community columbarium, constructed in the early 2000, served a key community need such that most niches quickly sold. By 2011, the cemetery was preparing to purchase another such unit. *Photograph by Trudy Irene Scee.*

that the Corporation wanted to see an actual pet cemetery established on its grounds.

Another request that the Corporation deemed best to decline was that of a land sale. Mount Hope received a request from an individual to buy land next to the former Buck property from the Corporation. The board discussed the offer and the long-term plans of the Corporation in December 2002 and decided that selling the property would not be in the best interests of the cemetery.[502]

In other matters, the Corporation continued to work with the local community as best it could, and such interactions were overwhelmingly deemed successful. It granted a site in the Northern Division to a group interested in establishing a small memorial to children who died in utero. The cemetery also allowed the Town of Veazie to establish a turnaround spot for snowplows in winter along its State Street boundary, and it continued to provide maintenance services to the City of Bangor section adjoining the corporate cemetery. However, in some cases, the Corporation had to decline a request. For example, the Town of Veazie inquired in July 2005 whether MHCC would be interested in managing

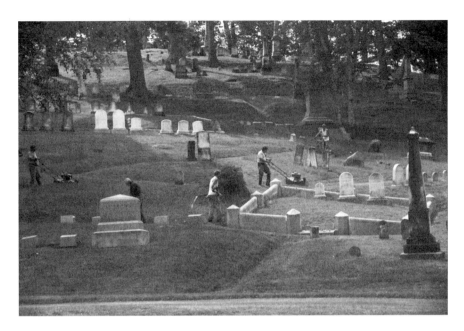

Keeping Cemetery Hill and other tricky landscape freshly mowed remained on ongoing duty during the early 2000s, and as the topography was unsuitable for larger riding mowers, the lawns still needed to be mowed using push mowers. *Photograph by Trudy Irene Scee.*

and possibly owning Veazie's Fairview Cemetery, located just off Mount Hope's property. The town had a trust with reserves of about $100,000 that would "follow ownership and management of the property." Mount Hope declined to accept, noting that its legislative charter granted the Corporation cemetery services only within the Bangor city limits.[503]

Mount Hope was able to accept two other requests for services. In 2006, the board voted to provide interment services to Beth Israel Cemetery, located north of the municipal section, at the Corporation's regular rates. Soon thereafter, the cemetery was approached by representatives of Beth Abraham and agreed to also provide interment services for its congregation.[504]

The work done for the city cemetery versus that provided for interments only was ongoing in a way that allowed for the City of Bangor and the Corporation to negotiate fees on an annual basis. By 2005, the cost for grounds upkeep to the City was $87,500, in 2007 it was $90,000 and in 2011 and 2012 it was $95,000. This did not, however, include the upkeep of individual graves, such as was performed on those located in the private Mount Hope Cemetery.[505]

While services overall increased, use of the Receiving Tomb decreased after the turn of the century and then ceased altogether. Some repairs of a sort had been made to the tomb by the City late in the twentieth century—a water seal coating of the tomb had been added by the municipality that ultimately caused as much of a visual mess when it started to peel as it resolved any moisture issues—but with modern machinery, the need to hold bodies for spring interments simply became almost nonexistent except during major storms. Use of the tomb dropped to a few per year and then practically ceased. The last use to date of the crypt occurred in 2008 when a local man, a welfare client, was held there before interment. The Receiving Tomb, however, remained structurally intact as of 2012, continued to hold aesthetic appeal and had certainly served the city and the region well since its construction in the 1800s for $5,000.[506]

One odd little quirk in corporate decisions involved the possibly of insuring the cannons at the GAR Fort on an individual basis. One of the cannons had been appraised at $15,000, informally, and the cemetery determined that having it individually insured would cost roughly $375 per year. Due to the weight of the cannons, their location and the difficulty in stealing such items, the board determined in 2001 that as the cannons were both covered in the Corporation's general insurance, they need not be insured individually. The Corporation also received a purchase offer for one of the cannons but decided to decline.[507]

A more persistent issue for the cemetery in the late 1990s and beyond was one with which Mount Hope had long contended and would continue to address in following years. Paving and improving cemetery roads had long been an ongoing project for Mount Hope Cemetery, and the mid- to late 1990s saw this process continue. It had a perhaps more formal plan for it than had been true for some time, working with Sunrise Materials in 1995 and over the following few years, dividing its project into sections, and by 1996, it projected that it would soon "complete the rebuilding and paving of all cemetery roads except those that should more appropriately be preserved as grass or gravel roads." The work would continue the following year.[508] Having all the more frequently used (by visitors, staff and funeral processions) roadways paved did make the cemetery function more smoothly and also helped prevent erosion, particularly on Cemetery Hill and along other inclines.

Yet the cemetery was not finished with paving roads as the century closed. Indeed, it was creating new roads. Furthermore, at the same May 1996 meeting at which the Executive Committee remarked on the

imminent completion of the road paving and rebuilding project, it also voted to "approve the concept of a master plan for laying out future lots on the next 50 or so acres in the Northern Division." This would be dependent on the superintendent's inquiries as to "the availability of local architectural-engineering firms competent to do so such work." The Corporation had previously used an out-of-state company to do work in the section, Grever and Ward of Orchard Park, New York.[509]

The development, in terms of landscaping, grave site layout, road construction and so forth, of the so-called Northern Division (probably better known to locals as the land on the north side of Mount Hope Avenue) would prove to be one of the most important developments of the era in terms of long-term impact on MHC and the community it served. The president and board of the Corporation were well aware of this significance and pondered the possibilities intensely.

In February 1997, the Executive Committee met and considered its options. The members wished to see, at the superintendent's encouragement, at least five to eight acres of the land developed in the near future. This particular portion of the project would (like other sections of the Northern Division) use topographical survey work performed by the James W. Sewall Company of Old Town, Maine, a well-respected and established firm, as a basis for laying out new lots and as a guide to landscaping the property. Individual lots would be surveyed. The cemetery had had contact with one local firm about the project but did not deem it able to take on the project in the near future. The members would try to locate other competent firms and in the meantime consult with Grever and Ward. They would also consider developing more than the minimal acreage should it prove to be more cost-effective in the long run to develop more land initially.[510]

In March 1997, having considered local options, the MHCC decided to accept the proposal submitted by Grever and Ward. In December, the Executive Committee discussed more details of the plan, which would ultimately develop more than 39.0 acres of non-wetland property, allowing for the creation of 28,600 new graves at an estimated total cost of $1,865,100, or $65 per grave. The project, when complete, would, the Committee anticipated, serve the needs of the community and Mount Hope for the next one hundred years. The project would be undertaken in a number of phases, with Phase One to be initiated during the coming year and creating close to 3,000 graves on roughly 4.5 acres at a cost of $313,500, or $104 per grave. The cost per grave would be above average

The Northern Division continued to be developed in the early 2000s but still had a long ways to go before gaining the maturity and look of the older sections of Mount Hope Cemetery. *Photographs by Stephen G. Burrill.*

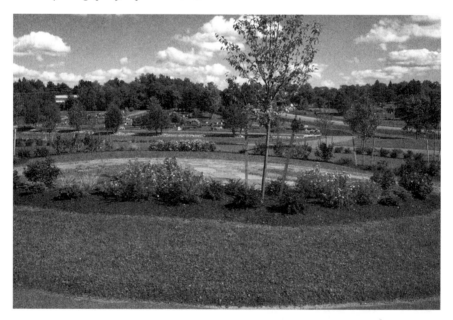

for the first phase, as that phase would include infrastructural work for not only Phase One but also for subsequent phases.[511]

Work in the Northern Division continued over the next few years. In 2000, the board voted to have a stretch of fencing moved from its current location near the office to the Northern Division, and in 2001, the cemetery had 942 feet of "iron-looking fencing" (a coated aluminum fencing purchased to match fence earlier purchased for other portions of the cemetery) installed

along Mount Hope Avenue to augment and protect the Northern Division. This negated the decision to relocate the older fencing, and the price of the new fence and its installation was to be provided by the interest from the Luther Peirce Fund.[512]

One problem did occur in the Northern Division, one that was concentrated there but also affected other portions of the cemetery to a lesser extent. In 2004, the board had a notice published in the *Bangor Daily News* and posted at the cemetery that from October 31, 2004, it would no longer allow people to place any "cement, plastic, wood, rubber edging, or fences around flowerbeds." Lot owners were advised that they would have to remove any existing such items, or the cemetery would do so. Furthermore, the cemetery would not allow any marble chips or other rock materials to be used in flowerbeds; only wood chips or bark mulch would be allowed. The reason behind the notice, as Superintendent Burrill described it, was that "families are bringing in these materials and are landscaping on their lots. It is beginning to make the cemetery very unsightly." According to Burrill, this was particularly a problem "in the newer part of the cemetery."[513]

The landscaping and other work in the Northern Division began to acquire a natural aging by the end of the first decade of the twenty-first century, but it still had a long way to age to match the older sections of the cemetery. Corporate president John W. Bragg, who had become president when his father, Charles Fred Bragg 2nd, had become ill a few years earlier, would like Superintendent Burrill immediately think of both the work north of Mount Hope Avenue and the change in energy sources as the two most important developments of the early 2000s. John Bragg stated in 2011 that the Northern Division "still has a long way to go to look like the rest of the cemetery because it is so young compared to the rest of the cemetery." Tree growth and such still lagged well behind that of the more southerly sections. Yet, as had been part of the original rationale for the work, Bragg stated, "There's ample acreage on the property to suffice for years to come. The challenge is to develop it as tastefully as the rest of the cemetery." In general, John Bragg noted in mid-2011, the work of the cemetery was largely concentrated on "maintaining the integrity of the place." This would, as recent years had shown, include maintaining a continuity or cohesiveness between older and newer sections of the cemetery.[514]

The Northern Division was under development early in the 2000s, but it did not encompass all of the land north of Mount Hope Avenue. Regular tree work was an ongoing focus in the cemetery, as the MHCC aimed to keep the roadways and grounds as neat and appealing as possible. Such

events as the massive ice storm that hit Maine in 1998, shutting off electricity to thousands of people for extended periods and bringing trees crashing down around the state—including several massive trees and limbs on Mount Hope Cemetery property—only added to the workload of cemetery staff. The cemetery had to close down for several weeks, in terms of allowing visitors in, and when it reopened, it had some roads blocked off until the Corporation bought a chipper and was able to finish with the cleanup work.

Mount Hope owned more that just the trees in the older sections of the cemetery and in the developing Northern Division. Beyond the acreage undergoing development as burial grounds, the Corporation owned further lands that could, even in the twenty-first century, be utilized as forested lands, with wood harvesting a valid option. In recognition of this, the board voted at a special meeting in June 2000 to authorize the superintendent "to hire a forester and investigate the harvest of the trees on the woodlot."[515]

Six months later, in December, the board discussed options that the consulted forester had suggested. Primarily, he suggested a five-year plan involving an active management program. He had also recommended that the Corporation establish a separate "tree fund" and opined that it might be possible to harvest pulpwood at the site. The board considered its options and, meanwhile, at the same meeting, voted to switch its fiscal year to coincide with the calendar year. The board did so on the advice

The Peggy Schomaker Tomb was the last tomb erected in Mount Hope Cemetery or, in this case, installed, as the unit was a purchased one and not built on-site as had been the cemetery's earlier tombs.
Photograph by Trudy Irene Scee.

of MHCC accountants.[516] At the same time the Corporation considered going back into harvesting natural or cultivated resources for sale, as it had done one hundred years earlier, it changed its calendar in a move not taken since the 1830s. Both actions were taken as a means of augmenting the efficiency of the Corporation and its various activities, which ranged far beyond simply selling grave plots, as had been true since Mount Hope's very beginnings.

The Corporation decided to go ahead with a harvesting and development program for about one hundred acres of its wooded land. Forester John Mills started the harvesting soon after the plan was implemented, originally focusing on the culling of trees to increase the value of those left standing. The harvesting continued for a few years and then came to a halt for about five years. Cutting resumed in spring 2011, largely in order to harvest hemlock and spruce, whose market value was potentially threatened by disease. While Mills continued to assess the need for further harvesting of hemlock, spruce and other species, Hurricane Irene hit the Bangor area in late August 2011, causing further damage in the cemetery proper as well as in the forested section.[517]

A number of other developments occurred after the turn of the century, some of them crucial. The crematory had been serving the community and the cemetery well during the mid- to late 1990s. Initially a section off the lodge, the crematory had by now been housed in its own building to the rear of the lodge, and in May 1996, the Executive Committee voted to have the now unused section of the lodge renovated and refurnished as a conference room and as a showroom for, as it turned out, cremation urns, markers and various related items.[518] The renovation would make the area into an integral portion of Mount Hope's office space and remain a meeting room and display area into the 2010s.

According to President Charles F. Bragg 2nd in 1995, the crematorium, which he credited to Superintendent Stephen G. Burrill, had been behind the recent and significant increase in revenue generated by cemetery operations. The crematory had been recently expanded, and the future looked positive. However, the cemetery experienced a decline in cremations during 1996. In February 1997, it changed its hours of operation, going to a six-day week schedule for cremations, in order to address the need for cremations over the weekends. By May of that year, the new hours had already seemed to have started to reverse the decline, and the following May, in 1998, the Executive Committee noted that, as reported by the superintendent, "the trend toward more cremations has

been resumed following the adjustment made in our weekend schedule a year ago."[519]

In 2001, the board decided to have the crematorium expanded to make it a "four-[re]tort crematory." Some portions of the crematorium would be redone and an older retort kept in place for a time as a backup. As it worked out, however, the new retort was indeed ordered, but the existing third retort, added in the early 1990s, remained in service. At the same time the board considered the crematory expansion, the superintendent brought it to the board's attention that the community cremation niches were almost full in the existing mausoleum, and the board decided that he should research designs and costs for a new cremation mausoleum. Existing burial spots for cremains were also rapidly filling, and something needed to be done to address that as well. At the following annual meeting, the superintendent had a new cremation garden plan in hand and reported that work on the same could begin after the spring rains ended. The cemetery could anticipate sales of about fifty lots per year in the new garden. However, the Corporation ultimately decided not to go ahead with creating a new cremation garden lot but rather to add new cremation lots to the Northern Division. Specifically, cremation lots were interspersed with various phases or sections of the Northern Division work, with such lots added to Section D in 2002 and Section F in 2006. Future plans for other sections were also to include such interspersed cremation lots.[520]

The cemetery did add a new community mausoleum for cremains, however. In 2003, the cemetery proceeded to secure an above-ground columbarium designed to hold 124 cremains, the columbarium divided into sections that were "single" (for one set of cremains) and other sections designed for "double" occupancy. The cemetery situated the structure on the southeast side of the brook, or that walled portion of it known as "the causeway" near the lodge. The niches sold well, and by autumn of 2011, the single niches were about 90 percent sold and the doubles about 60 percent sold. Demand for the niches continued to increase. Noting that in 2010 cremation interments accounted for roughly 52 percent of the cemetery's interments (even though many people, as had been true previously, elected to have their ashes, or those of their loved ones, sent elsewhere for interment, display or other), the cemetery began considering its options. Anticipating future needs, the cemetery began preparations in late 2011 to purchase another such columbarium, made by the same company for $38,000 (the initial one had cost $30,000). The new structure would hold 100 cremains, a smaller number than the first unit held, but

a larger percentage of them would be designed for single occupancy. The new columbarium would be placed on the opposite side of the causeway from the older unit and at an agreeable angle from it so as to showcase both structures while allowing the slight differences between the two to blend harmoniously into the general landscape.[521]

The decisions to modernize the crematory and add new cremation lots were good ones, as cremations were undergoing a rapid increase in numbers during the era. During the first five months of 2002, some 725 cremations were performed at MHC, an increase of almost 100 percent from recent years—an upswing Superintendent Burrill credited largely to an increase in the marketing of cremations by local undertakers. In addition, a large commercial chain, SCI, wanted to establish a formal relationship with MHCC and would be sending it paperwork for the same.

Until the early 2000s, Mount Hope held a virtual monopoly on cremations in central Maine, as no other crematory existed in the region. By early 2006, however, Bangor's Brookings-Smith Funeral Home had plans underway to construct a crematorium across the city on outer Hammond Street and "operate a crematory in Pine Grove Cemetery in Bangor."[522] The funeral home did ultimately construct a crematory in Bangor, but it did not have a long-term negative impact on cremation services at Mount Hope Cemetery.

Both John W. Bragg and Superintendent Stephen G. Burrill agreed in June 2011 that losing the local monopoly on cremations had not "had much of a negative impact" on cremations performed at MHC. As Bragg stated it, "Our numbers have stayed about level." Burrill noted that the cemetery performed about 1,400 cremations per year, with the peak capacity in 2010–11 averaging about 12 cremations per day. (This was, however, something of a dip, as cremations numbered 1,875 in 2004 and 2,000 in 2005, yet costs per cremation were decreasing with increased efficiency in operations.) Working hours were extended when necessary.[523]

Part of the potential loss of revenue to MHCC from the local change was offset by a rise in cremations in general in America. In addition, MHCC decreased its crematory costs in terms of costs per cremation. Cremations costs dropped for the cemetery because Mount Hope decided to change its energy source. The cemetery's retorts ran on propane gas during the 1990s and early 2000s, but propane costs rose significantly after the turn of the century. The costs to Mount Hope for propane increased 30 percent in 2005 alone at a time when the number of cremations was still rising, increasing by 9 percent over the previous two years. To meet

the short-term problem, the board voted in December 2005 to raise its rates effective February 1, 2006—rates that had remained unchanged for over two years.[524]

Propane prices continued to increase, however, and the cemetery explored other options. In May 2009, the Executive Committee voted to have the superintendent go ahead with his suggestion to explore converting the crematory and the office to natural gas as the heat or energy source. Burrill had already secured a proposal from Bangor Gas regarding rates and terms. The following year, the Committee voted to proceed with an energy conversion and to wait to determine if cremation rates needed to be increased based on how its natural gas rates and usage went for the crematory. As it turned out, energy costs dropped about 50 percent over the first year of the switch. In 2011, both the superintendent and the Corporate president agreed that the conversion to natural gas had been more than effective, that it had saved the Corporation a significant amount of money and that it represented a major cemetery development.[525]

Another development of the era, although one of less significance to the cemetery overall, was that a new private mausoleum was constructed at Mount Hope. The family of Peggy Schomaker, a former University of Maine professor, purchased a plot of land and a mausoleum for her remains, with a major portion of the combined purchase price going into the cemetery's perpetual-care fund.[526] The details took some time to arrange, but the mausoleum (a prefabricated unit as opposed to the older private mausoleums at Mount Hope, highlighting the changes of the era) was eventually placed across the brook from the lodge, at the northwesterly foot of Cemetery Hill.

As the twentieth century came to a close, the author's *Mount Hope Cemetery: A Twentieth-Century History* went to press. The book enjoyed a modest success through sales at the cemetery, over the Internet and at local and national bookstores, and it was favorably reviewed by local historian Richard Shaw of the *Bangor Daily News*.

Pleased that the book had gone into production, Charles F. Bragg 2nd informed the board in 1999 that there was another project that he wanted to see undertaken before he might retire as president of the Corporation: having the corporate bylaws updated, not as to content but for the purpose of modernizing the language. With that end in mind, the Corporation hired the author for the job.[527] Charles Bragg, however, did not retire as president after the 1999 rewrite; rather, he stayed on as president until shortly before his death in 2007. There were many more projects to be

Throughout his life, Charles Fred Bragg 2nd contributed to his community in innumerable ways. He is seen here during an interview on Bangor and his company's history with the author a few years before his death. *Photograph by Trudy Irene Scee.*

undertaken and tasks to be performed before Charles Bragg would step down and the reins pass to his son, John W. Bragg, who had joined the Executive Committee in 1997.

The loss of Charles F. Bragg 2nd to his community and to the cemetery he had so enjoyed working with for decades was one of the major changes of the early 2000s, as were a few other changes of Executive Committee members. LaJune S. Means, who had been part of the Executive Committee for a few years and its first female member, died at age eighty-eight in November 2007, and Robinson Speirs and Franklin W. Eaton, both former longtime members of the Executive Committee (Eaton also having served as both secretary and treasurer of the Corporation) died in May 2009 at age eighty-four and September 2009 at eighty-eight, respectively. The cemetery board noted the passing of each of them with respect and regret and expressed appreciation for the work they had done for the cemetery and the community. Each would, either immediately or eventually, be buried at Mount Hope, as would their long-term president.[528]

John Woodbury Bragg—president of the Mount Hope Cemetery Corporation at the close of the studied period—seen here receiving the Norbert X. Dowd Award, an award that his father and his cousin, C. Clifton Eames, had previously been awarded for outstanding service to the Bangor region. John's father and grandfather had previously maintained the position of president, resulting in an unprecedented longevity in the position and on the Executive Committee. *Courtesy of the* Bangor Daily News.

Longtime board member and corporate president Charles F. Bragg 2nd became ill in early 2007, and in June, just before his death, he sent in a letter of his intent not to stand for reelection for president of the Corporation. Bragg had held the presidency since April 9, 1951, and as the Executive Committee worded it in a letter to him, stated "with sincere appreciation of your outstanding service and commitment to the Corporation, the Executive Committee has voted to name you its first President Emeritus, as well as an Honorary Trustee. We wish you could be with us, sharing your thoughts and ideas."[529] Charles Fred Bragg 2nd died soon thereafter.

John Woodbury Bragg was elected a trustee of the cemetery trust fund and corporate president just before his father died. When asked about whether he had originally joined the cemetery board because of his father, he answered in 2011, "Yes. There's no question about it. Dad was on the library [the Bangor Public Library] board, on the cemetery board...There is no

question that he wanted to see his work continued, so my brother [Franklin Bragg] ended up on the library board, and I ended up on the cemetery board. It was no coincidence, but I enjoy doing the work." However, he added, regarding his election as president of the Corporation when his father stepped down, "Dad was still president when I joined as just a regular member. Dad was happy that it turned out that way"—that John became the next board president. "But," Bragg continued, "he wasn't lobbying for it. I stood for the position on my own merits."[530]

John Bragg, like his father before him, had had a great deal of experience in the business world and in benevolent work. As so many instances of family involvement in the cemetery (as in some other local institutions) had occurred over the decades, the reasons why John Bragg became a board president are not really in question. However, the expression of what it meant to members of one such active family to maintain such continuity is perhaps invaluable. To be able to hear one president call another "Dad" truly brings home a sense of the family dynamics operating in these circumstances. Mount Hope had grown and endured and prospered since the 1830s, but it still remained highly local and familial in the early 2000s. Even the writing of the prequel and sequel to *Mount Hope: A Twentieth-Century History* possessed a familial dynamic: Charles Bragg promoted the writing of the first work by the author and John Bragg the second, both in their positions as Corporate president.

Its history (for the present) written and its bylaws updated, its crematorium running at capacity much of the time and its other services to the community ongoing, Mount Hope entered the first and second decades of the new century on firm ground. In terms of its financial stability, although there were some downturns in the economy and in some aspects of portfolio and asset managements by investment firms, MHCC emerged from the first decade of the twenty-first century on solid financial footing. The cemetery assumed control of the Frederick Hill Trust soon after the period opened, and during the twenty-first century, it changed its investment company for its general endowments. The specific amount of money available via perpetual-care endowments varied each year during the early 2000s, averaging roughly $7–8 million per annum, according to board president John Bragg, and from each new lot sale the Corporation put 50 percent of the proceeds into the endowment and 50 percent into operations.[531]

Local citizens and tourists continued to visit MHC throughout the era to exercise and enjoy the peacefulness and beauty of the cemetery. The Bangor Historical Society (later renamed the Bangor Museum and History Center) conducted seasonal tours of Mount Hope. Numbers of tours varied, but in

1998, the number of people visiting the cemetery, according to corporate records, was "thirty to fifty people during the summer." That, the Executive Committee noted, along with the new website, had "engendered much interest in the cemetery among people from away." The expression "from away" anchored the cemetery in Maine, no matter the distance that knowledge of its existence might travel or from what distance people might come to visit. In Maine, "from away" continued to be a prime identifier of who was and who was not, as well as what was and what was not, from Maine, in Maine or an integral part of Maine culture.[532] Mount Hope Cemetery was and is part of that culture.

All of the developments of the early 2000s were undertaken as best as possible with, as John Bragg had expressed it, the goal of "maintaining the integrity" of Mount Hope Cemetery. Trees needed to be kept healthy and free of disease, land development decisions had to be made wisely and economic stability had to be ensured. As he said in June 2011, "I think the thing I keep in my mind is that sometimes it isn't easy but that the decisions we make, the decisions that are going to effect the way things look, [must be] tasteful so that whatever we do going forward is going to match what happened in the past."[533]

That many people continued to choose to be buried at Mount Hope Cemetery as the new century progressed, while other people continued to come to the cemetery to relax and visit loved ones, shows that, even though some decisions may have been difficult and some compromises might have been necessary along the way, the guardians of Mount Hope Cemetery had indeed chosen wisely. As well as being economically intact, the cemetery and its park-like appeal retained the integrity and beauty of earlier decades—and indeed of earlier centuries. The skyline had changed in some ways, as the pine trees that dominated in the mid-1800s had given way in the lotted areas to elms, maples and poplars; and then these in turn had given way to disease in the 1900s, and new ornamentals then grew up in their place. Yet trees, shrubs and flowers remained a part of the landscape, along with cemetery ponds, paths and the brook. Mount Hope remained one of the great attractions of the Bangor region, its appeal based on its history and its physical splendor and on the graciousness of its staff and governing board. As a haven for the living and a place of respite for the dead, Mount Hope Cemetery had only improved with the passage of the years.

List of Mount Hope Officers
and Superintendents

Presidents

Amos Patten	1834–1839
Thomas A. Hill	1839–1842
James Crosby	1842–1851
Amos M. Roberts	1851–1853
James Fiske	1853–1855
Moses L. Appleton	1855–1859
John E. Godfrey	1859–1865
Charles Stetson	1865–1873
Simon P. Bradbury	1873–1875
Joseph S. Wheelwright	1891–1895
James Adams	1895–1906
Manly G. Trask	1906–1914
Edwin A. Cummings	1914–1931
Franklin E. Bragg	1931–1951
Charles Fred Bragg 2nd	1951–2007
John Woodbury Bragg	2007–present

SECRETARIES

John Barstow	1834–1842
Samuel Thatcher Jr.	1842–1845
John Bright	1845–1886
Joseph M. Bright	1886–1932
Carl E. Danforth	1931–1947
Charles V. Lord	1947–1951
Horace S. Stewart Jr.	1951–1961
Donald J. Eames	1961–1965
Franklin W. Eaton	1965–1998
M. Ray Bradford Jr.	1998–present

TREASURERS

Thomas A. Hill	1834–1842
Asa Davis	1842–1843
Abner Taylor	1843–1851
John Wilkins	1851–1852
Albert W. Paine	1852–1902
Henry O. Pierce	1902–1930
Richard H. Palmer	1930–1945
Charles V. Lord	1945–1983
Franklin W. Eaton	1983–1998
John M. Lord	1998–present

SUPERINTENDENTS

Thomas J. Cole	1880s–1908
Rueben E. Hathorn	1908–1929
Harold S. Burrill	1929–1946
F. Stanley Howatt	1946–1969
Harold S. Burrill Jr.	1969–1992
Stephen G. Burrill	1992–present

Notes

Preface

1. Minutes of Mount Hope Corporation Annual Meetings, April 1, 1901, and April 7, 1902.
2. Minutes of Mount Hope Executive Committee Meeting, June 18, 1903, and April 13, 1906.
3. See Paine, *History of Mount Hope Cemetery*.

Part I

4. Scee, *City on the Penobscot*, 25, 29, 44. See book for in-depth information on the founding of the community and its growth into the twenty-first century.
5. See Scee, *City on the Penobscot*, regarding bridging the river and the stream and early graveyards, and see especially page 39 for construction of the first bridge across the Kenduskeag; also see Paine, *History of Mount Hope Cemetery*, 7–9. Sources differ as to exactly when and where some of the early graveyards were established.

6. See Scee, *City on the Penobscot*, on bridging the river and the stream and on early graveyards, and see especially page 39 for construction of the first bridge across the Kenduskeag; also see Paine, *History of Mount Hope Cemetery*, 7–9, on first cemetery and for quotes.

7. Scee, *City on the Penobscot*, 36, 48; "By-Laws of the Town of Bangor," available at the Bangor Public Library (hereafter cited as BPL).

8. *Private and Special Acts of the State of Maine, Passed by the Fourteenth Legislature*, chapter 469, 698–99.

9. Ibid.

10. Ibid.

11. Information on the incorporation taken from Mount Hope Cemetery Ledger (hereafter cited as MHCL) for 1834–58; see Scee, *City on the Penobscot*, 53–57, for Bryant.

12. From deed dated July 14, 1834, and later recorded with the Penobscot County Registry of Deeds, Bangor, Maine (hereafter cited as PCRD), Book 50, 320, and from later maps; also see Scee, *City on the Penobscot*, 35–37, on Holland.

13. Ibid.

14. MHCL for 1834–58.

15. Agreement of April 23, 1834, as recorded in the MHCL of 1834–58; PCRD, Book 50, 320.

16. Agreement of April 23, 1834, as recorded in the MHCL of 1834–58. See the records recorded in the same ledger on the acreage of the Garden Lot; Albert W. Paine, *History of Mount Hope Cemetery*, on the twelve-acre identification, as well as deed as recorded in PCRD, Book 50, 320.

17. Agreement of April 23, 1834, as recorded in the Mount Hope Cemetery Ledger of 1835–58; PCRD, Book 50, 320.

18. Agreement of April 23, 1834, as recorded in the Mount Hope Cemetery Ledger of 1835–58; PCRD, Book 50, 320.

19. Ibid.

20. "Copy of Application to Justice to be Incorporated Under the General Law as a Cemetery Corporation," 1834, MHC records; first name of Justice Cutting taken from *BDW&C*, August 3, 1887.

21. Copy of warrant, State of Maine, July 19, 1834.

22. MHCL of 1834–58.

23. Mount Hope Annual Meeting (hereafter MHAM) of 1835, from MHCL of 1834–58. Hereafter, the Annual Meetings will just be referred to by year unless otherwise indicated. The Corporation would eventually have three such general ledgers, and it will be so indicated when there is a switch in ledger.

24. MHCC Ledger of 1834–58. The date for the transfer agreement was either October 29, 1834, or October 29, 1839.

25. MHAMs for 1836–44.

26. Special Meeting of December 19, 1836, MHCL for 1834–58.

27. Ibid.

28. Ibid.

29. Special Meeting of February 5, 1836, MHCL for 1834–58; also see PCRD, Book 50, 299.

30. MHCL for 1834–58; see Paine, *History of Mount Hope Cemetery*, 22–25, on the one-cent consideration; PCRD, Book 72, 503.

31. PCRD, Book 75, 96.

32. *BDW&C*, July 8, 1836, and subsequent days up to July 22, 1836.

33. *BDW&C*, July 23, 1836.

34. Ibid.; Scee, *City on the Penobscot*, on Bangor's mayors and other community leaders, including Kent.

35. *BDW&C*, July 23, 1836

36. Paine, *History of Mount Hope Cemetery*, iv and 20.

37. *BDW&C*, August 26, 1836; Special Meeting of September 2, 1836, MHCL for 1834–58.

38. MHAM for 1838; MHAMs for surrounding years.

39. See MHCL for 1834–58; Paine, *History of Mount Hope Cemetery*, 29, on the sale of the eighty lots, and 59, on lot size and price at close of century.

40. MHCC Interment Records; Paine, *History of Mount Hope Cemetery*, 29; information from the Calls' headstones.

41. Information from tour of cemetery grounds; date from Paine, *History of Mount Hope Cemetery*, 58–59; use of tomb for holding bodies from interview with Stephen G. Burrill (hereafter SGB), July 2011.

42. See meetings of 1840–43, MHCL for 1834–58.

43. Special Meetings of June 1843, MHCL for 1834–58.

44. Ibid.

45. See meetings for 1843, MHCL for 1834–58.

46. See meetings for 1843, especially July 15, 1843, for quote, MHCL for 1834–58; see Scee, *City on the Penobscot*, 45, 53–57, 64, on Call, and 45, 169 and later pages, on the Bangor Mechanic Association.

47. Special Meeting of December 28, 1843, MHCL for 1834–58.

48. Special Meetings of December 1843 and January 1844, MHCL for 1834–58.

49. MHCCL for 1834–58; also see Paine, *History of Mount Hope Cemetery*, 12–13, 74–75, on the lease of a twelve-acre plot, as well as deeds on file at PCRD.

50. MHCCL for 1834–58; Special Meeting of March 16, 1844, for specific discussion; Scee, *City on the Penobscot*, first 300 pages in general on pigs, cows and other animal problems in the town and then the city.
51. Special Meetings of 1844, MHCCL for 1834–58.
52. MHAM for 1844.
53. Ibid.
54. Ibid.
55. Ibid.
56. Special Meetings of August 1844, MHCCL for 1834–58. Unfortunately, although the reports presented by the Executive Committee and Passott were read and "placed on file," these reports—as well as others from the era—are no longer available for the historian or other interested parties to peruse.
57. Ibid.
58. Ibid.
59. Ibid.
60. Ibid.
61. MHAMs for 1846 and 1847, and see other ledger entries as well.
62. MHAMs for 1847, 1848 and 1849.
63. MHAM for 1849.
64. Scee, *City on the Penobscot*, 97–99; see Mayors Annual Reports or Addresses, City of Bangor, Bangor, Maine, 1834–1931 (hereafter cited as MARs; most years available at BPL) for these years for further information on Bangor's rates of mortality.
65. MHAM for 1850.
66. MHAM for 1851.
67. Ibid.; also see Scee, *City on the Penobscot*, especially 52, 77–78, 94–95, 153, 230–31, as well as city records for the era, on the population and the reasons for that growth and also on its death rate.
68. MHAM for 1851 on meeting; see Scee, *City on the Penobscot*, on balance.
69. MHAMs for 1851 and 1852.
70. MHAM for 1852; Scee, *City of the Penobscot*, 117, 119 and subsequent pages, on the railroad, as well as 166, 171, 196, 202, on Pickering and Appleton, and 30, 33, 42, 45, 50, 54, 87, 172, 178, 185, 196, on Godfrey.
71. MHAM for 1852; Special Meeting, June 22, 1852, MHCL for 1834–58.
72. Special Meeting, June 22, 1852, MHCL for 1834–58.
73. MHAM for 1853; see Scee, *City on the Penobscot*, especially 111–40, on the building of this and other lines in the Bangor region.
74. Adjourned Meeting, July 9, 1853, MHCL for 1834–58.
75. MHAM for 1854.

76. MHAM for 1853.

77. See general cemetery records for the era.

78. MHAM for 1854; Special Meeting of September 1854; see Mount Hope Interment Records (hereafter cited as MHIR). No other records of the steps have been located.

79. MHAM for 1854.

80. MHAM for 1856.

81. MHAM for 1857.

82. Adjourned Meeting of June 30, 1857, MHCL for 1834–58.

83. Ibid.

84. Ibid.

85. "Act to Incorporate Mount Hope Cemetery," Maine State Legislature, 1858; MHCC records, 1858, in MHCL of 1834–58.

86. Adjourned Meeting of June 30, 1857, MHCL for 1834–58.

87. MHCC Ledger for 1834–58 and Ledger for 1858–85; PCRD, Book 287, 356.

88. MHAM for 1860, MHCL for 1859–85; see MHCL for 1834–58 for earlier records.

89. MHAM for 1861; also see subsequent ledger entries.

90. MHAM for 1861.

91. MHAMs for 1861, 1864 and 1862; see MHCL for 1834–58 for earlier records; Scee, *City on the Penobscot*, 42, 151, 185, 281, 289, 431, 436, 476, 493, on the Bangor Savings Bank. For a more in-depth history of the bank and its relationship with the local community, see Lunt, *Here for Generations*.

92. MHAM for 1861.

93. MHAMs for 1861 and 1866.

94. MHAM for 1862.

95. MHAMs for 1862 and 1863.

96. Ibid.; Paine, *History of Mount Hope Cemetery*, 41–42; PCRD, Book 318, 356.

97. MHAMs for 1862 and 1863; Paine, *History of Mount Hope Cemetery*, 41–42; PCRD, Book 319, 255.

98. MHAMs for 1861–64.

99. MHAM for 1866; also see subsequent years in ledger.

100. Scee, *City on the Penobscot*, 156, on the establishment of Mount Pleasant Cemetery. Other cemeteries are also discussed in the book.

101. MHAMs for 1866 and 1867.

102. MARs for 1870 and 1871, available at BPL. Quotes from report filed with MAR for 1871.

103. Information taken from a walkthrough in 2011 with SGB, superintendent; measurements and such taken by author; price of building from interview with Burrill, July 14, 2011.
104. MHAM for 1867.
105. Ibid.
106. Ibid.
107. MHAM for 1868; see Scee, *City on the Penobscot*, on the issue of livestock in the town and then the city, a problem that continued into the twentieth century, although it peaked in the nineteenth.
108. MHAM for 1869.
109. MHAM for 1870. The handwritten notes seem to have a "2ⁿᵈ" after his name, or a "2d," neither of them common in general but not unheard of in Bangor's history. His surname is also spelled different ways in the records: "Hathorn," "Hawthorne" and "Hawthorn."
110. MHAM for 1871.
111. MHAMs for 1871 and 1872; Scee, *City on the Penobscot*, 168, on Veazie's separation from Bangor.
112. MHAM for 1876; Scee, *City on the Penobscot*, 42, 151, 185 and subsequent pages, on the establishment and longevity of the bank; see Lunt, *Here for Generations*, for a more detailed history of the bank.
113. MHAM for 1876; also see Paine, *History of Mount Hope Cemetery*, 40, and other cemetery records.
114. Ibid. As a note, some of the writing in the ledger was especially hard to read in regards to many of the names mentioned during these years, so the spelling is particularly troublesome.
115. MHAM for 1876.
116. MHAM for 1877.
117. Ibid.
118. MHAM for 1878.
119. Ibid.
120. MHAM for 1877.
121. MHAM for 1878.
122. Ibid.
123. Ibid.
124. Ibid.
125. MHAMs for 1877 and 1878; see Scee, *City on the Penobscot*, 236, 266, 329–30, on some of the overlap of duties, as well as MARs for these years.
126. MHAM for 1878.
127. Ibid.

128. Mount Hope Executive Committee Report for 1878 (hereafter cited as MHECR).
129. MHAMs for 1879 and 1880.
130. MHAM for 1879.
131. Ibid.
132. Ibid.
133. Ibid. See the surrounding years for general information on lot sales and prices.
134. Ibid.
135. Report included with MARs for 1875 and 1866.
136. MHAMs for 1879 and 1880.
137. MHAMs for 1880 and 1881; Lunt, *Here for Generations*, 129–31, on bank problems, and 61–99, on the founders of the bank; Scee, *City on the Penobscot*, 103–151, on Maine and local railroads and their founders, as well as other pages on the particular individual and railroad.
138. MHAMs for 1880 and 1881; MHCCL for 1858–95.
139. MHAM for 1880.
140. Ibid.
141. Ibid.
142. Ibid.
143. Ibid.
144. Ibid.
145. Ibid.
146. Ibid.
147. Special Meeting of July 19, 1880; *BDW&C*, July 12, 1880. It should be noted that William H. Brown served as incoming mayor during early 1880 (Lysander Strickland was the outgoing mayor), but it is possible that he was out of town or incapacitated at the time of the meeting and that Jones was acting in his stead.
148. PCRD, Book 515, 47. The deed was dated July 19, 1880.
149. MHAM for 1881.
150. Ibid.
151. Ibid.
152. Ibid.
153. MHAMs for 1880–83.
154. MHAM for 1881.
155. Paine, *History of Mount Hope Cemetery*, 45–46.
156. MHAM for 1882.
157. MHAM for 1883.

158. MHAMs for 1882 and 1884.

159. MHAM for 1881.

160. MHAM for 1882.

161. Ibid.

162. Special Meeting of April 20, 1882.

163. Ibid.

164. Ibid. Also see subsequent entries.

165. Special Meeting of May 20, 1882; MHAM for 1883; Special Meeting of April 16, 1883.

166. MHAM for 1884.

167. MHAMs for 1884 and 1885.

168. MHAM for 1885.

169. Special Meetings of April 18–19, 1886; MHCCL for 1886–1998 for this and subsequent meetings during the era.

170. MHAM for 1885.

171. Ibid.

172. Ibid.; Scee, *City on the Penobscot*, 168.

173. MARs for 1875–80. See especially report filed with MARs of 1875 and 1876, BPL.

174. MHAM for 1886.

175. Scee, *City on the Penobscot*, 211–18, on development of the system. See subsequent chapters of Scee for additional information.

176. MHAM for 1885.

177. MHAM for 1886.

178. Ibid.

179. Ibid.

180. Ibid. The minutes here note that Cole had just eight years of consecutive service; this may be due to the exact date he started seemingly being unknown in contemporary records.

181. MHAMs for 1886 and 1887.

182. MHAM for 1886.

183. MHAMs for 1886–88.

184. MHAMs for 1882, 1883 and 1884. Also see the next few years.

185. MHAMs for 1887 and 1889.

186. MHAMs for 1887 and 1888; Special Meeting of August 21, 1888.

187. Special Meetings of August 21 and November 14, 1888; MHAM for 1889; PCRD, Book 610, 303; Paine, *History of Mount Hope Cemetery*, 43–45.

188. Ibid.

189. *BDW&C*, August 3, 1887; see "The Establishment of Mount Hope Cemetery."

190. MARs for 1861–64; Scee, *City on the Penobscot*, 182–86.

191. MHAM for 1863; MHCCL for 1858–95.

192. Ibid.; Scee, *City on the Penobscot*, 184.

193. MARs for 1864 and 1865; quote from Paine, *History of Mount Hope Cemetery*, 51; Scee, *City on the Penobscot*, 184–86.

194. Names and description from memorial at MHC; see Scee, *City on the Penobscot*, for more information on Pitcher, Jameson and Carpenter.

195. Names and description from memorial at MHC.

196. Names as recorded on the monument; information on Carpenter and deed from Paine, *History of Mount Hope Cemetery*, 52; Scee, *City on the Penobscot*, 184–86.

197. MHAM for 1864; see Scee, *Inmates and the Asylum*.

198. Scee, *Inmates and the Asylum*, 79; records of the Bangor Children's Home.

199. Scee, *Inmates and the Asylum*, 110–12.

200. MHAM for 1873; Scee, *Inmates and the Asylum*, 110–11.

201. Ibid.

202. Scee, *Inmates and the Asylum*, 52, 111–12, 133–35, as well as on-site information from the lot.

203. MHAMs for 1892 and 1877; Scee, *City on the Penobscot*, 206, 236, on the establishment of the Home for Aged Women; also see Scee, *Inmates and the Asylum*.

204. MHAMs for 1877 and 1892; information on the stones from on-site research.

205. PCRD, Book 114, 150.

206. PCRD, Book 114, 150; on-site examination of area in question; MHCC Interment Records.

207. On-site examination of the site.

208. Ibid.

209. Ibid.

210. Ibid. The author only went looking for the site with Stephen G. Burrill after finding mention of the deed transfer in Penobscot County records, and the only other written cemetery-related document subsequently located was made in a small notebook perhaps copied from an earlier record and simply noting the lot number and ownership.

211. MHAM for 1899; see *BDN* coverage/cemetery submissions for 1899 and the surrounding years; Paine, *History of Mount Hope Cemetery*, 53, on the site being different than one originally arranged.

212. Scee, *City on the Penobscot*, 34–35, 83; see other sources as indicated in Scee for further information.

213. Ibid.; see tombstone of Junin at MHC; see previous chapter on the Bangor Female Orphan Asylum, later the Bangor Children's Home.

214. Scee, *City on the Penobscot*, 65, 67, 85–86, 110, 112, 119, 158, for this and further information on Dwinel; see Scee, *Maine Explained*, on railroad involvement for Dwinel and the subsequent men; see Chase, *Maine Railroads*; Smith, *History of Lumbering*; and Wood, *History of Lumbering*, on their lumber industry activities.

215. The stories of Dwinel are regularly told, and according to local folk historian Sandy Ives, as discussed later, such stories are common in cemetery lore.

216. Scee, *City on the Penobscot*, 42, 51, 67, 73, 83–85, for this and further information on Kent; see Mount Hope Interment Records and his gravestone.

217. Scee, *City on the Penobscot*, 65, 110, 113, 158, and Scee, *Inmates and the Asylum*, 85, for this and further information on Veazie; interview with SGB, June 2011, on the use of the Veazie tomb as a holding spot, as passed down through his family and earlier superintendents.

218. Scee, *City on the Penobscot*, 117, 119, 171, 196, 202, for this and further information on Pickering; Lunt, *Here for Generations*, 76–78.

219. Scee, *City on the Penobscot*, 117, 119, 171, 196, 202, for this and further information on Pickering; see MHCC Interment Records; Lunt, *Here for Generations*, 76–78.

220. Scee, *City on the Penobscot*, 130, 155, 179, 181, 197, 221, 243, 244, 316, for this and further information on Hannibal Hamlin; see MHCC Interment Records.

221. Scee, *City on the Penobscot*, 118, 155, 156, 185, on Elijah L. Hamlin, and 133, 181, 211, 226, 232, 240, on Augustus C. Hamlin; also see MHCC Interment Records.

222. Calculated from MHCC Interment Records and author's previous research.

223. Scee, *Inmates and the Asylum*, 156, on Pitcher's death, as well as other pages, on her work for the home.

224. Scee, *City on the Penobscot*, 203, 205; MHCC Interment Records; tour of cemetery and discussion on pauper's graves with SGB, August 2010.

225. See previous chapters, as well as MARs for 1872–1900, especially report with MAR for 1885 on Cole becoming city undertaker; MHAMs for 1875–82.
226. Meeting of December 4, 1898, MHCC Ledger for EC, 1896–1964.
227. Conversation with SGB, July 2011.
228. Reports with MARS of 1869–82.
229. Ibid; Scee, *City on the Penobscot*, 207.
230. Scee, *City on the Penobscot*, 207, 266; reports with MARs of 1908, 1920 and 1930.
231. Scee, *City on the Penobscot*, 318, 329, 347; reports with MARs of 1930, 1939 and 1939.
232. See Scee, *City on the Penobscot*, on these and other community leaders.
233. MHAMs for 1887 and 1888; Adjourned Meeting of May 4, 1887.
234. MHAM for 1888; see Scee, *City on the Penobscot*, 182, on this group of men during the war. The notation on Bryant may have read "Charles D. Bryant." Either way, the inclusion demonstrates the continuity of certain Bangor families and leaders with both civic affairs and Mount Hope.
235. MHAMs for 1887 and 1888.
236. MHAM for 1889.
237. Ibid.; Scee, *City on the Penobscot*, 224, on the new city hall; 418, 431, on its destruction; and 134, 213, 227, on Strickland.
238. MHAM for 1889.
239. See Scee, *City on the Penobscot*, on the growth of Bangor's economy and its history from the 1800s to 2010.
240. MHAMs for 1889 to 1891; see Scee, *City on the Penobscot*, on Bangor newspapers from the early 1800s to 2010.
241. MHAM for 1890.
242. Ibid.
243. MHAMs for 1890 and 1892.
244. Special Meeting of February 4, 1891; MHAMs for 1891 and 1892; Paine, *History of Mount Hope Cemetery*, 42; BCRD, Book 610, 303; PCRD, Plan Book 6, 2–3, 35.
245. Note from Stetson as recorded in MHAM for 1891, MHCCL.
246. MHAMs for 1891 and 1892; MHCC Interment Records.
247. MHAM for 1891.
248. MHAM for 1892.
249. Ibid.
250. MHAM for 1893.
251. Ibid.

252. Ibid.

253. MHAMs for 1892–95.

254. MHAM for 1893.

255. MHAM for 1894.

256. MHAM for 1895.

257. MHAM for 1892.

258. Special Meeting of September 1, 1892.

259. Special Meeting of September 7, 1892; MHAM for 1893.

260. MHAMs for 1896 and 1897.

261. Mount Hope Executive Committee Meetings (hereafter cited as MHECMs) of May 27, 1896, and May 18, 1897, in Mount Hope Cemetery Corporation, Records of the Executive Committee Ledger from May 9, 1896, to May 12, 1964.

262. Ibid.

263. Meeting of May 9, 1898, MHCC Ledger for EC, 1896–1964; MHAM for 1899.

264. MHAMs for 1894 and 1895.

265. MHAMs for 1897 and 1900; *BDW&C*, undated clip from 1897 in MHCC records.

266. MHAMs for 1892–95, quote from 1894 meeting.

267. MHAM for 1895; MHCC Interment Records.

268. MHCC Interment Records; MHAM for 1896.

269. MHAM for 1894.

270. MHAMs for 1896–1900.

271. MHECM of May 9, 1896.

272. Ibid.

273. MHECMs of May 9, 1896, and May 18, 1897; also see subsequent meetings; see Scee, *City on the Penobscot*, on the treatment of the insane.

274. MHECM of May 9, 1896, and records for subsequent years; see Scee, *City on the Penobscot*, on Bangor's nineteenth-century heyday as the "lumber capital of the world."

275. MHECM of May 9, 1896.

276. MHAMs for 1894–1900.

277. Ibid; see MHECM of May 9, 1896.

278. MHAMs for 1896–99; quotes from MHAM for 1899; see MHECM, May 18, 1898, on the pond being "on Mt. Hope Avenue."

279. See following chapters for details.

280. MHAMs for 1899 and 1900.

281. MHAMs for 1896 and 1897.

282. MHAMs for 1899 and 1900.
283. MHAM for 1900.

Part II

284. Unless otherwise indicated, information on the cemetery's pre-1899 history is taken from previous chapters of the 2012 prequel ("Part I") as written by Trudy Irene Scee using corporate ledgers and other sources for the era, or from Paine, *History of Mount Hope Cemetery*.
285. Copy of Agreement, April 23, 1834; see previous chapters; Paine, *History of Mount Hope Cemetery*; and general cemetery records.
286. Thompson, *Bangor, Maine*, 207; *Bangor Daily News* (hereafter *BDN*), December 19, 1974. An entire literature has developed regarding cemetery and public sites and parks in recent years.
287. Mount Hope Cemetery Corporation (hereafter MHCC) By-Laws as adopted September 26, 1834, MHCL for 1834–58.
288. See previous chapters; MHCL for 1834–58; Paine, *History of Mount Hope Cemetery*, 18.
289. See previous chapters; MHCL for 1834–58; Paine, *History of Mount Hope Cemetery*, 22–25.
290. See previous chapters; MHCL for 1834–58; Paine, *History of Mount Hope Cemetery*, 19–20.
291. See previous chapters; MHCL for 1834–58; Paine, *History of Mount Hope Cemetery*, 29–31.
292. See previous chapters; MHCL for 1834–58; Paine, *History of Mount Hope Cemetery*, 32–34.
293. See previous chapters; MHCL for 1834–58; Paine, *History of Mount Hope Cemetery*, 36–38, 29.
294. See previous chapters; MHCL for 1834–58; Paine, *History of Mount Hope Cemetery*, 47–48; Thompson, *Bangor, Maine*, 375, on second tomb; role of the tomb in northern Maine from interview with SGB, October 1995.
295. See the minutes of MHAMs for the early twentieth century for reports on agriculture.
296. For examples of twentieth-century charitable relations or acts, see MHECMs, November 4, 1905; November 6, 1985; May 31, 1937; April

27, 1931; October 29, 1931; April 10, 1933; December 30, 1937; and April 28, 1956; also see Mrs. William Atwood to Franklin E. Bragg, November 9, 1940.

297. See following chapters for additional information on this and succeeding subjects.

298. James M. Mundy to Harold S. Burrill Jr., August 23, 1974; Burrill to Mundy, December 20, 1974; quote taken from "National Register of Historic Places, Criteria and Procedures for Nominating Properties," circa 1974.

299. Taken from "National Register of Historic Places in the State of Maine," certificate, December 4, 1974; *BDN*, December 19, 1974. The possibility existed of funding for restoration work, but to date, in spite of applications submitted for memorial restoration work, the cemetery received no such funding.

300. See *Best of Bangor* tour pamphlets and related documents, Bangor Historical Society, 1990s.

301. MHAM, April 2, 1900.

302. Ibid.

303. Ibid.

304. MHAM, April 1, 1907.

305. MHAMs, April 1, 1907; April 1, 1901; and April 17, 1902.

306. MHAMs, April 11, 1910, and April 10, 1911; MHECMs, May 12, 1909; May 12, 1910; and May 18, 1911.

307. MHECM, February 4, 1932; MHAM, April 11, 1932. Information on tree survey taken from Harold S. Burrill's (hereafter HSB) notebook for the 1930s.

308. MHECMs, June 14, 1939, and April 8, 1940; and MHAM, May 9, 1989; interview with SGB and Harold S. Burrill Jr. (hereafter HSB Jr.), October 17, 1996.

309. MHAM, April 4, 1904.

310. MHAM, April 2, 1900.

311. MHAMs, April 14, 1914; April 12, 1915; and April 11, 1930.

312. MHAM, April 8, 1908; MHECMs, September 30 and October 2, 1921.

313. MHECMs, June 14, 1904, and June 16, 1905.

314. MHAMs, April 1, 1907 (for first quote), and April 2, 1906 (second quote).

315. MHAM, April 13, 1908; MHECM, June 12, 1907.

316. MHAMs, April 12, 1915, and April 10, 1922; also see MHECM, May 12, 1914.

317. MHAMs, April 10, 1922, and April 9, 1923; MHECMs, October 2, 1921, and May 31, 1923.

318. MHAM, April 14, 1924.

319. MHAMs, April 13, 1925, and April 12, 1926 (for quotes); Special Meeting, August 23, 1927.

320. MHAMs, April 11, 1927, and April 11, 1930; MHECM, August 1, 1928.

321. MHAM, April 11, 1927.

322. MHAMs, April 2, 1900; April 1, 1901; April 10, 1911; April 11, 1910; April 1, 1907; April 2, 1906; April 3, 1905; and April 4, 1904; also see MHECM, June 14, 1904, on Portland cement.

323. MHAMs, April 14, 1924, and April 10, 1922; also see general MHC records for the 1930s.

324. MHAMs, May 10, 1966; April 1, 1969; and May 12, 1970; interview with SGB, October 17, 1996.

325. MHECMs, May 16, 1900; May 15, 1901; and May 13, 1902; MHAM, April 7, 1902, and general MHC records.

326. MHAM, April 4, 1904; MHECMs, 1903.

327. Thompson, *Bangor, Maine*, 499, on the trolley line as described here; see Scee, *City on the Penobscot*, for much further detail on trains, trolleys and other local transportation; MHAM, April 4, 1904, for quote on the waiting rooms.

328. Interview with SGB, October 17, 1996; see Thompson, *Bangor, Maine*, 497–98, for information on Mansur; MHECM, May 12, 1909, for information on waiting room being moved.

329. MHAMs, April 13, 1908, and April 11, 1921.

330. MHAM, April 12, 1909; architectural quote from Thompson, *Bangor, Maine*, 497.

331. MHAM, April 11, 1930.

332. Ibid.

333. MHAM, April 12, 1925; MHECM, February 26, 1935; general MHC records.

334. MHECMs, August 1, 1928, and July 1, 1931; also see *Bangor Daily Commercial*, undated but circa 1935, on file at MHC.

335. *Bangor Daily Commercial*, undated but circa 1935, on file at MHC.

336. Ibid.

337. Ibid.; see MHAMs for the 1920s and early 1930s.

338. Ibid.; interview with HSB Jr. and SGB, October 17, 1996; MHECMs, June 9, 1970, and June 6, 1984.

339. MHECM, April 10, 1950.

340. See general MHC records; MHECMs, July 18, 1903, and May 12, 1909.

341. Interview with HSB Jr. and SGB, October 17, 1996.

342. Ibid.

343. Interview with SGB, October 17, 1996; see MHECM, June 3, 1975, and general MHC records for the era.

344. Acreage totals vary by source. The records of the Bangor Tax Assessor's Office had somewhat varying acreages designated for a few of the parcels such that the total is between 263.39 and 264.88 acres depending on the use of the maps and various tax records. The most consistent number is 263.89.

345. Ibid.; see MHAMs, 1900–1930s.

346. MHAM, April 7, 1902; David J. Nason, Civil Engineer, "Title Plan Showing Property of Mount Hope Cemetery Corporation," updated and registered in 1948 by Charles V. Chapman, Civil Engineer.

347. MHECMs, June 7, 1902; May 5, 1908; and June 13, 1916; Nason, "Title Plan Showing Property."

348. MHECMs, April 11, 1927; April 8, 1940; and May 21, 1947; also see City of Bangor maps, available at BPL.

349. Ibid.

350. MHC Special Meeting of August 23, 1927; MHECM, October 1, 1932. Not shown as a separate lot on MHC or city maps and records.

351. MHECM, October 1, 1930; Nason, "Title Plan Showing Property"; MHECM, June 23, 1943; MHAM, April 12, 1943; James W. Sewall Company, "Survey Plan, Flagg and Mount Hope Cemetery Swap," July 1982; information on Chapman from interview with SGB, January 1996.

352. MHECM, March 12, 1931; MHAM, May 13, 1986; information on the 1996 survey from interview with SGB, January 1996.

353. MHECM, June 29, 1982; quitclaim deeds with covenants included in the records of MH; James W. Sewall Company, "Survey Plan."

354. Note to MHEC reports, July 26, 1982; City of Bangor tax records.

355. HSB Jr. to Ray Bradford Jr., January 3, 1990; MHECM, January 23, 1990; HSB Jr. to Frederick P. Gallant, February 13, 1990; MHECMs, September 19, 1990, and February 5, 1991.

356. MHECMs, April 9, 1951; April 14, 1941; and October 5, 1995; easement dated September 6, 1996; information on stumpage payments from SGB, January 1996.

357. MHECMs, April 8, 1946, and January 30, 1958 (second quote); Jerry Rudman to Horace Stewart Jr., January 13, 1958 (first quote); MHECMs, February 10 and May 11, 1982, and May 12, 1987.

358. MHAM, May 18, 1971; HSB Jr. to MHEC, May 18, 1971.

359. HSB Jr. to MHEC, April 28, 1972; interview with HSB Jr. and SGB, October 17, 1996.

360. MHECM, May 9, 1972; Margaret Chase Smith to HSB Jr., March 17, 1972.

361. MHECM, May 9, 1972.

362. MHECM, July 27, 1972.

363. MHECM, July 18, 1973.

364. MHECM, January 16, 1985.

365. MHECM, July 18, 1973; HSB Jr. to MHEC, May 13, 1974.

366. MHECM, May 21, 1974.

367. HSB Jr. to MHEC, May 20, 1975.

368. MHECMs, June 3, 1975, and May 11, 1976.

369. *BDN*, June 27–28, 1922; interview with HSB Jr. and SGB, October 17, 1996.

370. Overview of MHC cremation records.

371. Ibid.

372. *BDN*, June 27–28, 1982.

373. Taken from MHC cremation statistics; MHC Summary Income Statement, March 31, 1980.

374. HSB Jr. to MHEC, May 1, 1980.

375. HSB Jr. to MHEC, May 3, 1983; MHAM, May 10, 1983.

376. MHECM, November 28, 1983, Martin De Laureal to Charles F. Bragg 2nd, December 8, 1983.

377. MHECM, January 19, 1984.

378. MHECMs, June 6 and October 4, 1984.

379. Ibid. Quotation and related information taken from *The Garden Mausoleum at Mount Hope*, brochure dated December 1985.

380. HSB Jr. to De Laureal, October 5, 1984.

381. MHECMs, January 16 and March 4, 1985; MHAM, May 14, 1985.

382. See MH general records for further information.

383. MHECMs, May 14 and November 6, 1985; March 4, 1986 (with attached plan); also see HSB Jr. to De Laureal, September 25, 1985.

384. MHAM, May 13, 1986.

385. *BDN*, Memorial Day weekend, 1987.

386. Ibid.; HSB Jr. to De Laureal, May 27, 1987; MHECM, June 7, 1988.

387. MHECMs, May 12 and October 6, 1987, and March 2, 1988; MHAM, May 12, 1992.

388. MHECMs, May 12 and October 6, 1987, and March 2, 1988; MHAM, May 12, 1992.

389. MHECM, February 27, 1987; general MH records.

390. MHECMs, February 5, May 14 and December 11, 1991; May 8, 1990; and January 28, 1992.

391. MHECM, August 18, 1992, and attachment.

392. MHECM, August 25, 1992.

393. Interview with SGB, December 10, 1996.

394. MHECM, May 11, 1995.

395. MHAM, April 1, 1901; see Paine, *History of Mount Hope Cemetery*, 50–53.

396. *BDN*, May 31, 1924.

397. Ibid.

398. Ibid.

399. Ibid.

400. Ibid.

401. Ibid.

402. MHEC, *Memorial to the Second Maine Regiment of Volunteers* (Bangor, Maine, 1968), 1.

403. Taken from Whitman and True, *Maine in the War for the Union*, chapter 3; MHEC, *Memorial to the Second Maine Regiment of Volunteers*; some statistics taken from *BDN*, October 3, 1990, as excerpted from *The Civil War*, a Public Broadcast System production.

404. MHEC, *Memorial to the Second Maine Regiment of Volunteers*, 1.

405. MHECM, June 16, 1960.

406. MHECMs, July 13, 1960, and May 8 and December 12, 1961; also see "Standard Agreement Between Owner and Artist," circa December 1961, on file at MHC.

407. MHEC, *Memorial to the Second Maine Regiment of Volunteers*, 31.

408. *BDN*, October 3, 1990, from excerpts from *The Civil War*.

409. MHECM, June 3, 1969.

410. MHEC, *Memorial to the Second Maine Regiment of Volunteers*, 2; MHAMs, May 9, 1967, and May 14, 1968; also see MHECM, May 11, 1965, for more information on the pamphlet.

411. MHECM, October 4, 1994.

412. *BDN*, June 26, 1995; MHECMs, October 4 and 25, 1994.

413. *BDN*, June 26, 1995; MHECMs, October 4 and 25, 1994.

414. For ceremony information, see *BDN*, June 27 and July 27, 1995.

415. MHECM, November 4, 1905. Newspaper advertisement and letter included in minutes.

416. Interview with HSB Jr. and SGB, October 17, 1996; MHECM, May 11, 1965; MHAM, May 8, 1990.

417. Note found by SGB while giving the author a tour in autumn 1995.

418. Interview with HSB Jr. and SGB, October 17, 1996; see general MH records for the era.

419. See general MHC records for the era.

420. MHECMs, July 27, 1972, and May 8, 1973; HSB Jr. to MHEC, April 30, 1973.

421. HSB Jr. to MHEC, May 2, 1977; MHECM, May 10, 1977.

422. MHECMs, May 9, 1978, and May 19, 1979.

423. HSB Jr. to MHEC, May 1, 1980.

424. MHECM, May 20, 1980.

425. HSB Jr. to MHEC, May 5, 1981; MHECM, May 11, 1982.

426. MHECM, May 11, 1982.

427. HSB Jr. to MHEC, May 3, 1983.

428. MHECM, March 4, 1985.

429. MHECM, March 19, 1985; MHAM, May 13, 1986; interview with SGB and HSB Jr., October 17, 1996.

430. MHAM, May 13, 1986; MHECMs, June 7, 1988, and May 9, 1989.

431. MHECM, June 15, 1989.

432. MHECMs, June 7, 1988, and June 15, 1989.

433. MHECM, January 23, 1990.

434. See MHC financial statements for the indicated dates.

435. MHC interment records; general MHC records for the era; the will of Marianne Hill.

436. The will of Frederick W. Hill; MHC interment records.

437. Interview with Charles F. Bragg 2nd, January 1997; the will of Frederick Hill.

438. See MHC financial statements for the indicated dates.

439. Interview with HSB Jr. and SGB, October 17, 1996.

440. See MHECMs and MHAMs for the 1980s.

441. MHECMs, May 16, 1962, and May 9, 1976.

442. MHECM, June 29, 1982.

443. MHECM, November 3, 1988; Charles F. Bragg 2nd, "Location Agreement," MHCC, as well as Pet Film Productions, July 21, 1988; *Ellsworth American*, October 13, 1988.

444. HSB Jr.'s notes for the project, undated.

445. Bragg 2nd, "Location Agreement," as well as Pet Film Productions, July 21, 1988.

446. M. Ray Bradford Jr. to HSB Jr., July 28, 1988; Bragg 2nd, "Location Agreement," as well as Pet Film Productions, August 1, 1988.

447. Bragg 2nd, "Location Agreement," as well as Pet Film Productions, August 1, 1988; Certificate of Insurance on file at MHC.

448. Interview with HSB Jr. and SGB, October 17, 1996; King, *Pet Sematary*. Mount Hope Cemetery was mentioned several times in the book, see 197, 215, 218.

449. Interview with HSB Jr. and SGB, October 17, 1996; the *BDN* of September 24–25, 1988, numbered the crew as "over 100 persons at times."

450. *BDN*, September 24–25, 1988.

451. *Ellsworth American*, October 13, 1988.

452. MHECM, November 3, 1988; *The Register*, October 5, 1988.

453. MHAM, May 9, 1989.

454. Pet Film Productions to HSB Jr., November 14, 1988.

455. *The Register*, October 5, 1988.

456. Information on *Graveyard Shift* from interview with SGB, June 10, 1996; also see MHAMs, May 8, 1990, and May 14, 1991, for mention of the film.

457. Richard Rubinstein to "Dear Friend," March 23, 1989, as sent to MHC.

458. See the holdings of the Northeast Oral History Folklore Center for songs and interview about Fan Jones; see Shaw and Reilly, "In Search of the Real Fan Jones," for information about Jones's life and legal affairs; Adreana Hamlin Knowles, *Pink Chimneys*, 1987.

459. MHC interment records; *BDN*, August 13, 1917.

460. Information on Caddie Dudley taken from Shaw and Reilly; balance taken from MHC records.

461. See Bangor City Directories for the 1880s to 1910s for further information.

462. *BDN*, October 12–14, 1937.

463. Ibid.

464. Ibid.

465. *BDN*, October 15, 1937.

466. Discussion with SGB, spring of 1996; *Bangor Daily Commercial*, October 1937; *BDN*, October 16, 1937; Dick Shaw, *BDN*, February 1976, article with quote on Brady's grave; *BDN*, June 17, 1987.

467. *BDN*, November 2, 1939, and July 27, 1988.

468. The stories about Dwinel are oft repeated and known by seemingly everyone who has a long-term association with Mount Hope. The statement from Ives was part of an interview the author conducted with him on another topic on November 29, 1996.

469. Ibid.; also a discussion with SGB, November 29, 1996, as well as MHC interment records.
470. Unless otherwise indicated, most of the following is taken from general MHC records, especially the Annual Meetings and Executive Committee Meetings, with a few quotations taken from corporate bylaws.
471. MHAM, May 10, 1983; Special Meeting of May 8, 1984.
472. MHECM, June 10, 1930.
473. Interview with SGB and HSB Jr., October 17, 1996.
474. Taken from general MH records and interview with SGB and HSB Jr., October 17, 1996, and from unfolding events.
475. MHAM, April 6, 1903; also see earlier chapters of the new work.
476. MHAM, April 4, 1904.
477. Ibid.; MHAM, April 12, 1909.
478. MHAM, April 13, 1908.
479. Ibid.
480. MHAM, April 14, 1947.
481. MHAM, April 9, 1951.
482. MHAM, April 11, 1932.
483. MHAM, May 12, 1992.
484. MHAMs, April 18, 1918, and April 12, 1920.
485. MHAM, May 9, 1967.
486. President's report, April 18, 1929.
487. MHECMs, April 10 and August 8, 1933; April 19, 1934; and December 30, 1937.
488. MHAM, April 12, 1909.
489. MHECMs, May 14 and August 12, 1991; January 28, 1992; and March 6, 1969.
490. MHAM, April 2, 1900.
491. MHECMs, October 25, 1994, February 14 and August 15, 1995, and May 14, 1996; also see MHAM, May 11, 1995; information on general comments on system taken from discussions with SGB, as well as some information from Edward McCloskey III, 1996.
492. MHECMs, October 25, 1994, February 14 and August 15, 1995, and May 14, 1996; also see MHAM, May 11, 1995; information on general comments on system taken from discussions with SGB, as well as some information from Edward McCloskey III, 1996.
493. Figures provided by Edward McCloskey III, assistant to the superintendent; see HSB's notes for other statistics.
494. See MHAMs for indicated years.

Part III

495. MHECMs, August 15 and October 5, 1995, and May 14, 1996; interview with SGB, August 2001.
496. MHECMs, May 14, 1996, and subsequent meetings; interview with SGB, August 2001.
497. Interview with SGB, August 2011.
498. Ibid., and from the author's personal observation, the author being able to hear the bells, and see Mount Hope, from her home.
499. MHECM, May 13, 1997.
500. Special Meeting of June 5, 2000; also see subsequent signage and rules.
501. MHECM, May 8, 2001.
502. MHECM, December 2002.
503. Interview with SGB, August 2011; MHECM, December 2, 2002; William Reed, Town of Veazie, to Raymond Bradford, July 14, 2005; Raymond Bradford to William Reed, July 28, 2005.
504. MHECM, May 23, 2006; interview with SGB, August 2011.
505. See letters from MHCC to City of Bangor, 2000–2010.
506. MHCC Interment Ledger for Receiving Tomb; interview with SGB, August 2001; on-site observations; see previous chapters.
507. Quarterly Meeting of the Executive Committee, February 27, 2001.
508. MHECMs, May 9, 1995; May 14, 1996; and May 13, 1997.
509. MHECMs, May 14, 1996, and February 3 and March 7, 1997.
510. MHECM, February 3, 1997.
511. MHECM, December 10, 1997.
512. MHAM for 2001; MHECMs, May 13, 1997, and June 5, 2000; interview with SGB, August 2011.
513. Letter of SGB to Executive Committee, August 2, 2004, and "Notice" of August 2004.
514. Interview with John W. Bragg (hereafter JWB), June 2011.
515. MHAM for 2000; Special Meetings of June 5 and December 6, 2000 (also referred to now as Quarterly Meetings).
516. Special Meetings of December 6, 2000; John Mills, "Forestry Plan," December 6, 2000; interview with SGB, August 2011.
517. Interview with SGB, August 2011; Mills, "Forestry Plan."
518. MHECM, May 14, 1996.
519. MHAM for 1995; MHECMs of May 13, 1997, and May 12, 1998.
520. MHAM for 2001; and MHECM, May 14, 2002; interview with SGB, August 2011.

521. MHECMs, May 13, 2003, and May 11, 2010; interview with SGB, August 2011; design plan for new columbarium, 2011.

522. Letter from Eaton and Peabody, Attorneys at Law, to SGB, April 26, 2006.

523. Interviews with JWB and SGB, June 2011, as well as "Crematory Operations, 2001–2005," MHCC, undated but circa 2006.

524. MHECM, December 6, 2005.

525. MHECMs, May 12, 2009; May 11, 2010; and May 10, 2011; interviews with JWB and SGB, June 2011.

526. MHECM, May 13, 2003.

527. MHECM, May 1999; records of author and of Charles Fred Bragg 2nd.

528. See *BDN* obituaries for the era and general MHC records.

529. Letter from Executive Committee to Charles Fred Bragg 2nd, June 11, 2007.

530. Interview with JWB, June 2011.

531. Ibid.

532. MHECM, May 12, 1998.

533. Interview with JWB, June 2011.

Selected Bibliography

Bangor Daily Commercial, assorted dates.

Bangor Daily News, assorted dates.

Bangor Daily Whig & Courier, assorted dates.

Bangor Public Library, Bangor, Maine. Photograph and newspaper collections not otherwise listed.

Chase, Edward E. *Maine Railroads: A History of the Maine Railroad System*. Portland, ME: Southworth Press, 1926.

Ellsworth American, 1980s primarily.

Interviews with Charles Fred Bragg 2nd, 1997–2007.

Interviews with Harold S. Burrill Jr., 1996–1998.

Interviews with John Woodbury Bragg, 2003–2010.

Interview with Sandy Ives, November 1996.

Interviews with Stephen G. Burrill, 1996–1999 and 2008–2011.

King, Stephen. *Pet Sematary*. New York: Doubleday and Company, 1983.

Ledgers of the Bangor Almshouse, available at BPL.

Lunt, Dean Lawrence. *Here for Generations: The History of a Maine Bank and Its City*. Frenchboro, ME: Island Press/Bangor Savings Bank, 2002.

Maine State Legislature. "Act to Incorporate Bangor Horticultural Society," 1834. Maine State Legislature, Maine State Archives/State Library, Augusta, Maine, government headquarters.

———. "Act to Incorporate Mount Hope Cemetery," 1858. Maine State Legislature, Maine State Archives/State Library, Augusta, Maine, government headquarters.

Mayors Annual Addresses. City of Bangor, Bangor, Maine, 1834–1931.

Mount Hope Cemetery Corporation. "Copy of Application to Justice to Be Incorporated Under the General Law as a Cemetery Corporation," 1834. Mount Hope Cemetery, Bangor, Maine.

Mount Hope Cemetery Corporation General Records, 1834–2011, including numerous maps, reports, wills, tombstones, letters, legal documents, et cetera. Mount Hope Cemetery, Bangor Maine.

Mount Hope Cemetery Corporation Interment Records, 1866–2011. Mount Hope Cemetery, Bangor Maine.

Mount Hope Cemetery Corporation Ledger for 1859–85, 1886–1998 and 1999–2011. Mount Hope Cemetery, Bangor Maine.

Mount Hope Cemetery Corporation Ledger for Executive Committee, 1896–1964, 1964–98 and 1999–2011. Mount Hope Cemetery, Bangor Maine.

Mount Hope Cemetery Ledger for 1834–58. Mount Hope Cemetery Corporation, Bangor Maine.

SELECTED BIBLIOGRAPHY

Municipal Activities Reports. City of Bangor, Bangor, Maine, 1832–65.

Municipal Monthly Reports. City of Bangor, Bangor, Maine, 1996–2010.

Northeast Oral Folklore Center. Various documents and recordings. University of Maine, Orono.

Paine, Albert W. *History of Mount Hope Cemetery*. Bangor, ME: O.F. Knowles, 1907.

Penobscot Registry of Deeds, various deeds from 1834 to 1900. Penobscot County Courthouse, Bangor, Maine.

Private and Special Acts of the State of Maine, Passed by the Fourteenth Legislature. Augusta, ME: I. Berry & Co., Printers to the State, 1834.

Scee, Trudy Irene. *City on the Penobscot: A Comprehensive History of Bangor, Maine*. Charleston, SC: The History Press, 2010.

———. *The Inmates and the Asylum: The Bangor Children's Home, 1835–2002*. Gardiner, ME: Tilbury House/Bangor Children's Home, 2002.

———. *Maine Explained*. Bangor, ME: BookMarcs, 2012.

———. *N.H. Bragg & Sons: 150 Years of Service to the Maine Community and Economy, 1854–2004*. Gardiner, ME: Tilbury House/N.H. Bragg, 2005.

Shaw, Richard, and Wayne E. Reilly. "In Search of the Real Fan Jones." *Down East* (April 1988).

Smith, David C. *A History of Lumbering in Maine, 1861–1960*. University of Maine Studies no. 93. Orono: University of Maine Press, 1972.

Thompson, Deborah. *Bangor, Maine, 1760–1914: An Architectural History*. Orono: University of Maine Press, 1988.

Town of Bangor. "By-Laws of the Town of Bangor," adopted 1829. Available at BPL.

Whitman, William E.S., and Charles H. True. *Maine in the War for the Union: A History of the Part Borne by Maine Troops in the Suppression of the American Rebellion.* Lewiston, ME: Nelson Dingley Jr. and Company, 1865.

Wood, Richard G. *A History of Lumbering in Maine, 1820–1860.* University of Maine Studies no. 33. Orono: University of Maine Press, 1935. New edition with preface by David C. Smith, 1971.

ABOUT THE AUTHOR

Trudy Irene Scee is a free-lance writer and historian living in the Bangor, Maine area. She holds undergraduate degrees in forestry and history, a Masters of Arts in history from the University of Montana and a Doctor of Philosophy degree in history from the University of Maine. She has also studied engineering and anthropology and has received a number of academic fellowships and awards.

Dr. Scee has taught history at Mount Allison University in New Brunswick and worked extensively for the University of Maine system. For the past few years, she taught at Husson University in Bangor, and she now works with disadvantaged and other youth. She has published academic essays, held photographic exhibits and worked as a journalist. In addition to this volume, she has had published *A Bird for a Bonnet: Gender, Class in Culture in American Birdkeeping, 1776–2010*; *City on the Penobscot: A History of Bangor, Maine, Since 1769*; *Tragedy in the North Woods, The James Hicks Murders*; *In the Deeds We Trust: Baxter State Park, 1970–1994*; *The Inmates and the Asylum: The Bangor Children's Home, 1835–2002*; *Mount Hope Cemetery: A Twentieth-Century History*; *N.H. Bragg & Sons: 150 Years of Service to the Maine Community and Economy, 1854–2004*; and *Trudy Scee's Dictionary of Maine Words and Phrases*. Additional works are underway.

Visit us at
www.historypress.net